THE NELSON-ATKINS MUSEUM OF ART

The Nelson-Atkins Museum of Art

A HISTORY

Kristie C. Wolferman

UNIVERSITY OF MISSOURI PRESS

Columbia

Library of Congress Cataloging-in-Publication Data

Names: Wolferman, Kristie C., 1948- author.
Title: The Nelson-Atkins Museum of Art : a history / by Kristie C.
Wolferman.
Description: Columbia : University of Missouri Press, [2020] | Includes
bibliographical references and index.
Identifiers: LCCN 2019025978 (print) | LCCN 2019025979 (ebook) | ISBN
9780826221971 (hardcover) | ISBN 9780826274410 (ebook)
Subjects: LCSH: Nelson-Atkins Museum of Art--History.
Classification: LCC N582.K3 W66 2020 (print) | LCC N582.K3 (ebook) | DDC
708.1778/411--dc23
LC record available at https://lccn.loc.gov/2019025978
LC ebook record available at https://lccn.loc.gov/2019025979

This paper meets the requirements of the
American National Standard for Permanence of Paper
for Printed Library Materials, Z39.48, 1984.

Typefaces: Minion Pro

This book is a co-publication of the University of Missouri Press and the Nelson-Atkins Museum of Art

The
Nelson-Atkins
Museum
of Art

Contents

FOREWORD

A museum should never be finished, but boundless and ever in motion.

—Goethe

THE DAY-TO-DAY BUSINESS of running an encyclopedic art museum and welcoming visitors into our galleries is all-consuming. We rarely have a moment to look back and ponder the past. And yet each day here at The Nelson-Atkins Museum of Art, we are building on the decisions and generosity of individuals who, long ago, were deeply committed to creating a place of beauty and distinction in Kansas City.

I am delighted that Kristie Wolferman came to us months ago with the proposal to update her written history of the Nelson-Atkins. We were happy to give her full access to the museum's archives and to grant interviews so that she could ask questions about the past and present. Now we can all enjoy the results of her work in this detailed account.

Two observations, upon reading her history:

So many decisions about an art museum for Kansas City were made one hundred years ago, fifty years ago, twenty-five years ago. Today we feel immense gratitude that it all fell into place so beautifully—decisions about where the museum should be located, who would pay for the building, how involved the city would be, and how in the world to buy enough original works of art to fill a future museum.

However, I am also struck by the many threads of conversation from years ago that are still in discussion today. Should the art museum be a civic center? Should the museum sell lesser works of art and acquire finer pieces? How do

we best engage visitors? Who will emerge from the community to support the museum financially?

From my interactions with people across the region, I know they have experienced the Nelson-Atkins in many ways through the years. No one history can capture those diverse perspectives. Attempting to crystallize the past is like chasing the distant horizon; it always escapes.

In spite of that, Wolferman has given us an excellent account of events that unfolded and the people who were involved. It is fascinating to read the names of supporters I have come to know through their children and grandchildren, or from donor lists, or from documents that continue to guide us even now. What a gift!

The impact of the decisions and support of each individual have been immense, and I see it every day. The strong vision then allows us to focus now on the impact we have on each visitor. That is our ultimate goal: to be a museum *where the power of art engages the spirit of community.*

I like to think that if I could walk through the museum with the decision makers of the past, they would see the significance and immediacy of what they championed long ago and feel great pride!

Julián Zugazagoitia
Menefee D. and Mary Louise Blackwell Director & CEO
The Nelson-Atkins Museum of Art

ACKNOWLEDGMENTS

"LET'S MAKE HISTORY TOGETHER!" Julián Zugazagoitia, the Menefee D. and Mary Louise Blackwell Director and CEO of the Nelson-Atkins Museum of Art, exclaimed when I broached the subject of revising and updating my previous history of the museum. Julián's enthusiasm extended to his staff, who supported my research. Special thanks go to Archivist Tara Laver, with whom I spent every Monday and Thursday for more than a year and who made it her mission to find any and all information and images I requested. Gaylord Torrence, Fred and Virginia Merrill Curator of American Indian Art, volunteered his time and expertise to read and edit my text about the Nelson-Atkins's collection and display of Native American art. Catherine Futter, Director of Curatorial Affairs, expertly and promptly answered all my questions related to the collection, while Karen Christiansen, Chief Operating Officer, helped me understand the many changes that have been made in the organization, administration, and operation of the museum since I wrote my previous history. Keith Davis, Senior Curator of Photography, shared his thorough and careful research on the museum's amazing photographic collection, and MacKenzie Mallon, Provenance Specialist, checked the history of several works of art. The library staff, headed by Amelia Nelson, and Anne Manning, Director of Education and Interpretation, assisted me as did Stacey Sherman, who handled citations and permissions with alacrity and ease. I also came to know and appreciate Debbie Oliphant, James Hymes, and Robert Gotow in the Security Command Center.

Past staff members, trustees, and friends aided in my research. Many thanks go to Marc Wilson, Director Emeritus, who spent hours answering my innumerable questions and telling me about his experience as Curator of Oriental

Art and his twenty-eight years as director of the museum. Ellen Goheen, who served in many different positions at the museum over the course of thirty-one years, graciously and professionally filled in all the gaps in knowledge that I could not find in the trustees' minutes or directors' files. My talks with Father Thomas Wiederholt, Sarah Ingram-Eiser, Patricia Cleary Miller, Carolyn Kroh, Linda Woodsmall-DeBruce, Tom Bloch, Bruce Mathews, Elliot Rowlands, and Mary Lou Brous broadened my understanding of the social history of the museum while Laura Mombello at the Barstow School and the staff at *The Independent* helped me find information about the Nelson family.

My interest in writing about the Nelson-Atkins Museum of Art began with my master's thesis, so I would again like to thank my advisor in the UMKC history department, the late Richard D. McKinzie, and Lindsay Hughes Cooper, whose remarkable stories about the early days of the museum gave me perspective on what it was like. When Andrew Davidson, editor-in-chief at the University of Missouri Press, suggested that I write a new history of the Nelson-Atkins, I did not realize the extent of this project. I am grateful to Andrew for his confidence and support.

Finally, I would like to thank my friends and family, especially my husband, who have put up with my consuming focus on the stories about the museum.

THE NELSON-ATKINS MUSEUM OF ART

INTRODUCTION

T HE FIRST AMERICAN art museum open to the public was probably the personal gallery of painter Charles Willson Peale, founded in the 1780s, shortly after the American Revolution. Not only did Peale's museum display portraits of prominent men painted by Peale and his sons, but his exhibition hall was filled with stuffed animals and birds as well, since Peale was also a taxidermist and naturalist. A few other early museums comprising private collections were conceived shortly after Peale's, and some university and college art museums were founded in the first half of the nineteenth century. It was not until after the Civil War, however, that American art museums as we know them today began to proliferate.[1]

Although art museums in the United States derived their inspiration mainly from European prototypes, they were very different from European museums. First of all, the major movement to erect American art museums, which began in the 1860s and gained momentum in the early twentieth century, coincided with efforts to beautify American cities. The aim of the so-called City Beautiful movement was to transform urban areas into more aesthetic and hygienic places in which to live. Many American cities had grown uncontrollably, and urban planning became very important. The great American landscape architect Frederick Law Olmsted was a leading practitioner of the City Beautiful movement. Olmsted's 1851 design for New York City's Central Park and his 1870 plan for a complete New York City park system marked the beginning of the American beautification era. Making art accessible to all people was as much a part of the City Beautiful movement as were parks and boulevards. According to historians Charles N. Glaab and A. Theodore Brown, "City Beautiful always involved much more than the creation of monumental

3

public buildings, boulevards, and civic centers. The beautification of cities . . . was part of a long-standing middleclass effort based on religious principles to improve the moral conditions of the urban masses and to create civic responsibility in the urban community."[2]

Thus, American art museums were not created simply as places to visit in order to view and draw inspiration from works of art. From their inception, they were designed with an emphasis on their role as educational institutions. Their patrons came to expect a variety of teaching activities, which many European museums did not provide.

Another unique aspect of American art museums was that they were usually funded privately, unlike their European counterparts. With no royal or federal backing, most American museums came to be because of avid private collectors. For many wealthy Americans, summer treks to Europe not only heightened their awareness of the visual arts but also gave them opportunities to acquire art objects themselves. After viewing European museums and collections, many Americans returned home feeling that the United States lagged behind Europe in cultivating the arts. To narrow that cultural gap, concerned citizens in many cities began to raise money to build museums. Some cities, such as New York, St. Louis, and Detroit, used public funds for art institutions. In the majority of cases, however, donations from individual benefactors funded the building of art museums in the United States. Among those museums constructed through private funding was Kansas City's William Rockhill Nelson Gallery of Art and the Atkins Museum of Fine Arts, renamed the Nelson-Atkins Museum of Art in 1982.

When the Nelson-Atkins opened to the public in December 1933, it was viewed as somewhat of a miracle. Designed in the classical style of so many of its predecessors, the Nelson-Atkins was both more opulent and more beautifully landscaped than most other museums. In addition, no other art museum could claim to have acquired such a remarkable collection of art in such a short time. The objects displayed in the new museum—which included an impressive number of European masterpieces—were purchased by the trustees on a three-year buying spree. Because none of the major benefactors were serious art collectors, the museum's first trustees, curators, and advisers had to create an acquisition strategy. Finally, both the beautiful edifice and this remarkable art collection had come to exist in a midwestern city whose image was one of cowboys and steaks, not cultural institutions.

While outsiders and even Kansas Citians looked at the physical reality of the Nelson-Atkins Museum of Art as miraculous, the real miracle was in how

the institution came to be. Many fortuitous circumstances enabled the major benefactors' funds to be channeled together to build the institution and its collection. The worldwide financial and political situation during the 1930s and 1940s significantly helped the museum's efforts to build a collection of such merit. However, the people of Kansas City were the most important elements in creating the Nelson-Atkins Museum of Art. Their dreams and ambitions and hard-earned dollars made this art museum an oasis in an otherwise bleak midwestern cultural landscape.

An art museum, or any kind of institution, does not just happen; it requires someone who can see a need, provide the funds, and execute the plans. In the case of the Nelson-Atkins Museum of Art, many people were involved in a complex project that took more than twenty years to reach fruition. Kansas Citians first learned of the real possibility of building an art museum when a reclusive widow named Mary Atkins died in 1911, leaving part of her surprisingly large estate for that purpose. The trustees of the Atkins estate moved slowly and carefully, eventually joining forces with the trustees of several other estates, principally that of William Rockhill Nelson. Nelson, editor-in-chief and owner of the *Kansas City Star* and *Kansas City Times* newspapers, died in 1915, leaving an estimated $11 million to buy works of art. Nelson's will did not provide for a museum to house the art purchased with his funds, but the estates of his widow, daughter, son-in-law, and family lawyer did. Although the Nelson family and Mary Atkins made their bequests for separate museums, the trustees for their estates saw the similarities in their intentions. Built under one roof—with the William Rockhill Nelson Gallery of Art on the west and the Atkins Museum of Fine Arts on the east—the museums became far more grand than anything the individual donors could have imagined.

The benefactors determined that Kansas City needed an art museum and provided the funds to build one, but they made no provisions for running it. Each benefactor chose trustees to manage his or her estate; however, among those many trustees there was no one who knew much about art. The trustees stipulated by Nelson's will to manage his trust were named by the presidents of the three major universities in the vicinity, and they took over the business of establishing the art museum. Although they had no art background, these three men had business acumen and many talents. Real estate developer J. C. Nichols, wholesale businessman William Volker, and commercial realtor Herbert V. Jones began their service as University Trustees in 1926. Volker resigned before the museum opened, but Jones and Nichols held their positions

as trustees until their deaths, shaping and controlling the formation of the museum in ways the benefactors never could have conceived.

The University Trustees acquired art for the collections, selecting from objects offered for their consideration by their handpicked advisers. They set policies, interpreted Nelson's will as they saw fit, and hired staff. Fortunately for the museum, Nichols's and Jones's intuitions about art and about people were usually correct. They risked allowing a young graduate student in China to purchase artworks for them in the midst of the Great Depression. Out of this relationship grew the Nelson-Atkins's outstanding Chinese art collection and a lifelong commitment by Laurence Sickman to the institution. Thanks to the trustees, as well as the outstanding people they hired—most notably Director Paul Gardner—the Nelson-Atkins became the venerable institution it is. When Gardner retired and Nichols and Jones died, the museum was left with established objectives and, in Sickman, a new director who had been involved with the museum almost since its birth.

This is the story of the museum's establishment and succeeding years. Although the Nelson-Atkins Museum of Art is certainly a product of its time, it is also unique in many ways. In addition to being able to claim that both its art collection and its building were built from scratch, this major historical art museum began with no art experts at the helm. An amazingly fortuitous combination of people, events, and circumstances led to the creation of a much-lauded temple of art in a seemingly unlikely place.

PART I

THE EVOLUTION OF THE CONCEPT

1911–1927

CHAPTER 1

---◆---

MARY ATKINS'S DREAM OF AN
ART MUSEUM

W HEN MARY ATKINS died in 1911 at the age of seventy-four, few
people claimed to have known the reclusive woman. However,
almost everyone in Kansas City was curious about her once the
terms of her will became public. The headline in the *Kansas City Times* an-
nounced, "A Surprise to Art Lovers." Kansas Citians were amazed to learn that
Mary Atkins had left an estimated $1 million estate and that a portion of it was
"for the purchase of the necessary ground in Kansas City, Missouri, and the
erection of a building to be maintained and used as a Museum of Fine Arts
for the use and benefit of the public, to be called the 'Atkins Museum of Fine
Arts.'" A follow-up article on October 16, 1911, the day after Mary Atkins's
funeral, added, "Kansas City is to have its longed for art museum at last and
through the beneficence of a woman."[1]

The establishment of an art museum by Mary Atkins shocked even her
friends. Mrs. E. Popham, who lived at the Washington Hotel with Atkins for
five years and was with her at the Antlers Hotel in Colorado Springs at the time
of her death, never heard Atkins speak of the matter. State Senator Charles
Clarke, with whose family Atkins had lived from 1886 to 1893, told report-
ers that, although "Mrs. Atkins was greatly interested in Kansas City having
a civic center with a library, an art museum," she had never mentioned her
intention to make such a bequest. Howard E. Huselton, the secretary of the
Kansas City Art Institute, an organization formed by the Sketch Club in 1887
to train would-be artists, had met Atkins at the Antlers Hotel six weeks before
her death. He reported that she had expressed interest in the institute but had
said nothing of her plans to give Kansas City an art museum. Yet the money
bequeathed by Mary Atkins for a museum made her the most generous bene-
factress the community had ever known.[2]

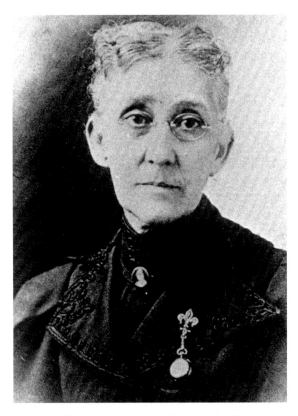

FIGURE 1.1 The reclusive Mary Atkins surprised Kansas
Citians when her 1911 will revealed she had left a portion
of her sizeable estate to build an art museum. (RG 70,
NAMAA)

From most evidence, Mary Atkins did not develop an interest in art until
fairly late in life. Born October 22, 1836, in Salvisa, near Lawrenceburg, Ken-
tucky, Mary McAfee taught school in Kentucky until her marriage to James
Burris Atkins. Although Mary had known James Atkins since she was a child,
their lives did not intersect for many years thereafter. In 1848 James Atkins,
who was ten years older than Mary, married Frances E. Hackley in Mercer
County, Kentucky, and the couple subsequently moved to Savannah, Missouri,
where Frances died in 1855. Legend has it that James foolishly promised Fran-
ces on her deathbed that he would never remarry, a promise he managed to
keep for many years. However, after moving to Kansas City in 1865 and start-
ing a milling business, Atkins began corresponding with Mary McAfee, and in
1878 he decided to go to Kentucky to marry her.[3]

When the forty-two-year-old Mary Atkins arrived in Kansas City, she found the city that would be her new home a coarse river town. Its streets were unpaved. There were no sewers or waterworks, no public schools worthy of the name, no police station or organized fire protection. Needless to say, there was no art museum. Yet Kansas City was booming. The town, which claimed a population of only about 3,500 at the end of the Civil War, had grown dramatically to 32,268 by the time of the 1870 Census, and the population would jump to 55,000 by 1880. The Hannibal Bridge, the first railroad bridge across the Missouri River, had opened in 1869, turning Kansas City into a burgeoning railroad center almost overnight. With this rapid growth came financial success for some entrepreneurs as well as new problems of social disorganization and urban sprawl. Although some areas of the city, notably Quality Hill, sported grand houses and spacious yards, a large portion of the populace lived in slum-like conditions. An ugly boomtown is probably an apt description of the Kansas City that greeted Mary Atkins.[4]

Mary and James Atkins settled in downtown Kansas City at 903 McGee Street, where they lived a quiet life. Even though Atkins had made a considerable fortune by speculating in downtown real estate, the Atkinses spent little; they had simple habits and were conscientiously religious. They attended the First Christian Church at 1112 East Tenth Street, where they had a small circle of friends, including the Jenkins family. Andrew Jenkins, who had been Atkins's business partner and best friend, died before Mary came to Kansas City, but Atkins stayed close to the Jenkins family and handled all business matters for Andrew's widow, Sarah. Their older son, Burris Atkins Jenkins, namesake of James Burris Atkins, knew the Atkinses as well as anyone. Jenkins recalled Mary Atkins as "a slender, angular-looking, spinsterish type of woman . . . but she had large eyes that dominated her face and made her nice looking." She and her husband both had a "dry humor, a quaint way of saying things, and a frequent smile which never broke out into laughter."[5]

That frequent smile disappeared from Mary's face in 1886 when James Atkins died suddenly at home one evening. Mary was brokenhearted; for a whole year, Burris Jenkins remembered, she never smiled. Then two people helped bring happiness back into her life. One of them was Sarah Jenkins. Although she and Mary had been friends since Mary came to Kansas City, their relationship grew closer after they both were widowed. Temperamentally, Mary Atkins and Sarah Jenkins presented quite a contrast. Mary was quiet, stern, very intelligent, and had little outward personality, while Sarah was full of life, vivacious, clever, and humorous. Nonetheless, the two women took comfort in each other's company. After James died, Mary moved in temporarily with

Sarah, who was living with her second son, Paul, and his wife. Later, when Mary went to live with Judge and Mrs. Charles Clarke on Locust Street, she still saw Sarah frequently, and the two women vacationed together.

In 1893 they visited the World's Columbian Exposition in Chicago, where they enjoyed the exhibitions, including a large collection of oil paintings and other art objects, and the beauty of the "White City" built for the fair. This World's Fair, which commemorated the four-hundredth anniversary of Christopher Columbus's "discovery" of the New World, also celebrated the idea of the City Beautiful. Supervisor Daniel Burnham, a well-known Chicago architect, coordinated the plans for the construction of the all-white fair buildings, while Frederick Law Olmsted, the noted landscape architect, planned the grounds. The White City was designed to be the ultimate example of urban planning, representing some twenty years of work in the field of city improvement and beautification.[6]

When Atkins returned to Kansas City, she brought with her the knowledge that cities could be beautiful and civilized places. There were Kansas Citians already on the City Beautiful bandwagon, working toward improving the aesthetics and hygiene of their city. Beginning with newspaper editorials in the 1870s, the beautification movement picked up enough momentum that Kansas City obtained its first public park, Cemetery Park, in 1879. Kansas City voters sanctioned the formation of a park board under an 1889 charter, and in 1893 the board's secretary, landscape architect George Kessler, presented a plan for extensive improvements. His report called for condemning blighted areas of the city and developing three major city parks with a grand boulevard system connecting them. Although it would take some time for Kessler's plan to be effected, Atkins lived to witness the transformation of Kansas City into a far more beautiful city than the one she had found when she arrived in 1878.[7]

In addition to Sarah Jenkins, the other person who brightened Mary's life was Elizabeth (Lizzie) Salmon, James's niece. Sometime after her husband's death, Mary asked the sixteen-year-old Elizabeth to come from Kentucky to live with her. While residing with her aunt at the Clarkes' home, Lizzie attended Central High School, where she met her future husband, Adolph Frederic "Fred" Jacquemot, who taught languages there. Fred, who hailed from a prosperous Swiss family, was considered an "exceptionally capable instructor" as well as a very handsome and polished young man. After Lizzie graduated from Central High in 1893 as valedictorian of her class, she went on to take postgraduate French classes from Jacquemot. Their classroom acquaintance became a friendship that eventually blossomed into a romance.[8]

Elizabeth Salmon married Fred Jacquemot at 7:30 on the evening of April 19, 1894, at Mary's church, the First Christian Church. Following the ceremony, the couple took a one-week wedding trip, cutting the honeymoon short so that Jacquemot could resume his duties at the high school. After the end of the school year, on June 1, the bride and groom embarked on a three-month tour of Europe, including a visit to Jacquemot's family home in Geneva.[9]

As a wedding gift, Mary Atkins gave her niece a $50,000 dowry, which would have shocked Mary's acquaintances had they known, for they knew her as an extremely penurious person. A quarter century of teaching school and taking care of herself had taught Mary Atkins to value parsimony; for most of her life it did not make sense to her to spend a single penny unnecessarily. Even after her husband died, Mary saved her money by living with friends until she moved into the Washington Hotel. She was also known as the only woman of wealth in Kansas City who did not own a carriage. In fact, she would not even call a cab when she had someplace to go, choosing instead to take a streetcar or walk. When solicited for money, Mary would inevitably say no at first but then, according to acquaintances of hers from the First Christian Church, she might well go home and write a generous check if she deemed the cause worthy. Perhaps seeing Lizzie happily married had finally made Mary realize that she actually might (and should) enjoy sharing some of her considerable fortune.[10]

After the Jacquemots returned home from their three-month wedding trip, Fred went back to his position at Central High, where he would continue to work until 1900. Meanwhile, Lizzie filled her aunt's head with the desire to see the places she and Fred had just visited in Europe. So, in 1897 the shy, spinsterish, unadventuresome, sixty-year-old Mary Atkins did the unthinkable. Inspired by her niece, she got a passport, took French lessons, and decided to go to Europe with Lizzie and Fred.[11]

Mary Atkins loved Switzerland and thought Geneva was the most beautiful city in the world, that is until she saw Paris! She decided to return to Europe the next summer (of 1898) and took with her a letter of credit for $800, $220 worth of gold, and $158.95 in paper money. The meticulous records she kept in her travel expense journal indicated that she spent only $919.40, as always a prudent person. Two years later, she wanted to go back to Europe. She had been continuing her French lessons and especially wanted to visit the Paris Exposition Universelle of 1900. Lizzie and Fred agreed to travel with her, but, obviously, they had plans to tour more than Europe. The "In Society" section of the *Kansas City Star* announced, "Professor and Mrs. Adolf Jaquemot [*sic*] and Mrs. Adkins [*sic*] left Thursday [May 30, 1900] for New York preparatory

to sailing for a trip around the world. They will be gone a year and a half." This article explains the Japanese and Turkish stamps on the back of Mary's 1900 passport, hand signed by the Acting Minister of the Empire of great Japan and the Turkish Consul General in Washington, D.C.[12]

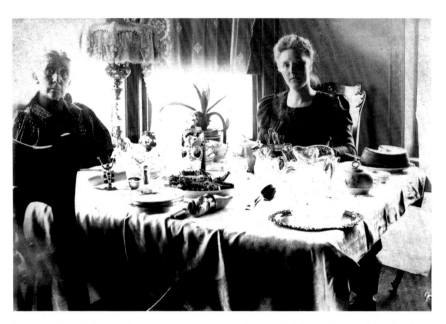

Figure 1.2 Lizzie Salmon Jacquemot, James Atkins's niece, brightened Mary Atkins's life, and with her husband introduced Mary to Europe and the world. (MSS 19, NAMAA)

After this trip, Mary Atkins's niece and her husband decided to live in Geneva. They, of course, encouraged Aunt Mary to visit them, which she did in 1902, her fourth trek to Europe. En route, she stopped in Kentucky to visit her childhood home and see her sisters. Again the next year, Mary went to Europe, leaving in September 1903. This was the last trip that she recorded in her travel expense journal. She noted that she spent all of September in Paris and all of October in Geneva, and kept detailed accounts of her travel expenditures: how much she spent on steamer tickets, sleeper cars, and incidentals such as meals, paper, whiskey, and stamps. Her last entry was, "Arrived in Kansas City for supper evening of 6th of September from Europe 1904." Although Mary may not have gone back to Europe, the Jacquemots would come visit her, and were in fact on their way to spend a month with Aunt Mary when she died.[13]

During her European visits, Mary saw many great cathedrals and museums, including the Luxembourg Palace and the Louvre in Paris, the National Gallery in London, and the Dresden Gallery. From each trip she brought back small treasures: fine vases, wrought metal pieces, pottery, and, perhaps, a heightened desire to leave something of beauty to her beloved Kansas City.[14]

Atkins's trips abroad were possibly the happiest times of her life, and allowed her to shed her reclusive "lady in black" image. Besides her French lessons, Mary began taking art lessons from a painter named Alice Murphy, who became a great friend and may have accompanied her to Europe on one or more trips. While allowing herself to engage in new subjects and new venues, Mary Atkins became less taciturn. She enjoyed the opportunity to share details of her European voyages and her inspiring visits to the art galleries of Europe. She encouraged a young, widowed neighbor in the Washington Hotel to take her three children to Europe to teach them to appreciate culture. The neighbor followed this advice. Her older daughter, Frederica Smeltzer Evans, remembered that their 1907 to 1910 tour of Europe had a "great influence" on her life; she noted, "We saw every cathedral and museum Mrs. Atkins had told my mother about." Also, Frances Logan, who knew Atkins from the First Christian Church, recalled that Mary was very interested in Frances's two years of art study in Paris: "I could tell from the joy she felt in the Louvre and the Florentine galleries that they satisfied a real hunger." Logan thought that, perhaps, she herself had put the idea into Mary's head to give the city an art museum. "I do recall," Frances Logan remembered twenty-five years after Mary Atkins had died, "that she smiled whenever I would say, 'I do wish someone would build us an art gallery.'" Logan added, "It is my opinion her gift to art led to the other and much greater gift from William Rockhill Nelson."[15]

Probably no one will ever know for certain why Atkins left a portion of her estate to establish an art museum. In addition to the love for art and beauty that she acquired during her visit to the White City of the Chicago World's Fair and her journeys through Europe, she believed in returning money to the city from which she had earned it. Edwin C. Meservey, Atkins's attorney, explained,

> Mrs. Atkins loved Kansas City. In her life she had seen it develop from a rough Western city into one of the most progressive and beautiful cities in our country. She was keenly aware that the remarkable increase in value of her estate during the past 25 years was due to the development of the business life of the city. . . . She sought an opportunity to repay in some measure the debt she acknowledged to Kansas City as a whole.[16]

Although she told friends that she dreamed of living in Paris, Atkins said her heart was in Kansas City, as well as her wealth. She had never even considered returning to Kentucky. By her own good management, Atkins had increased the value of her husband's $250,000 estate to more than $1 million. She had held on to her husband's Walnut Street and Grand Avenue property and purchased more real estate, including two lots at 1030 and 1733 Main Street that had more than doubled in value. In her will she provided for her four sisters and her husband's four sisters and their descendants in eight $50,000 bequests. She also made six $2,000 allotments to cousins and friends. Her endowment to the Jenkins family was a $100,000 contribution to the Linwood Christian Church, where Burris Atkins Jenkins served as pastor for many years. She left another $45,000 to various charities, including the George H. Nettleton Home for Aged Women, the Thomas H. Swope Settlement, and the Gillis Orphans Home. Mary Atkins also bequeathed $25,000 to her church, the First Christian Church "to be held as a memorial trust fund in the name of J. B. Atkins and myself." Once she had paid all the obligations she felt her husband would have wanted her to fulfill, Atkins thought she could finance her dream of establishing an art museum.[17]

After Mary Atkins's death in 1911, it took twenty-two years for her art museum to become a reality. Although Mary had wisely chosen as trustees of her estate her friends A. W. Childs and Herbert V. Jones, both of whom were commercial realtors, it was both a boon and a detriment that real estate composed most of her estate. Childs and Jones appraised the estate at $950,000, but they had to sell the property to realize that amount. The $582,000 Atkins had left to individuals and to various organizations all had to be paid, according to her will, before the remainder of her bequest could be used to build the Atkins Museum. By the middle of 1913, Childs and Jones had sold enough of Atkins's property to pay the legacies to her heirs and the organizations named in her will. Childs, in a speech before the Ways and Means Committee of the Commercial Club on June 11, 1913, said he hoped that the rest of the real estate would amount to $300,000. However, he and Jones did not want to sell the property hastily. Prominent businessmen had advised them to wait for a better market.[18]

The Atkins trustees also discovered that Atkins's money was insufficient to purchase a site and build, equip, and maintain a museum. They learned that just the buildings for the art museums in Minneapolis, Buffalo, and Toledo had cost about $1 million each. The trustees concluded that the Atkins Museum could exist only if funds for the site and for building maintenance were donated and if other gifts supplemented the costs of construction and of forming

an art collection. As Childs said, they wanted to make sure that "Kansas City will have a museum of fine arts of which it may well be proud."[19]

Meanwhile, a great deal of public discussion, beginning in 1911 and continuing until 1927, concentrated on the appropriate location for the Atkins Museum. Howard E. Huselton, the secretary of the Art Institute, said the museum should be located in the heart of the city, yet it should be "where there is neither smoke nor sordid surroundings." A committee of businessmen meeting at the Coates House Hotel shortly after the announcement of Atkins's gift argued the relative merits of two plans for incorporating the Atkins Museum into a civic center. They discussed building a twenty-story skyscraper somewhere between Ninth and Twelfth Streets with a two- or three-floor library, several floors for courtrooms, and space for the museum. The other plan they considered involved developing several special-use buildings on Grand Avenue. There is no indication that the Atkins trustees seriously pursued either of these proposals.[20]

One site the Atkins trustees did contemplate was in a proposed park at Twenty-third and Main, across from the site where the new Union Station was being built. Begun in 1909 to replace the undersized and disreputable Union Depot in the West Bottoms, Union Station was part of the city beautification plan drawn up by landscape engineer George Kessler. When architect Jarvis Hunt was hired in 1906 to design the new station, his original plans, as described to Kessler, included making the building part of a large civic center, a fashionable concept at the time. Hunt, who with his uncle Richard M. Hunt of New York had participated in planning the White City at the Chicago World's Fair, envisioned a beautiful parklike setting in keeping with the dignity of the railroad station he had designed. When in November 1909 Hunt announced his proposal for a concourse across the street from the station that would include an art gallery, a post office, a courthouse, and other public buildings, the idea received tacit approval from the *Kansas City Star*. One reason city fathers had initially approved Hunt's costly plans for the new Union Station was that travelers arriving at the depot in the West Bottoms had a terrible first impression of Kansas City, with shacks and ravines blocking their view of downtown. A group of Main Street businessmen, who called themselves the Central Improvement Association, feared that travelers might receive the same kind of view from the new terminal. The grandiose new building faced southward toward a high muddy unzoned hill that had already begun to collect undesirable tenants as work progressed on the station. Kessler, Hunt, and the Central Improvement Association urged the city to adopt the proposal for a park and cultural center. However, the park board's attorney disapproved of the plan,

suggesting other alternatives. Even when the announcement of Atkins's gift for an art museum became public knowledge in 1911, no coalition emerged to support the entire Jarvis Hunt scheme. The city postponed any decision.[21]

Nonetheless, in February 1913 the press reported that the Kansas City Park Board would approve the proposed Penn Valley Park and that the Atkins trustees would cooperate with the city and build the museum across the plaza from Union Station, due to be completed in 1914. Atkins had specified in her will that, given the city's consent, her museum could be constructed in a public park or on other ground acquired by the city and set aside as a "civic center." Therefore, the Atkins trustees had initiated meetings with members of the Kansas City Park Board, who said that they would consider locating the Atkins Museum in Penn Valley Park, the logical choice if the cultural center did, in fact, materialize. Other problems remained as well. The Park Department and the Atkins trustees would have to determine who would control a private building erected on public property. Also, some of Atkins's real estate remained to be sold, so the trustees did not yet have the necessary funds to build their museum. The financial constraints facing the Atkins trustees apparently did not worry Samuel Moore, president of the Kansas City Art Institute, who stated that he had studied art galleries in other cities the size of Kansas City and concluded that the Atkins Museum should emulate the Albright Art Gallery, a $1 million edifice overlooking a lake in Delaware Park in Buffalo, New York. "What Buffalo and Toledo have done, and what dozens of far smaller cities abroad are doing constantly, Kansas City can do and we want to do it on the Kansas City lines—a whole lot better and more permanent than the other fellow." Moore thought the proposed Union Station Park would be the ideal location and the most impressive site for the proposed Atkins Museum.[22]

Although trustees Childs and Jones had considered these possibilities for the museum site, nothing definite had been resolved when William Rockhill Nelson died in 1915, or, in fact, until 1927. Nelson's remarkable gift of art, did not, however, surprise Kansas Citians nearly as much as had Mary Atkins's bequest.

WILLIAM ROCKHILL NELSON'S BEQUEST

W HEN WILLIAM ROCKHILL Nelson died in 1915, he left most of his large estate to Kansas City for the purpose of purchasing works of art. Nelson had come to Kansas City in 1880, just two years after Mary Atkins, and at the age of thirty-nine began to build a fortune in real estate and as a newspaper publisher. Through his newspapers, Nelson expressed his commitment to making Kansas City a beautiful and cultivated place to live. An art collection was one of the amenities he thought a great American metropolis should have.

William Rockhill Nelson was born in Fort Wayne, Indiana, on March 7, 1841, to Isaac DeGroff Nelson and Elizabeth Rockhill Nelson. Although Isaac Nelson, a prosperous gentleman farmer, had plenty of money to provide for young William, his upbringing was very strict. His parents expected him to fulfill many responsibilities at home, and he had to earn all his spending money from the time he was a small boy. Occasionally, the young Nelson rebelled against such strictness, participating in numerous escapades. After one of his pranks, he decided to run away from home. When his father retrieved him, the senior Nelson's only admonishment was to tell his son, "If you are ever in trouble, bring it to me, and I'll always see you through." William never forgot his father's graciousness, evident later in life when he used his newspaper to offer paternalistic directives to Kansas Citians.[1]

In 1856 after Nelson graduated from high school, his parents, although not Catholic, sent him to Notre Dame University, thinking he could benefit from the discipline for which the institution was known. He was not interested in his studies there, and the university asked him to leave after two years. Now seventeen years old, Nelson returned to Fort Wayne and became a deputy clerk of the circuit court, which gave him the opportunity to study law. He

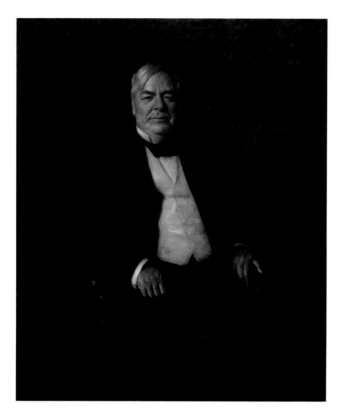

FIGURE 2.1 This portrait of William Rockhill Nelson was painted
by William Merritt Chase in 1907 and hung in Nelson's home, Oak
Hall. (Gift of William Rockhill Nelson, 34-316)

was admitted to the Indiana bar around 1860 and then "began the practice of
law in a small way," as he later related. He also traded in real estate and kept
both his business and his law practice going during the Civil War, in which his
father refused to let him serve. After the war, Nelson and a boyhood friend
went to Georgia, planning to make their fortunes in the sea-island cotton busi-
ness. Leaving his friend to deal with a failing business, Nelson returned to Fort
Wayne and worked for his maternal grandfather Rockhill, a builder who was
developing quality homes on a twelve-hundred-acre tract. This subdivision,
which Nelson's grandfather called the Rockhill Addition, was similar in more
than just name to the Rockhill District, the development Nelson would build
about twenty years later in Kansas City. Records indicate that Nelson was suc-
cessful in the contracting and construction business in Indiana, amassing a
sizable fortune of some $200,000 by 1874. Although this experience convinced

Nelson that contracting did not appeal to him as a career, land development did become a hobby for him later. "Building houses," he remarked as he was working on the Kansas City Rockhill area, "is the greatest fun in the world."[2]

It was during this profitable real estate interlude that Nelson also became interested in politics. He actively supported Samuel Tilden as a presidential candidate in 1876 and especially admired Tilden's stand against the Tweed Ring of New York City and other corrupt political machines. Some years later Nelson himself campaigned against the same kind of evils, which he believed existed as well in Missouri politics. He fashioned himself a progressive reformer and, through his newspaper editorializing, fought for city improvements of all kinds.

Nelson's contracting business in Fort Wayne came to an abrupt halt in 1879 when his investment in cotton growing in Georgia left him almost broke. All he managed to save was an interest in a newspaper his father had owned, the *Fort Wayne Sentinel*. Nelson and the other part owner of the *Sentinel*, Samuel E. Morss, published the Fort Wayne paper for about a year before they decided that the West offered greater opportunities for publishers. After considering a number of midwestern towns, Nelson and Morss sold the *Sentinel* and moved their newspaper business to Kansas City. The two remained partners for another year, until Morss sold his interest to Nelson, who became the sole owner of the paper.

The first issue of Nelson and Morss's Kansas City paper, the *Evening Star*, appeared on September 18, 1880. Although evening papers were still a novelty at the time, two evening and two morning papers were already circulating in Kansas City. Still, the market proved able to handle another paper and the *Star* became successful. Indeed, the recent invention of cheap wood-pulp paper, the production of rotary presses, and especially the rapid growth of cities made the publishing industry a good business to be in in the 1880s. Nelson took advantage of Kansas City's booming population and labored to make his paper different and appealing to the common man. Unlike other papers, the *Evening Star* concentrated on local news, with its entire front page devoted to what was happening in Kansas City. Nelson's paper also thrived because he charged two cents an issue instead of the usual nickel, and he offered a weekly rate of six evening issues for a dime. Circulation increased as Nelson borrowed money to buy fast new rotary presses, added a Sunday edition, and eventually took over two of the four other Kansas City papers—the *Mail*, a small paper with an Associated Press franchise, and the *Times*, a morning paper that Nelson absorbed in 1901 in order to have both a morning and an evening edition.

The *Kansas City Journal* and *Kansas City Post* provided Nelson's papers with their only competition, but they never seriously threatened the *Star* or the *Times*, whose circulation grew rapidly.[3]

When Nelson bought out his partner in 1881, he bragged that the *Star* had become "the Daily W. R. Nelson." Although Nelson rarely made public appearances, readers felt they knew him personally because his ideas pervaded the *Times* and the *Star*. He did not write articles himself, but he outlined what he wanted in his paper, using such clear and vivid language that much of what he said appeared verbatim. Nelson pontificated on any subject about which he had an opinion, no matter how personal or trivial. He advocated breast-feeding babies, putting windows in bathrooms, and affecting a cultivated voice. William Allen White, who worked for Nelson for a few years before becoming editor of the *Emporia Gazette* in 1895, offered the compliment that "Nelson literally gave color to the life and thought and aspirations of ten millions of people living between the Missouri River and the Rio Grande."[4]

People responded to Nelson. His admirers and business associates called him "colonel." He had never been colonel of anything, but, as White said, "He was just coloneliferous." His commanding demeanor led one reporter who interviewed Nelson for a national magazine to come away with the impression that he had been in the presence of a volcano. "He is even shaped like one," reported Julian Street, "being mountainous in his proportions and also in the way he tapers upward from his vast waist to his snow-capped peak. Even the voice that proceeds from the colonel's crater is Vesuvian: hoarse, deep, rumbling, strong." Because of his aristocratic bearing, Nelson's enemies began calling him "Baron Bill" or the "Baron of Brush Creek," after the meandering stream that bordered his real estate holdings some four miles south of downtown. Even though these comparisons to nobility were intended to be degrading, they seemed only appropriate to Nelson's friends and to Nelson himself, who liked to think he was descended from English royalty. Few people could remain neutral toward William Rockhill Nelson.[5]

Through his paper, Nelson earned a national reputation as a progressive reformer and civic leader. He found that his adopted city provided a plethora of issues to champion. To begin with, he, like Mary Atkins, was disturbed by Kansas City's ugliness and dirtiness. Though the city in 1880 had eighty-nine miles of streets, only about five hundred yards of them were paved with sandstone blocks. Broken limestone lined sixteen miles of road, but because of the heavy traffic, the limestone streets resembled the rest of the roads, which were either dusty or muddy and were often impassable. From the very first issue of the *Evening Star*, Nelson campaigned for paved roads: "The city is its

streets; the country is its roads. . . . Everything depends upon accessibility, and in human intercourse accessibility means pathways, roads, streets. Education languishes when mud blockades the road to the little red schoolhouse. . . . Art cannot ennoble or uplift or delight the multitude it cannot reach." The *Star* devoted more space to city streets than to any other subject during the 1880s, and Nelson's efforts for hard-surface roads eventually succeeded.[6]

Paved streets weren't the only things lacking in Kansas City. "Kansas City needs good streets, good sidewalks, good sewers, decent public buildings, better street lights, more fire protection, a more efficient police and many other things," Nelson declared. He thought he could get the city to make improvements and combat its backwardness if the *Star* repeatedly harped on issues until city officials did something about them. Historian William M. Reddig described Nelson's leadership: "The town got more streets, sidewalks, sewers and other things but it seldom had peace again."[7]

Nelson also attacked what he considered to be the source of Kansas City's woes, the city government. Nelson, who called himself an Independent, saw municipal government as "purely a business affair." His view was far from the truth. City government in 1880 had no political organizations or real leaders and was certainly not run like any business. "Mob primaries" took place in each city ward or township at election time and were simply mass meetings in which participants had to be both bold and strong to gain any kind of control. By 1892, when the political primary system had been reorganized to provide for committees to select delegates to the city convention, two Democratic factions had formed: the Pendergast Goats, followers of Jim Pendergast, and the Shannon Rabbits, followers of Joe Shannon. Of these two groups, the Pendergast Goats would continue to gain power, so that by 1902 the *Kansas City Star* reported that Jim Pendergast controlled over half the Democratic vote in the city. Two years later the *Star* contended that Pendergast ran the entire Kansas City Democratic machine. Although Nelson denounced the evils of political machines, he found that he and the Pendergast brothers, Jim and Tom, shared similar goals, one of which was to force the city government to spend some money. "The pinching economy, the picayunish policy, the miserable parsimony, which characterize our city government must be abandoned," Nelson proclaimed.[8]

Besides using city money to correct obvious urban defects, Nelson urged Kansas Citians to beautify their city by planning parks and a boulevard system. Although legend has credited Nelson with initiating the City Beautiful movement in Kansas City, it had started well before he moved to town. "Nelson's genius," historian William Wilson maintains, "lay not in beginning it, but in ably adding impetus to a movement already under way." On May 19, 1881, Nelson

used both the *Star* and the *Times* to launch a campaign for city parks. More than a decade before the carefully planned White City at the 1893 Chicago World's Fair would become a symbol of and an impetus for civic improvement throughout the United States, Nelson denounced the laissez-faire attitude that had predominated in Kansas City and asserted that his city needed controlled growth. Employing a variety of journalistic tactics, including planting letters to the editor, playing on rivalries between cities, and reproducing supportive magazine articles, Nelson promoted the City Beautiful movement by tireless repetition of the same two arguments for parks: "Other cities have them" and "Kansas City needs them." Although the City Council had considered purchasing land for a park as early as 1872 and Cemetery Park already existed (which the *Star* ignored), it took Nelson's constant editorializing to win over Kansas Citians to an ambitious beautification plan. Nelson argued that economic growth alone could not sustain a city. It was time for the "second act of the play"—control and planning of the booming metropolis.[9]

Early in his drive for city planning, Nelson won an ally in August R. Meyer, a refinery industrialist who became a devoted supporter of Nelson's cause. Other citizens were not so easily convinced. Nelson resorted to name-calling, designating those who disagreed with his City Beautiful scheme as "members of the Hammer and Padlock Club"—meaning they took a hammer to every improvement idea and put a padlock on their money pockets. In the *Star* and the *Times*, Nelson's reporters, cartoonists, and editorial writers "flailed, scourged and browbeat" beautification opponents, according to Reddig. These opponents were identified as "croakers, knockers, mossbacks and men without any redeeming qualities." Machine politicians played a dual role in resisting and assisting Nelson's beautification goals. Although Pendergast hoped to defeat Nelson's plan to have a park board independent of city management, he and his cronies supported a project that would provide many new job opportunities.[10]

It was Nelson who urged the city to hire George M. Kessler to draw up a beautification plan. Kessler, who had worked for the famous landscape architect Frederick Law Olmsted on New York's Central Park, had come to Kansas City to design a railroad park in nearby Merriam, Kansas. He had then been hired to beautify a high-priced residential area named Hyde Park. Both of these projects demonstrated Kessler's extraordinary ability to use the natural topography of an area and to visualize how it could be used to advantage to meet human needs. While Kessler was designing the landscaping for August Meyer's home, he had the opportunity to introduce himself to Nelson, whose newspapers were harping on the park issue and insisting on the formation of a park board. After much controversy and many legal problems, a park board

was created in 1892, with August R. Meyer as president. The board then asked Kessler to prepare a plan for city parks and boulevards. The document he presented became "a milestone along the path of American city planning," according to historians. His report gave specifics on how Kansas City could be made into a desirable environment for humans. "Life in cities is an unnatural life," Kessler said. "It has a tendency to stunt physical and moral growth." Kessler had found that many cities had grown by accident, out of control, devastating nature in their paths. He felt certain that through planning, Kansas City could be made into a desirable environment for human living, providing city dwellers needed access to trees, grass, and fresh air.[11]

The plan developed by Kessler eventually included 4,025 acres of parks and 119 miles of boulevards, an impressive and massive project that was adopted and eventually completed with a few exceptions. Kansas City became a much more beautiful city, which pleased Nelson. One of his favorite expressions was "Now, that's the real thing," and he certainly would have used that terminology to describe Kansas City's new parks and boulevards system. He said he once found Kansas City "incredibly ugly and commonplace," then added, "I decided if I were to live here the town must be made over." There remained a great deal that was commonplace, but Nelson could and did take credit for making over a significant part of the metropolis. As one historian determined and Nelson would have agreed, "There were two factors accounting for the phenomenal development of Kansas City—the great bend of the Missouri at Kawsmouth and Nelson."[12]

At the same time that Nelson was advocating city beautification, he started his personal version of a City Beautiful. On land he purchased two miles south of the city limits, Nelson began extensive real estate development in an area that he named Rockhill. He felt sure that Kansas City would develop southward, and his careful and picturesque planning of the Rockhill area virtually ensured that outcome.[13]

Nelson's first building project in Kansas City had been in 1883, when he developed a row of small houses between Walnut and Grand on Thirty-First Street. Because each lot was only twenty-five feet wide, his one-story houses were designed to run unusually deep but compact. On a side street north and west of the Thirty-First Street development, Nelson experimented with building small houses on shallow lots with intervening landscaping, adding beauty and a sense of space—both of which were important in all his future building plans.[14]

Trees, bushes, rambling roses, and especially native stone (from quarries north of Forty-Seventh Street) became trademarks of Nelson's Rockhill

project. Nelson laid out miles of curvilinear streets lined with elm trees and decorative stone walls on land others said had "no future except for pig farming." At his own expense Nelson built Rockhill Road, which ran southeast from the north end of his property at Forty-Third and Oak, crossed Brush Creek on a limestone bridge, and headed back to Oak at Fiftieth Street at the south end of his tract. He set aside twenty of his more than 275 acres for his home site, and in 1887 he tore down an existing farmhouse and began building a large English house of native yellow limestone on a wooded hill overlooking Brush Creek. The grounds of Nelson's house, which he named Oak Hall, covered more than six blocks, bounded by Forty-Fourth Street, Forty-Seventh Street, Oak Street, and Cherry Street. West of and adjacent to the Oak Hall site, Nelson began selling large lots in what he called the Southmoreland section of his property, which he intended for huge houses and estates. August Meyer, Nelson's friend and ally in the drive for city beautification, purchased a plot across Oak from Nelson's Oak Hall site and began building a mansion in 1896. Together Meyer and Nelson decided a park would be an added attraction to the area, and they laid out Southmoreland Park to run from Forty-Fifth to Forty-Seventh along the west side of Oak. By 1904 the Southmoreland area of Rockhill had attracted a large number of wealthy grain merchants, lawyers, and businessmen, who found the open space and picturesque layout of the area more pleasing than their former residences on Quality Hill near downtown.[15]

Nelson's goal for the Rockhill area, he said, was "to immutably establish it as a residence district of high class." He felt that could be accomplished because of the protection of the boulevard system to the east and the "high class" neighbors in Southmoreland on the west. Even though most of the houses Nelson built in the Rockhill District were small frame-and-stone rental homes to be used to provide affordable housing for *Star* employees or other tenants, they were of classic design and built to last. He instructed carpenters to use two-by-sixes instead of two-by-fours and to use twice as many nails as usual. To provide inexpensive transportation for the residents of these rental houses, Nelson by 1904 had deeded enough right-of-way to the Metropolitan Street Railway to allow the trolley to be extended from Westport to Rockhill and to connect with a line to Swope Park. Although public transportation was highly desirable, Nelson found the trolley tracks unsightly and therefore "beautified" them by blocking them with sidewalks, low stone walls, and plantings.[16]

A trip to Europe in 1896 strengthened Nelson's ideas about beauty and his thoughts on the kind of beauty that characterized a truly cultivated city.

FIGURE 2.2 In 1887 on land south of the city limits, Nelson began building Oak Hall, a large English-style home of native limestone. (RG 70, NAMAA)

Besides paved streets, a park and boulevard system, and planned residential areas, he decided a cultivated city needed an art collection. In Florence, Nelson purchased nineteen copies of old master paintings from the Pisani family, collectors of quality reproductions. When he returned from Europe, he brought this nucleus of a collection back with him and presented it to the Kansas City Art Association for the city. The Art Association, which had been incorporated in the state of Missouri in 1887, had as its object "the promotion of artistic education by means of exhibitions, of pictures, lectures, a school, and a museum of fine arts." Since the Art Association's collection of pictures had been destroyed by fire in January 1893, its administrators accepted Nelson's old master copies with grateful appreciation and agreed to display a permanent exhibition of these paintings in the city library. On February 23, 1897, Nelson's collection opened to the public. The only conditions that Nelson had stipulated upon the donation of his reproductions were that any admission fees "be devoted to the purchase of additions to the collection and that the gallery shall be open on Sundays," in order for the working class as well as those with leisure time to be inspired. Nelson named this collection the Western Gallery of Art to emphasize that it was Kansas City's own collection, but Kansas Citians always called it the "Nelson Gallery."[17]

An illustrated catalog described the oil paintings, which included copies of Velazquez's *Head of a Monk*, da Vinci's *Mona Lisa*, Botticelli's *Magnificat*, and

Raphael's *Sistine Madonna*. In addition to the paintings, the Western Gallery's collection included casts of antique and Renaissance works of sculpture and over five hundred photographs of well-known works of art. Nelson hoped that the art in the two rooms of the public library would teach people to recognize and appreciate excellence. The purpose of the collection, an early curator stated, was to "further the development of art appreciation by means of faithful copies of the greatest works of the greatest painters."[18]

Nelson thought people should see the best. Both private collectors and art academies in the late nineteenth century confirmed Nelson's preference for collecting reproductions of well-known paintings by the old masters rather than what they considered to be "inferior" original works. There was no hope of acquiring Europe's greats, like the *Mona Lisa*, but people could learn to recognize and appreciate renowned works of art that were over one hundred years old through the copies Nelson bought, all of which were the exact size of the original works and of the highest quality. Nelson not only felt that the cost of originals was prohibitive for a public gallery, but he knew that few people in Kansas City would have the opportunity to see any old masters in the original. He continued to add to the Western Collection, acquiring a copy of Rembrandt's *Night Watch* in 1900, along with reproductions of works by Frans Hals and Jusepe de Ribera. When Nelson formally transferred the collection from the Art Association to the School District of Kansas City, Missouri, on January 16, 1902, the Western Gallery consisted of a large number of photographs of masterworks and approximately sixty reproductions. Nelson's staff at the *Star* wrote in a commemorative book after Nelson's death, "It was this gallery that he sought to perpetuate and develop for the people of Kansas City by the provisions of his will."[19]

Nelson's interest in art extended beyond collecting reproductions for public enlightenment, and he began to acquire art objects and original paintings for his private enjoyment at Oak Hall. Among the art objects that Nelson's daughter, Laura Nelson Kirkwood, inherited from her father were original paintings by Camille Pissarro, Claude Monet, John Constable, Thomas Gainsborough, Marcus Gheeraerts, John Hoppner, Sir Thomas Lawrence, and Benjamin West.[20]

When William Rockhill Nelson died in 1915, he was effusively praised by almost everyone for his public spirit and was mourned by many. Telegrams of sympathy arrived from all over the country. Thousands of people tried to attend the services held for Nelson at Oak Hall. On that day, the post offices in Kansas City closed; schools dismissed students at noon, and most business stopped. The courts and public offices in Kansas City, Kansas, closed, but

City Hall in Kansas City, Missouri, stayed open and alert because, as Reddig speculated, the machine politicians "knew that Baron Bill wouldn't stay in his grave." The *Star* would continue to fight against machine politicians and to press for city improvements.[21]

Nelson's will delivered what most citizens expected from the man who had tried so hard to cultivate Kansas City, although no one knew then of the magnitude of Nelson's gift. They just knew that he left the majority of his estate for the purpose of purchasing additional works of art for the Kansas City community to enjoy. The only people who expressed surprise about the details of Nelson's will were certain members of his newspaper staff who had expected Baron Bill to reward them for their years of loyalty. Nelson named his wife and daughter trustees of his estate and provided each of them with funds for their personal use for the rest of their lives. He also left $1 million to each of any children his daughter, Laura, might have. He then specified that after the deaths of both his wife and his daughter, the presidents of the universities of Kansas, Missouri, and Oklahoma would appoint two or three "University Trustees" to manage his estate. The first duty of the University Trustees would be to sell Nelson's newspapers, a stipulation that came as a real shock to his staff. The money from the sale of the *Star* and the *Times* and of Nelson's other property would form the William Rockhill Nelson Trust. The University Trustees were to use the net income of the trust to purchase "works or reproductions of works of fine arts which will contribute to the delectation and enjoyment of the public generally."[22]

Nelson made no provision for housing this art collection. In a codicil to his will, he did make clear that any works purchased should be "kept and remain at all times in Kansas City, Missouri, for public exhibition in such buildings as may be provided by the public for that or similar purposes." He may have thought the University Trustees would add to the Western Gallery in the city library or that the city would build a museum to house his gift. Clarence W. Simpson, a former superintendent of the Nelson-Atkins Museum of Art and the chronicler of the museum's first forty years, said Nelson "assumed that because the city had provided public exhibition space for his collection of the Western Gallery of Art, it would house the new collection." Regardless of what Nelson may have had in mind, his wife, daughter, son-in-law, lawyer, and the trustees of Mary Atkins's estate eventually made plans for a project far more monumental than the two rooms the city had furnished at the public library.[23]

CHAPTER 3

———————————————◇———————————————

MAKING DREAMS A REALITY

NELSON'S WIDOW, IDA Houston Nelson, had always encouraged and sustained her husband's interests. After his death, she made sure that Nelson's legacy would be maintained. Rather than leaving the housing of his art collection up to the discretion of the city government, she made provisions in her will to build a museum. In addition, the wills of both Laura Nelson Kirkwood and her husband, Irwin, supported Ida Nelson's intentions, having been carefully worded by family lawyer and friend Frank Rozzelle. Finally, Rozzelle too determined to leave his estate toward erecting and maintaining a building for Nelson's collection.

Ida Houston met her future husband in the summer of 1881, less than a year after he came to Kansas City. The daughter of a physician from Champaign, Illinois, Ida was in Kansas City to visit friends. She and Nelson fell in love and were married that fall, on November 29. They made their first home in an apartment at Eleventh and Central on the fashionable west side of downtown and lived there until the birth of Laura, their only child, in February 1883. Needing more space, they moved to a larger apartment in the Coates House, probably the city's most luxurious hotel. Nelson, however, disliked hotel life and the downtown heat during the summers. He and his wife also wanted their daughter to have space to play outdoors. The income from his successful and growing newspaper business enabled Nelson to purchase a farm south of downtown and to begin construction of Oak Hall in 1887.[1]

Ida Nelson's life centered around her home, her family, and her husband's consuming interests in the newspapers and in cultivating and improving Kansas City. Known as a handsome woman and a gracious hostess, Ida held frequent receptions and dinners for notable guests at Oak Hall. She and her husband and daughter traveled to Europe and spent summers at Magnolia,

31

their home on the Massachusetts coast. In 1910, when Laura married Irwin Kirkwood, he too became involved in the Nelson family's civic interests and in the *Star*. After Nelson's death in 1915, Ida Nelson and Laura Kirkwood acted as trustees of his estate and made plans to bring his goals closer to reality. Most of all, Ida Nelson wanted to see the art her husband had left to the city properly housed.[2]

In 1921, six years after Nelson's death, the city still had not made any attempt to construct a building for his Western Gallery or for the collection that would be acquired by the William Rockhill Nelson Trust. The public library continued to exhibit Nelson's reproductions in two poorly lit rooms. Determined that the present and future art collection deserved a suitable building, Ida updated her will in June 1921 to commit money for that purpose. Apart from several personal bequests and a $25,000 bequest to Grace and Holy Trinity Church, Ida Nelson bequeathed to her daughter Laura "all sums due or owing to me at the time of my death by the trustees under the will of William Rockhill Nelson." The rest of Ida Nelson's money and property, once converted into cash, was to be used by the New England National Bank and Trust Company, trustee, to erect "a building in Kansas City, Missouri, to be used for art purposes and to bear the name of William Rockhill Nelson, followed by the words Gallery of Art." Although Ida Nelson did not specify the location of the building, she did dictate its function. It would house and display the "pictures, paintings, sculptures, rare books, tapestries, and works of the fine arts to be purchased pursuant to the provisions of the last will of William Rockhill Nelson" as well as the art Nelson had "donated to the public now known as the Western Gallery of Art." The Western Gallery would now legitimately be called the Nelson Gallery, and the collection would stand as a monument to the donor.[3]

When Ida Nelson died in October 1921, neither the executors of her will, Irwin R. Kirkwood and Frank F. Rozzelle, nor the New England National Bank, trustee of the estate, made an immediate decision about building the William Rockhill Nelson Gallery of Art as Ida Nelson's will had ordered. In fact, almost eight years would pass before the trustees took action. In the meantime, Frank Rozzelle, Laura Nelson Kirkwood, and Irwin Kirkwood all died. None of them left heirs; all of them made bequests toward building the William Rockhill Nelson Gallery of Art.[4]

The only person to leave money toward the construction of the Nelson Gallery of Art who was not a member of the Nelson family was Frank F. Rozzelle, a longtime friend as well as the family attorney. Born in Kentucky in 1857, he came to Missouri as a youth. He graduated from the University of Missouri,

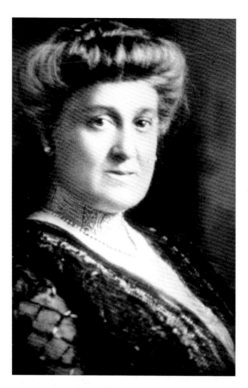

FIGURE 3.1 In her will, Ida Nelson instructed her trustees to erect "a building in Kansas City, Missouri, to be used for art purposes and to bear the name of William Rockhill Nelson, followed by the words 'Gallery of Art.'" (VRLSC, NAMA)

studied law at the University of Michigan, and then settled in Kansas City, where he built a large house at 3400 Main. Nelson credited Rozzelle with a fine civic sense: "I always like to call on Frank Rozzelle for help when I want to find a way to get public improvements done. The inclination of most lawyers is to tell me how it can't be done." Even after he became senior partner in the law firm Rozzelle, Vineyards, and Boys, Rozzelle remained active in Kansas City civic affairs. He pressed for a law that closed saloons on Sundays, and he served as city counselor, police commissioner, and counselor to the city court. He championed Nelson's causes to beautify Kansas City and to make it an art center. When interviewed shortly before his death about his greatest ambition for Kansas City, Rozzelle responded, "I would like to see erected in Kansas City, a great art gallery, similar to, but more splendid than the Metropolitan

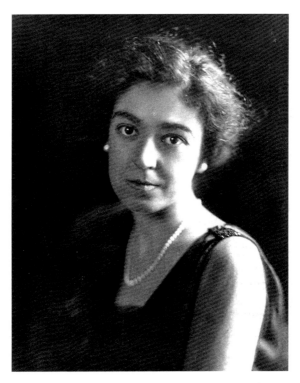

FIGURE 3.2 Laura Nelson Kirkwood, the only child of
William Rockhill and Ida Nelson, died in 1926 at the age
of forty-three, leaving her estate to help build the William
Rockhill Nelson Gallery of Art. (RG 70, NAMAA)

Museum of New York, the Corcoran in Washington, or the Carnegie Institute
in Pittsburgh. The foundation has already been laid to make Kansas City the
art center of the United States."[5]

When he died in 1923, Rozzelle, who had never married, left no heirs. Some
of his money he bequeathed to various relatives and organizations. To his per-
sonal secretary, Wilkie Albers, he left $30,000 in trust, the income of which
she could use in her lifetime. However, Albers never spent the money, and
upon her death the original $30,000 plus the accrued interest went back into
the Rozzelle Trust, which Rozzelle had designated "for the upkeep, mainte-
nance, operation, improvement, and construction of the art building erected
or to be erected under the provisions of the will of Ida H. Nelson." A modest
man, Rozzelle did not ask to have his name attached to his gift. Nevertheless,
the Kansas City public later came to associate his name with Rozzelle Court,
a pleasant courtyard in the center of the Nelson side of the museum, where

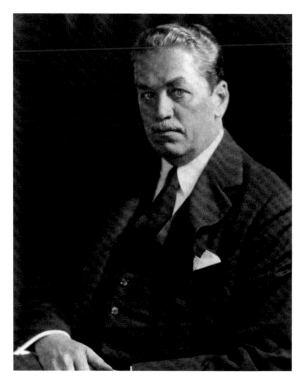

FIGURE 3.3 A little more than a year after his wife's death, Irwin R. Kirkwood also died, bequeathing additional funds to construct the William Rockhill Nelson Gallery of Art. (RG 70, NAMAA)

a plaque commemorates Rozzelle's generosity and which now serves as the Rozzelle Court Restaurant.[6]

Less than three years after Rozzelle's death, on February 27, 1926, Laura Nelson Kirkwood died suddenly in Baltimore at the home of Irwin's brother of what the coroner called an apoplectic stroke. According to Irwin, Laura had gone to Baltimore to have her eyes examined by a specialist and then planned to meet her husband to begin a trip to Europe. She was found beside her bed, dead at the age of forty-three. Her obituary suggested that she had been ill the month before but did not mention that she may have been suffering from alcoholism for some time. Whether her excessive drinking contributed to Laura's premature death has not been determined.[7]

People close to Laura described her as a vivacious, slight brunette with a strong personality, a great sense of humor, and a wide range of interests. According to Fred C. Vincent, the trustee of Laura's estate, Laura inherited

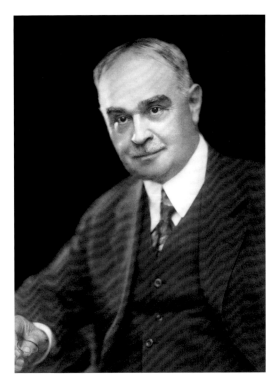

FIGURE 3.4 Frank F. Rozzelle, the Nelson family's friend and attorney, died in 1923 and left money for the upkeep, maintenance, operation, and/or construction of the William Rockhill Nelson Gallery of Art. (MSS 21, NAMAA)

kindness, sincerity, and a keen understanding of others from her mother. She inherited her independence, alert mind, and cultivated taste from her father. Both of Laura's parents had pampered her as a child; they wanted her to have every privilege and opportunity they could provide. Nelson, especially, doted on his daughter. When planning Oak Hall, he even built a barn where Laura could stable her pony and a second-story theater and dance floor so that she could entertain her friends. Although people envied Laura's fairytale existence, she was isolated, having been tutored at home and then at age eleven shipped off to a private academy in Paris. She spent two years there, homesick and lonely. Finally, Laura's parents heeded her pleas to bring her home to Kansas City, where in 1896 they enrolled her in the Barstow School. Barstow had always been a probable educational choice for Laura Nelson, as William Rockhill Nelson had been instrumental in the school's founding, its growth, and its move from Quality Hill to Westport Road and Fortieth Street. After two years at Barstow, though, Laura's parents sent her to finish her education at Miss Emerson's School in Boston.[8]

After Laura graduated from Miss Emerson's, she spent more time abroad. Paris became her home base, where a member of the *Star*'s Paris bureau was

supposed to watch out for her but could not prevent her from making un-authorized trips to Greece, Spain, and Egypt. Laura had developed a love of beauty during frequent trips to Europe with her parents; these travels further instilled in her an appreciation of art and history, one that she shared with her father. Since in this regard Laura's interests were one and the same as her father's, his dream of an art collection for Kansas City was her dream too.

One of the only things Laura and her father did not see eye to eye on was her marriage to Irwin Kirkwood, who had come to Kansas City from Balti-more in 1905. The son of Caroline and Robert J. Kirkwood, both descendants of old Maryland families, Kirkwood grew up and received his education in Baltimore before arriving in the Midwest at the age of twenty-six. He worked as a real estate salesman for the B. T. Whipple Real Estate Company, but he also kept himself busy by socializing with the drinking and gambling crowd that hung around the Missouri Hunt and Polo Club, which is where he met Laura. Irwin Kirkwood, who many described as quite charming, immediately enchanted Laura, a sentiment not shared by her father. He learned from hear-say that Kirkwood was practically broke and that he had, in fact, bragged to his friends that he was out to marry the richest girl in Kansas City, a rumor that did nothing to improve Nelson's opinion of the young man. Nelson did everything he could to discourage Kirkwood's relationship with Laura, but he could not end it. Irwin and Laura married on November 15, 1910, at Trinity Chapel in New York City. Ida and William Rockhill Nelson did not attend the wedding. Instead, Nelson sent a check and told his daughter that in time she would forgive him. When Laura threatened never to return to Kansas City, Nelson wired her, "Come home, Baby," and she did.[9]

After further thought on the matter, and concluding that he did not want to let his feelings cause him to lose his daughter, Nelson welcomed Irwin Kirk-wood into the family by building the newlyweds a large stone house near Oak Hall and by helping Irwin get started in a private real estate business with a $150,000 loan and land to develop south and east of Nelson's Rockhill area. To ensure he maintained controlling interest in the venture, Nelson set up the N-K [Nelson-Kirkwood] Realty Company, with Nelson owning 1,498 out of the 1,500 shares. Kirkwood, meanwhile, remained an enthusiastic polo player and man-about-town. He was also keenly interested in breeding racehorses and be-came somewhat involved in the operation of Nelson's Sni-A-Bar Farm, a model stock-breeding operation on 1,750 acres thirty miles outside Kansas City.[10]

Once the Kirkwoods had set up their home in Stone House, Laura became a typical society woman. She frequented the theatre, the opera, and horse shows, hosted bridge parties and luncheons, and supported many cultural and

philanthropic causes. Her name appeared frequently in society columns in *The Independent* magazine. Suddenly, however, in October 1914, with World War I raging in Europe, Laura found she had a new role to play as head of the local chapter of the Red Cross. No Red Cross chapter had existed in Kansas City prior to this time and no funds had been collected before Laura took the helm. "The selection of Mrs. Kirkwood was a stroke of acute astuteness," *The Independent* claimed. "Mrs. Kirkwood is a young woman of unusual brilliancy, and an honesty of purpose, far beyond her physical strength, but if she takes hold of anything she carries it through to a glorious finish." Supported, of course, by her father's newspaper that urged readers to make contributions, the Kansas City Red Cross chapter raised $50,000, more than any other city in the nation in proportion to population. Laura also raised money for another cause during the winter of 1914/15. She and her friend Mrs. John Fairbairn Binnie noticed a particular need at home. With many indigent people on the street, Laura and Ellen Binnie set up and funded the first-ever soup kitchen in Kansas City, a project that made Nelson very proud of his daughter.[11]

When William Nelson died on April 4, 1915, Laura's life took another turn. She dropped most of her social engagements to fulfill what she thought to be her father's "sacred trust." While Irwin Kirkwood named himself managing editor of the *Star* with his own private office, Laura and her mother became trustees of Nelson's estate, with Laura responsible for handling the money matters. These days Laura divided her time between the *Star* and Sni-A-Bar, the cattle-breeding farm that Nelson had specified in his will should remain intact for thirty years after his death "to promote and instill a better knowledge . . . concerning stock breeding and raising, especially of cattle."[12]

Laura continued her work as head of the Kansas City branch of the Red Cross but her job became more unwieldy once the United States entered the war. In May 1917, Laura resigned as head of the organization, but she continued to help raise funds. Meanwhile, she had taken a leading role at the newspaper. Although Irwin had his name on the masthead, Laura is the one who held a weekly Saturday supper for newspaper executives to discuss *Star* policy, which remained concerned with what Nelson thought was good for Kansas City. Laura often quoted her father's maxim: "The *Star* must be the attorney for its readers. They depend on us to see that their rights are safeguarded. We cannot fail them." It was also Laura who managed and settled the press strike of 1919. In the event, she dug out the pressmen's contracts, determined they were in the wrong, and recruited editors and reporters to support her. *The Independent* reported that "3 o'clock each morning found Mrs. Kirkwood sitting on a big roll of paper in command of the situation in the press room, and

there she remained until the last paper was off the presses." Laura's dominant personality overcame the strike.[13]

Laura lost her mother's support and company when Ida Nelson died in 1921. Now it fell to Laura alone to uphold her father's "sacred trust." Although rumors continued to circulate about her frail health and her drinking issues, the years between 1921 and 1926 were some of Laura's most productive. In 1921, she introduced photos and comic strips to the newspaper. Laura also founded the WDAF radio station in 1922 and oversaw the construction of a small radio studio in the *Star* building at Eighteenth and Grand Avenue. Putting news on the radio was a novelty, and the *Kansas City Star* was one of the first newspapers in the country to endorse and incorporate the innovative medium of radio. In addition, Laura added a Sunday literary and cultural magazine to the *Star*. Each week the cover of the magazine insert featured an old master painting, and the magazine included discussions of famous works of art as well as short stories, poems, and articles about Kansas City gardens, homes, and people.

Laura's premature death in 1926 shocked most everyone, and the provisions of her will surprised many. She bequeathed $60,000 to Irwin and entrusted him with executing her estate. Irwin's minor responsibilities in carrying out his wife's wishes included establishing a boys' choir at Grace and Holy Trinity Church in her mother's memory and managing a perpetual fund to beautify the Nelson Memorial Chapel at Mount Washington Cemetery. Laura committed the rest of her considerable estate to bringing the William Rockhill Nelson Gallery of Art closer to reality. She gave her husband—and, in the event of his death, Fred C. Vincent, John E. Wilson, and the New England National Bank and Trust Company—the right as he (or they) saw fit to convert any or all of her property into cash for the purpose of providing "a site for or the cost of construction of a building in Kansas City, Missouri, to bear the name of William Rockhill Nelson, followed by the words 'Gallery of Art.'" Her trustees could use any remaining funds to purchase works of art. She made no mention of reproductions.[14]

As in the case of her mother, Laura did not specify the location of the art gallery building in her will. She left Oak Hall, where she and her husband had lived since her mother's death, to Irwin, having sold Stone House to Devere Dierks in 1922. Laura gave Irwin full power to "sell or convey" the Oak Hall property, known as Block 6 of the Rockhill District. However, Laura's will contained specific provisions for the disposal of Oak Hall and its contents should Irwin pass away or decide to sell or give away the property. In either case, Laura's will directed that at least two experts examine all the contents

and furnishings of the house to determine which works should be added to William R. Nelson's collection of fine arts. Objects not selected should be sold "through dealers, merchants, or persons, strangers to me, doing business or living more than two hundred fifty miles from Kansas City, Missouri, and the sum or sums realized therefrom shall be placed in the trust estate; and said residence 'Oak Hall' shall be forthwith razed by said trustees." Like her father, Laura was extremely private and did not want anything that had been in her family used by anyone else, or at least anyone else living near Kansas City. (Nelson, who had his coach horses destroyed when they were no longer of use to him, had, during his last illness, toyed with the idea of dismantling the *Star*.) Once Laura's executors carried out her instructions to raze Oak Hall and sell all her personal effects, nothing would remain of the private life of William Rockhill Nelson's family.[15]

Irwin Kirkwood was now left alone to oversee the fulfillment of the Nelson family's intentions. In a seemingly coordinated effort, Nelson's estate would provide the art collection; his wife's estate, the building to house the art; Frank Rozzelle's estate, money for upkeep, maintenance, operation, or construction of the facility; and Laura Kirkwood's estate, funds for a site, construction, and works of art. The location of the gallery was the only crucial item still to be determined.

It was Irwin Kirkwood who answered the question of where to build the gallery when he came up with the ingenious idea of giving the Oak Hall property to the city in order to provide a location for the new museum and also to get the city to pay to have Oak Hall razed. Even though Laura's will, filed just months before her death, did not mention using the Oak Hall site as the location for the Nelson Gallery, Kirkwood maintained that Laura had always wanted to see her father's museum built where Oak Hall stood. Thus, Kirkwood had written to City Manager Henry F. McElroy on October 4, 1926, some seven months after Laura died, to ask if the city would be interested in acquiring the Oak Hall property on which to build the Nelson Gallery. "Nothing . . . would be more fitting," Kirkwood said in his letter, "than that this ground that was so identified with his [Nelson's] life should be taken as the site for the buildings that are to house the great art collection which he endowed." McElroy responded enthusiastically and immediately initiated condemnation proceedings to raze Oak Hall, as required by Laura Kirkwood's will, and acquire the site. Although they had many objections and legal questions about condemning the property, the City Council members voted unanimously to assume control of the Oak Hall tract through condemnation.

The condemnation papers did not, however, materialize, and Kirkwood finally decided in January 1927 to deed the property to the city without cost. In his announcement Kirkwood stated, "I had hoped that my offer of the site last October would make it possible to get the art gallery under construction soon, but I have come to fear that with the inevitable delays it may be several years before the city could acquire the property." Kirkwood felt that the art museum had been delayed long enough.[16]

At the same time that Kirkwood gave the land to the city, he met with the three University Trustees who had been appointed after his wife's death as directed by Nelson's will. Kirkwood proposed to them that the Oak Hall site be dedicated to the fine arts and, in particular, that they erect a building there to be known as the William Rockhill Nelson Gallery of Art. The University Trustees, he explained, would work with the New England National Bank and Trust Company in erecting the building specified in Ida Nelson's will. The trustees considered the proposed site ideal. They communicated their approval to the City Council of Kansas City and told the New England National Bank trust officers that they would cooperate with them in every way.[17]

Irwin Kirkwood forged the final link in putting together the art museum when he obtained the commitment of the city and trustees of the Nelson family estates to build the Nelson Gallery on the Oak Hall site, but Laura is the one really responsible for determining that the museum, to be called "The Nelson Gallery of Art," should be filled with original works of art. She designated that those original artworks from her father's collection go into the new museum, and she made sure her monies would be added to those left by her mother and Frank Rozzelle to erect a building to house such a collection, so that the reproductions at the public library would not solely represent her father's legacy.

Meanwhile, Irwin hoped to oversee the razing of Oak Hall and the construction of the gallery. Unfortunately, he did not live to see the plans of the Nelson family fulfilled. On August 29, 1927, at the age of forty-eight, Kirkwood died in Saratoga Springs, New York, where he had gone to sell some of his racehorses. Dr. Comstock of Saratoga, who had been summoned when Kirkwood became ill, had determined that his patient had severe stomach hemorrhages. Kirkwood lost consciousness, and twenty-four hours later he died of an acute heart attack. In his will, subject to and after fulfillment of payment to ten family members and friends, Kirkwood bequeathed an additional $250,000 toward the construction of the William Rockhill Nelson Gallery of Art and, if any money remained, toward the procurement of works

of art. Realizing that twelve years had passed since Nelson's death, Kirkwood specified that all his trust estate "shall be donated, used, and expended and all things done by my trustees, as aforesaid, within the period of ten years from my death and thereupon this trust shall cease." Apparently, Kirkwood was not the only Kansas Citian who felt that it was time to stop talking and start building an art museum.[18]

THE TIME WAS RIPE

THE PIVOTAL YEAR for the formation of the Nelson-Atkins Museum of Art was 1927. There was now plenty of money both to build an art museum and to purchase art to put into it. However, the whole idea of an art museum, so long talked about in Kansas City, had become increasingly complicated by all the bequests associated with it. Five major benefactors meant five sets of trustees. The trustees engaged in planning the Nelson Gallery included not only William Rockhill Nelson's University Trustees, who would be responsible for purchasing works of art, but also trustees of the estates of Ida Nelson, Frank Rozzelle, Laura Kirkwood, and Irwin Kirkwood. To make things more interesting, the trustees who represented Mary Atkins's estate had initiated conversations with the University Trustees. On July 11, 1927, the University Trustees consented to placing the Atkins Museum next to the Nelson Gallery on the Oak Hall site. This transaction was a miracle in itself; sixteen years had passed since Atkins's death, and her trustees had plans drawn for a museum in Penn Valley Park. However, a greater miracle would be needed to make this art institution a reality. Could six groups of trustees work together to accomplish what seemed an impossible task? Fortunately, they were an exceptional group of men whom fate had brought together at the right time.

Never before in the history of the United States had people been so interested in art. The number of art museums in the nation and the number of people attending those museums increased dramatically between 1911, the time of Atkins's bequest, and 1933, the year the William Rockhill Nelson Gallery of Art and the Atkins Museum of Fine Arts finally opened. The number of American public museums of all kinds almost doubled between 1921 and 1930, with art museums leading other types of museums in rate of growth, investment in

buildings, and annual incomes. The clientele of the visual arts also increased. Between 1924 and 1930, the Metropolitan Museum of Art in New York each year counted more visitors than the National Gallery in London or the Louvre in Paris. Perhaps the most important reason for the heightened interest in art was Americans' concern that they might lag behind Europe in cultural development. In order for America to be "as good as" Europe, many people believed the arts needed special cultivation.[1]

Not only did American cities try to equal their European counterparts, they also competed among themselves for recognition of their refinement. New York's Metropolitan Museum of Art, one of the oldest major museums in the United States, set the standards against which all others were measured. The conception for the "Met" took form at a Fourth of July celebration in Paris in 1866. There, John Jay, the grandson of the first chief justice of the United States, suggested in his oration prepared for the occasion that it was time for Americans to build a national gallery of art. To New Yorkers, a "national" gallery of art meant one in New York City. Jay's idea gathered support, and by 1870 the legislature of New York had incorporated the Metropolitan. Twenty-seven board members were elected, and New York City promised them a home for the art collection they planned to assemble through private subscriptions. Before this time private collections of art and even some art galleries, such as Charles Willson Peale's, existed in the United States, but the Metropolitan was the first American art museum that aspired to assemble a collection of objects illustrating the history of the world's art. The Metropolitan accomplished its purpose so well that in the 1960s one scholar would write without fear of contradiction that "no single American institution presents a more complete expression of man's artistic endeavor under one roof than the 'great gray lady' of upper Fifth Avenue."[2]

The Metropolitan also clearly illustrated the importance of private contributions to the growth of public museums in the United States. Unlike Europe, where almost all museums began as public institutions and major art collections belonged to the monarch or the state, wealthy patrons were essential to the development of art museums in the United States. On their requisite Grand Tour of Europe, Americans of means, education, and presumed sensitivity brought home paintings. Eventually a great number of these works, some of them masterpieces, ended up in public collections. The Metropolitan could not have attained the renown it did without its private donors.[3]

Other early museums established themselves on the model of the Metropolitan. When the Museum of Fine Arts in Boston opened in the 1870s, the city provided no financial support. Individual subscriptions paid for the building,

and private collectors offered their art objects as a nucleus for the museum's collection. The Museum of Fine Arts, Boston now considers itself to be "one of the most comprehensive museums in the world" with 450,000 works of art and more than one million visitors each year.[4]

The Art Institute of Chicago, opened in 1879, enjoys the prestige of being one of the oldest and largest art museums in the United States. In 1893 the Art Institute moved into its current Italianate quarters, built to house a part of the Chicago World's Fair visited by Mary Atkins. While public funds financed the building, private donors assembled the highly respected collection.[5]

The Centennial Exhibition of 1876 in Philadelphia's Fairmount Park spawned the Philadelphia Museum of Art. Originally, Memorial Hall housed the exhibition's art gallery, but a new building opened in 1928. The Philadelphia collection of European, post-Christian art resulted from generous private donations. Because the museum's first director, Fiske Kimball, was "an architectural historian of note," the Philadelphia Museum of Art contained some of the most complete historical rooms in the country, with decorative pieces of the periods represented.[6]

The building that houses the St. Louis Art Museum was also constructed for a world's fair. Planners of the Louisiana Purchase Exposition in 1904 decided to build the central portion of the Palace of Art as a permanent structure to house the fine arts collection begun in 1879 by Washington University. Practically all the financial support for this classical gray limestone building and its collection came from the Art Museum Law of 1907, which gave "any city in Missouri of 400,000 or more inhabitants the authority to establish and support an art museum by a property tax of one fifth mill on the dollar." The same year the Art Museum Law was adopted, St. Louis citizens voted to establish a museum as a municipal institution under the terms of the new law.[7]

A list of the first twenty-two art museums founded in the United States included not only the Metropolitan, the Museum of Fine Arts, Boston, the Art Institute of Chicago, the Albright Art Gallery in Buffalo, and the Corcoran Gallery in Washington, D.C., but two museums in Kansas City. These were the Kansas City Art Institute and the Western Gallery of Art (which was listed as the Nelson Art Gallery). Neither could be compared with the museums discussed above: the Kansas City Art Institute offered very little in the way of public art exhibition, while the Western Gallery of Art was Nelson's collection of reproductions in the public library. Kansas City did not have an art museum comparable to the best museums founded in the late nineteenth century, and some city leaders expressed concern that Kansas City was not "keeping up." "We have been so proud of our park and boulevard system," said

one distressed speaker at a city planning meeting in 1911, "that we have rested on our laurels while other cities have been progressing."[8]

In Toledo, Ohio, for example, Florence S. and Edward D. Libbey had organized a historical art museum in 1912 and contributed their collection of glass, Egyptian and Greek art, and paintings by Dutch and Flemish masters. In 1924, two large wings, including a concert hall and children's classrooms, were added to the growing Toledo Museum of Art.[9]

In 1883, twenty-five citizens in Minneapolis founded the Minnesota Society of Fine Arts, but the Minneapolis Institute of Art building, a neoclassical landmark, did not open until 1915. Minneapolis was, however, well ahead of Kansas City in having an art museum, as was Cleveland. The Cleveland Museum of Art, incorporated in 1914, owed its existence to bequests from four individuals. Modeled after the Metropolitan both in the design of its program and in its classical architecture, the Cleveland Museum of Art would serve as a model for the Nelson-Atkins Museum of Art.[10]

Although Kansas City had not succeeded in establishing an art museum during the early part of the twentieth century, Kansas Citians had made many attempts over the years. Colonel Thomas H. Swope, a city benefactor who in 1896 had given two square miles for a park, at one time planned an art museum. After traveling in Europe, Swope realized, just as the Nelsons and Mary Atkins had, the inspirational value of art. He commissioned an architectural design to duplicate the Albright Art Gallery of Buffalo, New York, on five acres near the entrance of Swope Park. However, bids close to $750,000, instead of the $300,000 he planned to spend, prompted Swope to abandon the project. Friends reported that shortly before his death in 1909, Swope contemplated changing his will to leave $1 million for an art museum. Had he lived long enough to make the change, Kansas City might have had a museum at an earlier date.[11]

Kansas Citians also had tried three times to use public improvement bonds to build an art museum. The fact that St. Louis established a municipal art museum under the Art Museum Law of 1907 increased Kansas Citians' desire to match their rival city across the state. However, Kansas City's population did not qualify it to enact a museum property tax, so bonds were the only alternative. A 1908 ballot contained a proposition that $300,000 be spent for an art museum. Voters rejected it in all precincts except "Jim Pendergast's little kingdom," but museum supporters tried again. At the polls on April 5, 1910, voters considered a $250,000 bond to build a permanent museum modeled on the Metropolitan. This time 24,000 people voted for the proposal, and only 9,000 voted against it. However, since approval of the bond required

two-thirds of the highest vote cast, and thousands more votes were cast for city officials than for the museum bond, the bond lacked the necessary two-thirds of the total. A third attempt to pass a museum bond supposedly fell victim to partisan politics. In 1911, citizens who had worked for thirteen years to promote an art museum through public bonds rejoiced at the news of Atkins's gift. The bequest came at a time, the *Kansas City Times* reported, "when such a museum is very much needed and at a time when there is an awakening interest in art."[12]

Indeed, many Americans, especially city dwellers, were interested in art. Since the middle of the nineteenth century, organizations such as the American Art Union of New York had attempted to bring art to the attention of people in American cities. The Art Union's first annual report in 1842 promoted art as a necessity for the urban middle class: "To the inhabitants of cities . . . a painted landscape is essential to preserve a healthy tone to the spirits, lest they forget in the wilderness of bricks which surrounds them the pure delights of nature and a country life. Those who cannot afford a seat in the country to refresh their wearied spirits, may at least have a country seat in their parlors."[13]

People like William Rockhill Nelson and Mary Atkins could afford a seat in the country and a view of Europe as well as original works of art, but their bequests aimed at benefiting the public, the people who could not afford these privileges, and at improving the tone of cultural life in Kansas City. Nelson was the personification of the City Beautiful movement. Through his newspapers, he urged the middle class to become involved in the community. He challenged Kansas Citians to build public buildings, parks, and boulevards and to make other improvements in the quality of urban life. Mary Atkins too seemed part of the City Beautiful idea. A woman with strong religious and moral principles, Atkins realized the influence of art in her own life. The museums of Europe, the beauty of Geneva, and the White City of the Chicago World's Fair benefited her in ways she wanted to share with other Kansas Citians. The somewhat reclusive Atkins and the boisterous and opinionated Nelson were as improbable a combination of donors as can be imagined. Yet their intentions were so similar that it seemed appropriate that their monies be pooled to make an art museum a reality for Kansas City.

It was almost too late when the Atkins trustees, A. W. Childs and Herbert V. Jones, realized that they should coordinate their efforts with those of the Nelson family. In 1927 when Irwin Kirkwood announced his decision to deed the Oak Hall site to the Nelson Trust for the purpose of building the Nelson Gallery, the Atkins trustees were on the brink of beginning construction of the Atkins Museum in Penn Valley Park.

They had been considering this site since before the completion of Union Station in 1914. However, the proposed cultural center across from the station, where they were to locate the museum, had not materialized. World War I had delayed beautification efforts. In 1919, after the war, when concerned citizens again raised the issue of a civic center in Penn Valley Park, the idea of a war memorial became a top priority. Lumber baron R. A. Long and real estate developer J. C. Nichols chaired the campaign to build a two-hundred-foot tower monument on the bluff south of Union Station. Other businessmen, including William Volker, Irwin Kirkwood, Walter Dickey, Henry McElroy, and Charles Armour, joined in the effort not only to erect a memorial to honor World War I servicemen but also to beautify the Union Station area. After calling a mass public meeting and devoting ten days to intensive fund-raising, Long and Nichols announced they had raised $2 million to fund the war monument and mall. Once again, the Atkins trustees talked about locating their museum in Penn Valley Park, near the newly planned memorial.[14]

Childs and Jones seemed ready to proceed in 1920 when they sold the last of Atkins's lots on Grand Avenue for $105,000 and retained the firm of Wight and Wight as museum architects. However, the Penn Valley site for the Liberty Memorial wasn't dedicated until Armistice Day 1921 and wouldn't be completed until 1926. Meanwhile, Ida H. Nelson died in 1921 and Frank Rozzelle in 1923, both, as mentioned, leaving money to build an art museum, and the trustees of their estates talked with the Atkins trustees about building the Nelson Gallery in Penn Valley Park with the Atkins Museum. When the new charter of Kansas City, Missouri, issued in 1925, specifically authorized locating the museums provided for in the wills of Atkins, Ida Nelson, and Rozzelle on Memorial Hill, seemingly a decision had been made. None of the trustees involved issued an official statement, though, until February 16, 1927, when A. W. Childs and Herbert V. Jones said they would build the Atkins Museum in Penn Valley Park, six hundred feet south of the Liberty Memorial. Wight and Wight submitted the architectural plans for a single-story classical building, and the trustees anticipated beginning construction in the summer of 1928. They estimated the construction of the museum would cost $700,000—the amount the trustees had accumulated in the Mary Atkins Trust through their careful management and from other bequests and gifts, including the $20,000 that Ellen L. St. Clair left in trust to Childs and Jones in 1923 to "be devoted toward the support and maintenance of said 'Atkins Museum of Fine Arts' and the purchase of such pictures, paintings, statuary or other works of art . . ."[15]

Plans to build the civic center at the Liberty Memorial site were still under debate. On May 9, 1926, the Art Commission, a three-member committee

created by the Park Board, proposed radical changes in the development of Memorial Park. The commissioners—Atkins Museum architect William D. Wight, landscape architect S. Herbert Hare, and Kansas City Art Institute director R. A. Holland—advised razing two buildings on the hill and realigning Pershing Road and the new approach road to the mall. Instead of a wall of buildings fronting Memorial Mall, only two main buildings would be on the mall itself, with two smaller museums across the oval in Penn Valley Park. These structures presumably would house an art museum, a natural history museum, a music hall, and another cultural institution. The Art Commission also reported that an amendment to the zoning law was imperative in order to protect the development of Liberty Memorial Hill as "the gateway and art center of Kansas City."[16]

While the art commissioners redesigned the Penn Valley cultural center, the Atkins and Nelson trustees continued to investigate other alternatives. In April 1927, the Atkins trustees sent R. A. Holland and architect Thomas Wight, the other brother of Wight and Wight, to study art museums in St. Louis, Cleveland, Minneapolis, Detroit, and Boston. Every museum director that Holland and Wight talked with emphasized the importance of keeping local art interests together and of urging all supporters of the arts in the community to cooperate.[17]

In light of Laura Nelson Kirkwood's death and Irwin Kirkwood's announcement in January 1927 that he had given the former Nelson property as a site for an art museum, the Atkins trustees decided to reconsider their plans to build on Memorial Hill. Herbert V. Jones, as trustee for both the Atkins and the Nelson trusts, thought collaboration could serve the purposes of both. The Nelson Trust would welcome more money to house the art that Nelson's funds would buy; conversely, as Jones put it, "It was the Atkins point of view that the Atkins Museum of Fine Arts would be enhanced by close association with the William Rockhill Nelson Gallery of Art." By joining with the Nelson Trust, the Atkins trustees could realize all their hopes.[18]

When Edwin C. Meservey, the attorney for the Atkins estate, met with the Nelson trustees on July 11, 1927, to propose that the Atkins Museum be built beside the Nelson Gallery, the Nelson trustees voted their approval. The museum would stand where once William Rockhill Nelson had lived at Oak Hall, and the years of talking about a cultural center at Penn Valley Park would come to an end.[19]

THE UNIVERSITY TRUSTEES
THE MEN WHO MADE IT HAPPEN

WILLIAM ROCKHILL NELSON'S will named his wife and daughter as trustees. Only after both their deaths would the presidents of the state universities of Kansas, Missouri, and Oklahoma appoint two or three trustees—whom Nelson called "University Trustees"—to manage the income from his estate for the primary purpose of purchasing works of art. When Nelson died, Laura Kirkwood was only thirty-two years old, so none of the current university presidents expected to be involved in the near future. A. Ross Hill, president of the University of Missouri in 1915, admitted to an attorney who wanted to represent the trust that he had not seen Nelson's will and assumed that he would have "nothing to do with the administration of the trust." Since Laura Kirkwood was so young, he anticipated that he would "escape all responsibility in the matter." He did escape, but Stratton D. Brooks, president of the university at the time of Laura's death on February 27, 1926, had to assume a great deal of responsibility.[1]

Soon after Laura's death, Brooks met with E. H. Lindley, chancellor of the University of Kansas, and W. B. Bizzell, president of the University of Oklahoma, to read Nelson's will and fulfill their obligation to choose trustees. It was because Nelson had wanted to keep his trust free of politics that he had chosen a board consisting of the presidents from "the three leading western universities" and instructed them to appoint "only such men as having superior taste and good business ability, will carefully and conservatively manage the trust estate for the best interests of all concerned." On March 3, 1926, the board named three trustees who met the criteria: William Volker, J. C. Nichols, and Herbert V. Jones.[2]

The University Trustees chosen by the Board of University Presidents possessed an excellent and varied combination of talents and interests. At the

age of sixty-seven the senior member of the group, William Volker, owned a prosperous business for the wholesaling of picture frames, patented window shades, and other home furnishings. He had come to Kansas City from Chicago in 1882, just two years after Nelson had moved there, because, like Nelson, he was looking for a place with more opportunity. He found that Kansas City provided what he needed for his picture-frame business—an ample supply of walnut lumber, good railroad connections, and a growing market. By the end of the nineteenth century, William Volker and Co., Furniture, Sundries, and Art Goods had six thousand employees in twelve cities, and Volker had become a millionaire. A shy, reserved man with an intense dislike for publicity, Volker was sometimes known as "Mr. Anonymous of Bell Street," a reference to his demeanor and the street on which he built a three-story house for his parents, sisters, brothers, and wife. Volker enjoyed the fact that he was rarely recognized. However, this modest man was known as a very generous philanthropist, reportedly spending $10 million of his own money on works for the public good during the thirty-six years he lived in Kansas City. Records of many of his donations exist only on scraps of paper, but we do know that Volker played a major role in establishing a tuberculosis treatment center, the Helping Hand Institute, the University of Kansas City, and Research Medical Center. Volker believed, as did Nelson and other progressive reformers, that "the rich man is merely the custodian of his money and . . . the real reason he has it is so he may use it for the benefit of others." At their first meeting, the University Trustees elected this quiet man, who listened more than he talked, as their chairman.[3]

The youngest trustee, J. C. Nichols, at age forty-six, already had a national reputation as a developer of suburban residential areas. A graduate of the University of Kansas, Nichols liked people to know that he had also earned a BA from Harvard, having received a one-year graduate scholarship to the Cambridge institution. Unlike Volker, Nichols loved publicity. His participation in many organizations and as a member of several boards, including those of the Kansas City Art Institute and the Liberty Memorial, kept him in the public eye. In the 1920s and 1930s, Nichols became a leading spokesman for the real estate industry and a strong advocate of planning and zoning, important facets of the City Beautiful movement. Often considered a "dollar-conscious creative genius," Nichols sincerely tried to solve the problems of urban sprawl while making a profit. He believed in hiring the best talent to help him in his real estate development, and he expected the most out of these people, a characteristic that carried over into his role as University Trustee. In one of

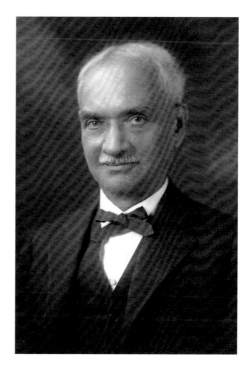

FIGURE 5.1 William Volker, a prosperous businessman and generous philanthropist, served as a University Trustee from 1926 to 1929. (RG 70, NAMAA)

Nichols's early developments, a ten-acre plot just south of Nelson's Rockhill area, he sought to mimic Nelson's ideas on planning and beautification. Having had "the good fortune," Nichols would later remark, "of having 'Baron' Nelson take him under his wing," Nichols went beyond copying his mentor's ideas. His famous Country Club District, an area Nichols began planning in the 1910s on a tract south of Rockhill, eventually totaled seventy-five hundred acres and extended on both sides of the Missouri-Kansas state line to Seventy-Ninth Street. Nichols adopted Nelson's ideas of curving streets, large shade trees, decorative stone walls, and substantial homes. Nichols did, however, leave his own signature in the form of restrictive zoning, parks, tennis courts, golf courses, and ornamental art, and he also made a less positive impact by introducing restrictive covenants. Nichols learned something about purchasing art in the course of acquiring a number of pieces to decorate his real estate developments. A three-hundred-year-old Venetian seahorse fountain valued at $18,000 that Nichols donated to Kansas City in 1925 for ornamentation of the traffic circle at Meyer Boulevard and Ward Parkway prompted the city to form the Art Commission to consult with the City Park Board on architecture and placement of decorative art. In the 1920s Nichols

also developed the Country Club Plaza, one of the world's first shopping centers and a close neighbor of the intended museum site. There is no doubt that Nichols contributed his expertise as an exceptional developer and planner to the endeavors of the University Trustees.[4]

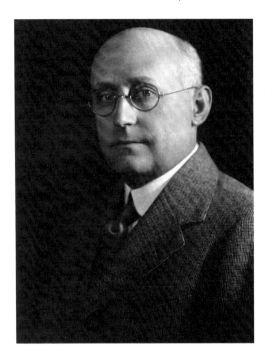

FIGURE 5.2 J. C. Nichols, known as a real estate developer, played a leading role as a trustee for the Nelson Trust from 1926 until his death in 1950. (RG 70, NAMAA)

The third University Trustee, Herbert V. Jones, aged forty-eight, was a pioneer in commercial real estate. A graduate of Vanderbilt University, Jones came to Kansas City in 1901 and began work as an employee of A. W. Childs and Company, a real estate firm. When he established Herbert V. Jones and Company in 1919, the firm was the first in Kansas City to offer site appraisal, financing, negotiating, leasing, and property management, and it became a prototype for modern, full-service firms in commercial real estate. Jones's colleagues elected him president of the Real Estate Board in 1918 and 1919; among his other responsibilities, he served as president of the University Club and of the Kansas City Country Club, director of the Chamber of Commerce, and chairman of the City Planning Commission. Besides his many civic honors, Jones also won acclaim before World War I as one of the best tennis players in the Midwest, winning the city tournament several times as well as the tristate championship for Kansas, Oklahoma, and Missouri. As trustee with A.

W. Childs of the Mary Atkins estate, Jones promoted the integration of funds left to build two museums and provided the crucial link between the Nelson and Atkins trusts.[5]

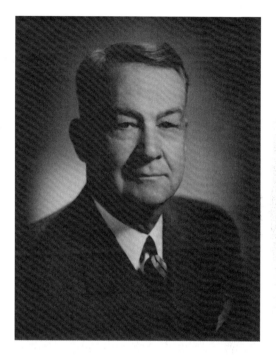

FIGURE 5.3 Herbert V. Jones, a pioneer in commercial real estate, served as a trustee for both the Nelson and the Atkins trusts, providing the crucial link to bring the two museums together. (RG 70, NAMAA)

Since all three University Trustees were successful and respected businessmen, they certainly met Nelson's criterion regarding their business ability. Befitting Nelson's desire to keep politics out of his trust, Volker, Nichols, and Jones represented three different political traditions within the city. Volker, a reform-minded Republican, quietly contributed funds to the Charter League, founded to fight the Pendergast machine, as well as funds to aid anyone he thought needed help. Nichols, considered "a machine Democrat" by the *Kansas City Star*, worked closely with "Boss" Pendergast and his ring until 1937, when Nichols had a falling out due to labor organization problems involving his company. Meanwhile Jones, the patrician Republican, was anti-Pendergast when machine politics threatened the business community or the stability of the Republican Party. The fact that three men with such different political views proved able to cooperate is testimony to their characters and to the seriousness with which they served. Although Nichols, Volker, and Jones had held other board positions, they had never worked as hard as they would have to for the Nelson Trust.

The three University Trustees first met on March 4, 1926, the day after their appointment. Also present at this first meeting at J. C. Nichols's office in the Commerce Building was John E. Wilson, who served as the trustees' counsel. Wilson's presence was critical, for in addition to advising the University Trustees in charge of Nelson's estate, he served as trustee of Laura Nelson Kirkwood's estate. Wilson's connection with the Kirkwoods had begun long before Laura's death. After attending the University of Maryland and being admitted to the Maryland bar in 1893, Wilson practiced law in Baltimore for two years. There he met and became friends with Irwin Kirkwood, six years his junior. The two continued their friendship when they both moved to Kansas City. After Irwin's marriage to Laura, the Kirkwoods relied on Wilson for legal advice, and each named him as an estate trustee. Wilson and Kirkwood shared many interests and political beliefs, and in 1926 they shared the personal tragedy of losing their wives. Wilson's wife, Anna Turpin Wilson, was killed in a car accident near Winston-Salem, North Carolina. Kirkwood demonstrated his sympathy and attachment to the Wilson family by remembering the Wilsons' two daughters in his will.[6]

Known for his honesty and integrity, Wilson took an active role in civic affairs in addition to practicing law. He served on the Civil Service Board, as police commissioner, and as the only Republican member of the Board of Election Commissioners. Taking the lead in the Republicans' fight against election fraud and the padding of voter registration rolls, Wilson succeeded in rewriting the state election laws that had been approved by the legislature in 1921. In the reform tradition of Nelson, Wilson campaigned against underworld crime, earning the hatred of the mob and the respect of fellow progressives. A man of ability and high ethical standards with a thorough knowledge of how Kansas City government worked, Wilson played an important part in orchestrating the many parties and trusts involved in the creation of the Nelson-Atkins Museum of Art.[7]

At the University Trustees' first meeting, they elected Volker as chairman; Nichols, vice chairman; and Jones, secretary. They ordered an appraisal and inventory of all the assets, liabilities, and property of the trust, including the *Kansas City Star* and *Times* and the Sni-A-Bar Farm. Nelson's will stated that the trustees' first major task should be to sell the *Times* and the *Star* "at the best price and on the best terms obtainable as soon as such sale can be made without sacrifice and not later than two years after the death of my wife and daughter." Before announcing the sale of the *Times* and the *Star*, however, the trustees tried to relieve any fears the public or the papers' employees might have about

the management and control of the newspapers by resolving not to interfere with editorial policy or current management.[8]

Meanwhile, Irwin Kirkwood, as soon as he learned of his wife's death, closeted himself with the *Star's* business manager, August F. Seested, to draw up an agreement to buy the newspaper. Within days, the two men had developed the Irwin R. Kirkwood Employee Ownership Plan, a legal instrument that would allow (selected) *Star* employees to buy stock in the *Kansas City Star* Company and allow Kirkwood to keep control of the paper, an idea that was a novelty in the newspaper business and that was certainly not incorporated in Nelson's will.[9]

On March 30, 1926, the trustees asked John C. Long, a respected contractor, to estimate the value of the newspapers' assets. Meanwhile, Nichols and Jones traveled to Chicago to investigate the recent sale of the *Chicago Daily News*, and Nichols continued eastward to seek advice from the owners of the *Washington Star* and *Post*, *Baltimore Sun*, and *New York Times*. In the middle of May, the Associated Press and United Press announced the sale of the *Kansas City Star* and *Times*. By June 10, the trustees had supplied eleven prospective purchasers with an inventory of equipment and an estimate of the building's worth. They decided to take offers on June 30 but subsequently postponed the date to July 9 because of additional inquiries and concerns raised by a Minneapolis newspaper editor named H. V. Jones. Jones stated that he had decided not to make a bid on the papers because of rumors that outside bids were only to establish a price and that the trustees had already decided to sell the *Star* and the *Times* to Irwin Kirkwood. The trustees wrote to Jones to deny these rumors and to reiterate their intention to conduct the sale of the newspaper in a businesslike manner and according to Nelson's will.[10]

On July 9, 1926, the trustees met in Room 914 of the Muehlebach Hotel to take bids from prospective purchasers. The first offer came in by wire from Jones of Minneapolis for $7 million. Seven other bidders appeared in person, including Colonel Luke Lea of Nashville, Tennessee; Frank Gannett of Rochester, New York; Kirkwood and Seested of the *Kansas City Star*; and Walter S. Dickey of the *Kansas City Post* and *Journal*. The trustees retired at midnight and met again the next morning to analyze the bids. By July 12, when they met with the Board of University Presidents, the trustees had decided to accept Bid Number Four as presented by Irwin R. Kirkwood and associates. The purchasers would pay the Nelson Trust $11 million and assume all current liabilities and accounts payable. The University Presidents and Trustees were satisfied with the price and terms and with the knowledge the papers would continue in the Nelson tradition.[11]

Most of the people who had tendered offers to buy the *Star* and the *Times* seemed pleased with the management of the sale. Colonel Lea, the bidder from Nashville, took the time to write a letter to the trustees praising the way they had conducted the bidding. The Parsons, Kansas, *Daily Sun* ran an editorial remarking on the fairness with which each potential buyer was given the same information and a complete financial report. However, Walter S. Dickey, the publisher of the *Kansas City Journal* and *Post*, claimed he had submitted a higher bid than Kirkwood and asked the attorney general of the State of Missouri to enjoin the sale. When the attorney general refused, Dickey brought suit in the circuit court. The court threw out the suit, and Dickey appealed to the Supreme Court of Missouri.[12]

In October 1928, more than two years after the sale, the Missouri Supreme Court ruled in favor of the University Trustees. In his opinion Judge Ernest S. Gantt stated, "The trustees in selling the properties carefully guarded the interests of the public, dealt fairly with all concerned, and obtained the best price and the best terms for the properties." Dickey's last resort was to appeal his case to the U.S. Supreme Court, which he did. That court's decision in March 1929 to deny Dickey's application for certiorari at last ended the case and released the income that the trustees needed to conduct their most important task—purchasing works of art. Although Walter Dickey's newspapers had always been the chief rivals of Nelson's *Star* and *Times*, they had never caused Nelson as much trouble during his lifetime. The trustees had accepted Irwin Kirkwood's offer to buy the newspaper a little over four months after Laura Kirkwood's death, but the legal proceedings initiated by Dickey tied up the trust's assets for three years.[13]

During those three years, the University Trustees met three to four times a month to oversee Sni-A-Bar Farm, determine the site of the new museum, manage the trust's substantial real estate holdings, and discuss proposals from art dealers and advisers. According to Nelson's will, the trustees had to maintain Sni-A-Bar Farm for thirty years after Nelson's death. They appointed a manager to handle the day-to-day operations, but they were anxious to find ways to make the stock-breeding facility more profitable. Although they were successful at reducing the deficit of the farm, this business was not an area of expertise for any of the trustees. The real estate experience of Jones and Nichols and the interest Volker had in educational and cultural institutions proved of much more value in executing another part of their job—determining the future of Nelson's Rockhill area.[14]

When Irwin Kirkwood deeded the Oak Hall site to the city for the purpose of building the Nelson Gallery, the entire focus of the Rockhill area and of the

trustees changed. Most parties who would be involved in the art museum were represented at the meeting Kirkwood called on January 29, 1927, to announce his decision. The University Trustees were there along with John E. Wilson as their counsel and as trustee for Laura Kirkwood's estate. John F. Downing, chairman of the board of the New England National Bank and Trust Company, and the bank's trust officer, Judge Thaddeus B. Landon, represented Ida H. Nelson's trust. Irwin Kirkwood also had asked Henry F. McElroy, the city manager, John T. Barker, the city counsel, and Judge E. B. Halsted, Barker's assistant, to attend. Although McElroy, Volker, Nichols, and Kirkwood had supported the plans for the Liberty Memorial and the effort to make the Penn Valley Park area into a cultural center, all parties agreed that the Oak Hall property made more sense as a site for the Nelson Gallery. Use of this site would not only honor Laura Kirkwood's presumed wishes but also free up funds that might otherwise have to be used to purchase land. McElroy, as one historian suggested, may have thought the construction of the new museum on a site owned by the city rather than one controlled by the Park Board, as was the case with Memorial Hill, would provide an endless source of opportunities for patronage appointments. This same historian hypothesized that Kirkwood may have promised just such opportunities to McElroy in order to receive a commitment from the city for the maintenance of the Oak Hall property as a museum site. It seems more likely that the University Trustees simply decided that the Oak Hall site would be a better location from which to launch a civic center. They could hope to attract other cultural and educational institutions to build on the undeveloped land that the Nelson Trust owned in the Rockhill area. This idea was especially appealing to Nichols, who wanted to protect and enhance the property values in his Country Club Plaza shopping area, just to the west of Rockhill, and in the residential areas he was developing south of the proposed museum site. All three trustees seemed to think they could make the Rockhill District the civic center that city leaders had been talking about for at least a decade.[15]

By July 1927, the University Trustees had voted unanimously to place the Atkins Museum on the Oak Hall site, and they did not have to wait long to find other cultural institutions for the Rockhill area. In December of the same year, Howard Vanderslice purchased the August R. Meyer mansion, just west of Oak Hall, and donated the estate to the Kansas City Art Institute. Having outgrown its location on Armour Boulevard, the Art Institute had made tentative plans to move into the proposed Atkins Museum on the Liberty Memorial Mall. Since the cultural center in Penn Valley had collapsed, the plans for a new home for the Kansas City Art Institute were in limbo. Early in 1927 R. A.

Holland, director of the Art Institute, wrote to Nichols, then president of the board of KCAI, expressing his hope for a close relationship with the Atkins Museum and Nelson Gallery. The University Trustees wanted cooperation among all the art interests in town. Therefore, news of Vanderslice's generosity prompted Nichols to issue a resolution stating that the gift of the Meyer/Vanderslice house to the Kansas City Art Institute was "of great importance to Kansas City as an Art Center," enriching the opportunities for all the institutions involved and for the development of the entire neighborhood.[16]

The Rockhill residents expressed more concern than elation over the transformation of their neighborhood. Officers of the Rockhill Homes Association sought and received assurances from the University Trustees that the "traditional standards and character of the Rockhill District" would be maintained. To protect the area, the trustees helped renew residential zoning requirements and restrictions on commercial construction. In exchange for these guarantees the association resolved,

> to cooperate in every way possible, to the end that the District covered by the Association may exceed all former aims and ambitions for dignity of appearance and for character and quality of residences, and maintenance and upkeep of private and public grounds therein, and such other forward development as now seems in order, to blend with the great improvement made possible by the recent generous act and gift of Mr. Irwin Kirkwood, with respect to the noble William Rockhill Nelson Art Gallery building and grounds, gift of those public spirited men and women who will thus have honored Kansas City and the Rockhill District.[17]

For their part, the trustees had hired Edgar L. Fleming in October 1926 to act as the trust's real estate manager. Not only would Fleming handle the rental of houses, the upkeep of rental property, and the sale of real estate in the Rockhill area, but he would also manage the Nelson Trust's real estate investments. According to Nelson's will, the University Trustees could spend the income from his trust estate to purchase works of art. However, the trust needed to be invested in "income-bearing real estate . . . situated within one hundred miles of the United States Custom House as now located in Kansas City, Missouri . . ." Although Fleming acted as manager, many real estate matters still came to the trustees' attention, and their minutes incorporated a variety of property-related issues. For example, in October 1927 Jones reported in the trustees' minutes that a transaction was almost complete to sell a tract of land at Forty-Ninth and Rockhill to the Jewish Memorial Hospital Association for

construction of what became the Menorah Medical Center and today is the location of the Stowers Institute. The Athenaeum Club wanted to locate its clubhouse in the Rockhill District, and several other businesses approached the trustees to buy plots of land as well.[18]

Most important, in late 1928 the trustees began considering the use of land from the Nelson estate as a site for a city university. The trustees of the newly forming University of Kansas City were interested in purchasing land south of Brush Creek between Oak and Troost. Pleased with the idea that another cultural institution might locate in the area of the art museum, Nelson's University Trustees suggested that competent appraisers be selected by the two groups of trustees to determine the land's value and that the university's board should then proceed with architectural plans. Not wanting to interfere but certainly not desirous of losing control over their cultural center, Nichols, Volker, and Jones cautioned that the university buildings should be well designed and the grounds beautifully developed. The University Trustees made known to the university advisory board that,

> It is our present plan to make every effort to develop one of the finest museums of art objects in the entire country in the Nelson Gallery of Art to be erected on the site of Oak Hall and it is our hope that the grounds south of the Nelson Gallery of Art will be developed in a manner that will be outstanding, in the manner of its architectural development and landscaping, in this part of the country. It also seems practicable and reasonable to anticipate the grouping of other cultural buildings as a part of this center.[19]

The university's advisory board understood these planning concerns and also appreciated the importance of locating the university near the art museum. In May 1931 when one hundred leading citizens, including Volker, William D. Wight, Howard Vanderslice, and former University of Missouri president A. Ross Hill, signed their names to the application for a charter for the University of Kansas City, they stated that they envisioned a 150-acre campus on the south hillside of the Rockhill District. The site was ideal because it was near the "geographical heart of Kansas City" and because it would provide the university with potential "affiliation with other educational and cultural institutions." In addition to addressing concerns about incorporation and financing, the university board heeded the advice of Nelson's University Trustees to consult an expert to design the campus. Ernest E. Howard, chairman of the University of Kansas City Board of Trustees, wrote to William D. Wight in December 1932, asking him to prepare outline studies for the campus and

sketches of initial education buildings. Although Howard said it was "impracticable to make conclusive arrangements at the time," when it was suitable the current board desired to retain Wight "as general University architect with general direction of the whole construction program, to carry out detailed work as may be assigned, and to coordinate the work of other experts who may from time to time be engaged." Wight was eventually hired to do some work for the university, although the extensive planning that the Nelson trustees anticipated he would do did not occur.[20]

In many ways, Nelson, Jones, and Volker became instrumental in establishing the Rockhill District as an educational and art center. At one point the area would include most of the art interests in the city—the Nelson Gallery, the Atkins Museum of Fine Arts, the Kansas City Art Institute—and many of the educational facilities—including the University of Missouri at Kansas City (originally the University of Kansas City), the Linda Hall Library, the Barstow School, Rockhurst College, the Stowers Institute, and the Midwest Research Institute.

Besides managing their real estate, the trustees began to learn about collecting art during those years when the trust's money was unspendable because of Walter Dickey's legal actions. In one way, the legal action from Dickey may have kept the trustees from making some advantageous early purchases, such as a collection offered by the von Nemes family that Nichols traveled to Munich to view in the spring of 1928. However, Dickey's suit also gave the trustees the perfect excuse to avoid making decisions and commitments for which they were not quite prepared. Applications from people seeking positions with the new museum or hoping to sell art objects were handled in the same manner. The trustees said they could not appoint anyone or buy anything because their counsel, John E. Wilson, viewed "any considerable use of income" unadvisable until the courts resolved the Dickey case.[21]

Nichols took a special interest in investigating other museums and trying to receive as much free advice as possible. On his trips east and to Europe, he interviewed such learned men as Henri Verne, director of the Louvre, and Sir Frederic Kenyon, director of the British Museum. Nichols also reported studying museum methods at the Metropolitan Museum of Art and consulted with the directors of the Philadelphia Museum of Art and of the Fogg Museum at Harvard. By the time construction of the building for the Nelson-Atkins Museum of Art had begun, the University Trustees had become much more knowledgeable about art and art museums.[22]

The University Trustees made their first decision about art in relation to the objects in Oak Hall itself. Under the terms of Laura Kirkwood's will, the

executors of her estate (Fred C. Vincent, Wilson, and the New England National Bank and Trust Company) were required "to have the furnishings, ornaments, and other contents of my said residence viewed by at least two experts for the purpose of determining and selecting therefrom all works and reproductions of works of the fine arts." Those pieces chosen were then to be tendered to the University Trustees as additions to the collection of fine arts to be acquired according to Nelson's will. After Irwin Kirkwood's death on August 29, 1927, Wilson, as both counsel for the University Trustees and executor of Laura's estate, stressed the advisability of having the art objects in Oak Hall assessed as soon as possible so that Oak Hall could be vacated.[23]

In October 1927 the University Trustees, employing a casual interpretation of Laura's will, voted to have R. A. Holland, the director of the Kansas City Art Institute, represent them in deciding which articles came under the category of fine arts, with the University Trustees retaining the privilege of final approval. Nichols and Jones spent two weekends at Oak Hall during January 1928 with Holland and Laura Kirkwood's trustees, Vincent and Wilson. Christine Preston Thomson remembered playing in Oak Hall while her uncle, Fred Vincent, and the other trustees made decisions about the objects in the house. Together they itemized and assessed the "Objects d'art" [sic] room by room. All the furnishings, paintings, china, rugs, and other fine arts recorded on the nine-page list of Laura Nelson Kirkwood's estate were then put into storage, with a few exceptions. Laura had specifically bequeathed to her father's art collection a portrait of Nelson painted by William Merritt Chase. Four oil paintings from Oak Hall were also retained to add to the trust collection. These four paintings—a John Hoppner portrait of a man, John Constable's *Cottage in Suffolk*, Sir Thomas Gainsborough's *Girl Standing with Dog*, and Marcus Gheeraerts the Younger's *Portrait of the Countess of Pembroke*—were accessioned by the art museum in 1934.[24]

In 1927 the only other items from Oak Hall that the trustees and their advisers decided to hold for the museum were those that composed the center hall of the house itself: the paneled walls, ceiling, bookcases, stairway foot, and furniture—even Nelson's red plush easy chair—were saved to install in the new museum. This central oak hall, from which the Nelsons' house took its name, became in some viewers' opinion the "very heart and core" of the new gallery. Fortunately, those who felt that way were probably not around to see the Oak Hall room dismantled in 1988 to make room for a photography studio. At that time, the museum staff assured patrons that Oak Hall could be reassembled should the building be expanded to provide the space to do so, but as of yet that has not happened.[25]

Apart from Nelson's Western Gallery and the Oak Hall art objects, the first objects for the museum actually came from an investment in an archaeological expedition to Tello in Asia Minor. Many universities and museums conducted expeditions to the area, and the trustees joined in sponsoring this particular one on the personal invitation of Henri Verne, director of the Louvre. After conferring with Verne, Nichols computed the cost to the trust at $6,000. In return the trust potentially could acquire valuable archaeological pieces and establish a desirable relationship with the prestigious French museum. In June 1928 the trustees voted to collaborate, but rather than risk the trust's money, they decided to advance the $6,000 personally. The understanding was that if the objects obtained did not prove to be of sufficient fine-art value to merit the cost of the expedition, Nichols, Jones, and Volker "would suffer whatever cost might accrue." A year and a half later, in March 1930, the objects procured on the Tello expedition arrived in Kansas City; the University Trustees' gamble paid off. Harold Woodbury Parsons, then adviser on ancient art to the Cleveland Museum of Art, verified the artistic merit of the archaeological finds and assessed their value at $7,000 to $8,000. Of special note was an eight-inch bronze sculpture, a kneeling *Foundation Figure*, from about 2090 BCE. Jones, Nichols, and Volker recouped their investment, and the new museum had its first fifty pieces of art.[26]

The University Trustees expended a great deal of time and energy as managers of the Nelson Trust, but they also received generous compensation for their services. Nelson's will specified that each member of the Board of University Presidents be paid $500 per annum plus necessary travel expenses, but it named no set amount for the University Trustees, stating only, "The university trustees shall receive such compensation for their services as may be fixed from time to time by the board."[27]

The University Presidents and University Trustees first discussed the matter of compensation at a joint meeting in December 1926, nine months after the trustees' appointment. The presidents deferred a decision until they could consult with others. At their next meeting, on March 29, 1927, they prepared a statement, which they made public the next day:

In view of the peculiar difficulties and problems involved, particularly in the sale of the newspaper, the University Trustees themselves assumed the burden of administrative duties. In recognition of such service the Board of University Presidents voted to the University Trustees a total allowance of Forty Thousand Dollars, which is approximately 4% of the gross income for the period.

The Board of University Presidents believe that the value of the Nelson properties has been greatly enhanced by the business experience and the public spirit of the University Trustees, William Volker, J. C. Nichols, and Herbert V. Jones.

W. B. Bizzell

E. H. Lindley

Stratton D. Brooks[28]

Thus, Volker, Jones, and Nichols divided $40,000 for their services from March 3 to December 31, 1926. In 1927 the gross income of the trust diminished to $599,193.02, but the board decided to pay the trustees 5 percent instead of 4 percent of the gross income. The trustees received $29,959.65 for services rendered during 1927 and $32,718.85 for 1928. At the joint meeting

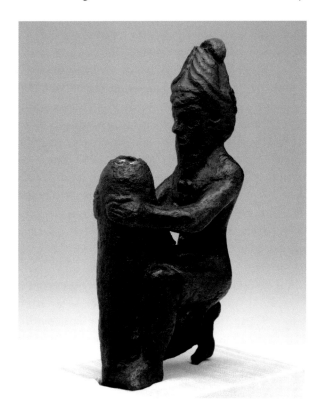

FIGURE 5.4 This Mesopotamian bronze *Foundation Figure*, from about 2090 BCE, was one of the first fifty pieces of art purchased by the Nelson Trust. (Purchase: William Rockhill Nelson Trust, 30-1/50)

of the University Presidents and University Trustees on May 10, 1930, "it was moved and unanimously carried that the salaries of the three University Trustees for the year 1929 be fixed at five percent of the gross income for the year, and the compensation for the current year be fixed at five percent of the gross income, which amount be paid in quarterly installments." The audits of Fraser, Dell, and Company, certified public accountants, show that the trustees jointly received $32,868.86 for 1929, $37,765.95 for 1930, $32,850.48 for 1931, and $24,332.62 for 1932. When the trust's income decreased during the Depression years because of delinquent interest payments on loans and real estate investments, the trustees' compensation decreased also. The University Presidents paid the trustees a fixed fee of $25,000 in 1933, $20,000 in 1934 and 1935, and then $17,000 in 1936, 1937, and 1938.[29]

The University Presidents had reason to be pleased with their handpicked trustees and must have accepted with sincere regret the resignation of William Volker on December 7, 1929. Volker, who resigned "because of other claims on my time and for other reasons," had served as a trustee for almost four years. Although the museum's development continued to interest him, Volker focused his attention on plans for the University of Kansas City. Always a strong advocate for education and a centrally located university, Volker became the person who turned the hopes of the university's advisory board into reality. In June 1930 Nelson's University Trustees agreed to sell the five-acre site south of Brush Creek that the advisory board had been considering since 1928. Volker purchased the land from the Nelson Trust for $100,000 and donated it as a site for the projected university. A year later Volker bought the Walter S. Dickey mansion at Fifty-First and Holmes from Dickey's heirs. The mansion became the university's first classroom building when the University of Kansas City opened in October 1933.[30]

To replace Volker, the Board of University Presidents appointed Arthur M. Hyde on December 31, 1929. Hyde, who had served as governor of the state of Missouri from 1921 to 1925, also received an appointment from President Herbert Hoover to become secretary of agriculture in 1929. Although Hyde's position in Washington proved helpful in allowing him to check on museums and art purchases in the East, Nichols and Jones made most of the decisions in Kansas City. Nichols, because of his outspoken nature, eagerness to take on a multitude of jobs, and genuine interest in the museum, had long been the dominant trustee. It seemed only fitting after Volker's resignation that Nichols become chairman of the University Trustees. Jones retained his job as secretary, and the trustees elected Hyde as vice chairman. The Board of University

Presidents acknowledged the difficult problems the University Trustees had faced during their first years governing the Nelson Trust. They probably did not foresee that the trustees' responsibility would continue to expand as they assumed the role of building and managing a major art collection.[31]

PART II

<div style="border:1px solid">

THE TEMPLE OF ART BECOMES A REALITY

1928–1933

</div>

BUILDING THE MUSEUM

W HEN THE VARIOUS groups of trustees began planning for the
Nelson-Atkins Museum of Art in 1928, they had no art collec-
tion (except for Nelson's reproductions) and no building to move
into, but they assuredly had the financial resources to achieve something mon-
umental. While the University Trustees managed the Nelson Trust and ac-
cumulated knowledge about art museums, the trustees named by Laura and
Irwin Kirkwood, Mary Atkins, Frank Rozzelle, and Ida H. Nelson planned
the physical structure of the museum. Seven men were involved in decisions
about the design and construction of the building: A. W. Childs and Herbert
V. Jones, as directors of Mary Atkins's estate; Fred C. Vincent, Earl McCollum,
and John E. Wilson, as trustees of Laura and Irwin Kirkwood's estates; and the
New England National Bank, represented by John F. Downing and Albert R.
Strother, as trustees for Laura Kirkwood, Ida H. Nelson, and Frank Rozzelle.
Although all seven men worked on plans for the museum, before the actual
groundbreaking took place in July of 1930 they chose from their number a
building committee composed of Strother, Jones, and Vincent, with Vincent
serving as chairman.[1]

Fred Cameron Vincent, president of Simons-Shields-Theis Grain Compa-
ny, would find his job as chairman of the building committee consuming his
full attention for more than three years. He spent long hours over blueprints,
traveled widely, and worked day and night to coordinate architects, trustees,
and the city government. If there is any truth to the idea that City Manager
McElroy had hoped to gain jobs for his Pendergast cronies in the construction
of the museum on city property, he must have been disappointed by Vincent's
control and management of the vast construction operation. Vincent proved
to be the perfect person to chair the building committee. Known as a shrewd

FIGURE 6.1 With the exception of A. W. Childs, the entire building committee, representing the estates of Mary Atkins, Ida Nelson, Laura and Irwin Kirkwood, and Frank Rozzelle, was on hand on July 16, 1930, for the groundbreaking ceremony. *From left to right*: John F. Downing, Herbert V. Jones, William D. Wight (architect), Earl C. McCollum, John E. Wilson, Fred C. Vincent (chairman), Albert R. Strother, and John C. Long (contractor). (Missouri Valley Special Collections, Kansas City Public Library)

and dependable businessman, he had wide experience and a vast number of contacts. He had come to Kansas City from Chicago in 1905 as the representative of Bartlett, Frazier, and Company, and then took a seat on the Board of Trade for Simon-Shields-Theis. He served as second vice president of the Board of Trade, vice president of the Council of the Grain Exchange, and president of the Johnson County National Bank and Trust Company. Besides his business ability to coordinate and compromise, Vincent had a keen interest in art and museums. He was a trustee of the Art Institute and had served three terms as the institute's president. He and his wife, Susan Gay Vincent, enjoyed studying art and took nine trips to Europe between 1919 and 1937 for that purpose. In addition to Vincent's gift of many hours of hard work as the chairman of the building committee, he and his wife would make several generous gifts of art to the new museum including Giuseppe Maria Crespi's *Young Man in a Helmet*.[2]

The first order of business for the trustees in charge of the building funds was to choose an architect to design the museum. On July 3, 1927, John F. Downing, the seventy-two-year-old chairman of the board of the New England National Bank, announced that as the representative trustee of Ida Nelson's estate, he had decided to retain the local firm of Wight and Wight, concurring with the choice made by Mary Atkins's trustees in 1920. Downing, a connoisseur, collector, and supporter of the arts, had a strong inclination toward the classical style. He had insisted on using Wight and Wight to design a classical building for his own bank, and since he had been Nelson's banker, felt he knew Nelson's taste. He was confident Nelson would have approved of a classical building to house his art collection. Like Vincent, Downing had a background in both business and art. He had served on the Missouri Capitol Art Commission and had been the treasurer for the Kansas City Art Institute for many years. If he had been a younger man, Downing undoubtedly would have taken a more active role on the building committee. He controlled the majority of the building funds and was called on frequently for consultation and ceremonial duties. The other trustees respected his opinions and supported his decision to hire Wight and Wight.[3]

The brothers Thomas Wight and William D. Wight were originally from Halifax, Nova Scotia. Each had worked for the well-known New York architectural firm of McKim, Mead, and White for about ten years, and each had spent a year studying in Greece and Italy. The older of the brothers, Thomas, came to Kansas City in 1904 as the partner of Edward T. Wilder. William joined the firm in 1911, and Wilder retired about five years later. In time, Wight and Wight designed such prominent buildings as the Kansas City Life Insurance Company, St. Joseph Hospital, the First National Bank, and the Wyandotte County Courthouse.[4]

The firm of Wight and Wight was appropriate for the museum project not only because it had become the most prestigious architectural firm in Kansas City by the late 1920s but also because it specialized in neoclassical buildings. Most of the art museums in the country at this time were constructed in the neoclassical style, which according to Kansas City architectural historian George Ehrlich both suggested the permanence of artistic values and allowed the art museum to appear as a symbol: "part monument, part temple to art." If Kansas City wanted its art museum to look like other American art museums, the design needed to imitate the neoclassical tradition of such museums as the Metropolitan, the Museum of Fine Arts, Boston, the Toledo Museum of Art, and the Cleveland Museum of Art. Besides, when Irwin Kirkwood had met with Thomas Wight in July 1927, a month before Kirkwood's death, he

had insisted on two things: Indiana limestone as the building material and a classical design. Knowing Nelson's predilection for art and architecture that had stood the test of time, Thomas Wight had agreed that a classical building would be appropriate.[5]

The Wight brothers began preliminary sketches during the summer of 1927. Every year both William's and Thomas's families rented cottages or stayed in the hotel at Hubbards Cove, Nova Scotia. William's daughter, Jean Rosahn Wight, remembers many things about those summer vacations, including her father's almost daily trek to the telegraph office to send fifty words or more back to the draftsmen in the Wight and Wight office in Kansas City. She also recalled her father's constant sketching. "We learned early never to throw away a scrap of paper," she explained. "Dad would pick up anything at hand and begin to draw. It might be an old envelope or the *Saturday Evening Post*." She particularly remembered what she called "Dad's Shoebox Church," a drawing he made on a shoebox lid of a small church for the nearby community of Martin's Point.[6]

The Wight brothers already had many ideas for the museum. In April 1927 the Atkins trustees had sent Thomas Wight along with R. A. Holland to study several other museums in order to plan for the proposed Atkins Museum in Penn Valley Park. Now Thomas found he needed to make only slight alterations to those plans in order to combine the Atkins Museum of Fine Arts with the Nelson part of the museum. By late 1929, when Wight and Wight submitted their completed plans, they had incorporated ideas from their studies abroad, their own buildings, and from several other museums, especially the Cleveland Museum of Art. Although the art museum in Cleveland was built of white Georgian marble instead of limestone and was only 300 feet by 120 feet as compared to the proposed dimensions for the Nelson-Atkins of 390 feet by 175 feet, the two buildings resembled each other in several respects. The neoclassical architecture and the way each museum was designed to sit on a prominent hill were similar. The garden court, an innovation in museum planning in Cleveland, was perfected in Wight and Wight's Rozzelle Court.[7]

Wight and Wight also kept Nelson's preferences in mind in their design, using limestone from Nelson's home state of Indiana for the exterior of the building. However, the Wight brothers also knew of Nelson's love of native Kansas City stone, which he used so lavishly in his own home and in his Rockhill development. They contacted the Kansas City Marble and Tile Company, which would work for two years to develop "Kacimo marble," native stone polished to a marble finish. The architects used the Kacimo marble in the museum's south vestibule and asked Leroy Daniel MacMorris, a Kansas City mural

painter whom both the Nelsons and the Kirkwoods had patronized, to paint the ceiling of the south vestibule as well as Rozzelle Court.[8]

As Wight and Wight worked on the final plans, the building committee decided in spring 1928 that it was time to tear down Oak Hall to prepare the site for the new museum. Even though Laura Nelson Kirkwood had specified in her will that Oak Hall be razed, the public was resistant to the idea. Many people viewed the stone mansion as a sort of shrine to Nelson and as a notable Kansas City landmark. The *Kansas City Times* reported on March 10, 1928, that "the tearing away of this beautiful structure of native stone, mellowed by time, related to the history and progress of Kansas City and the object of public sentiment, will be attended by many sincere regrets." Wilson, McCollum, and Vincent, acting as Laura Kirkwood's trustees and trying to follow the intent of her will, stated that after the house was torn down "every stone will be hauled away and every bit of wood will be taken elsewhere or burned on the premises." Every stone was hauled away, but the trustees had not anticipated what happened next. The Ward Investment Company, which was developing the subdivision of Sunset Hill, decided to play on the public's fond feelings toward Oak Hall. They advertised that two of their houses for sale on Fifty-Fourth Street and Fifty-Fourth Terrace were built of native stone from the Nelson home. E. L. Winn, the contractor for both houses, had seen recycling possibilities when he agreed to haul off the stone from the demolished Nelson estate. Winn was not the only builder to make use of the Oak Hall demolition. A survey investigating other uses of Oak Hall stone in Sunset Hill also found that at least one house in Mission Hills, Kansas, made use of the stone as well other materials from Oak Hall. Mr. and Mrs. John S. Wolcott spent $5,000 to purchase limestone, paneling, stone sills and caps, stairways, and copper guttering from Oak Hall for their two-and-a-half-story, stately home on Oakwood Road. The Wolcotts even named their home "Oak Hall" in honor of the original. Thus, although the trustees' efforts did not work out as Laura Kirkwood might have hoped, Oak Hall was razed, as she had directed.[9]

With the task of razing Oak Hall completed, the building committee met in February 1929 to review Wight and Wight's completed plans for the museum. Vincent was unwilling to approve the design without consulting one or two outstanding museum curators about the interior arrangement of the building. The University Trustees agreed with the advisability of soliciting outside opinions and decided to ask two museum directors to come to Kansas City. Nichols volunteered to ask Edward Robinson of the Metropolitan Museum of Art, whom he had met on a trip east in November 1928. Jones would communicate with Paul Sachs of the Fogg Museum at Harvard. Although no record of

these contacts exists in the University Trustees' minutes, Ethlyne Jackson Se-
ligmann, who served as assistant to the first director of the Nelson-Atkins and
as acting director during World War II, insisted that the trustees sought advice
from the staff of both these preeminent museums. The "most important source
of information" on museum planning would have been the Fogg Museum,
according to Seligmann. "The Fogg Museum . . . was 'the' school of museum
training, and I believe, the only one at the time." In fact, in the 1920s the Fogg
Museum at Harvard was the only place in America to teach museum science
as a specialized profession. Harvard was also the university Nichols claimed as
his alma mater and the first place he looked for advice.[10]

Six weeks after the decision to seek outside opinions, the University Trustees
and the building committee sent Vincent, Nichols, Jones, and Thomas Wight
to the East Coast to confer with museum directors and architects. Although
the University Trustees made no report on this trip in their minutes, their
findings probably included information on the proper arrangement, size, and
lighting for the interior galleries. However, even after this trip, the trustees re-
mained uncertain about giving their final approval to the architectural plans.
In December 1929 the trustees sought the advice of Frederic A. Whiting, di-
rector of the Cleveland Museum of Art. Whiting reviewed the museum plans
and recommended interior changes, for which service the University Trustees
and the building committee paid him $910. Over the next few years Whiting,
as director of the Cleveland Museum and then as president of the American
Federation of Arts, would continue to offer advice to the University Trustees.
The Kansas City museum would also continue to look to the Cleveland Mu-
seum of Art as a physical model, to the Metropolitan as the ultimate example
of a complete historical art collection, and to the Fogg Museum at Harvard
as a source of information. These three museums significantly influenced the
trustees in charge of art and of building the Nelson-Atkins Museum of Art.[11]

After architects Wight and Wight deliberated on the changes Whiting rec-
ommended, the building committee met once again with the University Trust-
ees; on March 17, 1930, all the trustees approved the revised building plans.
They agreed on a monumental neoclassical limestone building. It would be
the height of a six-story office building, large enough, they thought, to meet
all future art needs. The east wing of the building constituted the Atkins Mu-
seum, and from the east side the façade appeared separate from that of the
Nelson Gallery on the west. However, Wight and Wight had designed the two
institutions to appear as one entity from the two main—north and south—
perspectives. Perhaps the most distinctive features of the building were thirty-
two gigantic columns, each forty feet high and five feet in diameter, that would

ornament the four façades. Twenty-three panels on the exterior walls would depict the history of the country as rendered by American sculptor Charles Keck. The interior of the building would include fifty exhibition rooms, a magnificent central hall with twelve thirty-foot columns, a courtyard, and a large auditorium.[12]

The architects and the building committee considered the setting of the museum almost as important as the building itself. Wight and Wight wanted to extend the museum grounds over a quarter of a mile south, beyond Brush Creek to what was then the site of the Barstow School. They would use the land to create a mirror lake measuring 400 feet by 1,300 feet. The lake, although similar to the ones in Cleveland and in front of the Albright Art Gallery in Buffalo, New York, would be larger than either. The University Trustees acknowledged that "public sentiment seems to favor this plan." Nichols, in particular, liked the idea of a "reflecting pool as effective as the one that reflects the Lincoln Memorial and the Washington Monument." Land planner that he was, Nichols personally had topographical maps prepared of the area. In July 1930, the University Trustees met with Vincent and Wilson from the building committee and L. Newton Wylder, who represented the City Park Board, to discuss the city's plans to proceed with the construction of Brush Creek Boulevard, a major access route to the museum. Nichols shared his maps and asked Wylder to consider the possibility of enclosing Brush Creek in a sewer underneath the proposed mirror pool. The expense of diverting or burying the creek that ran right through the middle of the proposed lake site was just one of the many obstacles that eventually blocked construction of the pond. The Rockhill Homes Association posed another problem. The trustees would have to convince members of the association to release Block Seven from zoning restrictions in order to extend the grounds of the art gallery. The reluctance of the association to alter restrictions in Block Six to permit the museum itself had been extremely strong, as the Rockhill owners were concerned about protecting their residential area.[13]

The spectacular mirror lake never became a reality. Thomas Wight was as disappointed as Nichols about the lake, according to his daughter, Dorothy Wight Buckley. However, in 1955, the city did finally purchase Block Seven from the Nelson Trust. After diverting Brush Creek into a sewer similar to what Nichols had proposed twenty-five years earlier, the city removed rental houses on the block and created a broad lawn. City officials dedicated the site originally proposed for the reflecting pool to Frank J. Theis, a former president of the Park Board. To honor William Volker, the first president of the University Trustees and a founding father of the University of Kansas City, private

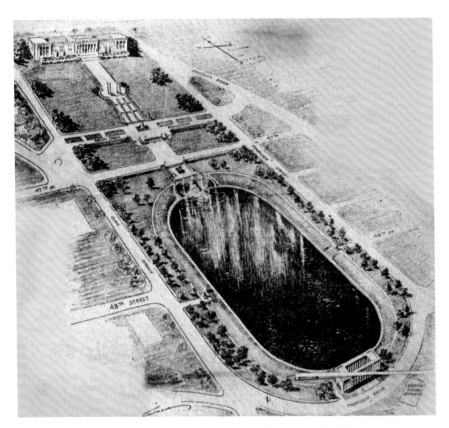

FIGURE 6.2 A member of the *Kansas City Star*'s art staff conceptualized the new museum with a mirror lake and extensive grounds. (*Kansas City Star*, March 17, 1929, NAMAA)

donors presented a fountain for the south end of the mall, near the street also named for Volker. Although not as impressive as Cleveland's mirror lake, the two-block-long sloping green lawn that viewers saw when looking north from Volker Boulevard toward the Nelson-Atkins Museum of Art was nonetheless a lovely sight.[14]

Even though the building committee abandoned the mirror lake, its members were determined to make the museum grounds as beautiful as possible. The idea of developing a parklike setting was not unique, but most city museums did not have the luxury of large, open areas. Some museums on spacious grounds, like the Cleveland Museum of Art, had not considered landscaping a top priority when they opened. In fact, when Cleveland's museum opened, it sat on an "unkempt and ragged hill" until the local garden club, trustees, and the city government decided to remedy the embarrassment. In 1924, $400,000

in private donations from Cleveland's concerned citizens paid for Frederick Law Olmsted Jr., a city planner and landscape architect like his father, to plan and execute a setting that included a mirror lake, sculptures, trees, and walks.[15]

The Nelson-Atkins building committee decided early in the planning stage to hire Kansas City's foremost landscape architects, Hare and Hare, a father-and-son team. The senior partner, Sid Hare, had worked with George Kessler, the designer of Kansas City's park and boulevard system, and then succeeded him as city engineer from 1885 to 1896. Later, as superintendent of Forest Hills Cemetery, Sid Hare won a national reputation for his design of one of the first planned garden cemeteries in the country, which served as an arboretum and bird sanctuary as well. S. Herbert Hare went into business with his father in 1810 when he graduated from Harvard, where he had studied under Frederick Law Olmsted Jr. During Hare and Hare's twenty-eight-year partnership, Sid Hare preferred cemetery and park commissions, while S. Herbert Hare concentrated on city planning—eventually taking commissions in thirty-three states and three foreign countries. Hare and Hare planned the grounds of most of the large projects in Kansas City from the late 1910s into the 1930s, including Nichols's Country Club Plaza and his residential developments. Besides doing subdivision layouts in the Country Club District and Mission Hills, Hare and Hare designed street entrances, island parks, and settings around the art objects that Nichols purchased. Kansas Citians agreed with Sid Hare's philosophy that "parks educate people in art equally as grand as the art of painting or sculpture." They also recognized Hare and Hare's trademarks: "winding roads contoured to natural topography, preservation of trees and valleys, an eye for the scenic vista, and an attention to charming detail." Much of the charm of Kansas City can be attributed to Hare and Hare's landscape design.[16]

The building committee considered Hare and Hare the natural choice to landscape the grounds of the Nelson-Atkins. Nichols, who could not stay out of the building committee's business, heartily endorsed the decision. Hare and Hare proposed a $125,000 project of walkways and stone walls that conformed to the natural topography together with planted shrubs and flowers to give color and seasonal variety. They also decided to match the native grove of pin oak, scarlet oak, hackberry, sugar maple, red maple, sweet gum, beech, and birch trees on the west of the grounds with a similar grove to the east. They moved seventy-five large trees with ten-foot balls of earth from other places on the property to the east grove and planted an additional two hundred trees around the museum. In time, the landscaping of the Nelson-Atkins became Hare and Hare's best-known work.[17]

FIGURE 6.3 The Kansas City landscaping firm of Hare and Hare planted three hundred trees on the museum grounds as part of its $125,000 project. (Historical VF, NAMAA)

The building committee selected the Long Construction Company to build the museum. John C. Long, the contractor the University Trustees had earlier asked to appraise the *Kansas City Star* building, had an established reputation for honesty and professional integrity. He had started his own construction company in 1906, just three years after he received an engineering degree from Princeton University. He had experience building houses, bridges, pipelines, and several buildings in Kansas City—St. Luke's Hospital, Menorah Medical Center, the Pickering Building, and the building for the American Hereford Cattle Breeding Association. Rumor had it that when the members of the building committee approached Long about building the museum, they trusted him so completely that they did not solicit competing bids and offered him a simple one-page contract. Long Construction Company agreed to build the museum according to Wight and Wight's plans for an estimated $2.6 million.

In March 1930, the trustees approved the architectural plans. In May, homeowners in the Rockhill area permitted rezoning. By summer, Long was prepared to begin construction. However, excavation awaited the City Council's approval of an ordinance to allow the Atkins Museum to occupy a part of the land given to the city by Irwin Kirkwood. Finally, on July 14, 1930, the City

Council of Kansas City, Missouri, took the requisite legal action. Two days later, on July 16, John F. Downing turned the first shovel of dirt. At this groundbreaking ceremony Downing spoke for the many people who had worked so hard for so long: "We launch this venture in gratitude in the hope it will prove a beacon of enlightenment to this city and territory for generations to come."[18]

Newspaper reports indicated that most Kansas Citians were interested in the details of the museum's development. Drawings and diagrams of the construction, which Long estimated would take at least two years, kept the public up-to-date. In the first stage, fifty men and many steam shovels spent over two months removing approximately sixty thousand tons of dirt and rock. By the end of September, foundation piers and retaining walls rose from the completed excavation. Long's construction company laid the foundation and raised the steel frame during the winter of 1930/31. The only potential problem occurred on December 1 when weather forecasters issued freeze warnings just as workmen prepared to pour concrete for the first floor. Fearful that freezing temperatures would damage fresh concrete but unwilling to wait for better weather with winter approaching, Long enlisted two concrete plants and poured the entire floor in one day—a record. Long then directed workmen to cover the floor with straw, an innovative technique still in use today, which prevented damage to the foundation by allowing ice to crust on top of the straw rather than directly on the surface layer of concrete.[19]

By the spring of 1931 construction had progressed sufficiently to allow installation of the cornerstones. Two separate ceremonies took place; one for the Atkins Museum on April 5, 1931, and one for the Nelson Gallery on May 3, 1931, which, according to the *Kansas City Star*, thousands of people attended. At each ceremony, a copper box containing the donor's will, biographical material, and a few artifacts was buried.[20]

Workmen finished the exterior of the building by the fall of 1932, and the trustees were besieged by requests for tours of the building even as work proceeded in the interior galleries. They decided to postpone any tours until the museum opened officially—which was not until December 1933, as it turned out. It took an entire year to complete the construction of the interior and install the art that was integral to the museum itself—including frescoes, period rooms, and display cases. The first and second floors of the west wing were left unfinished with the idea that this space could be used to meet future demands. The completed structure cost $2.75 million, very close to John Long's original estimate. Long said the museum was "built with as much economy as possible"; however, "beauty and lasting quality had the first consideration." It had also been important to Long, as it would have been to Nelson, that nearly all

the work on the museum was done by Kansas Citians in Kansas City; and Long assured the public that they had done a fine job. "Above everything else," Long said, when interviewed in March 1933, "is the knowledge that you are building a memorial to the life and works of a man"–and of a woman, he might have added. Long was proud of his accomplishment as were his employees—many of whom would have been out of work, given the economic times—who could say they had played important roles in creating a monument for the city.[21]

FIGURE 6.4 At the height of the Great Depression, over one hundred men went to work to construct the museum while countless others were employed to finish the interior. ("Builders of the William Rockhill Nelson Art Gallery," February 3, 1931, RG 70, NAMAA)

Although the building committee supervised construction and the details of successfully completing the museum, the University Trustees involved themselves in building decisions as well. Nichols met with the building committee, on which Jones served, and with its architects and contractor in order to make sure that the layout would be efficient as well as beautiful. Never loath to express his opinion, Nichols discussed such subjects as the installation of sidewalks, the widening and grading of Forty-Fifth Street, adequate parking, lighting inside and outside, and the allotment of space in the galleries themselves. The three members of the building committee must have felt relief when their part of the project was completed. They had built a monument that would enhance Kansas City's future. When Fred C. Vincent, as chairman of the building committee, turned the completed Nelson Gallery of Art over to the city, he could put away his little black book in which he had noted every expenditure and every change in plans. Now he could go back to his regular job, and the University Trustees could proceed with the task of filling the museum with art.[22]

BUILDING THE ART COLLECTION

W HILE THE BUILDING committee concentrated on construction of the Nelson-Atkins Museum of Art, the University Trustees began to purchase artwork. Of course, the trustees already had Nelson's Western Gallery of Art that had been on display in the city library, which included sixty reproductions of paintings by old masters as well as some plaster casts. As late as February 1929, the University Trustees expressed the opinion that it would be "a desirable and logical thing to use this collection as a nucleus of the Nelson Gallery of Art." Nonetheless, at some point they changed their minds and decided to collect original art objects rather than reproductions. Perhaps the wording of Laura Nelson Kirkwood's will and, subsequently, of her husband's will, influenced this decision. Laura omitted any mention of her father's Western Gallery and allowed for her trust to not only be used to provide a site and construction of the William Rockhill Nelson Gallery of Art but also to use any remaining funds to "acquire and purchase such pictures, paintings, and works of art as may be approved by at least two (2) experts."[1]

With the decision to collect original works, the trustees deviated from William Rockhill Nelson's idea of art for the public. The change in focus, however, definitely reflected the times, as collections of reproductions had gone out of vogue. The University Trustees wanted the Nelson collection to emulate the best art galleries in the country. Apart from the Fogg Museum—which at the time hung both reproductions and originals—most American art museums contained original works only. The University Trustees intended to fill their museum with the best art; while to Nelson "best" meant copies of the greatest works of all times, to the trustees "best" meant "original." Postponing any decision about the Western Gallery of Art that Nelson had presented to the Kansas

City School District in 1902, the trustees forged ahead with their own plan to collect original pieces.[2]

Besides making the decision to purchase only original works of art, Jones, Nichols, and Hyde also determined that the museum would house a general historical collection of art. They did not want to limit the scope of the art objects to a particular region or period. According to Laurence Sickman, the museum's first curator of Oriental Art and its second director, the University Trustees set this policy because they believed in the "equal validity of the arts of all people and times." Nelson's will already had limited the works of art that could be purchased with his funds to those crafted by artists who had been dead for at least thirty years. However, the trustees did not worry about this limitation. They immediately recognized that they could accept paintings and sculptures by contemporary artists as gifts to the museum and did so as early as 1928, when Mrs. James Townley informed them that she had purchased a painting, *The Valley of the Kaw* by living artist Ernest Lawson, with the intention of giving it to the museum. On December 20, 1928, Mrs. Townley presented the painting at the Art Institute, and Nichols received it on behalf of the University Trustees.[3]

Because they had no expertise in selecting art, with the exception of Nichols's experience with decorative landscaping, the University Trustees decided to hire professional art advisers. Early on they had sought advice from R. A. Holland, director of the Kansas City Art Institute, on the selection of appropriate objects for the museum from Nelson's possessions in Oak Hall, and the trustees and Holland had conferred periodically since then. The trustees had considered hiring a permanent art adviser in October 1928, but Jones said he did not think it was wise to employ a high-salaried curator at that point. He suggested giving Holland a temporary position at a nominal salary. Nichols conferred with Holland, who agreed to the arrangement. However, in April 1930 the University Trustees decided to offer Holland a job title and a regular salary. During a two-hour conference with Holland, Nichols told him that the trustees would like to name him the curator of collections for the Nelson Trust, a job he could hold while he continued to serve as director of the Art Institute. As curator, Holland would be paid $100 per month to oversee the various art objects purchased by the Nelson Trust, investigate local art, and handle correspondence referred to him by the trustees. Nichols also informed Holland that the trustees would pay him $500 for his past services. Although pleased that the trustees had offered him retroactive compensation, Holland was not entirely satisfied with the rest of the proposal. Having already served as an adviser since 1927, he had hoped to be named director of the new museum. Nichols

told Holland he could make no promises because "so far it was not known what group would be placed in authority of the Nelson Gallery of Art and the Atkins Museum, that the Nelson trustees are only charged with the purchase of art and exhibition of the same, and until some plan is finally worked out as to the control and conduct of the Gallery nothing could be determined as to the naming of officials in charge of the Gallery." This statement, although true, exaggerated the uncertain role of the University Trustees. In fact, in the plan that eventually evolved, the University Trustees, due to their power over the purse strings, their desire to direct policy, and the lack of any attractive alternatives, became the governors of the museum. Nelson's trustees did decide museum policy, and they appointed a director just two years later. It was not until Laurence Sickman became director in 1953 that the Atkins trustees asked for him to be named director of both the Atkins Museum of Fine Arts and the Nelson Gallery of Art. While the Atkins trustees maintained ownership of the Atkins side of the museum, they were not involved in many policy decisions.[4]

While Holland accepted the position as curator of collections and continued to offer advice on local art, the trustees looked outside Kansas City for an expert or experts to help them assemble the museum's treasures. Once again, they turned to Frederic A. Whiting, director of the Cleveland Museum. At the same time, Edward "Foggy" Forbes and Paul Sachs of the Fogg Museum at Harvard "certainly played a stellar role in advising about 'advisers,'" according to later acting museum director Ethlyne Jackson. Of the four art advisers and one director named by the University Trustees during the next few years, four had studied at Harvard and all had the endorsement of Whiting.[5]

The first adviser appointed by the trustees, Harold Woodbury Parsons, came with recommendation from Forbes, Sachs, and his employer, Cleveland's Director Whiting. In 1901 Parsons graduated from the Noble and Greenough School, a feeding school for Harvard, which he attended but where he was an indifferent student. After leaving Harvard in 1904, Parsons traveled in Europe, viewing art collections and developing an eye. A "self-described aesthete," Parsons became smitten with Greek and Roman art and with the entrepreneurial side of art collecting. He decided to become an art adviser and spent fifteen years as a consultant to society art collectors and museums. He received his first formal position in 1925 as European representative on the staff of the Cleveland Museum of Art, a job he held until 1941. The University Trustees hired Parsons with the understanding that he would continue his work with the museum in Cleveland and that Cleveland would continue to pay him $5,000 a year plus a travel allowance. The Kansas City museum would also pay him $5,000 a year and related travel expenses. The agreement with Parsons

allowed this experienced buyer to give the curators of the Cleveland museum the first option on the art objects he acquired, and those they did not want to the trustees of the Nelson Gallery of Art. Evidently, the trustees were willing to be offered second choice because they had confidence in Parsons and believed, as Jones recorded in their minutes, that "because the Cleveland Museum collection is rather complete," the policy "would seldom work to the disadvantage of the Nelson Trust."[6]

In retrospect it is difficult to know how much this arrangement hurt the Nelson collection, but it does demonstrate the naïveté and inexperience of Jones, Hyde, and Nichols. No museum collection is ever complete. Because of the dual role Parsons played with Cleveland and Kansas City, he encouraged competition, as Parsons tantalized trustees of both museums with objects he told each the other surely would want. Over time, Parsons's self-serving taunts became more transparent. Some twenty years later, in 1953, he would write to Nelson-Atkins director Laurence Sickman that a certain Sicilian bronze—"an astonishing object"—"might be too special for the Trustees to grasp, in which case I shall let the Cleveland Museum of Art consider it." Nonetheless, Parsons's record with both museums was, overall, commendable.[7]

Parsons began his work for the Nelson Trust on April 1, 1930. According to his long-standing practice, he watched the art market during the winter months from New York and during the rest of the year from Europe. He visited London, Paris, and the major cities of Italy, Germany, and Austria annually to remain current about what might be purchased and at what price. Parsons lived well with an apartment and a private secretary in New York, an automobile in Italy, and a seventy-five-foot yacht in the Mediterranean. This lifestyle, which Parsons estimated cost $20,000 to $25,000 per year in 1930 dollars, required more than he received from museum trustees in Cleveland and Kansas City. His "modest independent income" helped make up the difference, but Parsons also depended on commissions on art sales to private clients. He insisted on his right to offer private buyers the art he did not sell to either of the museums he represented, but he gave the trustees his assurance that he would not accept commissions from sellers of art objects. If, for some reason, Parsons should receive a commission from an art dealer or seller, that commission, he agreed, "shall be turned over to the Nelson Trust."[8]

Undoubtedly one of the most colorful figures in the early history of the Nelson-Atkins, Parsons made an impression on almost everyone he met. He certainly enchanted Nichols and Jones at their first meeting with him in March 1930. They had invited Parsons to come to Kansas City to evaluate the art

objects acquired on the Tello expedition. By pronouncing that two bronze fig-
urines, an alabaster vase, and some pottery pieces were of artistic interest and
exceptional rarity, Parsons put the money advanced by the trustees back into
their personal pockets. Parsons, however, had more to recommend him than
this popular opinion. Besides Whiting, who praised Parsons's expertise, Rob-
ert Harshe, director of the Art Institute of Chicago, and Meyric R. Rogers, di-
rector of the St. Louis Art Museum, recommended Parsons too. When Arthur
Hyde met with Parsons in New York he concurred with Nichols's and Jones's
decision to appoint Parsons as art adviser and foreign representative for the
trust. On Parsons's six-day introductory trip to Kansas City, those who met
him "universally endorsed him"—even Holland, according to Jones's minutes
of April 8, 1930. Over the years, Parsons may have made some enemies, but
Kansas Citians were enthusiastic about him initially.[9]

No one can disagree that Parsons strongly influenced the early develop-
ment of the Nelson-Atkins collection. Several experts and friends urged the
trustees to concentrate the collection in fields that had not been as thorough-
ly worked as had European old masters—for example, Persian, Chinese, or
Southwestern art, an area which University of Missouri's president, Stratton D.
Brooks, suggested that the trustees pursue, taking advantage of the expertise
of a retiring University of Missouri professor of art and archaeology, Dr. John
Pickard. When Professor Clarence Ward, head of the Fine Arts Department of
Oberlin College, lectured at the Kansas City Art Institute in March 1931, he
urged the Nelson trustees to find a field other than old masters. He cautioned
them against buying second-class European paintings because so few first-rate
old masters were available. Parsons, however, always assumed he had been
retained to assemble a general historical collection based on objects chosen
for their exceptional aesthetic quality. He encouraged the trustees to buy old
masters as well as original works from other geographical areas and other his-
torical periods. "We are building up a museum which will be known for qual-
ity rather than quantity," Parsons insisted. "All civilizations will be represented
in their arts but first of all it will be a great picture gallery." Parsons admitted
that all the rooms in the museum would not be full when the gallery opened,
but "we shall endeavor to obtain outstanding masterpieces in all schools of
painting and in the field of decorative arts." Parsons also steered the trustees
away from pieces that he considered mere archaeological relics. Parsons, who
could be as pedantic and pompous as he could be charming, used the former
tone in a letter to Nichols about the early purchases: "I have always assumed
that the intention of the Trustees is to form collections which will present the

artistic expression of past civilizations, rather than the collections in which archaeological matter would form an important part. . . . Let us, from the outset, avoid expanding into these archaeological groups."[10]

In order to assure his control over the collection, Parsons convinced the trustees not to make any purchase unless he or another competent expert approved of the object. Parsons, with more than a little arrogance, announced that he "did not want to be associated with an institution where unwise purchases might be made and reflect on him as Art Adviser of the Trust." After all, Parsons would confide to Laurence Sickman many years later, "When one has labored for nearly a quarter of a century, as I have done in Cleveland and in Kansas City, to help build up something beautiful, where nothing of the sort previously existed, one naturally feels a certain concern for the future development of what has been created."[11]

On April 17, 1930, just seventeen days after Parsons's appointment, the University Trustees announced the first acquisitions, which the *Kansas City Star*'s headline proclaimed as "Ten Masterpieces . . . All of Great Beauty and Outstanding Importance . . . An Impressive List of Authenticated Paintings." According to one report, the ten paintings, most of which were eighteenth-century portraits, had been selected by the University Trustees almost a year earlier, and without Parsons's help. The trustees had waited, however, for Holland's and Parsons's approval before announcing the purchase. The trust bought eight of the paintings—two by Sir Henry Raeburn and one each by John Hoppner, George Romney, Sir Joshua Reynolds, Sir Peter Lely, Francis Cotes, and John Opie—for $110,000 from the Yunt Art Gallery in Kansas City. Landscapes by Jean Baptiste Corot and Theodore Rousseau came from the Findlay Gallery, also a Kansas City institution that had been founded by William Findlay in 1870 to sell art supplies but then had evolved into a gallery that acquired art directly from Europe. The trustees wanted the public to know that they were going to buy from local dealers as well as from big city galleries.[12]

Public interest in these first acquisitions convinced the trustees of the desirability of exhibiting the paintings as soon as possible. Holland agreed to display them in the Kansas City Art Institute's Epperson Memorial Hall. The first day eight hundred people arrived to view the paintings, forcing the Institute to remain open past its closing time. A reporter from the *Kansas City Times* described the exhibition as one that brought "general delight" to its viewers. "There was little talk of technique and style, except among the artists present," according to the reporter, "but there was a genuine appreciation of the men and women so vigorously portrayed."[13]

The paintings made a deep impression. An editorial in the *Star*, perhaps predictably, concluded that the purchases showed the wisdom of the trustees, for the English portraits and French landscapes would "produce a steady income of artistic pleasure for this and future generations." An editorial writer for the *Kansas City Post*, the traditional rival of the *Star*, was disappointed in the ten paintings. He admitted the artists were among England's finest portrait painters of the eighteenth century; however, "the paintings themselves are not outstanding examples of either that particular school and period or of the individual painters." In many cases, time proved the *Post*'s opinions more accurate than those of the *Star*. In the early 1940s the director of the Nelson-Atkins, Paul Gardner, made a list of eleven paintings that were no longer on exhibit, not listed in the museum's handbook, and that in his opinion were not up to the museum's standards. Five of the first ten paintings purchased—Reynolds's *Portrait of George Ashby*, Romney's *Portrait of the Earl of Farnum*, Hoppner's *Portrait of a Lady*, Opie's *Portrait of Thomas Gertin*, and the 1930 favorite, Cotes's *Portrait of Miss Sarah Cruttenden*—made his list. Ethlyne Jackson, as acting director in 1944, suggested to Jones that the trustees arrange to sell or trade these portraits, although she expressed doubt that they could realize "anything like" the amounts for which the paintings had been purchased. In 1947, a list of "paintings recommended for sale or swap or trade" included four of the original ten paintings—those by Cotes, Reynolds, Romney, and Hoppner. The Francis Cotes portrait, however, was not sold but reattributed in 1979 to Nathaniel Dance-Holland, an English painter who abandoned painting when he inherited a fortune in 1776. By the time the museum celebrated its eighty-fifth anniversary in 2018, only one of the first ten purchases, Rousseau's *Cows Descending the Hills at Sunset*, was on exhibit. While the Raeburn portraits and the *Portrait of Miss Sarah Cruttenden* remained in the museum's collection, the other paintings had been sold or traded.[14]

Parsons announced a second purchase on May 20, 1930, just a month after the first. This lot included some undisputedly great works. Parsons had acquired seven paintings and some examples of ancient Greek and Egyptian art. Among the paintings was Titian's *Portrait of Antoine Perrenot de Granvelle*, which Parsons asserted "was the best Titian he had ever seen in a dealer's hands"; it was also the most expensive painting yet bought for the museum, having cost close to $100,000. Parsons billed Jean François Millet's *L'Attente*, another new work for the museum, as one of Millet's greatest masterpieces; John Singleton Copley's portrait of George Cooke (later attributed to Joseph Wright of Derby) as "splendid"; Gilbert Stuart's portrait of *The Right Honorable*

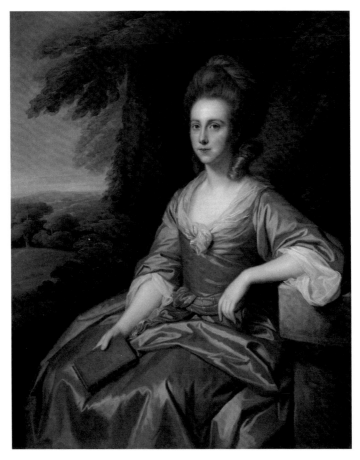

FIGURE 7.1 *Portrait of Miss Sarah Cruttenden* by Nathaniel Dance-Holland was the public's favorite among the first ten paintings purchased by the Nelson Trust. (Purchase: William Rockhill Nelson Trust, 30-6)

John Foster as one of the artist's best; Goya's *Portrait of a Nobleman* as a fine example of Goya's work; Guardi's *An Entrance to the Grand Canal, Venice* as superb; and Tiepolo's *The Apparition of the Angel to Hagar and Ishmael* as worthy of hanging with the four great Tiepolos in the Art Institute of Chicago. The *Kansas City Star* featured a front-page reproduction of the Titian portrait on May 20, 1930, and reported, "All agree that [the] new Nelson group is a notable one." Both Harshe of the Art Institute of Chicago and Whiting, now president of the American Federation of Arts, had reviewed the works and advised Parsons to buy them for Kansas City.[15]

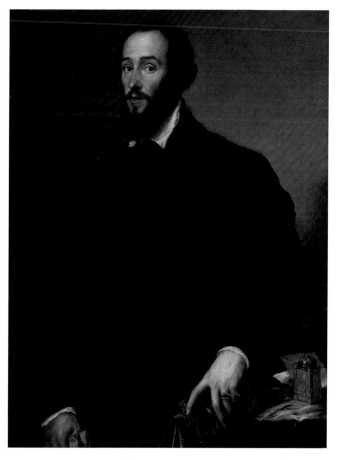

FIGURE 7.2 In May 1930, the University Trustees announced the
purchase of a second group of seven paintings, including such
masterworks as Titian's *Portrait of Antoine Perrenot de Granvelle*.
(Purchase: William Rockhill Nelson Trust, 30-15)

Even the *Post* considered the new paintings on display at the Art Institute a
"miraculous change" and a "welcome relief" after the "unhappy first choice."
The *Post* did not fail to bring to its readers' attention, however, the suspicion
that the Millet painting might be a fraud. The *Post* described how Millet's
grandson had made copies of several of his grandfather's works and had even
mastered his signature. Alarmed by the *Post*'s innuendos, Nichols contacted
M. Knoedler and Company, from whom the trust had purchased the painting.
In a letter of response dated August 22, 1930, Knoedler reiterated, "We un-
conditionally guarantee the authenticity of the paintings which we sold to the

University Trustees for the William Rockhill Nelson Trust, as we do in all cases to our clients." Knoedler acknowledged that Millet's son (not grandson) had reproduced some of his father's paintings but asserted that the reproductions were recognizable as such and that the press had exaggerated the problem. Meanwhile, the *Star* in presenting its view of the Millet painting may have exaggerated in the opposite direction. Describing *L'Attente* as one of the artist's most famous works, the *Star*'s art critic also claimed that the painting was "one of the greatest works of the 19th century . . . a superb great canvas which alone would put our museum on the map." Although the Nelson-Atkins Museum of Art has not become known for its Millet alone, the painting has been unconditionally attributed to Millet. All seven paintings Parsons purchased for the trust in 1930 are still in the museum's collection almost ninety years later.[16]

As the art collection grew, interest in the museum spread beyond Kansas City. The *Christian Science Monitor* ran an article on the painter Francis Cotes and praised his *Portrait of Miss Sarah Cruttenden*, the work the Nelson-Atkins later reattributed to Nathaniel Dance-Holland. The principal art magazine in the country, *Art News*, featured the Nelson's Titian portrait on its cover. Parsons spoke of the fame that art museums had brought such cities as Boston, New York, and Chicago and expressed confidence that Kansas City would attract attention commensurate with its art resources. In the meantime, the collection displayed at the Art Institute continued to expand. Three new paintings went on display in July 1930. An Etruscan bronze statuette and five other paintings, purchased in June, arrived at the Art Institute in October. R. A. Holland announced that the collection had outgrown its location, and he had the twenty-five paintings rehung in one of the school's larger galleries.[17]

In May 1930 the Nelson Trust's financial report showed a total of $2,016,482.23 available for art purchases. The trustees had succeeded in augmenting the art account by almost $500,000 in 1929, and the total assets of the trust now stood at over $13 million. Parsons seemed certain that with "wise purchases from that income," Kansas City should have "a museum which should exceed the art galleries of every other city in the country with the exception, of course, of New York."[18]

Parsons offered several pieces the trustees turned down. At one meeting, on August 5, 1930, the trustees decided to buy a *Madonna* by Murillo for $18,000 but decided against the purchase of other old masters. They rejected Chardin's *Cat, Dog, and Monkey* because they felt "they would be criticized for purchasing a picture of the subject at the price"—$50,000. They had no interest in a $65,000 Watteau or a $100,000 Turner or paintings by Velázquez or Van Dyck. Instead, they opted to pay $5,000 for paintings by two lesser-known artists,

FIGURE 7.3 The bronze *Statuette of a Warrior God*, probably of the warrior god Tinia, approximately 460–450 BCE, went on display at the Kansas City Art Institute with other early purchases. (Purchase: William Rockhill Nelson Trust, 30-12)

Francesco Zuccarelli and Quiryn van Brekelenkam. Since the Nelson trustees had funds to buy art second only to those of the Metropolitan Museum of Art, it is understandable that Parsons was sometimes miffed. When he present-ed the trustees with Vincent van Gogh's *Olive Trees,* it took a petition, spear-headed by local art dealer Effie Seachrest and signed by about two hundred admirers, to convince the trustees to make the purchase of an admittedly less conservative painting than anything they had yet acquired. Parsons asserted

that the University Trustees failed to appreciate the rarity of some of the paintings he found, and they groused about price while other museums leapt in and bought. Parsons may have had a point, as years later, Director Marc Wilson lamented that with the money they had to spend, "We should have had a Raphael."[19]

FIGURE 7.4 The University Trustees decided to purchase Vincent van Gogh's *Olive Trees*, which had been hung on approval at the Kansas City Art Institute, when about two hundred admirers signed a petition circulated by local art dealer Effie Seachrest. (Purchase: William Rockhill Nelson Trust, 32-2)

Parsons's view was that the Nelson trustees were perhaps more concerned with filling up a new museum than with buying first-rate art. The trustees defended themselves by issuing a statement asserting that they deemed quality as more important than quantity and "that in acquiring only objects of great beauty the public interest and that of students and connoisseurs can best be served." Unwilling to give Parsons complete freedom, the trustees offered their adviser some advice of their own. They cabled him, telling him to proceed with caution and "not to consider too many portraits for future acquisition."[20]

Meanwhile, the *Post* continued to raise doubts about both the quality and the authenticity of various new purchases. At one point, the paper tried to convince its readers that the trustees had paid a ring of crooks more than $1 million for fake art. In truth, an art dealer, either Sam Yunt or W. C. Findlay, had offered the trustees an unauthenticated Gilbert Stuart portrait at the very same time Boston police were looking for Wilbur F. Cooke, supposed swindler of several museums, who reputedly had sold some fake Gilbert Stuarts. Nichols was sure that the trustees had not been duped, but he confessed that he and Jones were haunted through sleepless nights by the prospect of buying forgeries. "We are going to buy a fake someday for the museum," Nichols admitted. "We know it is certain to happen. . . . " Perhaps because this fear of buying fakes remained so strong, the University Trustees continued to depend heavily on the advice of the best experts they could hire and to ask personnel of other museums for reassurance.[21]

In January 1931, Parsons accompanied Nichols and Jones to Cleveland and New York. In Cleveland, William Milliken, who was now director of the Cleveland Museum following Whiting's departure in August to assume the presidency of the American Federation of Arts, showed the trustees Cleveland's recently purchased Guelph Treasure. The eighty-two medieval pieces on display in Cleveland had been collected by the Guelphs, a princely German family. Milliken's purchase of part of the Guelph Treasure was considered a great coup, and it brought national and international recognition to the Cleveland Museum of Art. The Guelph Treasure also attracted record crowds—8,200 visitors on its opening day in 1931—and established Milliken's reputation as "an expert showman and promoter." Since by this time a worldwide economic depression was forcing many private art collectors in Europe, like the Guelph family, to sell their holdings, the University Trustees hoped to acquire a treasure as great as Cleveland's.[22]

When Parsons, Jones, and Nichols arrived in New York, Arthur Hyde joined them there for a three-day visit. The University Trustees thought they could gain a better understanding of the New York art market by establishing personal contact with dealers and private collectors and by participating in the selection of paintings and sculptures for the museum. The trip was productive in every respect. The trustees made fortuitous purchases, including Rubens's *Portrait of Old Parr*, Veronese's *Christ and the Centurion*, and Turner's *The Fish Market*. More significant for the future, they met dealers with whom they would have repeated contact. One of these was Dr. C. T. Loo, an eminent collector and dealer in Chinese art who made his headquarters in Paris. The trustees discussed with Loo the possibility of building a Chinese temple in a special

Chinese gallery in the new museum and of making various purchases. Since Parsons had arranged for Langdon Warner, the Field fellow in Chinese art at the Fogg Museum, to advise the trustees on Asian art, Warner, too, offered his opinions on the objects Loo had for sale. The trustees had met Warner previously when he made a special trip to Kansas City in May 1930 to examine a collection of Chinese art offered to the museum by Frederic H. Pugsley, and Warner was to play an important role leading to the establishment of the Asian collections of the Nelson-Atkins Museum.[23]

Warner, considered by the University Trustees as "probably one of the world's greatest authorities on Chinese art," had also been a classmate of Nichols's at Harvard. Since that time, he had been Asian adviser to the Cleveland Museum, assistant curator of Asian art at the Museum of Fine Arts, Boston, and director of the Philadelphia Museum of Art. In 1931, he was making preparations for his eighth trip to China. His main purpose was to conduct research on behalf of the Fogg Museum, but after talking with Nichols, Jones, and Hyde, he agreed to spend part of his time looking for objects that might interest the Nelson Trust. The trustees agreed to pay Warner's additional travel expenses, but they offered him no salary or official title. Before his journey, Warner visited Kansas City as Nichols's houseguest. Nichols and Jones introduced him to Kansas Citians interested in Asian art, honored him at a luncheon at the Kansas City Art Institute, and entertained him at numerous dinners. They also discussed his upcoming trip and the changing political situation in China, which suddenly made it impossible to travel into the interior of the country. Warner and his hosts agreed that he would be safe pursuing their goal of acquiring art objects in Shanghai and Beijing in China, and in Nara, Japan. The deal struck, Warner left for China on March 14, 1931, with a letter of credit for $30,000.[24]

The trustees did not see Warner again until August 1931. That month he returned to Kansas City to report on the objects he had acquired. Although the trustees were impressed with his purchases, the most important part of Warner's report related to the assistance he had received from one of his former students, Laurence Sickman. A Harvard fellow in Beijing, Sickman had established contacts that enabled Warner to make several advantageous purchases. The trustees sent Sickman $100 to reimburse his out-of-pocket expenses and agreed that Warner should encourage Sickman to seek out additional pieces of art during the span of his residency in China. That Warner's former pupil was in Beijing at the time and was amenable to further work on behalf of the Nelson Trust was a stroke of luck for Kansas City. It was, in fact, the beginning of a long relationship between Sickman and the Nelson-Atkins. In 1931, however, the University Trustees had not fully recognized the depth of young Sickman's abilities.[25]

FIGURE 7.5 Laurence Sickman, a student in Beijing, shopping at a market in Luoyang; he was in an advantageous position to make purchases for the Nelson Trust. (MSS 01, NAMAA)

From the age of seventeen, Sickman had wanted to become a curator of Asian art, a very unusual ambition for a young man growing up in Denver, Colorado. In order to pursue his goal, he wrote query letters to the few museum personnel specializing in Asian art at the time. John Ellerton Lodge, director of the Freer Gallery, responded to Sickman's inquiry and advised him that Harvard was the only university in the country offering courses in Chinese and Japanese art. To pursue his calling in Chinese studies with the hope of someday finding a museum job, in 1928 Sickman enrolled in Harvard as a transfer student, having attended the University of Colorado for two years. The outlook for Sickman's future was not auspicious. At the time there were only three museums—all on the East Coast—that had departments of Far Eastern art, and not one that could truly be called an art museum west of the Mississippi, let alone house an Asian art collection. When Sickman graduated from Harvard in June 1930, he received a fellowship to study in China under a new program of the Harvard-Yenching Institute in Beijing, a fortunate award for Sickman as well as, it would turn out, for Kansas City.[26]

When Warner arrived in Beijing in March 1931 to search for art for the Nelson Trust, he took his former student under his wing. "In his company," Sickman later wrote, "I had my first opportunity to visit some of the dealers in antiquities in the famous shops" in Beijing just outside Ch'ien-men Gate. For the most part, Warner's acquisitions for the Nelson Trust were made in the marketplaces in Beijing and Shanghai. Warner and Sickman, however, purchased three or four paintings directly from the ex-emperor, Pu Yi, the last emperor of China (and of the Qing Dynasty) who had reigned as a child with regents from 1908 to 1912 and then, after being ousted from the palace in 1924, kept a large house in the Japanese concession in Tientsin. The transaction between Pu Yi and Sickman and Warner came about because Warner happened to meet the emperor's tutor, who introduced Warner and Sickman to Pu Yi. According to Sickman, Pu Yi was totally uninterested in paintings but desired cash and therefore was certainly willing to let the Americans buy a few scrolls from his staff while he played with his new motorcycle. Among the paintings acquired for the Nelson on this visit was *Life Cycle of the Lotus*, a Ming Dynasty handscroll painted by Chen Chun.[27]

FIGURE 7.6 Among the scroll paintings Sickman purchased from ex-emperor Pu Yi was the Ming Dynasty *Life Cycle of the Lotus* by Chen Chun. (Purchase: William Rockhill Nelson Trust, 31-135/34)

After Warner's return to the United States in August 1931, Sickman was left on his own to seek out art objects for the unseen and as yet unfinished museum in Kansas City. In November the University Trustees, upon the recommendation of Warner, transmitted $5,000 to this unknown Sickman for his use in acquiring Chinese art, since he was "in a position to locate unusual objects of rare value" in connection with his travel and research work. Sickman remembers, "It was an opportunity heavily charged with responsibility, requiring more nerve and confidence than I really had at the time. As a beginner one can safely admire a painting or bronze exhibited in a museum and labeled,

presumably, by an expert. The same work of art unlabeled, without provenance and in the market place can be another thing altogether."[28]

Sickman, however, was a fast learner and had a remarkable eye for the unique. He mastered the skill of maintaining close contacts with the dozen or so dealers in Beijing. All their shops, he found, had a front room full of jades, porcelains, and curios. The rooms behind these front shops were where dealers kept their important works, brought in by their special agents in the interior. Sickman found himself bidding on objects against other buyers, most notably Loo of New York and Paris, the Japanese firm of Yamanaka, an agent buying for the king of Sweden, a German firm, and a British agent.[29]

During this time and for many years afterward, Sickman received invaluable advice and friendship from Dr. Otto Burchard, a German art dealer living in Beijing. In addition to being inexperienced in the art market, Sickman was pursuing studies in Chinese language and art that left him with limited time for tracking down artifacts. Often Burchard would make a contact for Sickman and then take him to see an art object he recommended. On occasion, Burchard would buy an object and then hold it for Sickman until the latter heard from Warner, who had to approve every purchase Sickman made.[30]

In January 1932, the University Trustees summoned Warner to Kansas City to confer with him on the blueprints for the Asian galleries in the museum and to acknowledge his work on behalf of the trust. Because Warner's "services in China the past year had been so valuable and all inquiries throughout the country had convinced the University Trustees that he was the best authority that could be found," the trustees' minutes state, they decided to make Warner their Asian adviser. They offered him $3,000 a year plus $25 per day travel expenses. He kept his position with the Fogg Museum and had the understanding with his Kansas City patrons that his research work with the Fogg came first. Warner previously had turned down a similar offer from the Cleveland Museum of Art and at one time had given up the directorship of the Philadelphia Museum of Art in order to devote himself to research. However, he took the Kansas City job because he was excited about the opportunity to create a great Chinese collection in the Midwest.[31]

Warner continued to solicit Sickman's help. Sickman would send Warner photographs of objects he thought the new museum might want. Warner would then advise the trustees; if the trustees wanted to buy, they wired Sickman the money. For example, in February 1932 the trustees wired Sickman $2,000 to pay for a Chou Dynasty bronze, recommended by Warner and approved by the trustees. Because this system was slow, Sickman often used his

own money or borrowed money from his mother rather than risk the loss of pieces he thought the museum should have. The trustees would have preferred that Sickman send works on approval. Although Sickman said he was willing to negotiate purchase-on-approval agreements, many dealers were not. Political turmoil in China made sellers anxious to receive silver coin at the time of purchase. Because of the worldwide depression and American manipulation of the dollar by mid-1933, Sickman was concerned that the prices quoted to him would not be honored by the time he received money to consummate the deals. For a twenty-seven-year-old student without spare cash, buying objects before trustee approval was risky business. In one instance, in February 1933, Sickman purchased an expensive jade object before consulting Warner or the trustees. As he explained in his follow-up letter,

> It was a question of buying the piece at once or not at all. I judged it to be a piece of such excellent quality and great value, that I bought and shipped it at once. I still owe 3,000 silver on it. . . . I have sent photos and a rubbing of the piece to Mr. Warner. . . . Naturally I feel uneasy at taking so much responsibility upon myself. And most especially I do not want the museum to feel that they are acquiring some objects which they do not wish to add to the collection at this time.

Fortunately for Sickman, the trustees definitely wanted the Eastern Zhou Dynasty *Ritual Disc with Dragon Motifs*, which became a prized possession of the museum, often used as an emblem, as it was for the museum's fiftieth anniversary.[32]

As the political problems in China intensified, the art market widened. In desperate need of money, the Chinese began to sell national treasures. One of these treasures literally arrived on Sickman's doorstep one night in 1933. A courier woke Sickman to negotiate a cash deal for a nine-hundred-year-old Song Dynasty handscroll. In his nightshirt, Sickman made the purchase of Xu Daoning's *Fishermen's Evening Song*, which Marc Wilson called "one of the greatest artistic treasures of all mankind."[33]

Another Chinese treasure in which Sickman took a keen interest was a Buddhist cave chapel in Longmen, Henan Province. When he first visited Longmen in 1931, there were no signs of destruction of the chapel's freestanding sculptures or of the cave's wall reliefs other than natural decay. Later that winter, Sickman found "fragments hacked and chipped from the living rock" for sale in Beijing shops. Viewing these fragments as "nothing but sheer vandalism," he informed the Chinese Committee for the Preservation of Antiquities and received a reply by letter: "The authorities are taking steps to stop

FIGURE 7.7 In 1933, Sickman negotiated to buy the *Ritual Disc with Dragon Motifs* (Bi), possibly the single most famous jade carving in the United States. (Purchase: William Rockhill Nelson Trust, 33-81)

FIGURE 7.8 The Song Dynasty handscroll, *Fishermen's Evening Song* by Xu Daoning, a great artistic treasure, literally arrived on Sickman's doorstep. (Purchase: William Rockhill Nelson Trust, 33-1559)

the ruthless destruction at the source." However, on Sickman's next trip to Longmen in March 1933, he found that an alarming amount of looting had taken place. Whole sculptures had disappeared, and reliefs had been chipped from the walls of the cave temple. Although he was appalled by what the Chinese were doing to their historical religious monuments, he recognized that their lack of concern also put him in a position to purchase some important Buddhist sculpture, provided he could act quickly. The American minister in China advised him to buy before the Chinese changed their attitude or the Japanese legation bought everything. In June 1933, Sickman wrote a desperate letter to Nichols asking him to cable $3,000 immediately if the trustees wanted a great stone lion from the Longmen caves. In a follow-up letter he again made his case for the lion and drew the trustees' attention to Chinese political conditions:

> If the museum can get it, it will certainly be one of the great treasurers of the collection. It is most regrettable that the caves of Lungmen are being so destroyed. However, the facts are known to the committee for the Preservation of Antiquities but they have done nothing about it. In the first place because the Chinese are not interested at all in Buddhist sculpture and in the second place because the sale of the pieces is more or less supervised by the officials of Lo Yang.[34]

Although Sickman finally succeeded in buying the lion for the Nelson collection, he temporarily lost the relief he also hoped to acquire from the Longmen caves. He had made a set of rubbings of the cave reliefs for himself in 1931 and had hoped to make a second set to send Warner when he returned to Longmen in 1933. However, at that time he found that "part of one relief has been destroyed." On his final trip to Longmen in 1934, he discovered that the bas-relief of the empress and her court from which he had made a rubbing three years earlier had been broken up and sold. After many inquiries, Sickman learned that the art thieves who had chipped out the empress relief had marketed the fragments in a wide arena—Beijing, Shanghai, Cheng-chou, Kaifeng, even Germany. At the time it seemed impossible that the relief could ever be reconstructed. Yet, because Sickman had the rubbing and the patience to seek out the pieces over a number of years, by 1940 he was able to reassemble the limestone relief, *The Offering Procession of the Empress as Donor with Her Court,* for the Nelson collection.[35]

The trustees had paid a total of $10,356.58 to Sickman's account in 1932, and his accounts were even larger in 1933, 1934, and 1935. Sickman sent crate

FIGURE 7.9 Sickman cabled Nichols for $3,000 in order to purchase a great stone *Guardian Lion* from the the Zhi-yun Cave, Longmen, Henan Province. (Purchase: William Rockhill Nelson Trust, 33-670)

after crate of Chinese art objects to the Nelson-Atkins. His purchase lists often stretched to several pages and included paintings, porcelains, a temple ceiling, brocade fragments, coats, bronze vessels, jade pieces, tomb figures, and painted wood sculptures, such as the well-preserved Buddhist *Guanyin of the Southern Sea.* The items Sickman was able to purchase were far less expensive than they would have been in the New York art market and in many instances would have been unavailable from dealers. The trustees' secretary, Sybil Brelsford, sent acknowledgments, but if the trustees singled out Sickman for praise, they left no record of it.[36]

Besides venturing into Asian art, which the trustees were doing not only through Sickman but also via purchases made on Warner's recommendations from dealers C. T. Loo and Yamanaka, the University Trustees also became interested in Native American art. As American Indian objects were, at the time, generally considered ethnographic artifacts and relegated to historical or natural history museums, the trustees were taking an adventurous step in deciding to include Native American art in the Nelson-Atkins collection. Although they had not been ready to consider any Southwestern art in 1929 when University of Missouri President Stratton D. Brooks had encouraged them to use the services of retiring professor of art and archaeology John Pickard, now they had determined that collecting Native American art reflected their broad policy of assembling from many lands the "best handiwork of civilized man in all known ages."[37]

In July 1931, Nichols and Jones conferred with representatives from Fred Harvey Company, the pioneer railroad restaurateurs, who in the course of opening restaurants along the Santa Fe Railway throughout the Southwest had engaged experts to purchase American Indian art to sell, first to the public in their restaurant shops and later to museums. When the University Trustees told Parsons that they were considering investing $50,000 with the Fred Harvey Company, he squelched that idea. Instead, Parsons recommended buying over 150 items of Native American art from George G. Heye, a passionate collector who amassed almost one million American Indian objects, "the largest assemblage of Native American artifacts ever gathered by a single individual." (The bulk of Heye's collection is now housed at the Smithsonian's National Museum of the American Indian, which opened in 1994.) The trustees authorized the $12,600 purchase that Parsons recommended from the Heye collection, thereby acquiring the museum's first American Indian objects, which included an 1850 Tlingit house post, Kwakiutl masks, Pomo baskets, Chilkat blankets, Sioux moccasins, and the magnificent Cheyenne *Eagle Feather Headdress.* Then in 1933, in order to have a more representative Native American

art display when the museum opened, the trustees went back to the Fred Harvey Company and added 415 Indian objects, including the Navajo *First Phase Chief Blanket* and some very important pieces of Pueblo pottery, like the "monumental Kiua polychrome *Jar*."[38]

FIGURE 7.10 The trustees purchased this classic and beautiful Northern Cheyenne *Eagle Feather Headdress* from the Heye Foundation in 1931. (Purchase: William Rockhill Nelson Trust, 31-125/38)

FIGURE 7.11 The museum acquired several important pottery pieces from the Fred Harvey Company including this Kiua polychrome *Jar*. (Purchase: William Rockhill Nelson Trust, 33-1140)

Although they had launched a Native American and Chinese art collection without a museum director, by early 1932 the University Trustees felt they needed an overall assistant. Parsons and Warner had guided them well in the European and Chinese collections, but the trustees were ready to hire an expert to oversee the entire gallery. Jones and Nichols were now conferring daily about various business related to the Nelson Trust: rental houses; agreements on zoning restrictions for the Rockhill District; insurance on the new building and art collection; the Sni-A-Bar Farm; the museum's grounds, sidewalks,

roads; and so forth. They did not have the time they felt was necessary to co-ordinate the art collection, nor did they have the expertise. In February 1932, Nichols, Jones, and Hyde spent three days in New York buying art objects and interviewing final candidates for the position of assistant to the trust. They hired Paul Gardner, who was completing his doctorate at Harvard's Fogg Museum and lecturing on art at the Museum of Fine Arts, Boston, and had received glowing reviews from Paul Sachs of the Fogg. Gardner had training in art, history, and architecture. He had earned a BA from the Massachusetts Institute of Technology and an MA in European history from George Washington University. He also had spent several years dancing in a ballet company. At thirty-six years of age, he eagerly accepted the position of assistant to the University Trustees at an annual salary of $3,600. Before Gardner started his work in Kansas City, the trustees arranged for him to tour a number of museums in the east to study objects of art, displays, cases, and other details.[39]

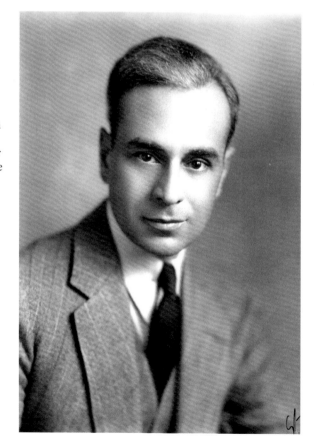

FIGURE 7.12 In February 1932, the University Trustees hired Paul Gardner as an assistant in charge of collections; in September 1933, Gardner was named director of the William Rockhill Nelson Gallery of Art. (MSS 02, NAMAA)

Meanwhile, the University Trustees, although spending literally millions of dollars, continued to think frugally. Nichols in particular took pride in talking dealers down to prices much lower than Parsons estimated as the bottom limit. For example, in April 1932 Nichols happily reported that a telegram had arrived accepting the University Trustees' offer of $16,000 for François Boucher's *Jupiter in the Guise of Diana, and the Nymph Callisto*. Parsons had recommended the Boucher painting, priced at $32,000, more than a year earlier, but Nichols had urged him to hold out in order to make an advantageous purchase. As the Depression dragged on, dealers were willing to accept lower offers, and the trustees bought a number of important paintings and sculptures at good prices. On a November 1932 trip to New York, Nichols reported, "We found a great decline in prices as compared with last spring. Most of the dealers have reached a position where they admit they are willing to take some less. Practically all of them state they have been making no sales and need money." The trustees felt they could move slowly and only buy things of exceptional quality and price.[40]

Although the Nelson Trust's income had decreased somewhat during the Depression years, the principal was little affected. The trustees were lucky to have substantial assets at their disposal to spend in an expanding art market with steadily declining prices; they were in a position that established museums and private collectors envied. The Board of University Presidents applauded the purchases made by the trustees, who had "secured many of the rarest art objects found available on the market at a saving of thousands of dollars." Gardner was extremely helpful in assuming much of the responsibility of bargaining for art, so the trustees asked him in October 1932 to get in touch with the dealers of certain period rooms they wanted for an American corridor. Negotiations had been going on for more than a year, and the trustees felt sure Gardner could settle with the dealers at lower prices than those advertised. Gardner succeeded in advancing the purchase of four rooms, including a keeping room from Deerfield, New Hampshire; paneling, installed as a bedroom, from Charleston, South Carolina; a dining room from Salem, Massachusetts; and a hall from Port Royal, Virginia. Gardner also suggested hiring an American art adviser to complete the American wing of the museum.[41]

In February 1933, the University Trustees appointed Charles O. Cornelius as adviser on American decorative art. Cornelius, a graduate of Princeton University and the Massachusetts Institute of Technology with a degree in architecture, was at the time an architect in New York. Formerly, he had been the associate curator of American art at the Metropolitan, where he had been largely responsible for assembling and installing the American wing. Cornelius

accepted the trustees' $1,000 offer to work for a year to install and furnish the Nelson-Atkins American wing. Within a few months, he had found and purchased an American drawing room or hall from the Robert Hooper House in Danvers, Massachusetts, the best room that was acquired for the museum and which completed the gallery's hall of American period rooms.[42]

The University Trustees now had an overall assistant and advisers in Asian, European, and American art. They had set the processes in motion that brought crates of art objects to the nearly completed museum almost daily. Now, in mid-1933, they found themselves with a whole new set of challenges and decisions. They needed to hire a staff to make the museum function; they needed to stage a grand opening; and they needed to set policies that would make the museum an uplifting and integral part of community life.

HIRING THE MUSEUM STAFF

As the William Rockhill Nelson Gallery of Art and Atkins Museum of Fine Arts neared completion, the University Trustees determined that they needed to hire staff, not only to advise them on art but also to take care of the building and run the museum. Realizing that the art collection and museum policy would continue to evolve through the years, the University Trustees set a date for opening the museum and worked toward accomplishing as much as possible before the big day, December 11, 1933.

The only person the University Trustees had hired to work full-time for the Nelson Trust was their assistant, Paul Gardner. After his appointment in February 1932, Gardner worked from the trust office at 418 Bryant Building, but by the end of the year he had set up a makeshift office in the new museum. Using orange crates for furniture, he unpacked and cataloged art objects, answered countless inquiries, and offered advice to the trustees. Both on the interior plans of the museum and on the choice of staff, Gardner greatly influenced the trustees' deliberations. He made decisions on wall coverings, seating arrangements, and the size of rooms. His career as a dancer in the theater provided important background, for he saw each gallery as a stage set and tried to make each vista beautiful. He believed that the display rooms should be small and intimate and contain a chair or bench for the patron who wished to spend time in contemplation. He also determined that each room should represent a different period and that the galleries should be set up in chronological order, enabling visitors to walk through the history of art. Gardner worked with Fred C. Vincent, the chairman of the building committee, to design the gallery layout and make plans for art objects to be shown in a symmetrical manner. His eye for display told him that each art object should be set off in such a way that it had the integrity it deserved. Thus he disagreed with the practice of the

Metropolitan of hanging one painting above another. Although the Nelson collection was not at the time nearly large enough to cover the museum walls with paintings, even when it did grow large enough to do so, Gardner did not alter his determination that each painting and work of sculpture should stand on its own.[1]

In October 1932, shortly after Gardner moved his office into the museum, the building committee informed the University Trustees of the necessity of hiring staff to run the heating plant and care for the building. There was some question as to who should hire and pay for the staff and upkeep of the museum. Vincent, as chair of the building committee, had contracted for insurance on the building. The University Trustees had presumed that the Nelson Trust should cover the cost of insurance for the art objects purchased. They had also paid for night watchmen to guard the paintings while they were still on display at the Art Institute. During the construction and finishing of the museum building, the trustees agreed that the Nelson Trust would pay for heating and lighting, and the janitorial, guard, and other services essential for the proper installation and protection of the art collection. However, the trustees assumed that since Irwin Kirkwood had given the city the property on which the Nelson-Atkins Museum of Art now stood, that the city would pay for all maintenance and staff requirements once the new museum opened.[2]

When Nichols met with City Manager McElroy in March 1933, McElroy promised that the city would appropriate funds for the museum's water bills, but he made no commitment to other services. Then in July, Nichols had several conferences with McElroy and the mayor to work out an agreement between the city and the museum. Although no percentages or amounts are indicated in the trustees' minutes, the city promised to be of assistance with seven categories of expenditures: (1) maintenance on the interior of the building, including elevator and major machinery repair; (2) maintenance on the exterior of the building; (3) maintenance on driveways, walks, and parking lots; (4) repair of electrical and mechanical problems; (5) insurance of the gallery structure; (6) boiler expenses; and (7) maintenance on the gallery grounds. However, shortly before the museum opened "the Trustees were shocked to be told by McElroy," trustee Herman Sutherland reported years later, "that because of the serious depression and the bad financial straits the City found itself in, it could no longer assume that responsibility."[3]

Since the city could not foot the bill for services and staff, the trustees had only two alternatives. They could either pay these expenses themselves or postpone opening the museum until the city was financially able to fulfill its promise. Not wanting to delay the opening any longer, the University Trustees

decided to continue to pay for upkeep and staff. They justified these expenditures by arguing, as Jones reported in the minutes, that Nelson's will gave them the job of purchasing and exhibiting works of art. Although Nelson's will certainly instructed the trustees to purchase works of art, it mentioned exhibition only in item three of the codicil, which stated that art objects should remain in Kansas City, Missouri, "for public exhibition." It was Ida H. Nelson's will that provided funds "for the purpose of housing and caring for . . . the fine arts to be purchased pursuant to the provisions of the last will of William Rockhill Nelson." There is no indication that the University Trustees ever approached Ida Nelson's trustee, the New England National Bank, represented by Downing and Strother, and it was the Nelson Trust, rather than Ida Nelson's funds, that paid for the care and staffing of the art museum. The city, as the University Trustees feared would happen, never completely kept its part of the bargain. Although the city eventually provided for some needed maintenance and care of the grounds, the trustees, museum director, and superintendent waged a constant battle with City Hall over the years. The city never seemed to have adequate funds to fully support the museum.[4]

The first staff hired by the University Trustees to maintain the building included an engineer to run the heating plant, a man to keep the museum clean, and guards to protect the art objects then being moved from storage to the museum. George Herrick remembered the day he was hired as museum engineer. Because of the scarcity of work due to the Depression, the Nichols Company had laid off Herrick from his job as labor foreman. Herrick had not had time to get used to the idea of being out of work when the Nichols' building superintendent informed him, "The man upstairs would like to see you." The man upstairs, Nichols, thought Herrick would be a good man for the new museum. Nichols explained that the Long Construction Company was about to turn the gallery over to the University Trustees: "This is something that is going to be new to all of us; we have a man who knows about Art [Gardner], and a secretary who can keep track of the art objects as they come in, but we do not have anyone who knows anything about boilers, engine rooms, fixing toilets, etc." Nichols suggested that Herrick go to see Gardner at the museum. When Herrick visited the museum the next day, Gardner introduced him to the steamfitter in the boiler room and handed him a set of building plans. Herrick went to work, dividing his time between running the heating plant and unpacking boxes. By the spring of 1933 he had decided he preferred uncrating art objects to working in the boiler room. For more than ten years, Herrick held one of two keys to the museum's storage facilities and was the chief person responsible for moving and storing objects belonging to the collection.[5]

To replace Herrick in the heating plant, Nichols advised giving the position of engineer and general maintenance man to Clarence Simpson, who had been an engineer and superintendent of construction work at the museum during the final phase of building. Simpson proved to be the ideal man for the job. He was able to keep the museum immaculate and running smoothly during the almost forty years he worked there, taking on a wide variety of jobs beyond general maintenance.[6]

Besides building personnel, Gardner himself needed staff to assist with the collection and with the operation of the museum. In June 1933, with the trustees' approval, Gardner hired Richard B. Freeman, a 1932 Yale graduate, and Philip C. Beam. The twenty-two-year-old Beam had just graduated cum laude from Harvard and happily agreed to a $100 a month salary. In August, Gardner replaced his soon-to-be-married secretary with Ethlyne Jackson, who had studied art history at the University of Kansas and earned a degree in applied art from the Kansas City Art Institute. Jackson, who had been Volker's secretary, took a pay cut for the privilege of working at the gallery. For $25 a week, she not only contributed secretarial skills but could also lecture on American and decorative arts. Otto Wittmann, a Kansas City native and another 1933 Harvard graduate, began work as the museum's registrar in September. The amount of his first salary, $75 a month, amused him forty-seven years later when University Trustee Herman Sutherland sent him an excerpt from the trustees' minutes for verification. Wittmann by then had served as director of the Toledo Museum of Art for thirty years and was vice chairman of the board of trustees for the J. Paul Getty Museum.[7]

On September 13, 1933, the University Trustees decided that Gardner, too, should have a new position. After eighteen months as assistant to the trustees, Gardner "had made a most excellent record for himself." The University Trustees voted to name him "Director of the Gallery." They also authorized Gardner to hire additional building personnel, including "such guards as were necessary at any time to properly protect the objects of art." Gardner employed W. B. MacLean, formerly with the Museum of Fine Arts, Boston, as superintendent of the gallery at an annual salary of $2,400. At the end of October, Gardner suggested that the trustees hire young guards, preferably art students, to staff the museum. He thought students from the Art Institute would present a neat appearance and be better able to answer the questions of the public than some of the older men who had been guarding the objects purchased for the museum. The trustees found the suggestion a good one, as they sought ways to bring the two art institutions, which were in such close geographic proximity, closer together in purpose. Not only were the Art Institute students well

qualified to serve as guides as well as guards, but they considered it a privilege to work at the new museum in any capacity.[8]

Once the newspapers announced Gardner's appointment, hundreds of job seekers applied to the new director, but few applicants were as persistent as Lindsay Hughes, a 1931 graduate of the University of Missouri. Although she exaggerated when she later claimed that she had commuted from Nevada, Missouri, every two weeks for eighteen months to ask Gardner for a job, Hughes did call at the gallery often enough that one day the man at the door, John Gwynne, refused to let her see Gardner. Gwynne told her she could not even sit in the parking lot. Undaunted, Hughes waited for Gardner to leave the museum; as he drove to the Sophian Plaza, where he lived, she pursued him on foot. Finally, overwhelmed, Gardner received permission from the trustees in September to hire both Lindsay Hughes and another applicant, Frankie Askew, for the weekly salary of $10 apiece as long as Gardner "felt he had work for them." The jobs given Hughes and Askew were supposedly "of a temporary nature and [it] would depend entirely on conditions after the opening of the Gallery and their abilities whether or not they remained on the staff." Their work, however, became anything but temporary. To begin with, Gardner had them repair a Persian rug, dust pottery, polish andirons, and clean chandeliers.[9]

Hughes described the atmosphere at the museum in the fall of 1933 as thoroughly exciting. They all would work hard doing whatever needed doing. In the late afternoon, Gardner, Wittmann, Beam, Freeman, Hughes, and Askew would gather in a basement area where Gardner had set up a sofa and chairs and a place to make tea. They would talk about the art objects, their visions for the museum, and what needed to be accomplished. The staff was at tea one afternoon when Hughes walked in a bit later than the others, catching the tail end of a conversation. Wittmann was volunteering to "cover" one of the painting galleries, and Hughes leaped in to claim Persian and Indian art, thinking that she was volunteering to be the hostess for those galleries on opening day. When Gardner asked if she really felt she had the expertise to write the explanatory booklet for the Persian and Indian collections, Hughes was shocked. However, she refused to admit her confusion and bluffed her way through, explaining that she had taken a course when she was at Mills College in Oakland, California. What she had learned during the three weeks she had spent studying East Asian art in her survey art course at Mills was scarcely sufficient to prepare her to write handbooks for the museum but, like everyone involved in putting this museum together, Hughes thought nothing was impossible. She made a frantic trip to the library to check out books on

East Asian art as well as on eighteenth-century French painting, which she had agreed to write about also—a subject about which Gardner announced he was quite knowledgeable![10]

Because of the lack of jobs generally and the allure of the museum, all the staff members felt lucky to have the opportunity to work there, and work they did. In September and October, five-and-a-half-day weeks seemed ample, but by November the entire staff was putting in seven-day weeks. Gardner, who considered the staff a family, provided inspiration. He "ran it [the museum] like a stock company for a theater," Hughes remembered. His enthusiasm never wavered. He himself saw the directorship of this museum as a unique opportunity, and he made the museum his life. Reminiscing years later, Gardner recalled "the old days when we loved to work seven days a week, four or five nights—none of us had a secretary—we all WORKED—and were able to make a GREAT GALLERY. It is our memorial—to hard, devoted work." In addition to the staff, Nichols, Jones, and Vincent toured the museum every day, practically giving up their regular jobs to immerse themselves in preparations to open the art galleries. From November 17 to December 30, Jones did not have time to keep trustees' minutes, but he did note, "This was the busiest period in the history of the Trust and one that involved more meetings than any other period." For the three weeks prior to the opening, Nichols reported in a memo written afterward, Nichols and Jones were at the gallery from 8:00 A.M. until midnight every day. Given the complexity of the trust's arrangements to put together the museum and its art objects, it is a real tribute to all the people involved that the final months before the opening of the museum, although hectic, were free of disaster.[11]

THE GRAND OPENING

J UST A MONTH before the opening of the museum, the University Trustees sent Paul Gardner to New York to borrow additional pieces from dealers to fill gaps in the collection. French and Company agreed to loan dishes, glassware, figures, and furniture. From Knoedler, Gardner borrowed paintings, including a Manet. A statue by Germain Pilon and an oil by Tiepolo came from Jacques Seligmann and Company. The New York dealer Pierre Durand-Ruel loaned paintings by Manet, Cezanne, Renoir, and Degas. The trustees had already arranged other loans, including the famous painting of Whistler's mother (*Arrangement in Grey and Black No.1,* 1871, Musée d'Orsay Paris), which had been on display in Chicago at the 1933 World's Fair, officially called the Century of Progress International Exposition, and more recently at the Cleveland Museum of Art. In fact, the date of the opening of the Nelson-Atkins was determined by when the Whistler could leave Cleveland. Other important objects that the trustees arranged to borrow included a fine collection of American furniture belonging to the Fish family of South Bend, Indiana, and a pair of rare Chinese chimeras owned by C. T. Loo.[1]

New acquisitions made by the art advisers for the Nelson Trust continued to arrive and be installed. Harold Woodbury Parson had said a first priority was to make the museum a picture gallery, which it would be with the arrival of paintings by El Greco, Murillo, Van Huysum, Boucher, Guardi, Hubert Robert, Ingres, Turner, Millet, Courbet, Van Gogh, Fantin-Latour, Gilbert Stuart, and others. However, the inaugural collection also included Native American art objects, Japanese woodblock prints, Indian bronzes, ancient sculptures such as the marble lion from Attica, a Romanesque sculpture of the apostles, as well as jades, bronzes, paintings, and other art objects from China. Besides the art purchased by the Nelson Trust fund, a few gifts came from individual

donors. Mrs. Francis M. Dean presented three oil paintings by Joseph En-
neking. Frances Logan donated many prints. Mr. and Mrs. Albert R. Jones
contributed several paintings, including two by Ernest Lawson (1873–1939)
and two by William Merritt Chase (1849–1916), which the Nelson Trust could
not have purchased because of the thirty-year rule in Nelson's will. Other items
placed on display included the four paintings from Nelson's personal estate left
in trust to Laura Nelson Kirkwood and the oak-paneled room from Oak Hall,
installed on the museum's second floor.[2]

One room in the museum was set aside for Nelson's Western Gallery of
Art, which had remained on display in the Kansas City School District's li-
brary building during the construction of the new museum. In fact, the *Star*
reported that "the little gallery that housed the first treasures purchased by Mr.
Nelson . . . continues to attract hundreds weekly." However, in July 1933, the
School Board decided to deed the Western Gallery to the University Trustees.
Because Ida Nelson's will provided funds to house both the Western Gallery
and new acquisitions purchased through the Nelson Trust, the School Board
felt that Ida Nelson's intent was to assemble her husband's treasures under one
roof. They therefore wrote a resolution transferring the Western Gallery of
Art to the University Trustees provided that the trustees "formally accept said
collection and certify that to the best of their ability they will carry out the
intentions as expressed in the gift of Colonel William Rockhill Nelson." The
University Trustees accepted the Western Gallery in toto but hung only a few
of the reproductions in a room in the new museum separated from the collec-
tion of originals.[3]

A secondary concern to having the art collections ready was planning for
the actual opening of the museum. Insurance was checked and rechecked.
Special security was arranged, and the University Trustees met with represen-
tatives from the police department to discuss how best to handle the crowds
that would gather. The Boy Scouts and the Junior League of Kansas City both
agreed to help host the opening events. The University Trustees decided to
send invitations to a special preview party for the evening of December 10.
The Nelson-Atkins Museum of Art would open to the public the following day.

Making an invitation list for the pre-opening party became a major under-
taking. Nichols collected and studied business and social lists and held con-
ferences with organizations and business firms. He set up a staff to prepare the
invitation list and address the cards. In addition to invitations for the preview
party, invitations also had to be sent for a tea for two thousand hosted by Mrs.
Edwin W. Shields, for a buffet supper at Mission Hills Country Club hosted by
the University Trustees, for a luncheon at the Kansas City Country Club, and

for a dinner party given by Mrs. Frederick H. Harvey. It made perfect sense to the museum staff to invite the president of the United States, the members of his cabinet, state officials, and out-of-town dignitaries to all of the parties, but deciding who else to include on the several invitation lists presented a far trickier proposition. Even though a great deal of care went into making these lists, Nichols reported that "many unpleasant circumstances arose, caused by people becoming disgruntled because they were not invited, and for two weeks prior to opening a great deal of diplomacy was required to deal with such complaints." The trustees felt that as a whole the invitation lists were appropriate and that they brought "the right kind of people to the Gallery."[4]

Apparently the University Trustees considered dignitaries, art dealers, and members of society the right kind of people, for they were at the pre-opening party in abundance. Held from 8:00 to 11:00 on the evening of Sunday, December 10, the party directly followed the buffet supper at Mission Hills Country Club for two thousand of the most honored guests. The invitees arrived in formal attire: the men in white ties and sporting gardenias in their lapels; the women in long gowns, many of which were described in detail on the society page of the *Kansas City Star*. Art dealers came from New York, London, Paris, and Venice. Many guests pulled into Kansas City for the festive event on trains. Aboard one from New York, art adviser Charles Cornelius and art dealers including Joseph Brummer, Paul Drey, Jacob Hirsch, Pierre Durand-Ruel, and Joseph Duveen spent the night playing poker. Although a staff of local people had volunteered to take care of out-of-town guests, meet trains, and handle hotel reservations, Nichols and Jones met almost every train personally. They also hosted many of the special guests in their own homes. To the dismay of Mrs. Nichols, one of her guests, Joseph Duveen, brought his own satin sheets![5]

The trustees were especially anxious to meet Laurence Sickman, whom they had invited for the opening. They liked Sickman instantly and felt "he would be a very valuable man in meeting the public on behalf of our collection and believe he could be very successful in helping to build up the attendance at our Gallery as well as presenting the technical side of our Oriental department." Knowing that Sickman's four years in China would give them "one of the best posted men in the country in Chinese art," the University Trustees reached a tentative understanding with Sickman, offering him $200 a month if he should return as Asian art curator upon completion of his fellowship in China. Sickman, in turn, promised that he would not make any other arrangements without talking with the trustees first. It was obvious to everyone, Hughes commented years later, that Sickman would become part of the museum staff as soon as he finished his studies.[6]

On the morning of December 11, the William Rockhill Nelson Gallery of Art and the Atkins Museum of Fine Arts opened to the public at 10:00 A.M.; 7,950 people went through the museum during the day. At 4:00 P.M. in the Atkins Auditorium, the dedication ceremony "was broadcast to the world" courtesy of NBC and WDAF, the radio station that Laura Nelson Kirkwood had established. In that broadcast the Kansas City Philharmonic, donating its performance, made its national debut. Chancellor E. H. Lindley of the University of Kansas, J. C. Nichols, and Paul Gardner spoke. Lindley's talk concerned the outstanding abilities of the University Trustees and the goal of William Rockhill Nelson to bring art to the people. Nichols introduced the building committee and the trustees of all the major benefactors. He described the collection the trustees had assembled as "reflecting the best handiwork of civilized man in all known ages." Nichols also discussed the building and grounds, making a plea for finishing the building and extending the grounds to include the reflecting pool he had envisioned. "No city in America claims a more imposing temple of art or a more magnificent setting," he stated.[7]

The main point of Nichols's opening speech was to urge all people in the Kansas City area to make the art collection their own. Even though a select group had been invited to preview the museum the night before, Nichols stressed that everyone was welcome in the museum regardless of class or wealth. Sounding very much like his mentor William Rockhill Nelson, who had fought so hard to beautify Kansas City, Nichols expressed the hope that the new museum would "make ugliness unknown in our part of the country." Art, he said, "is a vital force in the lives of us all." No one should be ashamed "because he feels a tug at his heart string and a tear glistens in his eye as he stands before objects of art which grip his soul." The museum would be a temple in which cultural appreciation could be achieved. Nichols's speech, like a religious service, ended with a benediction: "May these halls become a rallying place for high ideals and aspirations, may they crystalize a greater love of beauty, a fresh enthusiasm for living; may they be a happy, democratic meeting place for all groups, all races, all creeds, all men, who call the middle west their home."[8]

The idea that viewing art as an almost religious experience was typical of the times. Art represented an advancement of humankind to a higher level of moral values. "Every nation," Nichols pointed out, "after winning its struggle for existence, has turned its attention to the arts." Kansas Citians had conquered the prairie and were now ready to reach toward enjoyment of cultural pursuits. Art should not be viewed as a luxury for the rich or for the few who were educated about it but should be seen as a necessity that can "penetrate

every nook and cranny of the life and work of common men," as Lindley said in his opening remarks. *Christian Century* agreed that the Nelson Gallery "will do much, if well used, to nurture the religious development of the citizens of this territory."[9]

Thus, when the Nelson-Atkins Museum opened its doors to the public, it became a churchlike place to visit, a temple in which men and women could reflect and admire the advancement of the human race. The imposing limestone edifice and the beautifully landscaped grounds provided the setting. The art objects provided the inspiration. Frances O'Donnell Clark, who became the first director of education at the museum, said that most patrons came to the museum to be inspired. They rarely left disappointed. Viewing the classical architecture of the huge building and the collected works by old masters gave people faith in the future and in the city that could build such an impressive institution. The benefactors of the museum, according to Clark, were worshiped as if they were gods. Many people felt that the museum was the most wonderful thing that had ever happened to the city.[10]

Certainly Nelson and his family would have been pleased with the results of their bequests. According to Henry J. Haskell of the *Star*, Nelson "used to say that he desired the judgment of a hundred years on buildings and paintings." There was nothing experimental about the Nelson-Atkins Museum's classical architecture or historical art collection. Although gaps and weaknesses existed in the general historical collection of originals, the University Trustees had assembled an impressive collection. Equally impressive was the edifice they constructed to house the art collection. Its size (large enough to meet anticipated future needs), design, and sheer beauty would have pleased Mary Atkins and all those who left funds for the building. As Eloise Spaeth wrote in her guide to American museums, "Few museums have arrived on the scene so well accoutered."[11]

Nationwide, the public reacted favorably to the opening of the Nelson-Atkins Museum of Art. The *American Magazine of Art* proclaimed that the citizens of Kansas City should be "justly proud" that they appeared to already have a "museum in the great tradition and the grand manner." Few cities have art galleries on the scale of the Nelson Gallery, which represents the "crown of his [Nelson's] work for his city," the *Literary Digest* announced. *Christian Century* said that the opening of the Nelson-Atkins Museum was "the greatest event of the year for Kansas City, perhaps the greatest for a decade." The description of the museum in *Museums Journal* summed up the general sentiment: "The collection of Old Masters which has been acquired is a most remarkable one and probably no such public collection has been brought together in so short a time."[12]

The delays in coordinating Kansas City's art interests had in fact aided the trustees, because it would have been impossible for them to have built such a collection at pre-Depression prices. When the trustees began their search for art in the spring of 1930, Nichols remembered they were "feeling rather downcast. We decided to go East and look around a bit, but likewise to bide our time and be patient." In 1921, the Huntington Art Gallery in San Marino, California, had purchased Gainsborough's *Blue Boy* for a then-record price for any painting of $640,000, according to *The New York Times*. Peter and Hannah Widener of Philadelphia had purportedly paid $500,000 for a painting by Rembrandt called *The Mill*, which now hangs in the National Gallery of Art as part of the Widener Collection; and Duveen Brothers, art dealers, had according to Nichols acquired a Rembrandt that had been for sale for "a cool million." As it was, the trustees and their advisers were not only able to purchase some masterpieces previously unavailable and to do so at good prices, but they were also able to provide a market for art dealers who because of the Depression were faced with an otherwise vanishing clientele.[13]

A visitor to the Nelson-Atkins Museum of Art in 1933 could spend quite a while contemplating the building, a work of art in itself. The original 388-by-175-foot structure extends over more than a city block and is as high as a six-story office building. Despite its apparent starkness, the limestone building bears an abundance of symbolic details. Architects Thomas and William D. Wight had not been satisfied simply to use neoclassical lines and symmetry to symbolize that the museum was "part monument, part temple of art," so they incorporated classical reliefs and inscriptions. Altogether, thirty-two gigantic classical columns, each forty feet high and five feet in diameter, distinguish the four façades of the Greek-style building. The east wing, which is actually a separate unit, constitutes the Atkins Museum. Six columns with Ionic capitals stand above three bronze doors and support the entablature on which the words *Atkins Museum of Fine Arts* are carved. Above the south portal, which was designed to be the main entrance, are the words *William Rockhill Nelson Gallery of Art*. The southern exposure is ornamented by six columns, standing high above a flight of forty-five steps leading up to huge entrance doors. On either side of this southern entrance are classical bronze vases, seven and a half feet high and each weighing fifteen hundred pounds. Inscribed on these vases are figures representing the four seasons.[14]

It is on the east façade that sculptor Charles Keck began the series of twenty-three limestone panels that decorate the exterior of the building and, symbolically as well as literally, were meant to depict the history of midwestern

FIGURE 9.1 The east wing of the museum is the Atkins Museum of Fine Arts. (RG 70, NAMAA)

settlement. In two long panels at either side of the east façade, the story begins with the arrival of Spanish explorers led by Hernando De Soto pushing toward the Missouri River in search of the Seven Cities of Cibola. Keck's reliefs continue with the French invasion from the north with Marquette and Joliet at the helm of a boat on their trip down the Mississippi, and the struggle that resulted in the Louisiana Purchase in 1803. The panels carved into the south façade picture trappers, traders, scouts, and wagon trains heading westward from Westport Landing. The central panel on this façade represents the struggle between the white men and the Indians, with Fortitude, the central figure, protecting the pioneers. The story concludes on the west wall with reliefs depicting an early cattle roundup, an Indian buffalo hunt, a pioneer mother, an early settler cultivating his land, a pioneer house, and Indians observing the advance of the railroad. These rugged western scenes when viewed from a distance can be seen only faintly, as they were not meant to detract from the classical lines of the temple-like building. In 1933 Keck's reliefs showing the "pageant of civilization's conquest" were lauded as dramatic testimony to the tenacity of the white man and his belief in manifest destiny, but in the twenty-first century the panels depicting the slaughter of Native Americans and buffalo cause more outrage than inspiration.[15]

If these sculpted panels did not inspire the viewer, the inscriptions on the friezes of each façade—adaptations of quotations from the works of Wilde, Arnold, Gautier, Schiller, Plotinus, Goethe, Michelangelo, and Victor Hugo—were meant to serve that purpose. In all capital letters, the east side denotes,

> All passes, high art is eternal
> The sculpted bust outlasts the citadel
> Seraphs share with thee knowledge but art of man is thine alone
> True painting is only an image of the perfection of God.

The theme of art as enduring beauty and eternal reason is inherent in the inscriptions on all four façades. The verse on the north side, written by Plotinus in the third century, reads,

> Art deals with things forever incapable of definition and that belong
> to love, beauty, joy, and worship, the shapes, power, and glory of
> which are ever building and unbuilding and rebuilding in each man's
> soul and in the soul of the whole world.

On the south is inscribed,

> It is by the real that we exist; it is by the ideal that we live.
> The soul has greater need of the ideal than of the real.

And on the west the inscription reiterates the theme.

> As in all nature's one thousand changes but one changeless God proclaim.
> So in Art's wide kingdom ranges one sole meaning still the same,
> This is truth eternal reason which from beauty takes its dress
> And serene through time and season stands aye in loveliness.[16]

Other symbolic and inspirational details include the twenty-four panels of the bronze doors on the east side, which present dramatic passages from Longfellow's poem *Hiawatha*. Architect Max Keck, brother of Charles Keck, planned both the Hiawatha doors and the allegorical depictions of Inspiration, a woman, and Meditation, a man, on the south bronze doors. He also worked with his brother and the Wight brothers to decorate the grillwork above the south door and the stone panels on the north façade with the zodiacal figures representing the birth signs of Ida and William Rockhill Nelson and Laura and Irwin Kirkwood, and with oak-leaf motifs recalling Oak Hall.

Entering the museum was also an awe-inspiring experience. The north entrance, which became the main entrance, leads through a formal vestibule into Kirkwood Hall. The great hall is separated from galleries at both ends by highly polished golden pillars of Missouri marble quarried near Ste. Genevieve. In Kirkwood Hall stand twelve magnificent thirty-nine-foot-tall black Pyrenees marble columns. One pair of these columns is in the Composite order, while the others are topped with Corinthian capitals, copied from ancient temples in Rome and Greece.[17]

While they often juxtaposed native materials and midwestern themes with classical motifs and European marbles, Wight and Wight's greatest moment in melding the native and the classical is in their design of the south vestibule. Many of the architectural details William Wight sketched during his studies in Italy are evident in the vestibule, which was planned to resemble a fifteenth-century Italian villa near Rome but which used native Kacimo marble and the craftsmanship of Kansas City painter Daniel MacMorris. Thus, the arched and domed foyer looked much more like the Villa Madama, Thomas Wight's model, than the vestibule of a midwestern museum. The colors with which

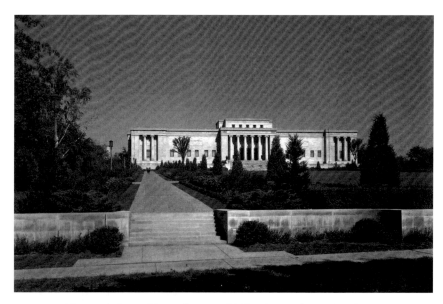

FIGURE 9.2 The north door of the William Rockhill Nelson Gallery of Art became the main entrance to the museum. (RG 70, NAMAA)

FIGURE 9.3 The north entrance leads through a formal vestibule into Kirkwood Hall with its magnificent thirty-nine foot columns of black Pyrenees marble. From *Handbook of the William Rockhill Nelson Gallery of Art*. (Kansas City: [The Gallery], 1933), 8.

MacMorris painted were reminiscent of Raphael and similar to the palette of High Renaissance Italian painting, as was the subject matter. The twelve signs of the zodiac painted inside connecting medallions created the Renaissance touch Wight and Wight desired.[18]

FIGURE 9.4 The walls of the south vestibule of Kirkwood Hall are of Kacimo marble, and the ceiling, painted by Daniel MacMorris, resembles that of a fifteenth-century Italian villa. (RG 70, NAMAA)

Immediately to the west of Kirkwood Hall is Rozzelle Court, centered on the site of the entrance hall of Nelson's home, Oak Hall, where presumably Nelson planned his bequest to Kansas City, possibly with his friend and lawyer Frank Rozzelle. The court is ninety feet square, decorated with columns and arches in the style of fifteenth-century Italy. The walls, floors, and columns, however, are of Mankato stone from a Michigan quarry. In the center of the courtyard is a huge marble bowl taken from the Roman baths of Emperor Hadrian. Left in ruin after the fall of the Roman Empire, the basin was repaired during the Renaissance, according to Harold Woodbury Parsons, who thought the artifact would be the perfect raison d'etre for Rozzelle Court.[19]

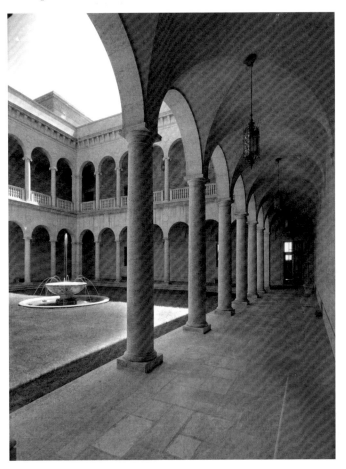

FIGURE 9.5 The ninety-foot square Rozzelle Court, in fifteenth-century style, was named for Frank Rozzelle, who was Nelson's friend and lawyer, as well as a museum benefactor. (RG 70, NAMAA)

Also of inspirational note is the magnificent marble stairway in the Atkins Museum, which leads from the east doors to the main floor of exhibition rooms. Murals painted by Andrew T. Schwartz decorate the stairway walls. The murals, like the reliefs on the outside of the building, represent the progress of civilization, this time in mastering the arts. Eleven paintings show eight periods in the history of art from cave men through the Italian Renaissance. A lunette above the central door, also painted by Schwartz, called *Genius of Art*, depicts Sculpture, Architecture, and Painting as cherubs. Dorothy Wight Buckley, Thomas Wight's daughter, said she always referred to the three figures as Charlie, Tom, and Andy, for they were modeled after Schwartz's three small sons.[20]

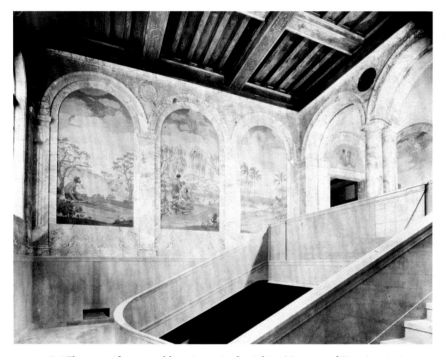

FIGURE 9.6 The magnificent marble stairway in the Atkins Museum of Fine Arts is decorated with murals painted by Andrew T. Schwartz. (VRLDC, NAMA)

It is no wonder that on completion of the Nelson-Atkins Museum, Thomas Wight declared, "Thank God, I am an architect." The beautiful temple of art was almost inspiration enough, but the University Trustees were equally proud of the collection of art objects they had assembled. Nichols expressed the hope of the trustees that the Nelson Gallery would bring "new courage to the hearts of our people, new joy to their souls."[21]

Six centuries of art were represented in the permanent painting collection of the new museum. Small exhibit rooms grouped paintings by century and national origin. Interspersed among those galleries were galleries for special exhibits and period rooms decorated to represent various eras. Because the picture galleries were arranged in chronological order, as Gardner had advised, a visitor to the museum could review the history of painting by beginning in Gallery I, the first room adjacent to Kirkwood Hall on the northeast, and proceeding clockwise back to the Great Hall.

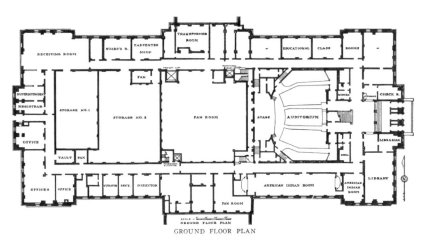

GROUND FLOOR PLAN

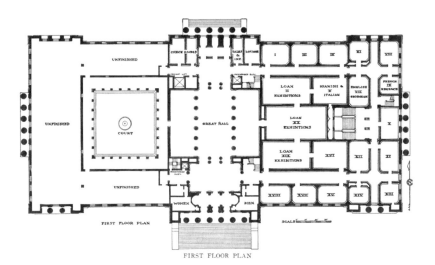

FIRST FLOOR PLAN

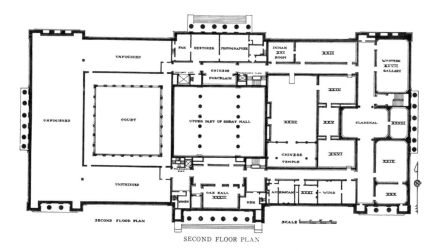

SECOND FLOOR PLAN

FIGURE 9.7 The east wing (the Atkins side) was completely finished when the museum opened in December 1933. On the first floor the visitor could review six centuries of the history of painting by beginning in Gallery I and proceeding clockwise to Kirkwood Hall. The American period rooms, American painting, and the Asian collection were housed on the second floor along with a small gallery devoted to Nelson's Western Collection. The Atkins auditorium, the Native American gallery, and space for offices and an education department were planned for the lower level. From *Handbook of the William Rockhill Nelson Gallery of Art*. (Kansas City: [The Gallery], 1933), 139–41.

Gallery I contained religious paintings from the Middle Ages while Gallery II was a room for special displays. The next exhibition room, numbered Gallery III, held fifteenth- and sixteenth-century Italian art and included paintings like Titian's portrait of *Antoine Perrenot de Granvelle*, which was, according to the *Kansas City Star*, "the envy of other museums" because of an arresting still life in the lower right-hand corner. Two of the earliest paintings purchased by the trustees in 1930 also hung in this Italian gallery. One was Guardi's *Entrance to the Grand Canal, Venice*, which represents the bustling life of that city in the eighteenth-century. Another, *The Apparition of the Angel to Hagar and Ishmael*, the twenty-third painting purchased for the museum, had been admired at the Kansas City Art Institute and was admired again in its new home. Originally accredited to Giovanni Baptista Tiepolo, this painting was later found to be the work of Tiepolo's capable but less famous son, Giovanni Domenico Tiepolo.[22]

Gallery IV featured northern European works from the late Gothic and early Renaissance periods and included some of the most outstanding paintings in the collection, especially Rembrandt's *Young Man in a Black Beret*, Frans

FIGURE 9.8 Giovanni Domenico Tiepolo's *Apparition of the Angel to Hagar and Ishmael*, one of the early purchases made by the Nelson Trust, was hung in Gallery II. (Purchase: William Rockhill Nelson Trust, 30-23)

Hals's *Portrait of a Gentleman*, and Jan van Huysum's *Flower Piece*. The Spanish Painting Gallery, Gallery VI, featured El Greco's *Penitent Magdalene*.

French art was hung in three exhibition rooms. Gallery VIII contained such seventeenth-century paintings as Nicolas Poussin's *The Triumph of Bacchus*, Boucher's *Jupiter in the Guise of Diana, and the Nymph Callisto*, and Chardin's *The Soap Bubble Blower*. Chardin was considered one of the greatest technical artists of his time, and his painting was a highlight of the new collection. The commentary written for the first handbook declared *The Soap Bubble Blower*, purchased in 1932, to be "a splendid example of Chardin's art" and "somewhat similar to the familiar painting of a boy blowing soap bubbles in the Louvre." Like all Chardin's paintings, the catalog said, this work was modeled "with great vigor and precision." The work was featured as the "Masterpiece of the Week" for the Sunday lecture on March 17, 1935; in 1948, it traveled to the Columbus Gallery for an exhibition on Chardin; and in 1961, Laurence Sickman granted permission for it to be used on television. However, in 1977, the painting was declared a copy. Wildenstein and Company, the dealer who had

FIGURE 9.9 (*Right*) and 9.10 (*Below*) Gallery IV featured two of the most outstanding paintings in the new collection: Rembrandt van Rijn's *Youth in a Black Beret* (Purchase: William Rockhill Nelson Trust 31-75) and Frans Hals's *Portrait of a Man*. (Purchase: William Rockhill Nelson Trust, 31-90)

sold the Chardin to the University Trustees forty-one years before, was con-
tacted. Still in business and of obvious professional integrity, Wildenstein gave
the museum full credit for the purchase price of the work. Ralph T. Coe, who
was the director of Nelson-Atkins Museum in 1977, requested that the Nel-
son "Chardin" be removed from the Chardin catalog of collected works. "Our
work is a copy," Coe lamented, "of which only the center part is even original to
the copy. . . . In short, the work should be thrown out of the Chardin literature
all together. Even the parts by the restorer are not good enough to be anywhere
near Chardin's own hand." In 1933, however, the Chardin looked quite repu-
table hanging in Gallery VIII, and the trustees did not have a hint that their
worst fear would be realized in their Chardin purchase.[23]

Gallery XI, which presented nineteenth-century French paintings, held
Millet's *L'Attente*, while the third exhibition room of French paintings, Gal-
lery XII, contained a few works that represented Romanticism, Realism, Im-
pressionism, Post-Impressionism, Fauvism, Cubism, and Expressionism. Of
course, these schools were not very well represented in the opening collection
of the museum, as most of these artists had not been dead for at least thirty
years and therefore, according to Nelson's will, their works could not be pur-
chased with monies from the Nelson Trust.

The only other major exhibition room for paintings on the first floor was
the English painting gallery. Since so many of the first paintings purchased by
the trustees were English portraits, the visitor to Gallery X would find himself
in the society of numerous aristocratic and elegant eighteenth-century fig-
ures. Portraits by Sir Henry Raeburn, John Hoppner, Sir Joshua Reynolds, and
George Romney dominated this room. However, there were also several land-
scapes by such well-known artists as Joseph M. W. Turner and John Constable.

In addition to reflecting on the many paintings on exhibit, the visitor to the
first-floor galleries could view examples of the decorative arts in cases in the
southeast corridor, visit period rooms representing the Georgian period in En-
gland or the French Regency era, or gain inspiration from the textiles, sculptures,
drawings, furniture, silver, and ceramics on display in Galleries XVII or XVIII.

Allocated to the second floor of the museum were Nelson's Oak Hall room
and his Western Gallery of reproductions. When the museum opened, Gard-
ner stated that he did not plan to exhibit all the paintings in the Western Gal-
lery collection at one time, "as a crowded gallery is confusing and inartistic."
Art history students could, therefore, look forward to changing exhibitions of
these copies of fifteenth-, sixteenth-, and seventeenth-century masterpieces.[24]

The American period rooms, which had been purchased and installed un-
der Charles Cornelius's supervision, stretched along the southeast corridor of

the second floor. Across the hallway American paintings were exhibited in Gallery XXIX. Gilbert Stuart's *The Right Honorable John Foster*, a painting purchased in 1930, was shown here, along with works by Ralph Earl, Thomas Sully, Rembrandt Peale, Samuel Lovett Waldo, Samuel Morse, Robert Fulton, Thomas Doughty, George Inness, John Henry Twachtman, and native Missourian George Caleb Bingham.

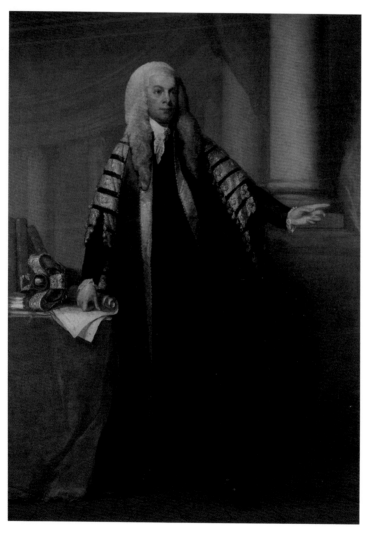

FIGURE 9.11 Gilbert Stuart's *The Right Honorable John Foster*, purchased in 1930, was shown on the second floor across the hallway from the American period rooms. (Purchase: William Rockhill Nelson Trust, 30-20)

The arts of India, China, and Japan, for which the Nelson-Atkins Museum would gain renown, were on display in Galleries XXII through XXVI. Even in 1933, the museum could claim to be unique in the way it presented its Asian collection. Warner had urged the trustees to use walls of ancient temples and shrines as backgrounds for displaying the assembled artifacts. The Indian room was lined with vermillion wood from a seventeenth-century Hindu temple and served as a realistic setting for various Indian bronze and stone sculptures. A Chinese temple room, designed to give the effect of a Buddhist temple, featured Ming Dynasty doors with bronze fittings, a ceiling from a Buddhist temple dated 1444 CE, and a fourteenth-century wall painting. Against this backdrop, Buddhist deities of polychrome wood reigned, including the magnificent *Guanyin of the Southern Sea*.

FIGURE 9.12 A Chinese temple room featuring Ming Dynasty doors, a fourteenth-century wall painting (Purchase: William Rockhill Nelson Trust 32-91/1) and a ceiling from a fifteenth-century Buddhist temple provided the setting for Buddhist sculptures. (VRLDC, NAMA)

On the ground floor of the museum, in addition to the necessary offices and storage rooms, were the Atkins Auditorium and the American Indian Room. Billed as being of special interest to Kansas Citians, the Native American gallery was decorated with adobelike walls and beamed ceilings and displayed works and life-size dioramas representing the southwestern Indians. A replica of a Navajo weaver was at one end of the room; at the other end was a model of Maria Martinez making pottery. On exhibit were examples of pottery, blankets, and jewelry from the Southwest. A few pieces from Native Americans indigenous to the Plains states were also in the collection, as well as some art objects from the Northwest Coast.

Two progressive features of the new museum enhanced the display of art and helped make the neoclassical building an example of midwestern know-how. A unique artificial lighting system illuminated works of art throughout the museum. National publications remarked on the "notable lack of skylights" in the Nelson-Atkins Museum. Designed by General Electric Company, the museum's invisible lighting was hidden under eaves and behind neutral glass ceilings. Through the use of blue bulbs and reflectors, various natural daylight conditions—including dawn, noon, sunset, and gray days—could be simulated according to the mood of a particular painting or of an individual exhibit room. The building trustees had decided on artificial lighting because of its consistent intensity and even diffusion.[25]

The second progressive feature was the heating and cooling system. To protect the art collection, an air system was designed to keep temperatures and humidity constant and to filter the air that flowed throughout the museum. A machine on the first floor cleansed the air of gases, soot, and dust and allowed fresh air to circulate at all times. While these two innovative systems were not readily apparent to the casual visitor, they were exemplary of the attitude of the benefactors, trustees, and architects of the museum. They all hoped to show the world that Kansas Citians could build an art museum and could do it, as the Art Institute's president Samuel Moore had said twenty years earlier, "a whole lot better and more permanent than the other fellow."[26]

Two-thirds of the Nelson Gallery part of the museum was left unfinished, while the Atkins Museum of Fine Art, which had been completed, was spacious enough to house the impressive collection of art assembled at the time. On opening day, midwesterners came to gape at the classical limestone building, loaded with symbolism both inside and out. They marveled at the combination of native talent and materials used so extensively

in this Greek-style building. They also visited the museum to view and to be inspired by the collection, classical in its scope, but purchased with hard-earned midwestern dollars. Indeed, the Nelson-Atkins Museum of Art was the temple of art its architects had envisioned.

PART III

THE BUSINESS OF RUNNING AN ART MUSEUM

1934–1977

CHAPTER 10

———————————◆———————————

THE NELSON-ATKINS
AS AN EDUCATIONAL INSTITUTION

T HE *KANSAS CITY STAR* devoted an entire section of the paper to the
Nelson-Atkins Museum of Art on the eve of its grand opening. Besides
giving readers an opportunity to preview some of the art pieces, one
of the articles offered advice on viewing the collection. "From all quarters of
the globe this eternal art has come," the article said. "Geographical names and
historical references that send both the student and lay reader to the world's
atlases and encyclopedias are there For art is like that," the writer con-
cluded; "it inspires study."[1]

In planning for the Nelson-Atkins, the University Trustees had learned as
they visited collections in other cities that the modern American art muse-
um had evolved into more than just a place to view paintings and sculpture,
more than just a temple of art. Many art museums, like the Fogg, had become
research centers, and almost all United States museums emphasized educa-
tional activities. In 1933 art historian L. C. Everard stated, "The chief function
of modern museums is education, although museums also serve as research
centers and repositories of art objects. . . . Fully developed education depart-
ments using school cooperation, guide service, publications, radio, loan ex-
hibits, slides, films, and all other educational devices are to be found only in
the United States." Although some European museums had established educa-
tional programs, almost all American museums had committed themselves to
using art to educate the public.[2]

American art museums, not satisfied with being mere repositories of art,
had decided to focus on becoming educational institutions for a number of
reasons. For one thing, the wealthy and socially prominent benefactors who
provided most of the funding for American museums had established art
museums to serve the public. In order to do so, museums needed to attract

visitors who not only had more free time than ever before but who also had more choices of what to do with their free time. Art museums began to offer lectures, moving pictures, and other activities to compete with other forms of entertainment. A 1934 survey by the American Association for Adult Education found that of the thirty-eight museums that responded, all held public lectures and many sponsored other educational programs as well. It can also be argued that the evolution of American art museums followed the pattern set earlier by the American public libraries, which began as literary clubs for the rich but emerged as instruments of public education. *American Mercury* magazine stated, "The functions of museums as storehouses and treasuries of the arts of another day will be increasingly subordinate as the museums learn to accept their responsibilities as—for want of a better term—institutions of adult education."[3]

From the beginning, the Nelson-Atkins trustees felt that a commitment to education was necessary in order to entice the public to visit and revisit the museum. The 2,000 preview attendees and the 7,950 people who toured the museum on opening day represented only a small percentage of the population of the Kansas City area. The trustees needed to convince all manner of Kansas Citians, most of whom had never been in an art museum, to use the city's newest institution for their personal benefit. Nelson had hoped that the works of art assembled with his funds would "contribute to the delectation and enjoyment of the public generally." The Nelson-Atkins Museum of Art would have to teach its public to enjoy, delight in, and be entertained by art, about which they knew little.[4]

Although the trustees appreciated the role education could play in making the museum more enticing to the public, they made no specific plans. It took Paul Gardner's prompting to get some educational programs off the ground. Even before the grand opening, Gardner had talked with Nichols and Jones about his desire to investigate various educational activities that would encourage people to make repeat museum visits. His idea was to emphasize both adult education through a series of weekly lectures and the education of children through tours for school groups. The University Trustees were willing to promote educational programs, but they felt they needed to do more research on the subject and to determine whence the funds to conduct such activities would come.

Nichols and Jones sought examples of education programs from other institutions. When Nichols visited the St. Louis Art Museum in November 1932, he spent time talking with the head of the Education Department. He found that in the preceding month, eight thousand people had attended lectures

and gallery talks. The St. Louis museum employed four people in its Educa-tion Department and considered education an extremely important feature of its work. The trustees learned that the Metropolitan Museum of Art had more than twenty-five years of experience in educational programming. The founders of the Metropolitan believed that if a museum did not educate the young, it failed in its mission. Therefore, the museum showed movies, held story hours, published a special bulletin for children, and eventually opened a children's museum. Edward D. Libbey, founder of the Toledo Museum of Art, encouraged art education as early as 1906 when he provided funds to take every schoolchild in Toledo through the museum. Not only did the Education Department in Toledo educate children through tours and classes, but it also had a museum school of design for adults, offered classes for teachers and commercial artists, and published monthly bulletins. The University Trustees also looked again to Cleveland, which had one of the largest and most active education departments in the museum world. Before the Cleveland Museum of Art opened, Director Whiting and the trustees approved the appointment of a director of education who would work with the schools to prepare children for visits to the museum. The Cleveland Museum of Art included a children's museum from its inception and within a year after opening began lectures for students, gallery talks for adults, art classes, concerts, movies, story hours, and docent-directed gallery tours.[5]

The idea of using docents to give guided tours through museums originated in Boston in 1907. The trustees of the Museum of Fine Arts realized that "not a tenth of the people" who went through the gallery in Copley Square "came away with any adequate idea of the treasures it held." The trustees hired a Cor-nell graduate with three years of experience in art lecturing to encourage peo-ple not to miss the best of the collection and to help those who knew nothing about art. The idea was an immediate success. In 1908 the American Museum of Natural History in New York and then the Metropolitan began docent pro-grams to guide both schoolchildren and the general public.[6]

While the University Trustees and Gardner recognized the importance of education programs, including docent-guided tours, lectures, and classes, funding was a problem. Nelson's will had not allocated money for educational purposes and contained no provision for an education department. The inge-nuity and versatility of Gardner and his staff and the willingness of the trust-ees, however, would create a viable program that would encompass most of the educational activities of other museums and even surpass them.

To provide adults with art enrichment, Gardner personally delivered a lec-ture on art every Wednesday night. A great success, the lecture series, which

began in January 1934, continued without interruption for years. When Gardner left in 1942 to serve in World War II, the public came to the museum to hear other staff members, either Ethlyne Jackson or Lindsay Hughes, deliver the regular Wednesday night lecture. It was not until 1945 that Jackson, as acting director of the museum, proposed to Nichols that outside lecturers of known reputation would enhance the public lecture series. Nichols agreed, acknowledging, "I am desirous of doing all the things possible to bring more people into the gallery, and confidentially, I have been thinking of making a little financial gift myself to such ends—perhaps $250 a year." Presumably Nichols's gift did not materialize, for it was under the joint sponsorship of the Nelson Trust and the Kansas City Art Institute that five outstanding speakers from various American art museums were asked to speak on their areas of expertise. The series proved successful, and occasional guest speakers augmented the adult-education program through the years.[7]

The lecture series provided an educational opportunity for adults, but Gardner's greatest interest was in educating the young. He did not, however, have the staff to give tours to the many schoolchildren in Kansas City. At a dinner party held the winter the museum opened, Gardner serendipitously found himself seated next to Jane Hemingway Gordon, the chair of the arts committee of the Kansas City, Missouri, Junior League. She suggested to Gardner that Junior League members, several of whom had served as hostesses at the museum's opening, would be interested and could be trained to give tours of the museum. Gardner liked the idea. He convinced the University Trustees that Nelson's intentions had included education—after all, Nelson had given his collection of reproductions to the School District of Kansas City, Missouri, presumably to help educate the young—and asked them to hire a director of junior education to coordinate a volunteer docent program.[8]

Tours to provide an art background for children began in the fall of 1934. Frances O'Donnell, a Barnard graduate with two years of training at the Buffalo Museum of Science, came to Kansas City as director of junior education. She had applied to work at the museum in 1931 before it opened, again in 1933, and finally in the spring of 1934 after she had completed her studies in museum science. Having received little encouragement from Gardner, O'Donnell went home to Ellsworth, Kansas. She was there when the telegraph operator called with a job offer from Gardner. The operator read the telegram offering O'Donnell the position of director of education at the museum at a salary of $100 per month; he then advised O'Donnell that, given the economic situation at the time, she'd better take the job. Apparently she agreed.[9]

O'Donnell proceeded to put together a volunteer docent program that would serve as an example for docent programs throughout the United States. Even the Metropolitan would come to model its docent in-service training on the Nelson's. Working with Gordon, director of the art department of the Kansas City, Missouri, public schools and the schools' chairman of curriculum, O'Donnell developed tours of sculpture, painting, tapestry, and glass and pottery. These tours were designed to enrich the education of Kansas City's sixth graders, who would take all four tours during the course of the school year. To prepare the students for their visits to the museum, O'Donnell wrote research guides and distributed them to the students' teachers three weeks prior to each tour. Meanwhile, Junior League volunteers trained for two weeks, eight hours a day, to prepare for each of the four tours. When the students arrived at the museum, they listened to a brief lecture and saw a demonstration or a motion picture in the Atkins Auditorium before being conducted through the galleries by the docents. During the first year of tours, five thousand sixth-grade students made four visits apiece to the Nelson-Atkins Museum of Art.[10]

FIGURE 10.1 As part of a sculpture tour, this Junior League docent asked Kansas City school children to carefully observe a marble lion from Attica ca. 325 B.C.E. (Purchase: William Rockhill Nelson Trust, 33-94). (RG 32, NAMAA)

FIGURE 10.2 Turnstiles kept count of the Kansas City public school sixth graders who came to the museum four times a year to take tours and enrich their education. (RG 32, NAMAA)

An entire issue of the *Teachers College Scout*, a magazine published by the Teachers College of Kansas City, was devoted to informing teachers of the educational opportunities available at the Nelson-Atkins. Students from the Teachers College worked with Lillian Weyl, director of art for the Kansas City School District, and with O'Donnell to explain in detail the contents of each of the museum's galleries and period rooms. So that all teachers could become even more familiar with the museum, the trustees agreed to issue free-admittance passes to teachers. As further encouragement, Gardner wrote a letter to all the principals of Kansas City schools to tell them about the teachers' passes and to ask them to inform their teachers that they should feel free to ask for information from the museum's staff at any time.[11]

The only problem that surfaced during that first year of tours concerned transporting all of the students to the museum. Streetcar transportation seemed the most viable, since tracks ran to the museum, laid according to Nelson's plan to provide convenient transportation for his Rockhill area development. However, scheduling did not provide direct service from many schools to the streetcar stop near the art gallery. Powell Groner, president of the Kansas City Transit Company, solved the problem by agreeing to schedule special streetcar service to the museum and to charge each student only a nickel. Even though teachers may have had to put nickels in some students' hands, O'Donnell remembered, every sixth grader in Kansas City was able to see the Nelson-Atkins collection, an especially exciting opportunity during Depression times.[12]

The Junior Education Department grew rapidly. When, in 1939, after five years as director, O'Donnell informed Nichols that she would be leaving to get married, he was shocked and quite put out, O'Donnell recalled. He scolded her and said he thought she would be there forever. Jones, on the other hand, received the news quite differently. He gave O'Donnell a big hug, wished her much happiness, and told her how proud he was of everything she had done. Once Nichols recovered, he and Jones both realized that O'Donnell's role had become essential to the museum's operation. They needed to name a new head of the Education Department.[13]

Gardner wrote a note to Nichols in June 1939 suggesting that the trustees promote Louise Nelson, O'Donnell's assistant, to the soon-to-be-vacated post of director of junior education. Having served as assistant director for three years, Nelson "can handle the job," Gardner affirmed. The one drawback he saw was that Nelson had never taken a European tour. Her art background was therefore deficient, according to Gardner. He urged the trustees to hire Nelson, pay her a salary, and advance her a loan of $400 so that she could have a trip to Europe before she assumed O'Donnell's job. "This phase of our educational work and our activities for the public schools," Gardner emphasized, "seem so important that I do hope that every effort can be made to make it possible for Miss Nelson to have this loan made to her and to go to Europe." The trustees agreed to provide Nelson with a loan and a salary to take a two-month tour of Europe. Gardner himself planned Nelson's itinerary, booked her hotels, and budgeted her expenses at $600.[14]

In November 1939, Nelson succeeded O'Donnell. She and two full-time assistants, Frances Webb and Mary Louise Clifton, continued to administer the education program, which now had an annual budget of $6,637.42 and

accommodated forty-six thousand children a year. By 1940, the program had expanded to include both sixth and seventh graders and some high-school and lower-school students. Nelson felt the Education Department needed more staff, more money, and some equipment. World War II intervened, however. Nelson left to work for the Red Cross, preceded by her assistant Frances Webb. Although Nelson did not return to her post at the museum, her connections there were not completely severed, for a few years later she married Robert W. Long, the son of John C. Long, the museum's contractor.[15]

Mary Louise Clifton replaced Nelson as director of education. Under Clifton's guidance, the education program continued to grow. By 1952, almost seventy thousand children were taking tours of the museum each year, and the Kansas City Board of Education decided that art tours were such an important part of the children's educational experience that they became a required part of the curriculum. By this time public school students visited the museum six times, beginning in the third grade, and the tours were integrated with the school curriculum. Third graders took the American Indian tour; fourth graders, the China tour; fifth graders, a painting tour; six graders, a sculpture tour or a tour of knights and armor; seventh graders, a tour of early American art; and eighth graders, a survey of ancient civilizations. Members of the Junior League continued to work as volunteer docents for the museum for forty years, and the contributions the Junior League made were invaluable to the art education of Kansas City children. In spite of limited funds, an inadequate staff, and the lack of any provision for education by the major benefactors of the museum, the junior education program of the Nelson-Atkins Museum of Art became a great success story. The museum was able to reach the public through the schoolchildren.[16]

In addition to the school tours, the Junior Education Department began to offer children's art classes. Gardner suggested a series of classes for children on Tuesdays, Thursdays, and Saturdays during the summer of 1935 and asked the *Star* to announce the program. On the first Tuesday, 125 children showed up. Totally unprepared for such a huge crowd, O'Donnell recruited everyone she could find to help. After that first experience, students were required to enroll and to pay a fee of one dollar, primarily so that the staff would know how many children to expect.

Additional children's classes were held on Saturday mornings during the school year. Often the morning's activity would begin with a game tray from which the children would take a clue or a picture that would lead them on a treasure hunt in the museum. Children were taught to draw, model clay, paint, and enjoy a number of other crafts. Phil Beam and James Roth, as well as

students from the Art Institute, helped O'Donnell teach the classes. Roth, who later became the conservator for the museum, demonstrated still-life painting and discussed painting materials and techniques. Marionette plays also became a feature of the Education Department. Hazel Hedges, who had been hired as the switchboard operator in 1934, was an expert marionette maker. She became a member of the Saturday morning staff, making the puppets while engineer George Herrick and Roth built an intricate stage and Lindsay Hughes wrote and produced the plays. Long after Hedges left and into the 1970s, making marionettes and producing plays remained part of the junior curriculum. Both the summer and the Saturday morning programs became a routine for children seven to fifteen years old and attracted young people and their parents to the museum.[17]

FIGURE 10.3 Almost from its opening, museum staff helped students in Saturday morning and summer classes stage marionette plays based on works in the collection, an educational program that continued into the 1970s. This photograph is from 1954. (RG 32, NAMAA)

By the fifth anniversary of the opening of the museum, education had become so much a part of its purpose that Gardner had forgotten whose idea education programs had been in the first place. He stated in a letter to the art editor of the *Tulsa World*, "It is our sincere hope that the citizens of your city feel that the Gallery is as much theirs as do the residents of Kansas City, as we know that Mr. Nelson left his bequest for the pleasure and education of the entire Middle West section of our country." Having expanded Nelson's intentions beyond pleasing the public through exhibiting art to also educating them, the University Trustees and Gardner worked together to reinterpret other limitations in Nelson's will as well.[18]

THE UNIVERSITY TRUSTEES
AND PAUL GARDNER SET POLICIES

D URING THE FIRST years of the museum's existence, the University
Trustees sought to redefine their role. Because no one had stepped
forward from the city or from among the other trustees, the Uni-
versity Trustees had become de facto administrators of the museum. William
Rockhill Nelson's will had granted them power to "employ a manager and all
necessary assistants and other persons for the management and control of said
trust estate." The Nelson Trust was not, however, synonymous with the Nelson
Gallery of Art, as Nelson's will provided only for a collection of art and not for
a full-fledged museum. Thus, the trustees had not concluded what authority
they now had or what authority they would turn over to Director Paul Gardner
and his staff. After having kept very tight control over the formation of the
collection, policy, and staff the University Trustees needed to decide, now that
the art gallery was open, whether they would continue to counsel Gardner
regarding all museum business.[1]

Nichols, Jones, and Hyde had other jobs to do besides directing a museum.
Hyde, who was still in Washington as secretary of agriculture, did not find it
difficult to stay out of the day-to-day operation of the art gallery. He appeared
for annual meetings and did some footwork for the trustees in the East; then,
in 1935, he resigned, leaving a duo until the University Presidents appointed a
new trustee in 1940. Nichols and Jones, however, remained very active, visit-
ing the museum often and continuing to meet at least twice monthly to make
decisions concerning the trust and to discuss policy. The vastly different per-
sonalities of these two trustees affected the relationship each would have with
Gardner and other staff members.

Lindsay Hughes and Frances O'Donnell remembered that Nichols and Jones
would come to the museum every Sunday afternoon with their wives. "H. V.

Jones was a wonderful man," O'Donnell opined, "very kind and soft-spoken." He always seemed to get along with everyone, remained calm, and took things as they came. His wife was a "lovely, quiet woman." Only once, Hughes and O'Donnell recall, did Eleanor Jones irk Gardner. When looking at some new piece of art, she said she could not see how it could possibly be as old as it was supposed to be. Jones vetoed buying the work, which Gardner had really wanted. Nonetheless, Mr. and Mrs. Jones enjoyed a warm friendship with Paul Gardner, who, along with Laurence Sickman, would meet at the Jones' home at 11:00 most Sunday mornings to enjoy an old-fashioned before the Jones had lunch and took their Sunday tour of the museum.[2]

Nichols, unlike the gentle Jones, was, according to O'Donnell, "a ball of fire." She described him as "just like his horse fountain on the [Country Club] Plaza with water going every which way." He was interested in everything; he wanted to know all; he took charge; and he always wanted to get the best deal. Nichols would drop in at the museum's closing time many evenings, Hughes said, bringing some out-of-town guests to tour "his" museum after having already given them the tour of "his" Plaza. Nichols's wife, Jessie, although she visited the museum on Sunday afternoons with her husband, did not make much of an impression on staff members. She came only on Sundays, she confided once to Hughes, because Nichols insisted that she open an account at each of his Country Club Plaza stores and that she use every account every month. Just trying to make that many purchases took most of her time.[3]

There was certainly the potential for conflict between Nichols and Gardner, the man whom Nichols had handpicked because he knew about art. From the trustees' minutes and memos between the two men, it does not appear that Nichols ever gave Gardner the authority to make any decisions by himself. Art purchases, appointments of personnel, salary raises, vacations, acceptance of gifts—all had to be approved by Nichols. Yet Gardner seems to have found the situation satisfactory. In a private letter to Hughes written years after he retired, Gardner recalled the hard work they all had done to build the gallery, adding, "Thank God for J. C., Herb Jones." These three men— Gardner, Nichols, and Jones—seemed to share a common vision of what their museum should be. During the first years after the museum opened, they worked together to set policies that would ensure a future of conservative but steady growth.[4]

From the very beginning of their tenure, the University Trustees grappled with interpretations of Nelson's will. They decided, with the help of advisers like Harold Woodbury Parsons, to interpret "works and reproductions of works of fine arts" to mean an historical collection of original works chosen for

their aesthetic value. Later, working with Gardner, they expanded the scope of the Nelson Trust to include educating the public as well as providing a temple in which art objects could be displayed. A broad interpretation of Nelson's will seemed necessary.[5]

One limitation in Nelson's will was a problematic clause concerning exhibition. Item three in the codicil designated that all works of art purchased by the University Trustees "shall be kept and remain at all times in Kansas City, Missouri, for public exhibition." This provision caused a political problem even before the opening of the museum. When the trustees decided to borrow art objects from other museums for the grand opening in order to fill gaps in their collection, they discovered they had no bargaining power. They could not extend the courtesy of offering to loan their paintings in return. Loaning an art object could not only gain a museum the right to ask reciprocal favors from other museums but could also enhance the image of the lending institution. It was with real regret that the trustees turned down a 1931 request by the Louvre to borrow Millet's *L'Attente*, since such a loan would have promoted the soon-to-be-opened Kansas City museum.

In 1934 the University Trustees decided to ask their counsel, John E. Wilson, and the attorney for Mary Atkins's estate, Edwin C. Meservey, to render opinions on this provision. Apparently, both lawyers felt that loaning art objects, as long as they remained in the permanent collection of the Kansas City museum, would not violate Nelson's intentions. Thus, the University Trustees established a very loose policy after the museum opened, which continued into the 1950s, of allowing some art objects to be loaned, but only within the continental United States and Canada. In 1954, when the Nelson Gallery Foundation was established, the trustees decided that Nelson's will would not restrict loaning out art objects purchased through the foundation, but that art purchased with the income from the William Rockhill Nelson Trust should not leave Kansas City. It was not until 1980, when Ralph T. Coe served as director of the museum, that the University Presidents went to court over this provision of Nelson's will. The Circuit Court authorized temporary loans of art objects, greatly expanding the museum's bargaining ability in borrowing and lending art.[6]

Another limitation in Nelson's will was the condition that his trust funds could be used only to purchase "works or reproductions of the works of artists who have been dead at least thirty years at the time of the purchase of the same." This thirty-year clause, so in keeping with Nelson's desire to let time be the ultimate test of worth, made it difficult, if not impossible, to build a collection of modern art. The University Trustees had already acknowledged that

they could accept art objects by contemporary artists as gifts, but they could not hope to assemble a balanced collection based on fortuitous presents. Harold Woodbury Parsons was most concerned that they "find some way, either through public subscription or gift to secure representations of a dozen leading masters of the modern movement, both because the values are constantly and rapidly increasing and because young America is much more interested in the great dynamic movement than in the most classic presentation of subject matter." Nichols and Gardner were also worried about getting the "art crowd," from the west side of Oak Street, where the Art Institute was, to the east side of Oak Street to view the Nelson-Atkins Museum of Art. Although the Art Institute students and supporters were interested in seeing the old masters, they were perhaps more interested in viewing more contemporary artwork.[7]

Gardner, with the University Trustees' endorsement, encouraged a group of interested citizens to organize themselves into a society to aid the museum in acquiring contemporary art. The Friends of Art resulted. Dorothy (Dot) H. Clark (Mrs. Alfred Clark, formerly Mrs. Logan Clendening), thirty years after the fact, told Herman Sutherland that she got the idea for the Friends of Art from the wife of an artist friend, Harold Sterner. Then "Paul Gardner and Mrs. Gerald Parker pounced on the idea, and we went ahead," she recalled. According to Inez Parker (Mrs. Gerald), the Friends of Art was her "brainchild," and the first discussions of the idea took place in the "beautiful drawing room" of her home on Sunset Drive. Paul Gardner was there along with Dot Clendening, Ruth Bohan (Mrs. Paul), and Helen Beals (Mrs. David). Subsequent planning sessions included Eleanor Jones (Mrs. Herbert V.), Susan Gay and Fred C. Vincent, Jo Zach Miller II, and Dr. Logan Clendening. These first members of the Friends were not rebel leaders but people seriously interested and involved in the museum.[8]

By the time the first official meeting of the Friends of Art was held on December 20, 1934, in the Atkins Auditorium of the year-old museum, the organizers of the Friends had written a constitution and bylaws. Their stated purpose was "to encourage and foster an interest in modern art in Kansas City, and to make possible for Kansas City to have as fine a collection of modern art as the collection of Old Masters and objects of antiquity made possible by the generosity of Mr. Nelson." Dr. Logan Clendening spoke adamantly and at length about the need to ensure that the Friends of Art retain legal ownership of any art objects purchased by their organization. The purchasing process was also discussed. According to the bylaws, a committee of three—composed of the president of the Art Institute (later rescinded), the chairman of the board of the Friends of Art, and the director of the Nelson-Atkins (later amended to

a representative)—would recommend art purchases. Then all of the members of the Friends of Art would determine by a majority vote the annual purchase of a contemporary work of art.[9]

From the beginning, these annual meetings ranged from being tame to mildly divisive to wildly chaotic. Henry Haskell Jr., art reporter for the *Kansas City Star* and son of the then-editor, noted that in most cases the Friends of Art's best purchasing decisions were those that had engendered the most heated discussions. At one purchase meeting, a small squabble took place when Eleanor Jones, who had the floor, was interrupted. "Please, sit down, young man. I haven't finished," she said to William T. Kemper Jr., a respected banker and businessman. Of course, Mr. Kemper complied, as Eleanor Jones was the epitome of a Friend of Art; she had been present at the founding meetings and served from 1934 until her death in 1962 in every capacity of the organization, including president, while her husband was both a University Trustee and an Atkins trustee. Certainly, one of the Friends' very best purchases was a package deal that included five German Expressionist paintings: Emil Nolde's *Masks,* Ernest L. Kirchner's *Portrait of the Poet Guthmann*, Oskar Kokoschka's *Pyramids*, Karl Hofer's *Record Player*, and Max Beckmann's *Baccarat.* The purchase went forward only after a heated argument during which one woman argued in favor of buying all five paintings, positing that if someone could buy five paintings for the price of one, would that not represent a bargain? To this another woman in the meeting responded, "If you are the kind of woman who would rather buy ten five dollar hats instead of one $50 hat, then you probably think it wise. But I don't." Sally Keith (Mrs. Edward) tried to end this line of argument with the statement, "Money has very little to do with it."[10]

Perhaps the most infamous of the Friends of Art debates occurred in 1958. This time the trouble began because the selection committee had options on eleven pieces of art. Three times the Friends voted by a show of hands whether to make a purchase; in none of the three votes did any of the pieces under consideration attain a majority approval. Finally, President Nicholas Pickard called for a vote by secret written ballots. When the votes were tallied, however, Pickard announced that the votes submitted added up to eighteen more votes than there were people in the room, to which longtime museum supporter Hugh Patrick Uhlmann shouted, "We are hoist on our own Pickard." Haskell's article in the paper the next morning was entitled, "Ethics and Art Tangle."[11]

Years later, when Director Ralph T. Coe spoke at the opening of the Parker-Grant Gallery of Contemporary Art, made possible by the generosity of Inez Parker, one of the Friends of Art founders, and her brother Earle Grant, Coe would comment that "despite an inevitable spottiness with regard to artistic

FIGURE 11.1 One of the most spirited town hall-style meetings of the Friends of Art
was held in 1954 and resulted in the purchase of five German Expressionist paintings,
including Emil Nolde's *Masks*. (Gift of the Friends of Art, 54-90)

representation," the "Kansas City tradition of the 'town meeting' system of
contemporary purchase" has "endowed the Nelson Gallery at no cost to itself
with a number of twentieth century works of art of which the entire commu-
nity can be proud." He added, "It is doubtful if any civic association has given
to an art gallery in the United States as much art representative of its times in
as much quantity. When one thinks of the major works which have entered
the gallery by this meeting procedure, the impact of the gift becomes etched
in high profile." However, it was Coe himself who put an end to the Friends of
Art purchasing art works through the majority vote of a raucous, unruly, and
largely unknowledgeable group of patrons convened at an annual meeting.[12]

Because the Friends of Art focused on contemporary art, the trustees and
Gardner hoped to keep the new museum's society from competing with the

FIGURE 11.2 Friends of Art annual meetings in which purchases were discussed ranged from docile, like this one in 1955, to belligerent. (RG 43/02, NAMAA)

much older Kansas City Art Institute Association. The Art Institute's support organization, incorporated in 1887, stated as its purpose "the promotion of artistic education by means of exhibitions of pictures, lectures, a school, and a museum of fine arts." The Friends of Art was in no way a general-membership organization, as was the Kansas City Art Institute Association. The Friends of Art intended only to heighten interest in modern art and raise funds to purchase at least one contemporary art object per year, thereby alleviating one of the limitations of Nelson's will.[13]

Not wanting to create an organization that would compete with the Kansas City Art Institute Association was only one of the ways in which the University Trustees and museum staff demonstrated their support of the policies of the Art Institute during the early years. Not only did the Art Institute and the Nelson-Atkins share obvious common interests, but they were also geographically contiguous, so it was important to the entire art community that both institutions not only get along but also promote common causes. Following Gardner's recommendation, the trustees had agreed to hire Art Institute students as guards. When O'Donnell began as director of education in 1934, she said all of the guards were students from the Art Institute, "darling boys" who considered it a privilege to work at the new museum. The trustees had

also agreed to cooperate with the Art Institute by offering free admission to students, allowing them to copy works of art in the museum, and employing them when extra help was needed on Saturdays and Sundays. At Gardner's suggestion, the trustees worked out a joint admission policy with the Art Institute in March 1934. Any member of the Kansas City Art Institute could gain free admission to the Nelson Gallery for one year. In return, the institute would pay the gallery a portion of its membership fees. However, in July 1934 the president of the Art Institute admitted to owing the Nelson Trust $1,000 in membership fees but said the institute lacked the funds at that time to make payment. Thereafter the joint membership provision was not reenacted, but the two institutions continued to coexist harmoniously.[14]

Other policies evolved that had little or nothing to do with interpreting Nelson's will but nevertheless had a measurable impact on the direction the museum would take. Even though it might strike one as counterintuitive at first mention, how to handle gifts of artwork proved to be a major concern. Long before the museum opened, individuals who wanted to donate art objects or collections to the museum began to contact the University Trustees. Gifts could be most helpful in building an art collection, the trustees felt, but they soon learned that dealing with certain givers and what they wanted to donate could be a real headache. As early as October 1930 a Mrs. Brown Harris called Nichols to offer the museum a collection of art objects she had inherited. Mrs. Harris was willing to donate the entire collection provided the museum pay the inheritance tax and the trustees promise to keep those objects they selected for the Nelson Gallery together. Rather than risk offending the donor, the University Trustees decided to let R. A. Holland of the Art Institute examine the proffered objects. The trustees later learned that they should not have even considered a gift with extensive conditions attached. "This was one of the things that the University Trustees had been warned to avoid by numerous museum directors," Jones recorded in the trustees' minutes.[15]

A few years later, Nichols and Jones were taking a harder line. On June 2, 1933, Jones recorded that he and Nichols had spent two hours with Mrs. Jacob L. Loose and her attorney, I. N. Ryland, at her safety deposit box and another two hours at Mrs. Loose's home. Although Jones and Nichols saw some things that they thought the museum could house, they told Mrs. Loose that "in accepting any gift the Trustees would have to have the right to select the items appropriate for museum exhibition and would only accept these providing there was no obligation for payment or continuous exhibition." The trustees would guarantee one thing only—that any art objects they chose for the museum would carry a designation as a gift of Mrs. Loose's.[16]

In many cases Nichols asked Gardner to look at a gift offered the museum and to make trips to visit potential donors. It is somewhat humorous that Nichols, not one known for his tact, repeatedly cautioned the very diplomatic Gardner in these instances. For example, before Gardner paid a visit to would-be benefactors Mr. and Mrs. Walter Jaccard at their home, Nichols advised him, "Of course, we will want to handle the situation very graciously and not offend them in any way." On another occasion, Nichols attended a dinner party with Mr. and Mrs. H. F. Hall, who, he told Gardner, "seemed to be very miffed" that they had heard nothing from the trustees about some things they wanted to give the museum. Another diplomatic trip by Gardner would settle the situation, Nichols resolved.[17]

Gardner became a master of diplomacy in writing letters to reject various gifts offered to the museum. To an Alice Klauber he wrote, "I have recommended that we do not accept it [a Japanese vase]," because "it would not seem fair to the donor [for the museum] to accept an object which from its nature would remain in storage." Concerning a collection of coins, spoons, and a tea set, Gardner wrote that it was "most kind of you to think of us," but "I am afraid it is not the sort of material which would fit into our collection." Fiercely protective of the small amount of storage space the museum contained, Gardner would not accept anything that he felt would not go on display. With Nichols's grudging consent, Gardner turned down pieces of primarily historical interest, objects with too many provisions attached, and all those he felt were not first rate.[18]

Sometimes Gardner could be downright blunt in his rejection of gifts. When writing to trust departments, he did not have to worry about offending individual donors. "It is a very undistinguished 19th century copy of a Murillo composition," he told D. M. Hall at the First National Bank Trust Department, "and I am afraid [it] could have no place in the Gallery collection." To Jones, as executor for the estate of Walker Hickman, Gardner confided that Hickman's objects included "second-hand furniture" that would not be displayed and a "mediocre" Bingham portrait, the same type as eight others in the museum collection already. Gardner even dared to chide Nichols on occasion regarding his apparent inability to flatly refuse any gift. "I am frankly upset about the group of dolls that Mr. Moore has sent," Gardner wrote Nichols. "I can not see how by any stretch of the word they could be termed works of art.... I am sure you realize that I am as anxious as you to have gifts made to the Gallery, but I feel if we are to keep it from becoming a storehouse of undesirable material, that we have got to be more careful of the type of thing that we accept."[19]

The penny-pinching Nichols had trouble saying no to anything free, and he may have made some errors in accepting undesirable objects for the museum,

but he also was able to entice some donors to bequeath wonderful additions to the gallery collection. Perhaps the most important of these was the Burnap Collection of English Pottery. In June 1935 Nichols spent several afternoons talking with Frank P. Burnap, who had decided to bequeath the extensive collection he and his wife, Harriet, had assembled. Nichols sought the advice of both Gardner and the trust's attorney, John E. Wilson, in order to counsel Burnap on how he should word his will to leave his treasures to the Nelson Trust. Care was taken to plan for the future exhibition of this fabulous pottery collection by establishing a fund to be used for photographing objects, maintaining exhibitions, buying books to interpret the pottery pieces, and adding to the original collection.[20]

Deciding how to handle gifts that are not of museum caliber is a problem that confronts all museums, and it has continued to face the Nelson-Atkins. However, Gardner, working with the trustees, established firm guidelines so that the museum storage would not be filled with rejects and so that those gifts the museum did accept did not come with too many strings attached.

In addition to the art objects presented to the museum as gifts, new purchases continued to arrive. The opening of the Nelson-Atkins Museum of Art did not signal the end of the buying spree the University Trustees had been engaged in for three years. In fact, after the opening, the trustees proceeded to acquire even more extensively. The gaps in the displayed collection became obvious, and a number of objects on loan would of course have to be returned at the end of the loan period. In addition, with the Great Depression far from over, it was still a buyer's market for pieces of fine art. Nichols didn't see anything wrong with letting art purchases exceed the trust's income for a short while, as long as the objects offered for sale were desirable additions to the collection bought at the best possible prices. The trustees and Gardner established a buying pattern that they continued to employ for many years. The trustees depended heavily on their art advisers—Warner and especially Parsons—to locate works they might be interested in purchasing. Nichols and Gardner (and sometimes Jones) would examine the objects offered for sale. If Gardner, the art expert, felt the piece would be a welcome or necessary addition to the museum collection, he would advise Nichols to proceed with negotiations.

Nichols took enormous pride in getting prices knocked down on objects for sale, and Jones recorded many of the transactions in detail in the trustees' minutes. On a trip to New York in February 1934, Nichols succeeded in buying Savoldo's *Adoration of the Shepherds*. "The owner of the picture," Jones reported, "said he had paid $14,000 for it. He asked $7,500 for it and Mr. Nichols got him to accept $3,000." On the same buying trip the Nelson Trust acquired a mahogany chest on chest and a late-eighteenth-century sofa; the two together

cost $6,000. According to J. C. Nichols, "This negotiation extended over three or four days coming down $500 at a time." On this trip Nichols had three sessions with the German art dealer Jacob Hirsch before purchasing an ancient Egyptian basalt hawk for $16,000 and an Egyptian head of a noble for $2,000. Jones recorded that Hirsch "insisted he had never made the Egyptian hawk less than $18,000. Harold [Parsons] contended he had practically said he would accept $16,000. He had an Egyptian Head and Paul and Harold were very anxious to have it. He said it cost him $3,600 on the old franc basis of exchange. He said he would let us have it for $4,000 and take $20,000 for the two. An offer of $18,000 was finally made for the two, which he accepted." Nichols delighted in such coups. On this same trip Nichols also purchased Raphaelle Peale's *After the Bath* (later renamed *Venus Rising from the Sea—A Deception*) for $2,500, which is now among the best-known holdings of the museum.[21]

FIGURE 11.3 In 1934, Nichols purchased Raphaelle Peale's *Venus Rising from the Sea – A Deception* from the Downtown Gallery for $2500. (Purchase: William Rockhill Nelson Trust, 34-147)

Occasionally Nichols worked himself into a frenzy trying to finalize art deals. He expected his negotiations to be kept private, whatever the outcome. Therefore, when the *Kansas City Times* carried a story regarding proposed purchases from Asian art dealer C. T. Loo, Nichols was outraged. He wrote to Roy Roberts at the *Times*, "Mr. Loo was here for two days and I spent over eight hours trying to save money for the trust, and we arrived at a tentative agreement." Nichols also felt compelled to explain his dilemma to *Times* editor Richard Fowler. "Personally I am almost a physical wreck after eight hours of continuous session with Mr. Loo the other day. For two days I neglected many important things in my own business and then to find that the story had been released after I specifically requested that it not be done was rather upsetting." Even though Nichols feared that publicity might jeopardize his supposedly private negotiations with Loo, their tentative agreement did materialize.[22]

In fact, at least in the trustees' minutes, Nichols always came out the winner. He insisted on paying no more than $8,000 for Jean Baptiste Pater's *L'Accord Parfait*, even though the original price asked by the dealer, Wildenstein and Company, was $14,000. After extensive negotiations with Nichols, Wildenstein sold the piece for $7,500. In trying to buy four pieces of Italian majolica pottery, one of which Parsons considered the finest in America with the possible exception of one in the Cleveland Museum, Parsons got the price down from $22,000 to $17,500; but Nichols worked it down to $16,000 and then to $12,500 in cash![23]

Besides negotiating deals on art objects, Nichols enthusiastically pursued any idea for attracting more visitors to the Nelson-Atkins. At a trustees' meeting on January 15, 1934, Nichols and Jones discussed allowing half-price admissions for large groups coming through the gallery, and Nichols raised the possibility of music programs on Sunday evenings. They also debated whether to allow various clubs or organizations to stage events at the museum. They decided to allow a Vassar Club-sponsored lecture on Russian art but turned down the Barstow School's request to rent the auditorium for a play. The policy they determined to adopt was that the museum should "be used only for lectures directly related to the fine arts." Over the years, however, the trustees stretched art-related criteria for museum usage. During World War II, dances were held in the museum, and eventually various boards and members of organizations, like the Society of Fellows, could rent museum space to hold private gatherings and receptions.[24]

After the meeting on January 15, 1934, Nichols obviously spent several days mulling over these new policies and ways to keep attendance up at the museum. On January 18, he sent Jones a long letter offering twenty-nine suggestions for making "our gallery the best patronized gallery in the entire country." A program needed to be mapped out with Gardner, Nichols insisted, because "we are going

to have a big job keeping up the interest." At a March 1934 trustees' meeting, Nichols presented another idea for increasing interest in the new museum. He suggested having a member of the staff devote most of his or her time to contacting private clubs throughout the Midwest to invite them to visit the museum.[25]

In July, Nichols involved himself again in the drive to extend the gallery grounds south of Brush Creek Boulevard for the purpose of installing the mirrored pool he wanted so desperately. Sure that such an improvement would attract many old and new visitors, Nichols was appalled when the Zoning Board rezoned for business the western side of Oak between Forty-Eighth and Forty-Ninth. Nichols, with Jones's support, asked the Nelson Trust's counsel to object to the rezoning, which would be an obstacle to the intended future development of the art museum grounds. Vincent said he and his fellow trustees for the Laura and Irwin Kirkwood trusts were in favor of the enlarged grounds with a reflecting pool, and he urged that restrictions remain on the property. The new zoning, however, still went into effect.[26]

Because of Nichols's many suggestions to increase interest in the museum, publicity became an area of focus early in its history. Newspapers, magazines, and radio programs all carried items about the museum. The trustees made certain that the public was informed about the hours and fees by listing both in public-service magazines and papers such as the *Merchants' Association Shoppers' Guide*. The *Guide* listed the hours as 10 to 5 on Tuesdays, Thursdays, Fridays, and Saturdays; 10 to 5 and 7 to 10 on Wednesdays, 2 to 6 on Sundays and holidays, closed on Mondays. There were no fees charged on Saturdays, Sundays, or holidays. The regular fee was twenty-five cents per adult and ten cents per child under twelve years of age. The publicity must have paid off, for 622,000 people visited the museum during its first three years of existence.[27]

Having worked together to broadly interpret Nelson's will and establish policies that would allow the museum to grow, Gardner and the University Trustees arrived at the fifth anniversary of the museum with a very satisfied feeling. The publicity sheet released summed up their idea of what they had accomplished in five years:

It is the consensus of opinion here and in Europe that the Gallery building is the most beautiful museum in the world and one of the finest from the point of view of equipment and installation. The permanent collections, outstanding at the time of the opening five years ago, have through the addition of purchases and gifts, assumed the rank of perhaps fifth in importance in the United States. This is an enviable record to have accomplished in so short a time.[28]

THE WAR YEARS UNDER ETHLYNE JACKSON

T HE REPUTATION THE Nelson-Atkins Museum of Art had gained for itself on its fifth anniversary was superseded by the status in which it was held on its tenth anniversary in December 1943. *Art News* featured the museum in its December edition, displaying a 1940 acquisition, Lorenzo Monaco's *Virgin and Child*, on its cover. The article, written by the museum's acting director Ethlyne Jackson, traced the museum's history, recalling that before 1933 "Kansas City had never had an art gallery, and it was as though a glamorous and well-publicized stranger had come here to live." Besides being a collecting museum, the Nelson-Atkins had facilities for community activities, *Art News* related. The Wednesday evening lecture series drew its attendance from the general public but also had been incorporated into the curriculum of Kansas City University. Children's tours brought eight thousand students a year into the museum. The docents, volunteers from the Kansas City, Missouri, Junior League, provided tours for children as well as adults, and Sunday afternoon concerts were an added feature. Since the museum's opening, 1.75 million people had toured the art galleries. The Nelson-Atkins Museum of Art's comprehensive historical collection, *Art News* reported, highlighted the finest examples in every area. If there were weaknesses, they might be in the European decorative arts and early Renaissance paintings, but the Chinese department, a "mecca for scholars in the field,"[1] was exceptionally strong and unique.

Art experts recognized the strength of the Nelson-Atkins's Chinese holdings as early as the winter of 1935–36 when Burlington House in London held a huge exhibition of Chinese art, drawing worldwide attention to Asian art. The Nelson-Atkins had lent some objects for this show based on the opinion rendered by attorneys Meservey and Wilson in 1934 that as long as art objects remained in the permanent collection, they could be loaned. The pieces sent

FIGURE 12.1 The cover of the December 1940 *Art News* displayed the Nelson-Atkins's painting of *Virgin and Child* by Lorenzo Monaco and assistant; the painting is now known as *Madonna of Humility*. (Purchase: William Rockhill Nelson Trust, 40-40)

to London demonstrated the exceptional quality and scope of the two-year-old museum's Chinese collection. Of course, the man most responsible for assembling what was already recognized as one of the world's finest collections of Chinese art was Laurence Sickman, who, as mentioned, had been in China until late 1935 finishing his Harvard fellowship and working for the Nelson Trust. He had established a reputation for having an eye for seeking out the unique and a talent for procuring the finest. Art critic and aesthete Sir Harold Acton, who knew Sickman during his years in China, claimed Sickman had a "profound intuitive understanding of Chinese art" and an "unerring sense of style, form, quality, in Chinese painting—apart from ceramics and the various crafts."[2]

When Sickman returned to the United States, he assumed the post of curator of Oriental Art at the Nelson-Atkins, the position the University Trustees had promised him in 1933. The trustees continued to trust this young scholar, allowing him the freedom to build the museum's strong Asian collection and to assume responsibility for its display. Under Sickman's direction, the collection expanded so much that by 1941 Sickman advised opening a new Chinese gallery to house both Chinese painting and sculpture. One of the prime attractions would be *The Offering Procession of the Empress as Donor with Her Court*, the relief from the Longmen caves that had been broken up and sold during the Great Depression and which Sickman had reassembled after several years of searching and piecing.

Aside from the new Chinese painting and sculpture gallery, the museum opened five other rooms in April 1941 to display classical artifacts, Egyptian art, Renaissance sculpture, prints, and the Burnap Collection of English Pottery. Frank P. and Harriet C. Burnap had promised their collection to the museum in 1935 as a bequest, but now, six years later, they decided to donate it to the museum in order to see it properly displayed there within their lifetimes. The Burnap Collection, which demonstrated the complete history of English pottery was, undoubtedly, the best and most extensive English pottery collection in the United States.

These six new galleries changed the museum dramatically and proved the foresight of the trustees who had served on the building committee from 1929 to 1933. They predicted that more exhibition space would be necessary as the collection grew; thus, in the planning stage, they had determined to leave one-third of the building unfinished to meet future needs. They also had invested wisely the residual trust funds from the estates of Ida H. Nelson, Laura Nelson Kirkwood, and Irwin Kirkwood, so that when they decided to expand in 1941,

FIGURE 12.2 *The Offering Procession of the Empress as Donor with Her Court,* chipped from the wall of a Buddhist temple cave in the Binyang Cave, Longmen, Henan Province, during the Great Depression, was later recovered and pieced together by Laurence Sickman. (Purchase: William Rockhill Nelson Trust, 40-38)

the space and financing were available to finish part of the west wing of the first floor and an area also in the west wing on the second floor.

Apart from the expansion noted by *Art News* on the tenth anniversary of the museum, another change occurred in the administration, with the addition in 1940 of a new University Trustee. After Arthur M. Hyde had resigned in 1935, the Board of University Presidents had not appointed a third trustee. Under the conditions of Nelson's will, "any two university trustees appointed by the board may do any act or exercise any power," and the board was to appoint an additional trustee only if it "deems it for the advantage of said trust estate." By 1940 both Nichols and Jones had worked for the Nelson Trust for fourteen years. Nichols had just turned sixty and was possibly not quite the "ball of fire" he had been some years earlier. However, he seemed unwilling to concede to that possibility and had just taken on a new job, agreeing to serve on the President's Advisory Council for the National Defense. During 1940, he spent a good deal of time in Washington, D.C., and returned to Kansas City with plans to build four huge defense plants in the area. Nichols, in any case, was

ready for some help with the Nelson Trust, and he had found someone whom he believed would be a welcome addition, Robert B. Caldwell.[3]

Nichols suggested Caldwell, a Kansas City corporate lawyer with the firm of Caldwell, Downing, Noble, and Garrity, for two reasons. First, Nichols knew Caldwell quite well; Caldwell's daughter Catherine was married to Nichols's son Miller. Even though Caldwell was a busy man, he had a great many contacts, which seemed auspicious. Caldwell represented as general counsel a number of major Kansas City businesses, and he served as chairman of the board of the Federal Reserve Bank and chairman of the board of the Cook Paint and Varnish Company. Moreover, during the 1920s, Caldwell had worked toward cleaning up the local government by advocating and serving on the Election Board of Kansas City. The Board of University Presidents approved Caldwell's appointment, and in early 1940, he began his service as a University Trustee. The editor of the *Kansas City Star*, Richard B. Fowler, described Caldwell's new role: "Bob Caldwell makes no claim to special art knowledge and doesn't attempt to acquire it." That he left to the experts. But what Caldwell enjoyed about his new position, Fowler maintained, was the "rough and tumble trading and bargaining" of the art world. Is it any wonder that Nichols liked Caldwell's style?[4]

Other than the new galleries and a new trustee, the most important and noticeable change at the museum on the occasion of its tenth anniversary was the absence of some of the key players. As noted earlier, the Education Department was in flux, as the head, Louise Nelson, took a one-and-a-half-year leave to work for the Red Cross, preceded into the same service by her assistant, Frances Webb. Director Paul Gardner and Oriental Art Curator Laurence Sickman also left to serve in World War II. When Sickman departed in May 1942, Lindsay Hughes was the natural choice to act as curator of Oriental Art in Sickman's absence, since she had worked with him since his arrival in Kansas City. When Gardner received his notice from the War Department in the fall of 1942, he may have been somewhat shocked. He was forty-eight years old and a veteran of World War I. However, Gardner was willing and able to serve the nation as long as he did not have to relinquish his job. In his formal letter to the University Trustees, he stated, "As the War Department has called me to the army, I trust that the Trustees will feel that they can grant me a leave of absence from my duties at the Gallery for the duration [of the war]." Gardner recommended that the trustees give his secretary and assistant, Ethlyne Jackson, an "appreciable raise and perhaps some temporary title" to take over his obligations, including his lecture schedule and public contacts.[5]

FIGURE 12.3 Paul Gardner's able assistant, Ethlyne Jackson, took over his duties when the War Department called him into the US Army in fall 1942. (MSS 08, NAMAA)

The University Trustees agreed to appoint Jackson acting director. The "appreciable raise" was another matter entirely. Nichols wrote to Miss Jackson (the way he addressed her for most of her tenure) on January 9, 1943, a month into her new job, to warn her that he could do nothing about salary increases without going through the War Labor Board. However, Nichols had requested permission from the Labor Board to raise the salary of building engineer Clarence Simpson and to pay Gardner $175 a month and Sickman $100 a month in absentia. As for Jackson, Nichols said, "I felt it was unwise to as yet suggest a raise for you because of the issue which has arisen and which I think I have to take up with my co-trustees before any determination although I am willing to recommend some reasonable raise but not anything like you suggest." Apparently, Jackson had raised the issue that she was earning $160 a month as secretary to the director and thought she deserved a sizable increase in her new position.[6]

In March, Nichols requested a pay hike for Jackson. On a memo to the secretary of the Nelson Trust, Nichols notated an increase in Jackson's salary from $160 to $175 a month. He had second thoughts, crossed out the $175, and changed it to $200 a month. The same memo requested raises for Clarence Simpson from $215 to $265 a month and for George Herrick, who was in

charge of museum storage, from $145 to $175. It did not bother Nichols that those men in charge of maintenance earned almost the same or more than the new acting director. Nichols jotted a note to Jackson to inform her of her salary hike. Jackson responded courteously: "I want to thank you for the consideration which you and the other Trustees have given us in the matter of salaries." However, she did not give up the fight for more equitable pay.[7]

Just as Gardner had done in past years, Jackson sent a year-end memo to the trustees in December 1943 with salary recommendations for the coming year. Jackson felt that position changes and additional responsibilities warranted salary increases at least until the war's end. She suggested that Simpson receive an increase from his $265, because he "has maintained the high level of 'housekeeping' at the Gallery under the most trying conditions." She thought Herrick's salary should be advanced from $175 to $185, since in the absence of his assistant, James Roth, Herrick was solely in charge of packing, unpacking, and changing exhibitions. For her secretary, Louise Lebrecht, who had previously been the cashier and switchboard operator, she requested $100, up from $85 per month. Jackson urged the trustees to give Hughes a substantial pay raise too. "Lindsay has been acting Curator of the Oriental Department since May of 1942," Jackson reminded the trustees, "and while she was given a substantial increase at that time, that is a year and a half ago and I am sure I need not tell you with what enthusiasm and success she has conducted her department." Finally Jackson made her plea to have her own salary brought "more into line with the duties involved as Acting Director." She was working seven days and four nights a week, supporting her mother, and trying to scrape together enough money to buy presentable clothes for her social duties as acting director. Her present salary of $200 a month, she said, "is one fifth of what Mr. Gardner was receiving, and while it is certainly not my contention that I am as well qualified as he, I think I can truthfully say that I am doing much more than one fifth of the job that he was doing." She reminded the trustees that she had started at the gallery ten years before at $90 a month, $20 less than she received at her previous job. The trustees' response was to raise Herrick's salary as requested to $185, Lebrecht's to $100, Hughes's to $225, and Jackson's to $250. Since Jackson's figures about Gardner's salary were correct (Gardner's salary as of September 1942 was $10,200 or $850 per month), the University Trustees may have determined that Jackson was no longer doing just one fifth of the director's job, but a little more than one fourth.[8]

In fact, Jackson assumed the responsibility of acting director with poise and vigor. She had worked closely with Gardner and possessed a sound knowledge

of art and museum operation. Because Gardner left at the end of 1942, one of Jackson's first responsibilities was to file a year-end report, which Nichols admitted was "a very fine complete form." Nichols was considerably more resistant to trusting Jackson's judgments on acquisitions, a major part of the director's role as Gardner had defined it. When on January 28, 1943, Jackson wrote to Nichols to recommend the purchase of a commode being offered by a dealer in New York, Nichols insisted that Jackson write to Gardner to get his opinion. "Personally," Nichols added characteristically, "I think prices are going to go lower." He urged that they try to bargain to get a better deal if Gardner gave the okay. Gardner responded quickly, telling Jackson to buy the commode at the price offered.[9]

Nichols's opinion that the war would bring down art prices had few supporters. A prominent New York dealer, Germain Seligmann, whom Jackson would later marry, had written to Jones in 1941 to explain his understanding of the effect the war could be expected to have on the art market.

> I know that in the minds of many trustees and museum directors there is the fear or the hope that once this war is over public institutions in Europe will be compelled to sell their art treasures. I think that this is more in the realm of fantasy than anything else. The best examples we have had in our days, were the sales made at fantastically high prices by the government of the U.S.S.R., which government, after a short time completely stopped this process (I am only talking about important paintings), after it suddenly realized that a few millions of dollars collected were but a "drop in the bucket." You will see also that if the Louvre, the Kaiser Friedrichs Museum, the Uffizi, and the National Gallery, etc. etc. were to sell all of their art treasures, there wouldn't be enough money in the country to buy them, as it is only if they could be sold at very high prices that it would have any meaning for them to part with their treasures.[10]

Many art collectors and museums had moved their treasures to repositories in the United States. René Batigne, the curator of French collections imported to the United States for safekeeping, spent two days touring the Nelson-Atkins with Nichols in October 1943 and was impressed with the condition and display of the sixty paintings he examined in the Nelson's European galleries. Nichols, always looking for opportunities, reported that Batigne was enthusiastic about the collection, and "I believe may be in position to help us in interesting some private collectors of art to ultimately leave some things to our gallery." Nichols's hope was that Batigne would sing the praises of the

Nelson collection to American collectors of French art, who would eventually bequeath their paintings to the Kansas City museum.[11]

Jackson was convinced that the Nelson Trust should continue to acquire important pieces to augment its collection even during wartime and not wait to see if prices would drop or gifts fall into their laps. She asked Nichols for permission to go to New York in early October 1943 to see some works art advisor Harold Woodbury Parsons wanted the museum to consider. Jackson tried to convince Nichols of her ability to make this buying trip: "As I have worked so closely with the collection, I feel that I have knowledge of what things are most needed for our educational work and to fill out the collections, and what Mr. Gardner's ideas are for the future growth of the museum." Although Nichols would eventually send Jackson to New York, where she would meet with Parsons and see what he described as "the few remaining good things on the market here," that visit would not occur until June 1945. Meanwhile, in fall 1943, Nichols and Jones made the trip instead of Jackson. Before they left, they gave her the lists of objects various dealers had for sale and asked her to offer suggestions. Admitting to the difficulty of making any statement without having seen photographs of the objects, much less the objects themselves, Jackson swallowed her disappointment about not being included in the buying trip to New York and gave her opinions. She felt especially strongly about acquiring a Winslow Homer painting.[12]

Shortly after the Japanese bombed Pearl Harbor in December 1941, Gardner and his staff decided to remove all Japanese art objects from exhibit in order to protect them from vandalism. The duty of defending this decision to the University Trustees fell on Jackson, for Gardner had acted without their assent before he had gone abroad. It was not until October 1943 that anyone raised the question of the Japanese collection. A single protest came from Mrs. Parke Johnson, the wife of the minister at the Second Presbyterian Church in Kansas City. Mrs. Johnson feared that the objects had been removed for "reasons of racial prejudice." Hughes, who belonged to the Second Presbyterian Church, explained that the Japanese art had been stored solely for its safety. Jackson wrote Nichols to inform him of the protest and to assure him that other museums had taken actions similar to that of the Nelson-Atkins. The Museum of Fine Arts, Boston, Jackson explained, had taken down its Japanese objects after a vandalism attempt. The Metropolitan had kept a few minor Japanese pieces on display, but most were in storage. The National Gallery had no Japanese art out, and the Fogg Museum was considering taking its down. Jackson confirmed that the museum's Japanese collection was available for study

purposes, although no requests had been made. Nichols seemed well satisfied with Jackson's explanation, and actually seemed to be growing more comfortable with the idea of Miss Jackson acting as director of his museum.[13]

By May 1944, Nichols had begun addressing Jackson as Ethlyne. "Dear Ethlyne," he wrote. "Just this afternoon I had time to go over your yearly report, and I think you and the rest of the staff are doing a wonderful job." This was high praise indeed, and seemingly true. Jackson was a good manager. She saw to many details that might have been overlooked, like replacing carpeting in Atkins Auditorium and notifying Nichols of a proposed public transit change that might deprive the gallery of transportation from downtown and Union Station. She was a list maker, like Nichols, and when asked to make suggestions would respond with items numbered in order of importance. Nichols, who always remained concerned about keeping attendance up at the museum, was impressed with Jackson's ideas for attracting the general public. Her top priority was to start a moving-picture program, which drew a lot of public support. Nichols enjoyed receiving letters from enthusiastic patrons of the movies, but he cautioned Jackson to ensure that all the pictures shown at least related to art.[14]

Other public service activities launched during Jackson's tenure included a series of subscription lectures sponsored by the Chinese Women's Relief Association and organized by Lindsay Hughes. The proceeds of these lectures would benefit Chinese children. Jackson also proposed that a room in the museum be designated as a soldiers' lounge, and she suggested getting outside speakers for the Wednesday night lecture series, even though she and Hughes were doing a fine job of attracting listeners. Hughes had become such a popular speaker on Chinese art that she was invited to the Metropolitan to deliver a lecture on Chinese textiles to the Chinese Art Society.[15]

Nichols actually began to consult Jackson on art purchases, although he remained paternalistic. A typical note from Nichols read, "Dear Ethlyne, please let me know your judgment and desires on the purchases Harold [Parsons] has outlined on the attached. Don't let Harold's enthusiasm carry you off your feet." By mid-1944, Jackson was advising the trustees on pieces with some authority, citing deficiencies in the collection and displaying her familiarity with relevant publications. For example, she advocated that the Nelson Trust buy a Memling painting, *Virgin and Child Enthroned*. When Nichols asked her to compare the Memling painting to a work by Isenbrandt that was also for sale, Jackson replied that they were not comparable. Although the Memling painting might be twice as expensive, it was more than twice as important. She quoted Gardner's letter on the subject: "I still believe the Memling is the most

important painting on the market for the needs of the collection." Not only would *Virgin and Child Enthroned* augment the museum's somewhat weak Flemish painting collection, Jackson maintained, but the work in question was one of the most important works by Memling, having been reproduced in an authoritative book on Memling and compared to the Memling painting in the National Gallery in London. Ultimately the trustees went ahead with the purchase of the *Virgin and Child Enthroned*.[16]

FIGURE 12.4 Ethlyne Jackson, as acting director, convinced J. C. Nichols to purchase Hans Memling's *Madonna and Child Enthroned* (formerly titled *Virgin and Child Enthroned*). (Purchase: William Rockhill Nelson Trust, 44-43)

In July 1944 Nichols made a deal with the Asian art dealer C. T. Loo that at least two members of the staff—namely Jackson and Hughes—had feared would never transpire. In 1933 Loo had loaned the Nelson-Atkins a large number of objects from his collection for the museum's grand opening, including a pair of Chinese chimeras, massive stone mythical animals, which stood on either side of the doorway into the Nelson's main Chinese gallery. Hughes said that everyone could see that the chimeras were fabulous and assumed that Nichols would purchase them. However, Loo wanted $50,000, and Nichols refused to pay that much. The chimeras were returned to Loo, who kept them in his gallery. Hughes and Jackson never stopped mentioning to Nichols how much they and others missed the winged lions. Finally, after a decade's worth of prodding, Nichols conceded and bought the chimeras in 1944, paying Loo $75,000. On a carbon copy of the letter he wrote to the trust secretary regarding the purchase, Nichols added a personal note to Jackson: "Hope you are PLEASED and Lindsay can sleep nights." Both Jackson and Hughes were thrilled indeed, and the chimeras resumed their places at the entrance to the main Chinese gallery.[17]

It was during Jackson's term as acting director that another piece of very old business was resolved—the sale of household goods, personal effects, and artwork from Laura Nelson Kirkwood's estate. Before the sale took place, Fred C. Vincent, as trustee for Laura Kirkwood, asked the University Trustees and Jackson to ascertain whether the museum wished to have any of the art objects from the estate. Four paintings—a Hoppner, Constable, Gainsborough, and Gheeraerts—had already been set aside, along with the portrait of William Rockhill Nelson by William Merritt Chase, the oak-paneled central room from Oak Hall, and certain furnishings. Now, in addition, Jackson asked that two Impressionist paintings be exempted from the estate sale. One of the two, *View of Argenteuil, Snow* by Claude Monet was put on display. The other, a painting by Camille Pissarro called *Poplars, Sunset at Éragny,* was set aside and put into storage, because its attribution was questioned. Not until 1988 was the latter painting "rediscovered," cleaned, and hung in the Impressionist Gallery. The trustees may also have had Jackson to thank for saving two other paintings for the museum. Benjamin West's painting of his sons, *Raphael West and Benjamin West Jr.,* had hung in the music room at Oak Hall. It was originally listed in the Kirkwood estate catalog but apparently was withdrawn from the sale. The other painting, Sir Thomas Lawrence's *Portrait of a Lady*, also was salvaged from the sale but was sold at Christie's Auction House in 1989.[18]

The rest of the items in Laura Kirkwood's estate were sold, somewhat in accordance to the unusual requirements of her will, which specified that

FIGURE 12.5 In July 1944, J. C. Nichols made a deal with Asian art dealer C. T. Loo to buy a pair of *Chimera Tomb Guardians,* which Loo had loaned to the museum for its grand opening. (Purchase: William Rockhill Nelson Trust, 44-26/1,2)

her executor should sell her effects "through dealers, merchants or persons, strangers to me, doing business or living more than Two Hundred Fifty (250) miles from Kansas City, Missouri." Although it would have seemed logical to hold the sale 250 miles away from town, the sale took place in Kansas City. Charles P. Woodbury acted as the agent for the trustees: Fred C. Vincent, John E. Wilson, and Fidelity National Trust. The introduction to the nine-page sales catalog clearly stated the terms: Purchases needed to be made in cash; works would be shown by appointment only; and there was no warranty. Finally, those who purchased items at the sale needed to attest to the following condition: "All purchasers hereby accept the above terms and agree they are strangers to the late Mrs. Laura Nelson Kirkwood and are doing business or living more than two hundred and fifty miles from Kansas City, Missouri." In such a manner, Laura Nelson Kirkwood's estate was finally laid to rest eighteen years after her death.[19]

Ethlyne Jackson also made some decisions regarding William Rockhill Nelson's Western Gallery, his collection of old masters reproductions. Because Ida H. Nelson's will instructed her trustees to use her funds to erect the William

FIGURE 12.6 Ethlyne Jackson asked Fred C. Vincent, a trustee for Laura Nelson Kirkwood, to exempt two paintings from the Kirkwood sale, including this 1894 oil by Camille Pissarro, *Poplars, Sunset at Éragny*. (Gift of the Laura Nelson Kirkwood Residuary Trust, 44-41/2)

Rockhill Nelson Gallery of Art "for the purpose of housing and caring for pictures, paintings, sculptures, rare books, tapestries, and works of the fine arts to be purchased pursuant to the provisions of the last will of William Rockhill Nelson . . . and such as he donated to the public now known as the Western Gallery of Art," the trustees had accepted the Western Gallery from the Kansas City School District. However, neither the trustees nor Gardner planned to exhibit all of the Western Gallery nor did they see the necessity of keeping all of Nelson's reproductions. A little over a month after receiving the collection, on August 22, 1933, Nichols asked Gardner to send a group of paintings and photographs from the Western Gallery back to the Board of Education on "indefinite loan to be used for purposes of education, or as the Board sees fit." This was just the beginning of a gradual process whereby the trustees phased out Nelson's reproductions. By 1942 none of the Western Gallery remained on exhibit, and no one seemed to miss it. "To the best of our information," Acting Director Ethlyne Jackson wrote the University Trustees in 1945, "there have been no complaints about it [the missing Western Gallery], but rather a general expression of approval, even from local people."[20]

In 1945, Jackson hoped to convince the trustees to remove the Western Gallery not only from exhibition but from the museum altogether. The reproductions were taking up a good deal of space in the storeroom, and Jackson felt that they might be of use in Catholic schools or churches, as so many of the paintings were of a religious nature. "All of us here at the Gallery feel that they should not go back on exhibition," Jackson reiterated. Although the majority of the reproductions that made up Nelson's collection stayed in museum storage for some time, the University Trustees eventually did begin to distribute them piecemeal to institutions that could exhibit them or use them as teaching tools. In 1954, the Kansas City Art Institute received eleven paintings from the Western Gallery. In 1970 Rosemary Beymer, the art director for the Board of Education of Kansas City, Missouri, agreed to borrow "on indefinite loan" various replicas from the Western Gallery, including seventeen paintings and seven Renaissance busts. The Kansas City Art Institute took six sculpture replicas in February 1973. Avila College received copies of paintings by Raphael, Van Dyck, Ribera, Rubens, Veronese, and Murillo in November 1973 and the prized replica of Raphael's *Madonna* in October 1974. Other pieces in the Western Gallery went to the Department of Art and Archaeology at the University of Missouri-Columbia, to Rockhurst College, and to the Playhouse at the University of Missouri-Kansas City. In April 1974 a list showed that twenty-three paintings from Nelson's original collection remained at

the museum. The University Trustees and a supportive museum staff, led by Gardner and Jackson, had decided that Nelson's Western Gallery should not be considered a part of "all works and reproductions of works" that Nelson's will stated should be on public display.[21]

While Jackson and her staff carried on business as usual at the museum, Lt. Col. Gardner and Major Sickman served the nation abroad. Eventually, they, along with former museum registrar Otto Wittmann, would become "Monuments Men," a special group of 345 men and women from fourteen nations who had expertise as museum directors, art historians, curators, artists, architects, or educators. Their sole job was to preserve and protect cultural treasures. In June 1943, President Franklin D. Roosevelt had approved the formation of the American Commission for the Protection and Salvage of Artistic and Historic Monuments in War Areas, also known as the Roberts Commission, after its chairman, Supreme Court Justice Owen J. Roberts. This commission led to the birth of the MFAA (Monuments, Fine Arts, Archives), which functioned under the Civil Affairs and Military Government Sections of the Allied Armies. During the last year of the war and for up to six years after it ended, the Monuments Men tracked, located, and returned more than five million artistic and cultural items stolen by Hitler and the Nazis and also helped rebuild the cultural life in devastated countries.[22]

Paul Gardner's role as a Monuments Man began after he had served a short stint as military governor of Ischia, a small volcanic island in the Gulf of Naples. In October 1943 Lt. Colonel Gardner accompanied the U.S. Fifth Army into Naples. He carried out inspections of the ruined city and surrounding towns and was promoted to lieutenant colonel in 1945 as well as director of the MFAA Section of the Allied Military Government for the liberated provinces of Italy. While Gardner was in Naples administering and safeguarding the national treasures for the military government, he did on several occasions find art objects he wanted to buy for the museum. Each time, he wrote Jackson about his discoveries. In February 1944 he informed her that he had found a painting by Alessandro Longhi for $500, "a grand Venetian portrait of a decadent youth in armour and red coat." Jackson, in turn, wrote the trustees to ask them to forward money to Gardner. "It sounds like a bargain to me," she assured Nichols; "and, of course, Mr. Gardner's judgment on both quality and suitability is good as gold."[23]

Meanwhile, Laurence Sickman first served in the U.S. Army Air Corps as an intelligence officer stationed in England. Then the Army sent Captain and soon-to-be Major Sickman to India, and by July 1945, to China. Reminiscent

FIGURE 12.7 Lieutenant Colonel Paul Gardner, as the first Monuments Man to reach mainland Italy, carried out inspections of the ruins in Naples and became director of the MFAA section of the Allied Military Government in liberated Italy. (MSS 06, NAMAA)

of his days as a student, Sickman found himself in an advantageous position to purchase Asian artworks for the Nelson-Atkins Museum of Art. He began corresponding directly with the University Trustees, who authorized him to make purchases but to do so with care. At a March 1944 trustees' meeting, Nichols, Jones, and Caldwell cautioned Sickman to talk to the American consul and make sure his acquisitions could be shipped to Kansas City without getting lost. They also urged him to insure everything he shipped. "We do not want to discourage you, and we are willing to back you a million percent, but we want to be dead sure you are thinking of all of the above in making any considerable investment where there is any risk involved." The trustees sent Sickman a letter of authorization allowing him to purchase in the name of the Nelson Trust of Kansas City, Missouri, which held assets valued at over $11 million.[24]

Although he was given carte blanche, Sickman did not have the opportunity to use the extensive line of credit extended to him. The acquisitions he did make in China came from two different sources, neither of which needed a letter of credit. One source was Sickman's old friend Sir Harold Acton, who

FIGURE 12.8 Captain (later Major) Laurence Sickman first served as an intelligence officer in England. He was then sent to India, and by July 1945 to China, where he worked in aerial bombing intelligence. (RG 73, NAMAA)

presented him with some of his own treasures for the Nelson-Atkins Museum of Art. In order to get Acton's pieces out of China, Sickman depended on another friend, art dealer Otto Burchard, who, after the war ended, crated and shipped the art objects. "A ticklish job" it was, Burchard remembered, trying to get art out of Communist China. Burchard thought he had succeeded in his task, but the Nelson-Atkins did not receive the treasures. Almost eight years later, in March 1953, the crate full of art objects resurfaced. When Sickman received the Chinese pottery, scrolls, albums, and books, he wrote to Burchard to tell him of the miracle and to thank him for his role. No thanks were necessary, Burchard responded, he had helped him as a friend.[25]

The other acquisitions Sickman made came from dealers and constituted another coup. In September 1945, a month after the Japanese surrendered, Sickman flew into Beijing to take possession of Japanese intelligence papers. While there he acquired some porcelain objects from dealer Hsia Hsi-chou and bought several important Ming Dynasty paintings from Jean-Pierre Dubosc. Since both dealers demanded cash, Sickman could not use his line of

credit. Instead, he decided to borrow money for these art objects from the $250,000 in the suitcase belonging to the Quartermaster Corps. Sickman put the paintings—masterpieces by Qiu Ying, Wen Zhengming, Shen Zhou, and Tang Yin that would form the nucleus of an outstanding collection of Ming Dynasty scrolls at the Nelson-Atkins—into the bomb bay of his B-25![26]

After departing Beijing, Sickman would spend November and December 1945 in Shanghai, where he would purchase more items for the museum, before being transferred to Tokyo to begin his service in the Monuments, Fine Arts, and Archives Section of the U.S. Army. As a Monuments Man, Sickman was sent to Korea to assess the cultural heritage situation there. Then he would spend January and February 1946 in Tokyo, where he again had the opportunity to acquire some Chinese paintings, purchased from art dealer Michelangelo Piacentini. Sickman's MFAA work would take him to Nanking, Shanghai, and back to Tokyo in May 1946. He would return to Kansas City in June with new treasures for the museum.[27]

Nichols had been correct when he predicted in 1942 that prices would go lower as the war progressed and that the museum should look for good opportunities. Certainly, both Gardner and Sickman took advantage of their wartime situations to add to the museum's holdings. On the home front, Jackson cajoled Nichols into spending money on several very important additions, at prices no one would see after the war. New acquisitions included the chimeras and the Memling painting, as well as Bernardo Strozzi's *St. Cecilia*, Winslow Homer's *Three Boys in a Dory*, *Frances Eakins* by Thomas Eakins, an Indian red sandstone Standing Buddha from the Gupta period, and a small group of Persian miniatures, the most significant being *The Meeting of the Theologians*. The last major purchase of Jackson's temporary directorship was made in August 1945. At that time, Jackson wrote to Nichols, enclosing Gardner's most recent letter and surmising that Gardner would be home soon and that she could postpone most remaining decisions until he arrived.[28]

Thrown into her role as acting director while the nation was at war, Ethlyne Jackson had guided the museum adeptly for three years, encouraging some important purchases and more public use of museum facilities and seeing to the administrative details. Although Jackson was never compensated nearly as well as Gardner had been, Jones, and even Nichols, admitted that she had done a fine job as interim director. The museum was very lucky that Jackson was in the right place at the right time; she is one of many unsung heroes of the early years of the Nelson-Atkins Museum of Art.

FIGURE 12.9 The museum made several important acquisitions during Ethlyne Jackson's tenure, including this Persian illuminated manuscript, *The Meeting of the Theologians,* attributed to 'Abd Allah Musawwir. (Purchase: William Rockhill Nelson Trust, 43-5)

THE MONUMENTS MEN RETURN

P AUL GARDNER AND Laurence Sickman both returned safely from their service as Monuments Men: Gardner in December 1945; Sickman in June of 1946. Like most of the rest of those select men and women who served as Monuments Men, these two, along with Otto Wittman, would go on to play important roles in building great cultural and educational institutions in the United States and abroad. They "became directors and curators of world renowned museums such as the Metropolitan, the MOMA, the National Gallery of Art, the Cleveland Museum of Art, the Toledo Museum of Art, the Nelson-Atkins Museum of Art, and many others," according to the Monuments Men Foundation, and they developed institutions such as the New York City Ballet and the National Endowments for the Arts and Humanities.[1]

For the time being, both Gardner and Sickman resumed their former positions at the Nelson-Atkins, but the museum they found on their return was somewhat different from the one they had left. The various programs that Jackson and Nichols had instituted to attract visitors had become services the public liked and expected to continue. Gardner lamented that "the interest in art per se is not as great as it could be." However, the movies, musical programs, teas, previews, and other new functions attracted large numbers of visitors who, once in the museum, could be introduced to the collections.[2]

Visitors would also come to the museum to see new installations, for shortly after Gardner's return, he and the University Trustees began to make plans to complete the first-floor west wing of the museum. It had been their hope to open new galleries in time to celebrate the Nelson-Atkins's fifteenth anniversary in December 1948. Although art costs were skyrocketing, construction costs remained reasonable, so they saw no reason not to proceed. The University Trustees and Gardner worked again with the Long Construction Company to

add seven new rooms. A Gothic cloister from a chapel near Beauvais, France, was installed, in addition to another classical gallery, a medieval sculpture gallery, a Spanish baroque chapel, an English Tudor room, a French seventeenth-century room, and a Venetian eighteenth-century alcove. The final cost of the construction and the installation of art objects totaled $14,962.54. Gardner praised the work done by John Long and his crew. "Our plans," he said, "called for the same specialized installations which I believe have made our Gallery foremost in this field in the United States." Long accomplished what the particular and demanding trustees and director wanted.[3]

FIGURE 13.1 To complete the first floor of the museum, seven new rooms were finished in 1948, including this Gothic cloister said to have come from an Augustinian Abbey near Beauvais, north of Paris. (Purchase: William Rockhill Nelson Trust, 41-31)

Finishing the first floor was the last major project for two of the University Trustees. Herbert V. Jones died in January 1949, shortly after the museum's fifteenth birthday celebration. Not long thereafter, in 1950, J. C. Nichols passed away too. Both men had served the Nelson Trust admirably since 1926, devoting an enormous amount of time and energy to their jobs. To fill the vacancies the Board of University Presidents named Milton McGreevy and David T. Beals Jr. to join Robert Caldwell as University Trustees.

Milton McGreevy was very familiar with the Nelson-Atkins Museum of Art. He had served as a Friends of Art president and had a keen interest in art, manifested by his personal collection of old masters drawings. McGreevy had an impressive resume, with a BA and a graduate degree in business from Harvard and a career at a brokerage firm his father had started and where he would continue to work until he retired in 1979. McGreevy's business sense would prove invaluable during his long tenure as University Trustee from 1949 to 1980, and like J. C. Nichols, McGreevy would become the dominant trustee, questioning and controlling all decisions made by the director and staff.

David T. Beals Jr. began as trustee in 1950 and would serve until his death in January 1963. As president of First National Bank, Beals was known for his good judgment and devotion to his work. He contributed his many talents to the Nelson Trust, and he passed his love of art and dedication to the museum on to his son, David T. Beals III, whose charitable trust would contribute $1 million in 2016 to the Nelson-Atkins education programs. Banker Beals, investment expert McGreevy, and attorney Caldwell would form an awesome team of trustees who would initiate some significant changes in museum policy.[4]

Meanwhile, many of the others who had played a major role in the museum's formation had left. Ethlyne Jackson stayed on for a short time after Gardner's return from World War II. She resigned in June 1946 to marry art dealer Germain Seligmann and move to New York, where she assisted him in his business. By August 1946, Lindsay Hughes had been named assistant curator of Oriental Art, but she left the museum in November 1946 to marry Frank Cooper. They moved to New York, where for several years Lindsay worked for C. T. Loo, the prominent Chinese art dealer. When she and her husband returned to Kansas City in 1971, after having spent some time living in Iran, Lindsay Hughes Cooper became a lecturer and special assistant to the director of the museum, her former mentor Laurence Sickman.

In 1952, the trustees decided to discontinue their relationship with longtime art advisor Harold Woodbury Parsons. At their annual spring meeting the University Presidents expressed the thought "that the character of the service he rendered the Gallery in its formative period no longer is so necessary." The University Trustees agreed and terminated Parsons's employment as a retained advisor as of December 31, 1952. No hard feelings existed, as Parsons continued to write the occasional letter of advice to Sickman and donate books to the museum library.[5]

The scarcity of great works in the postwar art market and the tightening art market in general had contributed to the decision to terminate the contract

with Parsons. Although the Nelson-Atkins Museum of Art's collection contin-ued to grow, it did so at a far slower rate. In calendar year 1933 the museum had acquired 1,684 objects. Calendar year 1952 saw a record low number of acquisitions with ten. However, two of those ten purchases—El Greco's *Por-trait of a Trinitarian Monk* and Caravaggio's *Saint John the Baptist*—still rank among the great treasures of the museum. Acquiring the Caravaggio, indeed, was an amazing coup, as Milton and Barbara McGreevy discovered the paint-ing in a gallery in London, and the Nelson Trust was able to make the purchase. In addition to these acquisitions, a windfall loan from the Kress Foundation arrived. Thanks to a set of serendipitous circumstances, Rush Kress decided to loan, and eventually give, the Nelson-Atkins sixteen pieces from his brother's collection.[6]

Samuel H. Kress began collecting Italian Renaissance art in 1920. Then in 1929, he, along with his brothers Claude W. Kress and Rush H. Kress, found-ed the Samuel H. Kress Foundation. Its mission was to administer funds "to promote the moral, physical and mental well-being and progress of the human race," principally in the fields of art, medicine, and general education. During the Great Depression a touring exhibition of fifty pieces from Samuel Kress's private collection went to twenty-four American cities, awakening public in-terest in Italian Renaissance art. In 1941 Samuel and Rush Kress donated 415 paintings and 35 pieces of sculpture to the National Gallery in Washington, D.C., for its grand opening. Then, beginning in the 1950s the Kress Founda-tion began donating the rest of Samuel Kress's collection, eventually giving more than seven hundred old masters to museums in eighteen cities. Kansas City is not one of the cities that should have received artwork from the Kress Foundation, because Samuel Kress's rules stipulated that no part of his col-lection should go to a town where there were no Kress variety stores. (There was only one Kress store in the area, and it was in Kansas City, Kansas.) Also, no paintings should go to large, actively collecting museums, which of course ruled out the Nelson-Atkins. However, when Rush Kress came to Kansas City in 1952 to work with University of Kansas Chancellor Franklin Murphy on financing the expansion of the graduate program at the University of Kansas Medical Center, Murphy (who was a member of the Board of University Pres-idents) took Kress to visit the Nelson-Atkins Museum of Art. Director Paul Gardner informed Kress that the Nelson collection of Italian fourteenth- and fifteenth-century paintings was weak, and that the museum had little hope of adding great paintings in this area. Therefore, Rush Kress decided to do something about it; he would loan some pieces from the Kress Collection to

FIGURE 13.2 University Trustee Milton McGreevy and his wife Barbara discovered Caravaggio's *Saint John the Baptist in the Wilderness* in a London gallery. The painting is a much-treasured acquisition. (Purchase: William Rockhill Nelson Trust, 52-25)

the Nelson-Atkins. On October 10, 1952, at 11:00 A.M., twenty-two paintings and four sculptures from the Kress Collection arrived at the Nelson-Atkins. Within the hour, the staff hung paintings by Lippo Memmi, Giovanni di Paolo, Luca Signorelli, Bernardo Daddi, and Giovanni Bellini, among others, creating yet another reason for midwesterners to visit the museum.[7]

FIGURE 13.3 The Samuel H. Kress Foundation gave the museum Giovanni Bellini's *Madonna and Child* along with other Italian fourteenth- and fifteenth-century paintings. (Gift of the Samuel H. Kress Foundation, F61-66)

In the fall of 1952, Gardner announced his intention to retire as director the following May. He was worn out after twenty years of hard work for the museum and wanted to spend the rest of his days in New Mexico. The trustees accepted his resignation with "deep appreciation and gratitude for his great service." They praised his "loyal and devoted efforts and the constant application of his exceptional talents to the selection, purchase, and exhibition of works of art, the operation of the Gallery, and the direction of its staff." Although Gardner would be leaving, he agreed to serve as a temporary consultant for the museum for fifty months at $200 a month, and he would continue to stay in touch with Sickman and the many friends he had made through the years.[8]

By 1953 the museum, in Gardner's opinion, had accomplished its primary aims: (1) to illustrate the history of art with the best examples available; (2) to assemble outstanding works of art for the enjoyment and edification of the public; and (3) to gain a wide reputation in a particular field. Certainly, the museum owed a debt of gratitude to its founders and their trustees, but an important element in the development of the museum had been a case of nearly unbelievable serendipity: circumstances had brought together the human and financial resources at a time when worldwide political and economic events provided a window of opportunity to create a world-class museum. After World War II, the situation was entirely different, yet the next director and the new trustees would continue to guide the Nelson-Atkins toward becoming and remaining a premiere museum of art.[9]

Laurence Sickman was the logical choice to succeed Gardner as director, an appointment that the latter supported. Sickman had molded the museum's outstanding Chinese collection, been involved with the museum from its inception, and since 1945 had acted as assistant director, proving his ability to deal with the public. However, as soon as Gardner announced his intended retirement, the trustees began a series of extended discussions about his successor and how the staff could be strengthened after Gardner's departure. One of their ideas was to hire a new director or co-director who, unlike Gardner, was a married man, which precluded Sickman. The trustees wanted "someone well qualified to meet the public and strengthen the public relations," and "it was felt it would be particularly important that he be married to a woman of background, education, and charm, who would be of material help to him in his relationship with those persons most interested in the Gallery and prospective benefactors," an idea that was typical of the era. The trustees' discussions went on for months, and even though they knew Gardner was definitely leaving on

May 1, 1953, the trustees had one last "extended discussion of the question of a Director and Assistant Director" on April 18 and said that, once again, they expected "to explore the matter at length with Mr. Sickman."[10]

Finally on April 23, the University Trustees named Laurence Sickman director of the Nelson Gallery of Art, and the University Presidents heartily supported his appointment, for, even though they might have preferred a married man, they realized Sickman's exceptional strengths as a scholar, educator, and promoter of the museum. At the same time, the Atkins trustees asked that Sickman also be named director of the Atkins Museum of Fine Arts. Director Sickman would continue to develop and enhance the Nelson-Atkins's art collections but would also extend the services offered to the community that Acting Director Ethylene Jackson and her staff had initiated during the war.

FIGURE 13.4 On April 23, 1953, the University Presidents and Trustees named Laurence Sickman director of the William Rockhill Nelson Gallery of Art. He would begin his twenty-four-year tenure on May 1. (Laurence Sickman, VF, NAMAA)

When the announcement of Sickman's appointment became known, among the first to send a congratulatory note were the president of the Junior League of Kansas City, Missouri, Mrs. John H. Kreamer, and the Junior League Arts Chairman, Mrs. Robert B. Riss. In response to their letter of May 20, 1953, Sickman reiterated a theme that he would repeat throughout his twenty-four years as director: that without the community's support, the museum could not fulfill its primary function to educate and illuminate the public through art. More specifically, he praised the Junior League as being "among our most staunch and loyal supporters in Kansas City. Indeed," he added, "it would, I believe, be impossible for us to pursue our educational program without the invaluable assistance of the League" conducting school tours and working in the children's library. Reassuring the League ladies that he would continue to support them, as had his predecessor, he added, "Mr. Gardner has always felt, and I concur with him, that our most valuable contribution lies in our work with the school children, and I only hope our community appreciates the contributions of the League to this program as much as we and the Trustees do." This opening overture led to a very healthy relationship between the new director and the Junior League volunteers.[11]

Sickman had not even had a chance to settle into his position when the University Trustees asked the newly appointed director to join their meeting on May 9, 1953, to discuss the expansion of the museum's curatorial staff. They suggested that he take a trip to the East as soon as possible to interview a number of candidates to find someone who could act as associate director and/or curator of European Art. Milton McGreevy had already made some inquiries through the Fogg Museum at Harvard, the Kress Foundation, and the National Gallery. Sickman agreed and planned a trip to take place within the next ten days. However, finding the right person for the job was not an easy task. Interviews and inquiries went on for months. Several candidates came to Kansas City with their wives, obviously an important criterion, but none seemed like a perfect fit.

Then Sickman suggested Patrick J. Kelleher, who was currently employed as the chief curator of the Albright Art Gallery in Buffalo. Kelleher had excellent credentials. For one, he had been a member of that elite group of 345 Monuments Men and had served at the Wiesbaden Collecting Point, where the Holy Crown of Hungary had been brought for safekeeping before its transfer to Fort Knox. After graduating from Colorado College with a degree in classics, Kelleher had earned an MFA from Princeton in art and archaeology before going to war. After the war he returned to Princeton to earn his PhD

in art, specializing in early Christian art and writing his thesis on the rescued Holy Crown. Mr. and Mrs. David Beals met Kelleher and his wife in New York, and they "thought that he and his wife were attractive and might be a desirable addition to the staff." Sickman asked the Kellehers to visit Kansas City, which they did October 17–18. They met and talked with the trustees and staff, and when offered the position of curator of European Art, Kelleher accepted and planned to begin on January 1, 1954.[12]

FIGURE 13.5 Patrick J. Kelleher became the curator of European Art in 1954, taking on the task of strengthening the European painting and sculpture collection. (RG 43/02, NAMAA)

With Kelleher on the staff, Sickman would divide curatorial responsibilities. Sickman would remain curator of Oriental Art as well as director. Ross Taggart, who had been on staff since September 1947 when he began as the registrar, would curate Ancient World: 3000 BCE to 500 CE; Decorative Arts in America and Europe: 1400 to the Present; and Prints and Drawings. Patrick Kelleher would curate Medieval Art, European Painting and Sculpture: 1400–1900, and Contemporary Painting and Sculpture in Europe and America: 1900 to the Present.

Having succeeded in strengthening the curatorial staff, the University Trustees made several important decisions during 1954, Sickman's first full year as director. One was to create the museum's first written acquisition policy. "It seems an appropriate time after 21 years of buying," the *Annual Report* stated,

"to review the existing collection in light of its strengths and weaknesses and to restate the objectives of our current acquisition policy." Basically, the acquisition policy, which was prepared by the staff for the University Trustees and the University Presidents, was a reiteration of what they had been doing in recent years and a recapitulation of the suggestions Gardner had written to the trustees before he left:

> I think it is most important to bear in mind that for the most part during the past twenty years we have been opportunists on our collecting and have never made a set policy of allocating certain percentages to certain departments, but have been interested in what has turned up on the market. It seems to me that with the increasing rarity of great objects which the Gallery now only needs, this idea will have to be continued.

After making specific suggestions, Gardner added, "I feel very strongly that the Oriental field should not be neglected as we have already formed too great a collection here to let it lapse. In this respect, I have every confidence in any recommendation by the new Director, Larry Sickman." In fact, the Asian collection would not be ignored. Sickman continued to shop for outstanding pieces of Chinese art and had already begun work in cooperation with Alexander Coburn Soper on *The Art and Architecture of China,* a book in the Pelican History of Art series that would be published in 1956 and which would contribute to Sickman's reputation as a great authority on Chinese painting as well as enhance the stature of the Nelson-Atkins Museum of Art.[13]

The museum no longer had "the problem of having to acquire a large number of works of art to form a basic collection as it did twenty years ago," the staff wrote in their suggestions to the trustees, but is now "free to look for those objects of prime importance and great artistic merit in any field which will add distinction to the collection, be of interest to the scholar, and appeal to the general public." The Nelson-Atkins, "has emerged with (1) a superb collection of Oriental Art which ranks among the first half dozen in the country: (2) the Burnap Collection of English Pottery, unique in quantity and quality in America," and "(3) a good basic collection of the Art of the Western World from Egyptian times to the present." Therefore, the Nelson Trust could be "somewhat opportunistic" in its purchases, although the curatorial staff should keep in mind when recommending a work for purchase "genuineness, physical condition, quality as a work of art, relation to the artist's whole body of work, value to the collection." The University Trustees' responsibility then was also

to consider the relation of the art object to the market and the best use of trust funds. In summary, the trustees stated, "The Gallery must acquire 'only the best' and has no room for 'the second rate.'"[14]

The trustees added to their acquisition report that the weakest area appeared to be in European painting and sculpture, so the objectives in 1954 were to concentrate "on the effort to raise the level of the collection of Western Art to the distinction enjoyed by the collection of Oriental art." As curator of European Art, Patrick J. Kelleher took on the task of strengthening the museum's European painting and sculpture collection. By the end of the year, Kelleher still had a long list of "desiderata," but he was able to convince the trustees to purchase some very important European paintings including George de la Tour's *St. Sebastian*, Sir Thomas Lawrence's *Mrs. William Lock of Norbury* (among the masterworks of this painter), Jacques Louis David's *Portrait of Diane de la Vaupaliere, Countess de Langeron*, which visiting experts said was of "Louvre quality," and Nicolas de Largilliere's *Augustus the Strong*. This latter painting had belonged to Baron Alphonse and Clarice von Rothschild, was confiscated by the Nazis in 1938, soon after the annexation of Poland, and then was retrieved by the Monuments Men, who had found it in a salt mine in Austria in May 1945. After the return of *Augustus* to the Rothschilds, the Nelson-Atkins was able to acquire the painting when the widow Rothschild put it up for sale through a New York gallery. Also, in 1954 the museum purchased a twelfth-century French Romanesque relief and a bronze statue of Louis XIV as an Augustan general, a model for the destroyed equestrian statue in the Place Vendôme in Paris.[15]

Kelleher would continue to scout for outstanding pieces of European art, adding in 1955 Renoir's *Portrait of Georges Haviland*, Rubens's *Battle of Constantine and Licinius*, Canaletto's *The Clocktower in the Piazza, San Marco, Venice*, and Constable's *Dell in Helmingham Park*. In 1956, the museum acquired a painting by Petrus Christus, *Virgin and Child in a Domestic Interior*, that Kelleher and the other curators thought was the one of the finest early Flemish pictures in America as well as being the most expensive piece of art the museum had ever purchased. During his tenure at the museum, Kelleher definitely improved the "weakest area" of the collection.[16]

It was also during the 1950s that the Nelson-Atkins Museum of Art decided to enhance its collection by adding fine-arts photographs. Although the museum had recognized photography as an art form almost from the beginning of its history, mounting its first photography exhibit in 1936 and holding thirty-nine exhibits prior to 1957, the concept of collecting photographs was

FIGURE 13.6 Kelleher purchased Nicolas de Largillière's *Augustus the Strong, Elector of Saxony and King of Poland,* which was in Baron Alphonse and Clarice von Rothschild's collection before being stolen by the Nazis, returned to the Rothschilds, and subsequently sold to the museum through a New York dealer. (Purchase: William Rockhill Nelson Trust, 54-35)

FIGURE 13.7 When the museum purchased Petrus Christus's *Virgin and Child in a Domestic Interior,* Kelleher pronounced it to be one of the finest early Flemish pictures in America. (Purchase: William Rockhill Nelson Trust, 56-51)

innovative for a general historical art museum. Today, according to the muse-um's senior curator of photography, Keith F. Davis, the idea seems "positively visionary." Using money from the Westport Fund, University Trustee Milton McGreevy and his wife, Barbara, initiated the purchase of sixty photographs (at $25 each!) from Edward Weston, a great American modernist photographer. Lawrence Sickman, with help from Kelleher and Ross Taggart, worked with Weston to select the photographs, and in October 1957 an exhibition, *Photographs by Edward Weston*, was presented at the museum. The following year the museum purchased 173 photographs of Pablo Picasso taken by native Kansas Citian David Douglas Duncan, who had developed a special relationship with the artist. Another popular exhibit highlighted these new acquisitions. After 1958, although significant photographic exhibits continued to be mounted, few fine-arts photographs entered the collection for another twenty-five years. The museum clearly had, however, made a great start in a new field of fine art.[17]

FIGURE 13.8 In 1957, Mr. and Mrs. Milton McGreevy initiated the purchase of the museum's first fine-art photographs—sixty images, including *Dunes, Oceano*, taken by American modernist Edward Weston. (Gift of Mr. and Mrs. Milton McGreevy through the Mission Fund, F57-76/25)

Although art and education were the trustees' main priorities, in 1954 the University Trustees agreed, if reluctantly, to hold more social events at the museum. The lecture programs and film series that Ethlyne Jackson had initiated during the war years were connected to art education in some ways, yet new requests by society matrons for the holding of a debutante ball and a flower show stretched the trustees' concept of the function of the Nelson-Atkins Museum of Art. McGreevy, Beals, and Caldwell were leery about holding such events. The trustees would find, however, that "these two activities which increase the Gallery's funds also . . . bring to the Gallery a number of people who do not otherwise attend our events" and provide "favorable publicity" which highlights "the Gallery's contribution to the civic and cultural life of Kansas City." Relying on the grandeur of the facility and playing on the importance of the museum to the city, the Jewel Ball Committee and the Westport Garden Club secured new museum patrons.[18]

In January 1954 both Milton McGreevy and Laurence Sickman received letters from Clara Hockaday (Mrs. Burnham) stating that "a great deal of interest has been developed among leading citizens in the community for arranging a very beautiful ball, to be given at the Nelson Gallery of Art, in behalf of the Philharmonic Orchestra." McGreevy responded that they would consider the idea, but they had many concerns ranging from security of the art collection to insurance to designation of smoking and drinking areas. At a March 5 meeting, the trustees had become more positive about the ball, possibly because they learned that it was to be a debutante festivity to introduce to society young ladies, freshmen in college, who hailed from some of Kansas City's most prominent families. The ball also promised to be a "full dress affair . . . with a carefully selected invitation list." The trustees asked Sickman to check out similar parties held in St. Louis and San Francisco and also to find out whether the City of Kansas City, the legal owner of the Gallery building, would agree to an event that involved selling tickets and serving liquor. They had promised Mrs. Hockaday a response by March 15, but a decision had not yet been reached when the trustees met on April 28 with members of the Jewel Ball committee: Mrs. R. Crosby Kemper, Mrs. Leonard Kline, and Mrs. Hockaday. Although the Jewel Ball was scheduled for Saturday, June 6, the trustees did not give their final approval until May 11. Obviously, by that time the ladies had already made plans and sent invitations, as 1,300 guests attended the ball. The Philharmonic Association netted $13,791.87. Although none of the profit went to the Nelson-Atkins, the Jewel Ball Committee reimbursed the museum for the expenses incurred.[19]

A month after the first Jewel Ball, Caldwell wrote to Mrs. Kemper stating that the trustees felt that the ball "was a great success, a credit to the community and certainly a great tribute to those of you who made it possible." He also stated that the trustees would give serious consideration to the Jewel Ball Committee's request to hold the ball at the museum again the following year. Due consideration was given, and a detailed five-page agreement was drawn up between the University Trustees and the Kansas City Philharmonic Association, which would assure the museum 25 percent of the net proceeds of the 1955 Jewel Ball. The $4,294.87 that the Gallery netted, according to Director Sickman, would allow the 1956 *Century of Mozart* exhibit to be organized on a more comprehensive scale.[20]

The Jewel Ball quickly became an institution, and by 1963, the museum began receiving 50 percent of the net ticket sales. Also, the ball chairman of 1958, Peggy Barnes, set a precedent by asking that both the chairman of the Kansas City Philharmonic, Lewis Kitchen, and University Trustee Milton McGreevy receive the debutantes on behalf of the two beneficiary organizations. In 1963, an agreement written by Kenneth Myers, the attorney for the Jewel Ball Committee, stated, "While the Ball was started some ten years ago by several ladies who were largely interested in the Philharmonic, the ladies who have been active in it in recent years have been equally, if not more interested in the Gallery." The museum was also more interested, as not only had its image as a social institution been raised through its hosting of the ball, but so had its intake of unrestricted funds: $12,714.65 in 1965.[21]

Laurence Sickman certainly did his part to promote the Jewel Ball, for he had little trouble expressing his appreciation of the annual event. After each ball, he sent a personal note to that year's ball chairwoman. In 1956 he wrote to Enid Kemper (Mrs. R. Crosby) to thank her for her organization, ideas, and "insistence that it be done properly." He added that, "The Ball has become much more than another device for raising funds, it has become a social institution that is a great asset to the community." In 1958 he wrote to Peggy Barnes, "I quite agree with you that it was the most beautiful [ball] of all," but then again in 1964, he penned a note to Clara Hockaday in which he stated, "It is difficult to say, year after year, that the current Jewel Ball was the best . . . but I do think the Ball this year was perfect in every respect." Over the many years he always managed to keep the superlatives coming. In 1966 he wrote to Libby Adams to tell her that the recent event was "the most beautiful Jewel Ball to be held at the Gallery," and in 1969 he allowed in his letter to Barbara Seidlitz, "Never have we had such a superb evening, and for my own feeling,

and I speak from experience, never a more beautiful or successful Jewel Ball."
In 1973, Sickman thanked Mary Grant (Mrs. William) saying, "In my twenti-
eth year of the Jewel Ball, I cannot remember one that has been more beautiful,
more impressive, or better organized." The Jewel Ball was, obviously, beauti-
ful every year and was a great success as a social occasion besides providing
financial support to the museum. The ball continued to be held in Kirkwood
Hall and Rozzelle Court from 1954 to 2000, when because of the museum's
major construction project, it was temporarily moved to Swope Park's Starlight
Theatre. The Jewel Ball returned to the Nelson-Atkins in 2008, where it has
remained the social highlight of the year.[22]

The Westport Garden Club also petitioned the University Trustees in 1954 to
allow them to hold a flower show in the museum's Rozzelle Court. Since "this
organization is composed of some fifty prominent young matrons and most of
them are members of the Friends of Art," the trustees reasoned, the show "would
bring an increased number of desirable people into the Gallery." Therefore, the
trustees approved the Westport Garden Club's request. The show, held in May
1956, was a success, although the museum's share of the proceeds was negli-
gible: $364.08. Nonetheless, the trustees agreed to make the show an annual
event. In 1955, the museum only received $239.55 from the Flower Festival, but
the Westport Garden Club volunteered to use their talent and $1,400 from their
treasury "to beautify Rozzelle Court." The trustees expressed their gratitude to
the garden club and also to Director Sickman for encouraging them. In 1957
the museum's share of the Flower Festival profit was $900, and the Westport
Garden Club also volunteered their time, talent, and money to prepare floral
arrangements for special museum occasions. Although the Westport Garden
Club would hold its Flower Festival at the museum only a few more times, the
club made many significant contributions to the museum throughout the years,
including building the Westport Garden Room. "The generous cooperation of
the members is a valuable asset," the trustees wrote in their minutes.[23]

Most important, in 1954 the University Trustees decided to establish a new
trust, the Nelson Gallery Foundation, "to provide funds for broader opera-
tion of the Gallery than the Nelson Funds provide." The University Trustees
would administer the Foundation Trust, just as they did the Nelson Trust, but
the will of William Rockhill Nelson would not limit the new trust. Nelson's
will instructed the University Trustees to use the net income of his estate only
"for the purchase of works and reproductions of works of the fine arts, such
as paintings, engravings, sculpture, tapestries, and rare books," by artists who
have "been dead at least thirty years at the time of the purchase." Through the
Nelson Foundation the trustees could "do various things related to the Gallery

which the Nelson Trust funds cannot be used for," including buying contemporary works of art, funding special exhibitions, and providing for the Education Department and the research library. Before the foundation was established, the trustees were often hampered regarding acquisitions as well as ancillary activities. For example, the University Trustees had to appeal to the trustees of the estates of Mary Atkins and Ellen St. Clair to purchase Maillol's *Ile de France*, which the curators called "the most significant modern sculpture to enter the collection since its opening." In December 1954, Vernon Kassebaum, attorney for the Nelson Trust, presented the trustees with the final document of the Nelson Gallery Foundation, which they would release to the *Kansas City Star* about ten days later. Meanwhile, McGreevy, Beals, and Caldwell each contributed $500 to open the Nelson Gallery Foundation account, a very important step for the museum.[24]

FIGURE 13.9 The Nelson Trust could not purchase Aristide Maillol's *Ile de France* because of Nelson's thirty-year rule, so the University Trustees asked the trustees of the Mary Atkins and the Ellen St. Clair estates to fund this significant piece of modern sculpture. (Purchase: the Mary Atkins and Ellen St. Clair Estates, A54-94)

When Robert B. Caldwell died in 1956 the Board of University Presidents praised him: "Simplicity was his strength, nothing cluttered the operation of his mind that distinguished him at the highest levels of legal practice and business." On a more humorous note, "As expected in such a dedicated worker, golf was not one of Bob's greatest accomplishments. Some of us have teased him for driving off the tee with an iron. But his shots were always down the middle, and he made few mistakes. In the fields that brought out his greatest capabilities, too, he was down the middle and immune from distractions."[25]

The University Trustees and Presidents had considered it a great privilege to work with Bob Caldwell, and they chose Menefee D. Blackwell as a very worthy successor. He, like Caldwell, was an attorney. After earning a BA from the University of Missouri in 1936 and a JD from the University of Michigan in 1939, he began a private practice, which became Blackwell, Sanders, Matheny, Weary, and Lombardi. Blackwell's career was interrupted by World War II, during which he served as a major from 1942 to 1946 and was decorated with a Silver Star, a Bronze Star with two clusters, and a Purple Heart. At the time he was tapped to become a University Trustee, Blackwell was not only a well-established and well-respected attorney, but also was serving on several foundations and a member of various associations and clubs. Undoubtedly a busy man, Blackwell nonetheless devoted himself to his new post with clairvoyance and dedication.

When the University Trustees had established the Nelson Foundation, they had effectively undone the main purpose for which modern art lovers had started the Friends of Art in 1934. However, with the passage of time the Friends of Art organization had grown in size—850 members in 1956—and broadened its interests beyond its annual purchase of a modern art piece. The Friends led the way in adult education at the museum. They sponsored four or five free lectures a year given on Thursday evenings by speakers distinguished in their fields as well as afternoon lectures—fourteen in 1958—followed by tea and refreshments. Under the leadership of Mrs. Donald R. Elbel, the Friends of Art formed a new education committee in 1956. Consisting of thirty members, including many former Junior League docents, these ladies, after completing training, became general tour guides. Not meant to overlap the work being done by the Junior League, the Friends of Art docents began giving tours to the general public at 2:00 on weekdays and 3:00 on Sundays as well as scheduled tours for clubs, churches, and conventions.[26]

Moreover, in 1958 the Women's Committee of the Friends of Art took three major steps. First, in February, Karen Dean "K. D." Bunting (Mrs. George H., Jr.) and Diana James (Mrs. Frederick) organized the first Collectors' Market,

offering in an annual, often-thematic, sale a number of art objects of excellent quality and variety, drawing new and old patrons into the museum. Later that year, on November 9, the two ladies started the Sales and Rental Gallery with Bunting as director and James in charge of selections. This gallery became a winning combination that proved to be of remarkable importance to the museum for a number of years, as the gallery mounted varied small exhibitions and provided a venue for the work of regional as well as national artists. Then, on November 11, 1958, the Women's Committee opened the Coffee Lounge on the mezzanine level under the direction of Mrs. Tracy C. Weltmer. Staffed at first solely by volunteers, the lounge became a gathering place and, as the trustees cited, "a factor in public relations not to be underestimated."[27]

FIGURE 13.10 Karen "K. D." Bunting organized the first Collectors' Market in 1958 and with Diana James opened a Sales and Rental Gallery, both of which were Friends of Art projects. (RG 73, NAMAA)

The University Trustees, on the recommendation of the newest trustee, Menefee D. Blackwell, decided it was time to clarify the museum's relationship to the Friends of Art and to formally recognize the work the organization performed for the museum. In a letter to Dr. Nicholas Pickard, president of the

Friends of Art, the trustees acknowledged the organization's importance and requested more help in the future "to foster and develop an interest in art and to increase attendance at the Gallery" as well as to provide assistance "in the field of public relations." In addition, the trustees asked the Friends of Art to amend their bylaws so that all future purchases by the Friends would become the property of the Nelson Gallery Foundation, which they did at their annual meeting on November 6, 1958.[28]

As the University Trustees and staff prepared for the museum's twenty-fifth anniversary, to be celebrated on December 11, 1958, they realized it had been quite a year: 255,285 people had visited the museum, 57,878 more than in 1957. This number broke all attendance records except for the 315,000 people who came to the museum in its opening year. Sickman credited this increase in visitors to the Collector's Market, the opening of both the Coffee Lounge and the Sales and Rental Gallery, and some popular exhibits, including the paintings of Sir Winston Churchill and *Japanese Art of the Edo Period*. Also in 1958, the museum published its second *Nelson Gallery and Atkins Museum Bulletin* to celebrate the anniversary; the first had inaugurated the *Century of Mozart* exhibition. Ross Taggart also finished editing a new handbook—the fourth edition—that illustrated the quality of the growing collection. Titling the handbook, however, had involved the University Trustees, who could not decide if it was appropriate to include the Atkins Museum of Fine Arts. They eventually determined to use the handbook's third edition as an example, going with "The William Rockhill Nelson Collection" on the outside cover and "The William Rockhill Nelson Gallery of Art and the Atkins Museum of Fine Arts" on the title page. Their reasoning was that the art collection was housed in the entire museum, while the Atkins Trust had contributed less than 1 percent to purchasing the collection.[29]

The Nelson-Atkins anniversary celebration began with a dinner on Wednesday, December 10, for fifty to sixty "of the leading citizens of the town, with the thought that a speech be made to these people emphasizing their responsibility to help the Gallery financially over the years." The next day the twenty-fifth anniversary show would open with special exhibits of the best art objects bought over the years. The plans originally called for one or two galleries filled with the Nelson-Atkins own "best of the best" collections and then one room of borrowed objects representing what the museum would like to acquire over the next twenty-five years, but the second part of this plan never reached fruition.[30]

At the anniversary celebration, Sickman delivered a speech that traced the history of both the museum's building and its collections. He explained that

the Indiana limestone structure, when erected in 1933, was left unfinished to allow for expansion. Galleries were added in 1941, and the first floor was completed in 1949. Presently (in 1958) forty exhibition galleries and ten period rooms were open. Sickman gave the first Board of University Presidents credit for deciding "the scope of the collection should not be limited to any specific phases or periods of art." Although the museum had acquired most of its works through the Nelson Trust, he took time to thank the museum's many benefactors, beginning, of course, with the Burnaps.[31]

As mentioned, in 1941 Frank P. and Harriet C. Burnap donated to the museum their extensive collection, which traces the history of English pottery from medieval wares to nineteenth-century wares by Wedgwood. The museum dedicated a room to display the Burnaps' pottery, and in 1953, after Harriet Burnap's death in 1947, Sickman talked with Frank Burnap about publishing a catalogue. Enthusiastic about the idea, Burnap agreed to split the cost of the publication with the museum. The catalogue resulted in wide publicity for the collection, including a review in *Art Quarterly*. The magazine praised the quality and scope of the Burnap Collection but observed a certain weakness in its "English Delftware," tin-glazed earthenware that is often called Delftware because of its similarities to Dutch wares made in Delft. This criticism caused Frank Burnap, at the age of ninety-three, to "begin anew to add extensively to the collection which already was world famous and unquestionably the best and most extensive in this country," Sickman noted in the 1954 *Annual Report*. Thus, almost immediately, Burnap rendered the newly published catalogue obsolete. He gave seventeen new pieces to the museum in 1954, fifty-six pieces of great rarity in 1955, and thirty-one pieces in 1956, including what was then considered the greatest prize of the collection: the 1668 Yacht dish/charger, which shows Charles II's Royal Yacht *Mary*, given to him by the Dutch people in 1660. "During the past few years every important example of English pottery that has come up at auction in London has been purchased by Mr. Burnap," Sickman explained. The collection of more than 1,300 items was now internationally famous, and Curator Ross Taggart would eventually publish a new and complete Burnap catalogue, partly financed by the Ford Foundation. When in November 1957 Frank Burnap died, Sickman said that his death "deprived the Gallery of its most munificent patron and a true friend." The trustees "noted with regret the death of Mr. Frank P. Burnap, who outside the Nelson Family and Mr. Rozzelle and Mary Atkins, has been the principal benefactor of the Gallery."[32]

FIGURE 13.11 Considered the greatest prize of the Burnap Collection in 1956 was the
Yacht *Charger*, English tin-glazed earthenware decorated with Charles II's Royal Yacht
Mary, given to him by the Dutch people in 1660. (Gift of Frank P. Burnap, 56-101)

In his anniversary speech, Sickman also recognized other important pa-
trons. Miss Frances Logan, who as a child had known Mary Atkins, bequeathed
her collection of European and American prints in 1953. Henry J. Haskell,
editor of the *Kansas City Star*, had left a bequest that enabled the museum
to acquire some important paintings. Laura McCurdy, Ida Nelson's niece, left
funds for the library. Mr. and Mrs. Joseph Atha had given the museum many
masterworks of silver, while Robert B. Fizzell Sr. added to the print collection.
Mrs. Ida C. Robinson had bequeathed $25,000 to the Gallery in June 1958
"for the purpose of acquiring objects of art as selected at the sole discretion
of the Board of Trustees." Sickman also acknowledged gifts of art from many

FIGURE 13.12 When Frank Burnap died in 1957, Sickman said his death "deprived the Gallery of its most munificent patron and a true friend." (*Kansas City Star*, Dec. 27, 1953)

individuals, trusts, and funds and expressed his deep appreciation to the Kress Foundation, the Friends of Art, the Junior League of Kansas City, the committee and patrons of the Jewel Ball, and the Westport Garden Club.[33]

With the celebration of the Nelson's twenty-fifth anniversary another great collection had come to the museum from Mr. and Mrs. John W. Starr and the Starr Foundation. Over the years the Starrs had assembled over one hundred English, Continental, and American miniatures, one of the most comprehensive collection of miniatures in America. When Sickman had begun

talking with the Starrs in 1957, they had expressed their willingness to loan their collection to the gallery "on a more or less permanent basis." After much discussion, however, the Starrs decided to donate most of their collection of miniatures, which were temporarily installed for the anniversary celebration.[34]

FIGURE 13.13 At the time of the museum's twenty-fifth anniversary, Mr. and Mrs. John W. Starr donated their comprehensive collection of nearly two hundred English, Continental, and American miniatures. (1994 installation, VRLSC, NAMA)

Thus, the Nelson-Atkins Museum of Art had turned twenty-five, but Sickman had only been at its helm for five years and would see many more anniversaries under his directorship. His role would be not only to act as an administrator but also, increasingly, to foster patrons and benefactors.

CHAPTER 14

ENTER RALPH T. COE

T HE AFTERGLOW OF the twenty-fifth anniversary year lingered into 1959 with much talk about the bright future of the museum. While the trustees continued discussing ways to raise money so that they could add more personnel, make improvements to the building, and support the expanding roles of the museum, the director and curators concentrated on acquisitions and education and did their part to secure grants, fellowships, and gifts.

One of the first wrinkles in 1959 was the resignation of Patrick J. Kelleher. Perseverance and dedication had characterized both curators and support staff throughout the museum's first twenty-five years. Curators were expected to work long hours and take care of many tasks not in their job description, and Kelleher seemed to have done both. However, from the beginning, the match of Kelleher to the Nelson-Atkins Museum of Art was not one made in heaven. Even before he started there, he ruffled the trustees' feathers by asking them to pay $1,000 for his moving expenses; they agreed to pay half. Occasional spats arose that first year between the trustees and Kelleher, usually based on some piece of information that the trustees felt he should have told them. Then, only a year and a half into Kelleher's curatorship, the trustees learned from Sickman that Kelleher had applied for both a Fulbright and Guggenheim Scholarship and that even if he received neither scholarship he planned to spend six to eight months in Europe. This situation did not sit well with either the trustees or with Sickman. In addition and perhaps most important, Mrs. Kelleher, whose family lived in Princeton, New Jersey, was not happy in Kansas City. She had urged her husband "to find some other field of activity other than that involved in his work for the Nelson Gallery." With this news, the trustees informed Kelleher through Sickman that if he did not intend to stay at the

211

museum full time for the next five to ten years, they needed to replace him. Apparently, this ultimatum cooled Kelleher's idea of departing immediately, although Sickman reported that Kelleher continued to have a desire to associate with a museum in the East.[1]

In fact, in April 1959 Sickman told the trustees that Kelleher would be leaving June 1 to become director of the Princeton University Museum. "In the five years Mr. Kelleher was with the Gallery," Sickman attested, "the collection was enriched by some of its most distinguished purchases," including Lucas Cranach the Elder's *The Three Graces*, Petrus Christus's *Virgin and Child in a Domestic Interior*, the Jean-Antoine Houdon sculpture of Benjamin Franklin, *Landscape with a Watermill* by Francois Boucher, and Claude Monet's *Water Lilies*, a painting that proved so popular with Art Institute students that, once they saw it on display for consideration, they petitioned the trustees to purchase it.

FIGURE 14.1 When Patrick Kelleher hung Claude Monet's *Water Lilies* at the museum on approval, the painting proved to be so popular with Kansas City Art Institute students that they petitioned the trustees to purchase it. (Purchase: William Rockhill Nelson Trust, 57-26)

In addition, Kelleher did "much to stimulate interest in the gallery, particularly in contemporary art," said Sickman. Kelleher had lectured to docents, traveled with and advised the Friends of Art, done radio and television spots, fulfilled all his curatorial responsibilities, and was the right person at the

right time. With Kelleher's resignation, however, the trustees needed to replace him.[2]

At the trustees' June 10 meeting, Sickman informed them that Ralph Tracy Coe was the "most promising prospect" to replace Kelleher. Coe, called Ted by his friends, was born and raised in Cleveland, Ohio. He and his two sisters grew up knowing the art world, for their father, Ralph M. Coe, an industrialist, collected Impressionist art, most of which, unfortunately, he had been forced to sell during the Great Depression. The senior Coe had also served as a trustee of the Cleveland Museum of Art, where Ted's sister Nancy currently worked as assistant curator of painting. The director of the museum, William Milliken, who had just retired in 1958, was so close to the Coe family that he joined them for all major holidays, took Ted on trips, was affectionately called "Uncle William," and was someone Ted Coe wanted to emulate. Coe had graduated from Oberlin College and received a graduate degree in art history from Yale University. He had previously been on the staff of the Victoria and Albert Museum in London and was currently an assistant curator of the National Gallery in Washington, D.C. The University Trustees noted in their minutes that Ralph T. Coe was "29, unmarried, 5′ 8″ " as if these were his most important attributes, and that his specialties were Renaissance sculpture and nineteenth-century French painting. He also had a profound interest in American Indian art. When he came to Kansas City for an interview in June, the trustees said that they "thought well of Mr. Coe" but wanted to give the matter further thought. Since none of the other candidates compared with him, Ralph T. Coe became the new curator of Painting and Sculpture in September 1959, shortly after the death of his father and the marriage of his sister Nancy to Bill Wixom, another curator at the Cleveland Museum of Art, who in 1979 would become chairman of the medieval section of the Metropolitan Museum of Art. According to Sickman, from the start Coe fit in very well at the Nelson-Atkins, and the staff enjoyed working with him. His hiring was serendipitous, for he made a profound difference to the museum, as a scholar, as an art enthusiast, and as someone who vigorously encouraged art collectors and the collecting of many varieties of high-quality art works.[3]

Sickman and the trustees immediately put their confidence in Coe. He reported for his first day of work on September 15, 1959; six days later the trustees sent him to London to look at a Rubens painting owned by the Duke of Devonshire. Coe would cable Sickman from London recommending the purchase of the Devonshire Rubens, but the transaction, due to many other considerations, never came to fruition. Just a few months later, however, Coe

FIGURE 14.2 Ralph T. Coe became curator of Painting and Sculpture in September 1959.
(Ted Coe VF, NAMAA)

and Senior Curator Ross Taggart appeared before the trustees to recommend
the purchase of two remarkable works that Coe thought would lend vitality to
the collection: *The Last Judgment* by Lucas Cranach the Elder and Pissarro's
Le Jardin des Mathurins, Pontoise. Both paintings became valued acquisitions.
In May 1960, Sickman asked Coe to work with him to make a complete sur-
vey of the art collection. Once they had embarked on this endeavor, the two
rooms devoted to objects donated by the Kress Foundation became a discus-
sion point.[4]

Dr. Franklin Murphy, chancellor of the University of Kansas and the person
who had initiated the Kress connection, had suggested at the annual meeting
of the University Presidents and University Trustees in April 1958 that Sick-
man go to the Kress place in Huckleberry Hill to discuss an exchange of some
of the Kress pieces with others that would better balance the Nelson collec-
tion. Whether this trip happened is uncertain, but after Coe and Sickman had
concluded their survey of all of the museum's holdings, both agreed that the
Kress art objects on display at the Nelson were of uneven quality. In June 1960,

Coe went to New York to talk with two Kress Foundation representatives. He presented a list of the paintings and sculptures that the Nelson-Atkins wanted to exchange, and discussed various possibilities for the trade. The end goal was for the Nelson-Atkins Museum of Art to have two rooms of Kress paintings— one of early Italian paintings and one of seventeenth-century paintings—that would "in every way be a credit to us and to the Kress Foundation," as Sickman wrote to Guy Emerson, head of the foundation. Eventually, a satisfactory agreement was reached, and in a ceremony in December 1961 in Washington, D.C., the Kress Foundation formally donated fourteen paintings and two sculptures to the Nelson-Atkins. The Kress Collection was shown in its entirety, as stipulated by the deed of gift, until that limitation was rescinded in 1969. Then Coe and Ellen Goheen redistributed and comingled the Kress pieces with the Nelson Trust collection, making sure they were labeled accordingly.[5]

While the art collection was paramount, education, especially junior education, had always been a top priority for the Nelson-Atkins, as Sickman (and Gardner before him) had stated. In 1959 to 1960, the Junior Education Department received a great boost from the Westport Garden Club and from the Junior League of Kansas City, Missouri. First, the Junior League presented the museum with a gift to celebrate the twenty-five years their organization had cooperated with it. League members had not only given school tours since 1934, establishing a docent program unlike any other in the country, but they had also promoted the junior library. Over the years, they had donated hundreds of books and, at times, staffed the library. Now the Junior League bestowed $6,000 for a new and improved children's library to be located in the southwest corner in what was the Junior Education Department. With his customary graciousness, Laurence Sickman wrote, "I want to take this opportunity to tell you and the members of your committee how much the Trustees, the Staff, and I appreciate this gift from the Junior League and assure you that it will be put to the best possible service for the welfare of the community."[6]

In a seemingly coordinated effort, the Westport Garden Club, which held its fifth Flower Festival at the museum in 1959, decided to contribute the money it had raised from its festivals to establish a new Junior Gallery and Creative Art Center, a center that would be as unique in its design as the Junior League docent program. The new art center would offer classes in horticulture and conservation so "that youth may participate in the creative force transforming nature into the world of art." Equipped with exhibition areas, art studios, classrooms, display cases, and audio-visual aids, the space was designed and "scaled to the needs of the growing child."[7]

The Junior Gallery and Creative Art Center and the new Junior Library opened on January 30, 1960. The trustees of the William Rockhill Nelson Gallery of Art and the Mary Atkins Museum of Fine Arts, the Junior League of Kansas City, Missouri, and the Westport Garden Club sent out a joint invitation to the gala celebration of the new facilities. Educators and other interested persons received an opportunity to come for tea and a preview of the area in the afternoon, and three hundred people attended the black-tie event the same evening. Miss Louise Condit, supervisor of the Metropolitan's Junior Museum, was the guest speaker, and she talked about the importance of children having a place of their own. "Schools cannot teach children enough about art," Miss Condit said, "since there are already too many pressures on schools." She praised the new facilities, as did the *Kansas City Star*: "To the children, it is like one big package of surprises. . . . Telephones and peepholes intrigue children and excite their interest in art." The director of the new Junior Gallery and Creative Art Center, James E. Seidelman, added his accolades and thanks: "I speak for the youth of greater Kansas City in expressing appreciation for the dedicated interest and support of the Westport Garden Club." The Garden Club would continue to provide additional equipment, audio-visual aids, and books relating to art and nature during the coming years, and attendance at the Junior Gallery would steadily increase throughout the 1960s.[8]

FIGURE 14.3 Equipped with audio-visual aids as well as exhibition areas, art studios, classrooms, and display cases, the new Junior Gallery and Creative Art Center, funded by the Westport Garden Club, was unique in its design. (RG 32, NAMAA)

Besides their work on the new children's library and with the docent pro-
gram, the Junior League ladies of Kansas City, Missouri, ran an invitation-
al exhibit, the Mid-America Annual, which featured works by artists in an
eight-state area. During the 1960s, these juried shows attracted large audiences
interested in contemporary art and offered regional artists the chance to win
prizes and sell their work. The Junior League was committed to the museum
in many ways, which a June 1960 letter to Sickman from Marilyn P. Patter-
son (Mrs. Doyle), president of the League, formalized. The League promised
to allot $150 a year to the Education Department to fund docent programs,
provide sixty-five volunteer docents to conduct tours Tuesday, Wednesday,
Thursday mornings, and Friday afternoons, and to require all docents to take
training and be approved by the Education Department staff.[9]

Meanwhile, the Junior League's Art Committee had already started work-
ing with James Seidelman to produce films that would help children better
understand art. A series of thirteen television programs—titled *The Magic
Glove*—had started production in fall 1957 and been very successful. Further
collaboration between the Nelson-Atkins's Education Department and the Ju-
nior League resulted in four *Treasures of Time* films, which introduced school
children to painting, sculpture, Asian art, and American art. Since the films
could be borrowed before tours, students could acquire the knowledge nec-
essary to fully appreciate what they would see when they visited the museum.
Besides the educational value of the *Treasures of Time* series, the Junior League
donated the profits from the venture, and the University Trustees expressed
that they were truly "grateful for your generous provision for the Education
Department." Sickman added in one of his ever-effusive letters, this one writ-
ten to Mrs. A. J. Woolridge, then president of the Junior League: "You might
be interested to know that at the recent meeting of the American Association
of Museum Directors, the pattern set by the Junior League of Kansas City was
discussed and highly praised. You were pioneers in this field and the Directors
were again deeply impressed by the number of volunteers supplied the Gallery
by the League and the contributions you are making in this way to the cultural
life of the community."[10]

Coe quickly settled into his position at the Nelson-Atkins Museum of Art.
In 1960, his first full year as curator, the museum launched two major exhibits,
one on George Caleb Bingham, curated by Ross Taggart; the other, *The Logic
of Modern Art*, which Coe organized. The exhibition, according to Coe, "was
to be specifically tailored to take advantage of the wide interest (although con-
troversial) already expressed by the Kansas City public over the problem of

understanding 20th century art." With the aim of covering all the important art movements of the past sixty years, Coe borrowed from thirty-six collectors and museums in order to "promote a firm basis for the appreciation of modern art locally" and to promote "the image of the Nelson Gallery as a center for the creation" of such a movement.[11]

Indicative of the local interest in modern art was the phenomenal growth of the Friends of Art, which in 1960 numbered 1,573 members and would grow even larger with the addition of the Friends of Art Guild, a subgroup of Friends of Art members who were under age thirty-five. The idea of a junior membership group originated with Sarah Foresman and Mary Jones (Mrs. J. P.). They had lamented to Jane Rosenthal, staff advisor to the Friends of Art, that they wanted to be involved at the museum, but all the Friends of Art activities were rather stodgy. Rosenthal, with University Trustee Milton McGreevy's blessing, decided to research what other museums were doing to attract the young adult audience. As Ms. Rosenthal stated in the form letter she sent, "We have become conscious of the fact that we are sadly missing the interest and support of young people up to age thirty-five." Ms. Rosenthal learned that the Detroit Art Museum had no junior membership group and that the Museum of Modern Art had a group called the Junior Council, which was actually a "misnomer," as its members were mostly around forty years old. However, Margaret R. Parkin from the Cleveland Museum of Art responded that their museum had a Junior Council and sent along a copy of their bylaws, stating, "Ordinarily we do not give copies of the By-Laws of our Junior Council to anyone, but since Ralph Coe is so closely associated with you and us I am enclosing a copy." Although the organization of Cleveland's Junior Council proved useful, the criteria for membership did not, as Cleveland's junior membership group was limited to young women, mostly from the Junior League.[12]

Meanwhile, on June 10, 1960, Jane Rosenthal reported to McGreevy that she had held an "unofficial gathering" at her home to pursue the idea of a junior membership group; she hoped he approved. Besides Sarah Foresman and Mr. and Mrs. J. P. Jones, she invited Guyton Hamilton, George Langworthy, Mrs. David Hughes, Mr. and Mrs. Joseph Crowe, and Mr. and Mrs. Charles Buckwalter. Ted Coe was also there to explain "at some length the various needs of the Gallery." He stressed that the proposed organization "should not be just a social one but one with real purpose," and he urged the group gathered there to take an interest in the "purpose and projects of the Friends of Art and to begin to collect for themselves." Rosenthal reported that all those present were enthusiastic and vocal about getting involved.[13]

Authorized by the University Trustees and by the Board of Governors of the Friends of Art in June 1960, the Friends of Art Guild (commonly referred to as "the Guild") became a reality with Guyton Hamilton as the first chairperson and Coe as the Guild's advisor. In July, Hamilton and his committee sent invitations to encourage their friends and acquaintances to become charter members of the Guild with annual dues of five dollars for a single membership and ten dollars for a family. When, after only two months, the Guild was already one-third the size of the Friends of Art and had three times as many members as they had anticipated garnering in one year, the group canceled its intended fall membership drive. In a letter of October 6, 1960, Hamilton announced the first of many Guild programs, "Operation Nelson Atkins."[14]

As advisor to the Guild, Ralph T. Coe would encourage its members to organize an annual charter flight to Europe, volunteer activities at the museum (especially in the Junior Education Department), a Thursday evening lecture series, exhibits focused on contemporary art, educational art parties (like treasure hunts through the museum), "behind the scenes" tours of the museum, family nights, and an art theatre. In July 1961, the Guild presented a Dylan Thomas play, and in November, "An Evening of Mime" under the direction of Molly McGreevy, University Trustee Milton McGreevy's daughter, who had been a student of Marcel Marceau in Paris. The Guild raised money by starting a recycling program and by selling needlepoint kits that had designs of well-known works of art. The Guild also sponsored trips to other cities, and because of Coe's connections in the art world, he could facilitate tours of many private homes and collections. Mary Lou Brous, now an Atkins trustee, remembers that on a Guild trip to Washington, D.C., the hostess/owner of a fine private art collection had to yield to Ted Coe, who explained an Impressionist painting that had been in his father's possession. Also, on these trips to Chicago, Minneapolis, Dallas, New York, Iowa, etc., Ted Coe not only taught Guild members how to look at and appreciate various genres of art but also how to become art collectors. When visiting art dealers, Coe recommended, always ask to see what is in the back room, as that is where the "good stuff" is. He also advised the Guild on art purchases, and in 1963 the Guild donated to the Nelson Foundation Andy Warhol's *Baseball*, followed by other important acquisitions.[15]

Besides sponsoring the Friends of Art Guild, Ted Coe also started the Print Club in 1964, which was based on the same concepts as a similar club at the Cleveland Museum. Periodically the members of the club would be offered the chance to buy a limited edition print by a twentieth-century artist. "The

FIGURE 14.4 In 1963 the Friends of Art Guild donated Andy
Warhol's *Baseball* to the Nelson Foundation. (Gift of the Guild of
the Friends of Art and other friends of the Museum, F63-16)

edition is 101," Coe explained to Helen Frankenthaler when asking her to be
part of the program, "with 100 prints going to the membership and one being
reserved for the Gallery collection." Print collectors had already had the op-
portunity to acquire works by Wesselman, Lichtenstein, and Rauschenberg in
1974 when Coe approached Frankenthaler. When Ellen Goheen became cura-
tor of Twentieth-Century Art in 1975, she took over advising the Print Club.[16]

Coe's influence extended beyond advising the Friends of Art Guild and the
Print Club, and he did not limit himself to his specific area of curatorship. In
July 1961, he went to New York to look at some American Indian pieces, as
well as a Rubens, for possible purchase by the museum. Then in September,
he went to Germany as a guest of the German government to study their mu-
seums and cultural institutions. Between these two trips, on August 5, 1961,
Ted Coe married Sarah Frances Foresman in Riverside, California, where Sar-
ah's parents lived. Sarah, one of the cofounders of the Guild, had grown up

in Kansas City, was a recent graduate in English literature of Scripps, Clare-
mont, and had just returned to Kansas City after an extended trip to Italy.
She not only represented all those attributes that the trustees had wanted in
the wife of a Nelson-Atkins's director or co-director—charm, education, and
background—but she was also interested in art. Although her marriage with
Ted only lasted a few years, Sarah would be a great helpmate to him, providing
him with contacts to the right people (including her aunt Helen Foresman
Spencer), supporting his art interests, and helping with the details (for exam-
ple, of the Guild's annual charter flight), which Coe sometimes neglected in his
enthusiasm. Sarah herself stated, "We were a good team." If the trustees had
not had previous thoughts about Coe becoming an administrator, they soon
would have.[17]

In fact, on a 1963 Friends of Art Guild trip to Dallas to view private col-
lections and museums, Coe received a very gracious invitation to become di-
rector of the museum there. After the Guild tour, Sarah and Ted had spent an
extra day in Dallas in order for Ted to give a lecture, and that evening, at the
home of the Murchisons, Stanley Marcus and Clint Murchison approached
Ted about heading the Dallas museum. When Ted said one of his objections
was that the new-ish museum had no library, Marcus asked how much Ted
thought a library would cost. A phone call later, Ted was told they he could
have a library. Nonetheless, after returning to Kansas City, Ted decided not to
accept the Dallas offer, and Sickman heartily supported that decision, saying
he did not think that the Dallas museum was comparable in either size or col-
lection to the Nelson-Atkins. When Sickman told the trustees about Coe's job
offer, he also appealed to them to raise Coe's salary, given the compensation
the Dallas museum had proposed.[18]

The next year, however, when the St. Louis museum offered Coe a position
as director, Sickman's first reaction was anger, as he thought Coe was soliciting
offers, which, in fact, he was not. When Sickman calmed down, he reasoned
that another raise alone might not suffice to keep Coe in Kansas City. Sick-
man suggested to the trustees that Coe "might stay" if they appointed him as
assistant director, with another salary increase and the possibility of becom-
ing director when Sickman retired, which he thought would probably be in
five years. Coe decided against the St. Louis position, retained his position as
curator of Painting and Sculpture, and officially became assistant director of
the Nelson-Atkins in 1965 with the promise of a directorship in the not-too-
distant future. Sickman's imminent retirement did not, however, materialize;
he would remain at the helm of the museum until 1977.[19]

Although Coe's guidance of the Guild and his support of the exhibitions presented by the Sales and Rental Gallery increased attendance at the museum, Sickman had frequently said that the attendance count was only one part of the story. "The really important thing is the quality of what the visitors do when they come," he said, noting that the number of visitors often reflected the interest generated by special exhibitions. Certainly that was the case in 1963 when attendance records of 327,688 surpassed all previous years, due to the popularity of *Paintings and Drawings by Vincent van Gogh*, an exhibition organized by Coe. The van Gogh exhibit was not only the first major traveling exhibition that the Nelson-Atkins Museum of Art had ever organized, but it also involved "a budget in such amount that it was necessary to charge admission." The trustees had agreed to underwrite the exhibition for $25,000 and were very pleased when admission receipts and the sale of catalogues and reproductions helped them recoup their investment and net the Nelson Foundation $31,143.14. Much of the credit, Sickman admitted, went to Coe and to the Friends of Art Guild members, who handled a lot of the publicity for the show and volunteered during the exhibit.[20]

When, in the 1964 *Annual Report*, Sickman remarked on a drop in attendance, he related the decline to the fact that the museum had only been able to afford to mount one major exhibition. Also, he noted the decrease in acquisition funds, which Coe said had deteriorated to the point that his department's purchasing power was severely impaired, especially in a market of rising prices. For the time being, Sickman thought attention might be diverted to acquisitions outside of great European paintings, always following the "policy of concentrating the available funds on a few objects of first importance."[21]

Just as European paintings had become expensive, so had the costs of exhibitions of European art. Therefore, Assistant Director Coe began organizing some more affordable if less orthodox exhibitions. In 1965, he invited his friend Howard Jones to present a show of his "light paintings" as a Sales and Rental Gallery exhibition. Coe published a study of the exhibit in *Art International Magazine*, stating that the light bulbs Jones used in his "light paintings" were no more important than paint is to painting, but were just a means to an end and a beginning of the post-pop art possibilities. This exhibit attracted many visitors, but not as many as *Sound, Light, Silence: Art that Performs*, a so-called "psychic" art display held in 1966. Again Coe organized the exhibit and wrote an essay for the catalog. Later that year—from December 17, 1966, to January 29, 1967—*Ethnic Art from the Collection of Mr. and Mrs. Herbert Baker* went on display. In the introduction to the exhibition catalog, Sickman noted that the Bakers "have lent virtually the entire contents of their Highland

Park, Illinois, home in order to facilitate this exhibition" of African and Oceanic art, organized by Coe and designed and installed by the Nelson's very creative designer, Craig Craven.[22]

While Sickman, Coe, and the rest of the staff focused on exhibitions, tours, and the museum's primary function as an educational art institute, McGreevy, Blackwell, and Beals concerned themselves with trying to solve some of the problems noted in the 1964 *Annual Report*. The trustees recognized the importance of the bequests the museum received, the support that came from various organizations, and the income that resulted from special events, such as the J. C. Nichols office party and the Maria Callas concert in 1959, as well as the use of the Atkins Auditorium for Sunday afternoon Chamber Orchestra concerts and performances by the Barn Players. However, the University Trustees found that they urgently needed more "unrestricted funds," money given to the museum with no strings attached, money that could be used not just to buy works of art but also to expand the services and activities the museum offered, to finance loan exhibitions, to hire new curators and assistants, to publicize the museum, and to strengthen the Education Department and the library.

Having a research library was essential to a major art museum, and the Nelson-Atkins Museum Reference Library, according to Sickman, "might be described as minimal and rudimentary." Thus, in 1962 when Sarah Foresman Coe's aunt, Helen Foresman Spencer (Mrs. Kenneth A.) discussed with Sickman the idea of making a substantial gift to the museum, he consulted with both Coe and Taggart who agreed that "nothing at the Gallery needs as much support as does the art library." When Helen Spencer announced her gift of $25,000 for the library, she wrote the University Trustees, "It has long been Kenneth's and my wish to make a gift to the Nelson Gallery of Art in a way that would at once aid its growth as a cultural institution and broaden its services to the community." To help determine how to use this gracious gift, McGreevy asked Charlotte Vander Veer, associate librarian at the Cleveland Museum, to assess the Nelson-Atkins's needs. To begin with, she stated, "In contrast to the exquisite collection of objects, I found the Art Library rather meager and inadequate and far out of proportion to the displays in the Galleries." Besides providing a long list of necessary books for study and research, Vander Veer also recommended more shelving, files, catalogs, and the hire of at least one trained librarian. Although she thought that Helen Spencer's gift was a good start, additional funds of at least $12,000 to $15,000 a year needed to be set aside to establish and maintain a serious art library. The Nelson Trust could not provide this kind of funding, but Spencer came through again in 1965

with another $25,000 gift, one matched with $15,000 from the Kress Foundation and $10,000 from the Nelson Foundation. Sickman said this funding gave the library "significant status" and was of "inestimable value" to the staff and students of the Universities of Missouri and Kansas and other institutions of higher education.[23]

Meanwhile, the University Trustees looked for other answers to monetary problems. They decided that one obstacle in generating income from the Nelson Trust stemmed from William Rockhill Nelson's will, which limited the trustees to investing solely in "income-bearing real estate or in real estate to be improved by them situated within one hundred miles of the United States Custom House as now located in Kansas City, Missouri, or interest-bearing notes secured by a first lien on any such real estate." Real estate investments were not the same kind of income generator they had been when James and Mary Atkins and William Rockhill Nelson made their fortunes. Even though the University Trustees had a property manager, Edgar L. Fleming, who had worked with them since 1926 and would be followed by Woodford C. Taylor in 1969, real estate-related issues occupied a great amount of time and were cumbersome and often unprofitable.[24]

At the annual meeting of the University Trustees and the University Presidents on May 12, 1962, McGreevy, Blackwell, and Beals suggested that they take Nelson's will to court "to change the investment provisions to provide for something along the general lines of letting the Trust operate under the so-called 'Prudent Man' rule." The University Presidents were sympathetic to the idea, so the trustees hired Arthur Mag to represent them. In December, Mag filed a petition in the Circuit Court in Jackson County stating that, "Changes in the times since Mr. Nelson's death in 1915, inflation, the shrinking purchasing power of the dollar, the rising costs of art works, the new conditions in real estate investments in the last century, etc. are the reasons for the need to broaden the Trustees' area of investment." The University Trustees wanted the authority "to make such Trust investments and reinvestments as a prudent man would make of his own property." In its decision rendered in April 1963, the court acknowledged that William Rockhill Nelson could not have anticipated the conditions and circumstances of the present time. In order to carry out the purposes of the Trust in the best interest of the public, the court agreed to give the University Trustees "authority to make such investments as a prudent man would make in his own property having primarily in view the preservation of the estate and the amount and regularity of the income to be derived." Being given the opportunity to invest in stocks, securities, and real

estate outside the Kansas City area untied the hands of the University Trustees. They eagerly changed their investment strategies, hoping to generate more income for both the Trust and the Foundation.[25]

By the time the Circuit Court of Jackson County had rendered judgment, University Trustee David Beals had died. McGreevy and Blackwell mourned Beals's passing in January 1963 and expressed their appreciation of his work. "His constant search for quality and his unfailing good judgment have been of the greatest aid in management of the Trust," they said. The University Presidents and Trustees discussed possible successors to Beals at their annual meeting in May, but they did not reach a conclusion until fall, when they selected Cliff C. Jones to join McGreevy and Blackwell.[26]

FIGURE 14.5 Although Cliff C. Jones only served as University Trustee from 1964 to 1969, he made an impact on the museum's future. (RG 70, NAMAA)

Although Jones had a short tenure as a University Trustee, serving only from 1964 to 1969, when he returned full time to his business, he laid a new set of eyes on the museum's problems and made a positive impact on the museum's future. As the chief executive of R. B. Jones Insurance Company, one of Cliff Jones's first actions was to recuse his company as the primary insurance agency for the museum and solicit bids. Thinking it unwise to put all their eggs

in one basket, Jones suggested using three different insurers, an idea that was approved. Also in fall of 1964, Jones acted on a rumor that the Kansas City, Missouri, Earnings Tax was producing more income than expected. The city had already agreed to help Kansas City's historical museum, so Jones wondered if the Nelson-Atkins could benefit too. Superintendent Clarence Simpson had repeatedly talked to the City Engineers Department about the fact that the air conditioning did not "work properly or effectively." In March, the University Trustees had invited Ilus Davis, mayor of Kansas City, and Carleton Sharpe, city manager, to lunch at the River Club to discuss the major expense of replacing the air conditioning, estimated to be around $200,000; the two men "indicated a friendly interest in the matter." The air conditioning problem needed more, however, than just "friendly interest," so Jones informed McGreevy and Blackwell that he had phoned Sharpe to reiterate that which Nelson-Atkins needed, a conversation in which he also mentioned the rumor he had heard about the city now having the money on hand. Jones concluded the call by offering Sharpe the use of the museum for an upcoming dinner party the city manager had planned for the Missouri State Legislature. Soon thereafter, the city agreed to do phase one of the air conditioning repairs for $56,582 and provide $10,000 that year for upkeep of the grounds.[27]

Jones also suggested to McGreevy and Blackwell that they set up "a planning session" with Sickman and staff, "with emphasis on the direction the gallery might take in the future." He cited an article from *Management News* and explained the success that R. B. Jones had enjoyed with such meetings. Points of discussion, Jones suggested, should include ideas for making the Nelson-Atkins Museum of Art more prominent as the center of an art and cultural district, certainly a concept that had been floating around for many years, and, also, how to sell the museum to a wider audience and gain more corporate support. He threw out the idea of "visual selling" by setting up a very small mock gallery "in run-down and terrible shape with miserable pictures hanging on torn, smeared walls," and having a tour guide say, "Behold, this is what could happen to the Nelson Gallery throughout if the business leaders of the community don't care enough to give just very moderate corporate support." Jones thought this sales pitch could be a powerful motivator, but luncheons with corporate executives, a more conventional approach, might also work.[28]

When in 1954 the trustees had solved one of the limitations of the Nelson Trust by establishing the Nelson Foundation, they had the idea of building the fund up to provide an annual income of $25,000 to $50,000, an amount that now seemed insufficient. A strategy for augmenting this fund had first been introduced by Milton McGreevy back in 1959. He had suggested creating

an ancillary organization of wealthy and prominent men in the community who would enter into some kind of annual giving program. However, any such change would have to been conducted with care, as not to offend the Friends of Art, which remained an independent, large, enthusiastic, supportive, and far-reaching group with several different committees that ran important sections of the museum, including the Coffee Lounge and the Sales and Rental Gallery.[29]

Although McGreevy had planted the seed for what became the Society of Fellows, the organization did not blossom until 1965. First, the trustees selected a forty-seven-member governing board, the Council of the Society of Fellows, a few of whom were not local but had Kansas City connections, like Earle Grant and Inez Parker. The council, with respected businessman Herman Sutherland appointed chairman, held an organizational meeting on November 16, 1965, during which they laid out the benefits of such an organization. By agreeing to pay $300 annually for the privilege of belonging, members would be invited to special pre-openings of exhibitions, to preview new acquisitions, and to an annual dinner to honor benefactors, patrons, and donors. They could attend an annual business meeting to offer advice and to review the progress of the museum, and they could request consultation with curators on the formation of personal collections. Fellows would be given, free of charge, all publications—exhibition catalogues, handbooks, and bulletins—and, of course, they would receive an annual pass to the museum. Potential members were told, "The Society of Fellows, as you know, is not a service organization, but is dedicated to maintaining the high place in the nation that the Gallery has long enjoyed and assuring its future progress for the people of Kansas City and Mid-America." The University Trustees and Sickman would send invitations to potential Society of Fellows members.[30]

Retired Colonel C. M. Peeke became the administrator for the Fellows, which had grown to 250 members by the end of 1966. By then, Society members had come to expect more than just the privileges initially promised to them, and, accordingly, Society trips to visit great collections were planned: to Philadelphia and Wilmington, Boston, Los Angeles and Pasadena, and to Asia. One of the Fellows' most interesting trips, however, was their "Trip to Kansas City," offered in September 1974. Thirty-nine Fellows spent two nights at the Howard Johnson's north of the river and came back by day "to see what we regard as the finest things in our community" as well as tour four private collections—those of Mrs. Joseph S. Atha, Mr. and Mrs. Louis Sosland, Mr. and Mrs. Morton Sosland, and Laurence Sickman. Other perquisites for the Society of Fellows members included adult education opportunities—including Sunday walks and gallery talks.[31]

Although the University Trustees did not want the organization to grow too large, they did continue to recruit, informing potential members that the role of the Society of Fellows was "to inspire by involvement and gift" and "to provide the finest base of leadership for the Gallery's future." Talk of limiting the number of Fellows inspired Chuck Blackwell to write to his fellow trustees McGreevy and Jones, "I don't think it is wise to close the membership of the Society of Fellows. For a long time there was a feeling in the community that the Gallery was only for the 'in' crowd." The Friends of Art did not take off until that feeling was dispelled, Blackwell reminded them, and for those who want exclusivity the Society of Fellows was already too large. Expansion of the Society of Fellows, however, could and would take on a new dimension, by encouraging corporate members. Colonel Peeke wrote to some business leaders, urging them to move from the $300 individual Society of Fellows membership to the $1,000 corporate membership, and the University Trustees devoted many Wednesdays to business lunches, Jones's alternative idea to "visual selling," which proved to be highly successful in recruiting corporate members.[32]

At one point, Laurence Sickman had said that he would hate to have to depend on funds from foundations, trusts, and gifts to keep the museum up to high standards, but, in fact, it seemed inevitable that the Nelson-Atkins had to do so. Benefactors were essential to all American art museums, and the Nelson-Atkins had been blessed with the generosity of many patrons. In February 1963 Sickman mentioned to the trustees that some public recognition should be given to the people and organizations that had made gifts to the gallery. He suggested bronze lettered names be put on the walls just inside the north front door. The trustees tentatively approved the idea and asked Sickman to make a list of who might qualify as benefactors ($50,000 or more) or donors ($10,000 or more). After all, the trustees thought it might be desirable not only to recognize those people who had made donations but, by posting their names, to issue an implied invitation to others to make similar gifts. However, little progress was made in recognizing these donors, and in 1965, Ross Taggart expressed his concern to Sickman that certain large gifts had never been honored.[33]

Finally, with the formation of the Society of Fellows, an annual dinner would acknowledge donors (those who had given $10,000 to $25,000), patrons (those who had given $25,000 to $50,000) and benefactors (those who had given more than $50,000). Before the first Society of Fellows annual recognition dinner held January 20, 1966, the trustees sent out letters requesting permission to memorialize patrons and also to make sure their records were

correct: "From research our records show that you (and _____) have contributed over the years, in cash or works of art, $_____ to the enhancement of the Gallery and its collection." Soon thereafter names began to appear in bronze on the walls of Kirkwood Hall, along with the names of sustaining organizations—the Ford Foundation, the Friends of Art, the Hallmark Foundation, the Jewel Ball Committee, the Junior League of Kansas City, Missouri, the Kress Foundation, and the Westport Garden Club.[34]

The museum would become increasingly reliant on funds from foundations and trusts, as well as from individual benefactors. In 1964 James M. Kemper Jr. informed Ted Coe that Commerce Bank was in the process of setting up a Foundation for Education in Fine Arts and that one of the foundation's first moves "might be to make a contribution to various exhibitions brought here." Coe responded enthusiastically, as did Sickman, saying the museum would be very interested in this kind of support since "bringing exhibitions to Kansas City is an area in which we are indeed, notably hampered through lack of available funds."[35]

In 1965 the arts gained wider recognition on both the state and national level, and the Nelson-Atkins Museum of Art had high hopes of benefiting from connections and funds that might be available. First, the Missouri Council on the Arts was founded, with its first official meeting on September 15, 1965, held in the Nelson-Atkins library. Writing to thank Sickman for hosting the meeting, the executive director of the Missouri Council on the Arts said, "our eyes were opened with envy at your Museum. It is beautifully maintained, and the exhibits we saw were imaginatively presented." Then on September 29, 1965, President Lyndon B. Johnson signed the National Foundation on the Arts and the Humanities Act, thereby creating the National Endowment for the Arts and the National Endowment for the Humanities, independent agencies with funds to promote and strengthen communities "by providing all Americans with diverse opportunities for arts participation." The Nelson-Atkins, Sickman learned, could qualify for grants from either of these agencies after filing a disclaimer that the museum did not receive any federal, state, county, or municipal aid. Although the city owns the building, Sickman explained, the city's assistance is limited to external maintenance only. "The William Rockhill Nelson Trust and the Nelson Gallery Foundation finance our operations, maintenance, and acquisitions," and "we are hopeful about qualifying to receive federal aid for Junior and Adult Education programs."[36]

Sickman, meanwhile, had developed a relationship with the Ford Foundation, would participate in a conference "on the Situation of the Artist and the

Institutions in the Arts 1957–1967," and would serve as a consultant to the Ford Foundation Humanities and Arts Division. Established by Edsel Ford and Henry Ford in 1936, the Ford Foundation began as a $25,000 fund to be used for "scientific, educational, and charitable purposes, all for the public welfare." When the Ford brothers died in the mid-1940s, their bequests turned the Ford Foundation into the largest philanthropy in the world, pledged to investing in innovative ideas and individuals as well as progressive institutions. In January 1964, the Ford Foundation announced a grant to the Nelson-Atkins Museum of Art for $10,212 under the Museum Scholarly Catalogues Program, which, with matching funds, would allow the publication of an updated catalog of the Frank P. and Harriet C. Burnap Collection of English pottery. At the same time, the Ford Foundation announced "a five year program designed to assist in the training of curatorial personnel for museums of fine arts." Of course, Sickman immediately applied to adopt a Ford Fellow, and the Nelson-Atkins, along with the Cleveland Museum of Art, the Toledo Museum of Art, the Worcester Art Museum, and the Walker Art Center in Minneapolis, all agreed to cooperate with the Ford Foundation Museum Curatorial Training Program during its first year of operation.[37]

The Nelson-Atkins welcomed intern Nancy Gray Thompson in September 1965. She would receive a stipend for the year from the Ford Foundation as well as travel expenses so that she could visit other art museums and, after her second year as an intern, could visit East Asia, her area of specialty. Nancy Thompson's internship was so successful that the Nelson-Atkins opted for another intern beginning in the fall of 1967. Marc Wilson, another specialist in Asian art, came to the museum just days after Ellen Goheen was appointed as assistant to the curator of Painting and Sculpture, Ted Coe. Previously, Ann (Mrs. Edward) Lawrence had moved from the Education Department to help Coe in handling public inquiries, notebooks, labels, and giving special lectures in art history. Goheen would now take over many of Lawrence's duties, all while sharing a table/desk with Marc Wilson in what had previously been the staff lunchroom. Two very important new players had just entered the scene.

CHAPTER 15

THE MUSEUM EMBRACES CHANGE
1967–1977

IN AN ARTICLE in *Harper's Magazine* in September 1968, Sherman E. Lee, one of the Monuments Men who had served with Laurence Sickman and was now director of the Cleveland Museum of Art, posed the perennial question: Does the real justification of an art museum lie in its usefulness to society, or should it be solely an artistic institution with educational pursuits and demands? In an address to the Society of Fellows in 1971, Sickman identified the same question as the "Museum Crisis." He explained that in the 1920s and 1930s when Paul Sachs at the Fogg Museum taught or influenced most museum curators and directors in the country, the art museum existed as "the custodian of the artistic heritage of the world" and "as a citadel of scholarship." An art museum could no longer operate on such a simple, straightforward philosophy, Sickman contended. Consideration needed to be given to the "ever-increasing demands for services from an ever-growing public," yet do so in the face of "ever-mounting costs and dwindling income."[1]

Equally problematic was the question of precisely what role the curator should play. "Should he be a scholarly art historian highly trained in connoisseurship, or a popularizer and skillful showman?" Sickman queried. This question was especially troubling to Sickman, a distinguished scholar who bemoaned the fact that he and other curators did not have the time to research and publish as they should, not only for their own enlightenment but also for the success and reputation of the museum. Specifically, in January 1967, he said, "My publishers have been after me for well over a year to produce a revision of the third edition of my book, but I have been unable to attend to this urgent matter without neglecting my other duties." Although he and Assistant Director Ralph T. Coe made a mighty pair, combining both academic acumen and showmanship, they and the rest of the curatorial staff struggled to meet

231

new demands and attract new audiences while continuing to focus on education and acquisitions, so important to an art museum's vitality. While the philosophical crisis affecting all art museums started to escalate in the late 1960s and continued through the 1970s and into the 1980s and beyond, most visitors to the Nelson-Atkins were happily unaware. Varied exhibitions, many educational opportunities, the opening of new exhibition spaces, and some glorious acquisitions provided by generous gifts and bequests gratified the public.[2]

At the annual meeting of University Presidents and University Trustees in May of 1967, which looked back at the prior year, all seemed positive. The attendance in 1966 of 344,266 surpassed all previous years due to four outstanding exhibitions: *Treasures of Peruvian Gold*; *Contemporary French Tapestries*; *New Chinese Landscapes*; and *Sound, Light, Silence: Art that Performs*. Also, Sickman reported that 1966 was "one of the most important years in the Gallery's history" for acquisitions. Peter Paul Rubens's *Sacrifice of Isaac*, Sickman said, was "surely among the five or so greatest paintings in the permanent collection and an acquisition to be coveted by any museum of fine arts." In addition, thanks to an anonymous gift, the museum had opened new galleries dedicated to Chinese furniture. The Friends of Art and Guild members now numbered 5,000; the Society of Fellows, 265 members. More than 200,000 people had taken instructional tours of the museum guided by 288 volunteers. Besides the popular and well-attended children's creative art classes, the Education Department offered art history lecture courses to adults. Also, on Thursday evenings in Atkins Auditorium, discerning filmgoers had the opportunity to view, free of charge, classic films acclaimed for their artistic merit. Yet, some problems lurked behind the pretty picture painted in 1966.[3]

The University Trustees—Menefee Blackwell, Milton McGreevy, and Cliff Jones—dealt with many issues in the day-to-day operation of the museum. McGreevy, in a voluminous number of notes to Sickman, asked about loans, events, meetings, acquisitions, curatorial travel expenses, investments, programs, salaries, and benefits. A growing concern for the trustees was the state of the building itself, which would be forty years old in 1973. When Fred C. Vincent and the building committee turned the William Rockhill Nelson Gallery of Art over to Kansas City, Missouri, in 1933, City Manager McElroy made a verbal commitment that the city would insure and maintain the building, but this agreement was not legally binding. Therefore, the relationship between the Nelson-Atkins and the city had always been cloudy. In 1943, the city attorney, Ben M. Powers, expressed his opinion that "the City might lawfully provide, but was not required to provide, structural repairs to the buildings";

FIGURE 15.1 Peter Paul Rubens's *Sacrifice of Isaac* was one of the prized acquisitions of 1966, "surely among the five or so greatest paintings in the permanent collection," Sickman reported. (Purchase: William Rockhill Nelson Trust, 66-3)

he entertained "serious doubts as to whether the City might lawfully expend funds for the purpose of operating the buildings and Art Museum, such as heating, cooling, and janitorial service." In following years, the city took the position that, although not legally required to do so, it would expend money for insurance, structural maintenance, and upkeep of the grounds, including sidewalks and curbs. However, in 1967, the trustees and staff felt that the city had not done its part and that the building and grounds were in dire need of repair. In a letter to City Manager Carleton Sharpe, the trustees ascertained,

> "Our situation can be simply described: The Nelson Gallery is acclaimed as the number one cultural asset of the city. . . . Because of the generosity of the Nelson family and associates, and Mary Atkins, the City in 1933 was given the building and grounds with only the obligation to maintain [them]. The collection that has been acquired in the thirty-four succeeding years, we are told, now ranks number seven in the nation, but the building exterior and interior during many of these years has been maintained strictly on an emergency basis only."

The trustees had submitted a budget of $38,565 to the city for 1967, which had been cut to zero. For the fiscal year ending April 30, 1968, "The City Counselor's Office has ruled that no funds can be provided for the Gallery except to prevent the structure from falling down."[4]

In June 1968 the three University Trustees, Sickman, and Superintendent Clarence Simpson met with the new city manager, John Taylor; the city's attorney, Lawrence B. Saunders; and Robert I. Donnellan, attorney for the Nelson Trust, to again discuss maintenance of the building. Mr. Saunders said that the city "could not legally give money for interior maintenance, although they have provided these funds for a period of thirty years." Taylor was sympathetic to the museum's needs and thought the city could continue to give $3,000 a year as a maintenance allowance and also possibly pay $2,700 for new auditorium curtains. Later, the city's legal department ruled out such expenses as stage curtains and recovering walls because "decorations or furnishing are not structural repairs." Then in November 1968 the city said it would give the Nelson Gallery an as-yet-unknown sum to do all maintenance and repairs. Simpson wondered whether enough money would be allocated since "Maintenance of the building, sidewalks, platforms, and curbing has been neglected for so long."[5]

Meanwhile, the Atkins trustees had retained ownership of the Atkins Museum of Fine Arts, the east side of the building. In 1968 the University Trustees met with the trustees of the estate of Mary Atkins—David B. Childs and

Herbert Vincent Jones Jr.—along with their attorneys to discuss releasing the easement of the Atkins Museum to the city to "help the Nelson Gallery and the Atkins Museum obtain City funds for building maintenance." The idea was that the city might increase funds if they were supporting the whole museum rather than just the Nelson Gallery. Childs opposed making any changes, because no one had any proof that the situation with the city would be improved by this action. If the city did not have money or the legal obligation to maintain the Nelson Gallery, it would be unlikely to increase its funding once it owned the Atkins Museum.[6]

Security also became a concern, which only added to the art museum's philosophical crisis. As Vietnam War protests and riots swept college campuses in the late 1960s and into the 1970s, the University Presidents urged the trustees to develop internal security plans. Cliff Jones contacted Joseph M. Chapman, the security specialist who had worked with the Art Institute of Chicago, and Sickman received a further recommendation of Chapman from Otto Wittmann, now director of the Toledo Museum of Art. The trustees acted on Mr. Chapman's suggestions: installing a security system, putting bars and bullet-proof Lexan coverings on all ground floor windows, mounting roll-down metal shutters on the north doors and new cylinder locks on all exterior doors, equipping guards with chemical Mace and walkie-talkies, and hiring extra personnel to police the parking lots. Sickman drew up a list of potential problems that he discussed with Police Chief Clarence Kelly and the museum's building superintendent, Sherwood Songer, who had replaced Clarence Simpson when he retired in 1969 after serving the museum for thirty-six years. All of these precautions either prevented or averted major issues; the only matter that drew public attention was the "hippie problem."

A large number of hippies, many of whom were Art Institute students, frequented the museum. These students were encouraged to use the museum as a teaching laboratory, and when the Art Institute was hard-pressed for classroom space, Sickman made the Atkins Auditorium available to them for lectures. However, the hippies' monopolization of the Coffee Lounge and of the free movies on Thursday evenings disturbed some people. When Cliff Jones passed on a newspaper article to Sickman in which a local resident complained about the hippies' attire and demeanor, recalling the day when an art museum was "a place of quiet dignity," Sickman said he too liked "quiet dignity," but he also liked to see the museum full. "One simply can't have both," he concluded, going on to say, "Our experience with the Hippies has been that for the most part they are quiet, well-behaved, and agreeable people, and while I have no personal sympathy for their eccentricities, I do feel that the Gallery serves all

the public, and the only answer to this is like so many present day problems, and that is mutual tolerance." For those truly interested in art, Sickman could not see how the way other visitors were dressed posed much of a distraction. Trustee Chuck Blackwell was not as sanguine about the hippies and considered their behavior offensive and their outfits outlandish. The real problem, he thought, had started when many hippies had flocked to the museum to see the popular but unorthodox exhibition *The Magic Theatre*, organized and coordinated by Ted Coe.[7]

At one time, special exhibitions, especially of art produced by living artists, would have been displayed in salons, academies, or galleries. American museum directors realized, however, that the modern art museum needed to serve the purpose of showing works by contemporary artists, as long as they, according to Sherman Lee, were "within reason." For some, the "psychic art" displayed in *The Magic Theatre* stretched that boundary. David Stickleber, a longtime museum supporter and member of the Performing Arts Foundation of Kansas City, had approached Coe in August 1967 about holding a contemporary art exhibit at the Nelson-Atkins, sponsored and paid for by the foundation. Over the course of six weeks, with the assistance of the museum staff, art patrons, students, and teachers, eight artists designed works on site that involved light and interactivity. On May 25, 1968, Performing Arts Foundation members, Nelson-Atkins patrons, art critics, and directors and trustees from other cities celebrated this complex and dramatic exhibit at a gala champagne opening in the museum's four loan galleries. The show proved to be so popular that protesters petitioned to keep the exhibition open beyond its scheduled close date of June 23, resulting in *The Magic Theatre* being held over before traveling to four other museums. Granted, as Blackwell surmised, *The Magic Theatre* attracted hippies, but by doing so brought in many new patrons.[8]

While the trustees' jobs seemed endless, the slim and overburdened curatorial staff also juggled a growing number of responsibilities. When Ellen Goheen began working as assistant to the curator of Painting and Sculpture, Ted Coe, in 1967, she was thrilled to have a job in which she could apply her University of Kansas art history background. Like the rest of the staff, however, her job was not purely about art or education. Although she delivered lectures and wrote labels for art objects, she also cleaned out the storage area, helped set up and take down exhibits, and mopped up leaks in Kirkwood Hall and in the first-floor galleries when the windows frosted over. According to Goheen, her job was rather overwhelming; it was unbelievable how much needed to be done and how much such a small staff managed to accomplish.[9]

FIGURE 15.2 (*Above*) For the *Magic Theatre* exhibition, eight artists designed works on site that involved light and interactivity. (RG 24/01, NAMAA)

FIGURE 15.3 (*Below*) The *Magic Theatre* was so popular that visitors picketed to keep the show open beyond its scheduled end date. (RG 24/01, NAMAA)

FIGURE 15.4 As assistant to Ted Coe, curator of Painting and Sculpture, Ellen R. Goheen juggled multiple responsibilities in her original role, eventually holding the position of director of Collections and Special Exhibitions in the 1990s. (RG 45, NAMAA)

Two years into Goheen's first of many positions at the museum, Sickman and Coe suggested to the trustees that since she was giving lectures on European art but had never been to Europe, perhaps she should go to the Continent on the Friends of Art charter flight. Her airfare would be complimentary, and the University Trustees, on Sickman's request, granted Goheen an additional $300 in travel expenses: "Mrs. Goheen has, as you may have heard, performed excellent service at the Gallery, and her course of lectures has proved particularly outstanding." In 1969, upon her return from Europe, Goheen was named assistant curator in charge of art history programs. However, in 1973, she would return to Coe's department as assistant curator of Painting and Sculpture before becoming curator of Twentieth-Century Art in 1975.[10]

The year before Goheen began at the museum, Coe had written a twelve-page position paper on the status of adult education at the museum, and the lectures Goheen had begun to deliver were largely a result of this treatise. Coe lamented, "We have been missing the boat here. Since the Nelson Gallery pioneered the docent training program . . . why do we not pioneer the updating of this concept to fit a far more sophisticated environment than functioned a quarter century back?" Sounding much like William Rockhill Nelson years before when he had urged the city to spend money on parks because other cities had them, Coe remarked that "most large metropolitan museums in the country have long since embarked upon adult education programs in the professional sense: in the Nelson Gallery a de facto lecture program for adults has been maintained." Coe urged the museum to expand and enhance the core

adult education programs already in place: the docent training courses, lecture courses in art history, and guest lecture programs. He also urged closer ties between the museum and local universities, with more faculty members being invited to speak at the museum, more college credit courses offered, and more seminar-type programs run by the curatorial staff.[11]

In 1971 a more formal adult education program began. Besides lecturing to the docents, Goheen began giving a spring and a fall subscription series of lectures, each course lasting for ten weeks. In connection with the University of Kansas, Professor Chu-tsing Li and Laurence Sickman offered for-credit seminars on Asian art, while Ralph T. Coe and Dr. Marilyn Stokstad taught spring and fall university art history courses in their respective fields of expertise. Coe offered classes on Impressionist and American Indian art. Stokstad, who was a professor at the University of Kansas and a consulting curator for the Nelson-Atkins, taught courses in medieval and Spanish art. Moreover, all of the curators—Sickman, Coe, Taggart, Wilson, Goheen, Stokstad, and Curator of Prints George McKenna—participated in a new program of curatorial lectures offered on Wednesday afternoons and, at one time or another, gave talks at the monthly meetings of the Art Study Club. However, as more formalized adult education programs were put in place, the Art Study Club lectures became a burden to the staff, and in 1975 Senior Curator Ross Taggart had to inform the members that, "The Gallery staff will have to curtail its participation in presenting the Art Study Club programs." In response, the club members graciously started a fund to help with visiting lecturer expenses, known as the Florence Eliot Memorial Lecture Fund, in honor of the prime donor. Moreover, the Art Study Club would continue to meet at and frequent the museum.[12]

Of course, the person most responsible for education programs was Director of Education Larry Eikleberry, who took over in August 1968 when James Seidelman left. Eikleberry first concentrated on creative art classes. The primary goal of the Education Department, Eikleberry asserted "is to provide young people an opportunity to develop their awareness and sensitivity to art forms through a variety of two or three-dimensional experiences." Preschool class sessions gave three- to six-year-olds an opportunity to paint and draw. Kindergarteners through sixth graders could take creative art classes offered on Saturdays and during the summer. A special Saturday class featured holiday gift-making, and the Westport Garden Club sponsored a class on art and nature. Marionette programs for ages ten to sixteen; high school classes in painting, watercolor, and film-making; project classes for Girl Scouts; and "picture

lady" workshops rounded out the Education Department's offerings. The creative art program had grown steadily during its thirty-five-year history.[13]

In November of 1970, Eikleberry began to focus on the docent program. He thought the children's tours needed revamping, and Coe, Taggart, and Goheen agreed. Early tours at the museum were not culture-based, except for the American Indian art tour. Docents lectured to the students rather than getting them to look, ask questions, participate, and engage. Relying on advice from experienced docents, Eikleberry set up a new agenda that he hoped would be entirely operational by September of 1971. The first year for new docents would be a "provisional year," during which they would take training courses for the five school tours. During the second year, docents could take the training and test in order to qualify to give general tours. The training courses were carefully delineated and would introduce "controls of quality" to the entire docent program, since school tours would follow an "articulate script," and general tour docents would have to pass a qualifying test.[14]

Sickman's interest in tours peaked after attending a meeting of the Association of Art Museum Directors (AAMD) in August 1971. He reported that not only museum directors but also the IRS expressed concern about how museums were serving the public. "The Gallery is classified as an educational, tax-exempt institution," which is a classification it needs to take seriously, Sickman related. Docents should emphasize "visual apperception" and present "material in such a way that the children really look at the objects," he added. At the Visual Literacy Conference held the April before the AAMD meeting, Elizabeth Goldring of the Smithsonian presented another version of the Museum Crisis, posturing that "Any museum is in a sense a repository," yet "if the museum is to answer today's cry for relevance, its objects must be more than expertly arranged or spotlighted. They must be made to come alive in the sense that the visitor realizes their immediate relationship to his life." To make this happen, the tour leader must become the catalyst, to make visually illiterate visitors look at art objects and make them relevant. Thus, Ellen Goheen set to work on writing outlines and scripts for the new era of docent training. Once she completed her fifteen-page outline of the fifth-grade painting tour, she sent it to Sickman for his approval. "Very good," he wrote; "hope it works." Besides scripts, Goheen inaugurated weekly training lectures for docents with the specific "aim of improving the quality of the tours," not only by incorporating art history and culture but also teaching techniques.[15]

Eikleberry realized, however, that the new docent program did not solve all the problems, as he indicated in an internal memo he wrote in early 1972 entitled "The Deliberations, Convictions, Frustrations, Attitudes, Vehements,

Insecurities, 'Illusions of Grandeur,' and Occasional Gross Oversimplifications of Larry D. Eikleberry Regarding the Further Development of the Tour Program and Other Related Projects." Besides making tours more culture-based, more visual, and more interactive, an additional criterion had been to free up curatorial time. Still, the old method of curators training docents in galleries by looking at real art objects had, perhaps, been preferable. Lectures in the auditorium were not always good substitutes, but they were more practical for a program with more than one hundred docents-in-training or in-review. Now Eikleberry decided his prime objective would be to improve the quality of tours by improving the quality of the tools used to teach docents, especially films and slides. He turned to Jan McKenna, the slide librarian, and to the Merrill Trust, which in 1973 awarded a $25,000 grant to the Nelson-Atkins "to augment research facilities" and for "inaugurating new programs in adult and junior education employing recently advanced techniques in audio-visual material."[16]

Sickman's interest in education extended beyond tours to encompass training curators. He enthusiastically supported the Ford Foundation's Museum Curatorial Training Program, which both educated Ford Fellows and provided the museum with extra staff. In all, the Nelson would have four Ford Fellows before the program was discontinued. Undoubtedly Wilson's arrival at the Nelson-Atkins as the second Ford Fellow was a serendipitous moment for both the museum and Wilson. Wilson had earned a BA in 1963 from Yale, intending to go on to law school. However, the summer after he graduated he went home to Cleveland, entered Western Reserve University, and happened to take an Asian art survey course from Dr. Sherman Lee. "As soon as I saw Chinese bronzes," Wilson said, he knew he had found his passion. "My lord, I'd never seen anything like this in my life." The following summer Wilson worked at the Cleveland Museum of Art, and in the fall he returned to Yale, earning an MA in 1967 in Chinese and Asian studies before applying to the Ford Foundation for a fellowship grant.[17]

Sickman personally mentored Wilson, as Sickman, besides being director, remained curator of Oriental Art, with Jeanne Harris acting as associate curator. After Wilson's first year as a Ford Fellow, Sickman remarked, "Mr. Wilson has adjusted with great ease into the museum routine." He dealt facilely with the public, gave lectures to docents, and received general training in museum techniques, particularly installation, with his knowledge of electronics proving to be very helpful in mounting *The Magic Theatre* exhibition. After Wilson's second internship year, Sickman reported to the Ford Foundation that Wilson had made "phenomenal" progress, "and I feel confident that in time he will be one of our most distinguished curators of Far Eastern art." Under Sickman's

tutelage, Wilson ascribed his "blossoming progress, not to any particular talent of my own, but rather to a kind of luck to one of those happy fortuities when people, place, time, technical resources, good will and opportunity converge to produce success."[18]

FIGURE 15.5 Laurence Sickman mentored Marc Wilson, who first came to the museum as a Ford Fellow in 1967. (MSS 01, NAMAA)

When his fellowship at the Nelson-Atkins Museum of Art ended in summer 1969, Wilson would further his professional training through study of the collections of the Palace Museum in Taipei, Taiwan, and of museums in Japan, having been awarded a one-year Ford Foundation Travel and Study grant. Sickman, sensing that Wilson's role at the Nelson had not ended, expressed his appreciation to the foundation for supporting the education of this "promising young person," whose "dedication to museum work is unalterable." In fact, in 1970 after completing his study abroad, the twenty-nine-year-old Marc Wilson would return to the Nelson-Atkins as associate curator of Oriental Art. The fortuitous combination of having a Ford Fellowship and then a Study and Travel grant made Wilson feel that he was "worth hiring." He and Sickman began work on reorganizing the museum's Asian library and co-authoring a scholarly catalogue, for which the Ford Foundation had provided matching funds, on Chinese paintings in the Nelson-Atkins's permanent collection.

Wilson, meanwhile, pursued his PhD from the University of Kansas, and when Sickman retired as curator of Oriental Art in 1973, Wilson succeeded him.[19]

While the curatorial staff wished they had more support, costs also affected exhibitions, many of which were organized around the Nelson's own collection and art purchases. Although few in number, some of the pieces the museum acquired during the late 1960s and early 1970s were quite notable. In the 1967 *Annual Report*, Sickman highlighted the purchase of *The Van Goyen Family*, a Dutch seventeenth-century painting by Jan Steen. In 1968, a tondo, *Madonna and Child and St. John* by Giuliano Bugiardini, provided "a much needed Renaissance painting of a kind almost unobtainable today," according to Coe; in addition the Nelson Trust purchased a late fifteenth-century marble bust of Saint John by the Master of the Marble Madonnas along with a Chinese painting (in two sections) "of major significance," Gong Xian's *Cloudy Peaks*. The acquisitions for 1969 included a late eighteenth-century French commode by Adam Weisweiler and a Japanese screen from the Momoyama period. Although the Nelson Trust funds purchased two paintings in 1970, Philippe de Champaigne's *Crucifixion* and Hendrik Van Vliet's *New Church at Delft*, Sickman remarked, "In the face of dwindling acquisition funds and the phenomenal upward spiral of the art market, gifts of works of art to the collections assume an even more vital role." Indeed, at the 1975 annual meeting, the University Trustees told the University Presidents that despite receiving many gifts, they had made very few purchases during the previous two years through either the Nelson Trust or the Nelson Foundation, and in 1975 the Trust purchased no works of art. Moreover, the next year "the truly important acquisitions" were made through gifts.[20]

Even though purchased acquisitions were at an all-time low, the museum's collection had outgrown the finished galleries. When J. F. Ponder, chairman of the Benton Memorial Committee, asked Laurence Sickman to study the possibility of establishing a Thomas Hart Benton Room at the Nelson, Sickman replied that a dedicated room was not an option; the museum had simply run out of space. Adequate room for the Friends of Art collection presented the most pressing issue, and the trustees had considered using the residue of Laura Nelson Kirkwood's Trust, some $50,000, to finish a larger gallery for the Friends of Art purchases. However, the 1969 estimates to complete a new room in the unfinished wing ranged around $150,000. Motivated to complete the west wing of the second floor of the building, the trustees began seeking patrons to help with the expense, which brought up the idea of memorializing galleries. Milton McGreevy was initially opposed to naming rooms after

FIGURE 15.6 An important late eighteenth-century *Chest of Drawers with Doors* designed by Adam Weisweiler was a highlight of purchases made in 1969. (Purchase: the Kenneth A. and Helen F. Spencer Foundation Acquisition Fund, F70-43)

donors, as he indicated in a letter that he wrote to Sickman and fellow trustees Jones and Blackwell in February 1968: "The more usual practice I believe is to have a list such as the one we now have in Kirkwood Hall of donors and benefactors. . . . I think putting a name on a room is done in hospitals but not in art galleries."[21]

However, Inez Grant Parker sparked increased discussion about endowing galleries when, in a June 30, 1968, letter to Sickman, she mentioned that she and her brother Earle Grant were considering changing their wills to include the Nelson Gallery. More specifically, Mrs. Parker expressed her interest in contributing to the unfinished wing of the museum by establishing a Friends of Art gallery, since she and Paul Gardner, along with Dot Clendening, had started the organization. Sickman visited the Parkers and Earle Grant in California, where they now lived. Several conversations between Sickman and Inez Parker, as well as consultations with architects and contractors, resulted in a definite proposal. On September 16, 1968, Inez Parker and Earle Grant decided that, rather than wait to make an endowment, they would prefer to give the

museum a quarter million dollars right away in order to see a Friends of Art Gallery established within their lifetimes. When the trustees wrote Mrs. Parker to thank her for her gift, they assured her that, "The new facilities will carry the Parker-Grant designation, together with an appropriate plaque." Sickman also wrote to Inez Parker, "It is a most heartening thing to know that we can proceed with our plans for the Friends of Art Gallery, which is so desperately needed. . . . Inez, I cannot tell you how much the interest you and Earle have shown in the Gallery has encouraged me, and how profoundly I am personally grateful to you both." In another note to Earle Grant, Sickman not only thanked him for his "extraordinary generosity" but also spoke of how the Parker-Grant Gallery "will be a perpetual memorial to those who took so lively an interest in the Gallery during its infancy." The gift from Inez Parker and Earle Grant was the largest gift to the museum since its founding.[22]

Mrs. Parker and Mr. Grant had every intention of seeing their contemporary art gallery open, but its construction took much more time than anticipated. First, the southeast section of the second story west wing, which had been used as a storage area, "largely occupied by such objects as the paintings and plaster casts from the Gallery of Western Art" (William Rockhill Nelson's collection), needed to be cleaned out. Once these items were removed and the designer, John Yeon, could have a better look at the space, he decided to alter the plans from a 35 by 35-foot gallery with 13-foot ceilings to a room that was "really monumental" in scale: 80 by 35 feet with 18½-foot ceilings. In February 1969, Sickman wrote to Inez Parker that he thought the new design was "precisely what we were looking for." New plans were drawn, and work was set to begin when a building strike occurred. Then in January 1970, Sickman notified the trustees that he had spoken to Kansas City Mayor Ilus Davis concerning the new gallery. "He pointed out," related Sickman, "that according to the city charter, no alterations, additions, or modifications can be made to a city building without the approval of the Municipal Art Commission." Thus, Milton McGreevy, Menefee D. Blackwell, and Herman Sutherland, who had taken Cliff Jones's place as University Trustee, sent drawings and specifics to the city along with a note that concluded, "We are confident you will feel as we do that Kansas City is remarkably fortunate in receiving support of this kind so vital to the development of the Gallery services in the community." Several months later, the Municipal Art Commission approved the new gallery, and work began with hopes that the gala opening would occur in October 1970. However, the Parker-Grant Gallery, which the newspaper said "inaugurates a new era in the history of the Friends of Art," did not open until May 13, 1971. By that time Inez Parker's husband Gerald had died as had Earle Grant, and

Inez Parker herself was too ill to travel. All three—Earl Grant, Gerald Parker, and Inez Grant Parker—left art gifts and large bequests to the Nelson-Atkins in addition to the Parker-Grant Gallery. Sickman wrote, "Their gift is a gift to this whole community, and Kansas City joins the Trustees and Gallery staff in expressing profound gratitude."[23]

FIGURE 15.7 The Parker-Grant Gallery, designed to house the Friends of Art collection, opened in May 1971. (VRLSC, NAMA)

Meanwhile, in 1969, the trustees learned of the bequest of the late Mrs. Frank Grant Crowell. Mrs. Crowell, whose home was at Forty-Sixth and Warwick across the street from the Nelson-Atkins Museum of Art, had been a widow since her husband, a grain broker, had died in 1936. Now, long after Mr. Crowell's death, encouraged by her neighbor and longtime museum supporter James L. Miller, Renee Clements Crowell decided to make a major gift to the museum in her husband's name. She began discussing various options with Sickman in 1963, and in 1966 Mrs. Crowell's lawyer, Arthur Mag, asked University Trustee Menefee Blackwell to determine how much it would cost to complete the entire west wing of the museum. After receiving architectural drawings and estimated costs, Mag suggested that Mrs. Crowell specify a bequest of $700,000 to finish the west wing and provide some funds for maintenance. In February 1969 when Mrs. Crowell died, she, who said she "had never done anything for the Gallery," left "the largest bequest made since its opening

in 1933." Her funds would assure the completion of the Frank Grant Crowell Wing "in a manner commensurate with the rest of the Gallery," with some operational funds remaining. Using four different kinds of marble and many precious woods, architects John Hinchcliffe and Stuart Hutchinson and designer John Yeon created a space that was so special that it won an Allied Arts and Craftsmanship Award for the millwork installation. The Crowell Wing included a Japanese screen room, the Spencer Gallery for Impressionist paintings, and the Parker-Grant Gallery and extension while the Crowell Stairway, which was built to accommodate the *Amitabha Buddha*, a nine-foot-high gilded sculpture purchased in 1931 by Langdon Warner, led to a mezzanine level. African, Oceanic, and Native American art occupied one large gallery, and Persian and Japanese art were in a smaller gallery.[24]

FIGURE 15.8 (*Right*) At the opening of the Crowell Wing in 1976, University Trustees Herman R. Sutherland (center) and Menefee D. Blackwell (right) pose with Jennifer Lee Blair, the great-niece of Mr. and Mrs. Frank Crowell, in front of the nine-foot-tall *Amitabha Buddha* (Purchase: William Rockhill Nelson Trust, 31-141/1) purchased by Langdon Warner in 1931. (RG 45, NAMAA)

FIGURE 15.9 (*Left*) Also at the Crowell Wing opening, University Trustee Milton McGreevy and his wife, Barbara, stand in front of the Burne-Jones gouache painting they had given to the museum. (Purchase: acquired through the generosity of Mr. and Mrs. Milton McGreevy through the Westport Fund, F59-59)

Georgia and Elmer Pierson provided another major gift, one that would extend the Nelson-Atkins Museum of Art beyond its walls. Pierson, a prominent Kansas City businessman and co-owner of the Vendo Company, had expressed an interest to Sickman in making a contribution to the museum through the Elmer F. Pierson Foundation. Ted Coe knew of Pierson's intentions but did not know the man. Therefore, when Coe saw Pierson approaching him at a gala event at the museum, Coe panicked, having no idea what to say. Luckily, his wife, Sarah, was at his side and whispered something to the effect of, "Ask him about his golf game. He loves golf." Even though Coe knew nothing about golf, he and Pierson had a delightful conversation about the sport and myriad other subjects, establishing a relationship that resulted in the Pierson Sculpture Garden and other handsome gifts to the museum.[25]

The Piersons hired landscape architects Hare and Hare to draw plans, which the trustees approved in December 1971 and the Kansas City Park Board several months later. Once work began, Georgia Pierson was often on the job supervising the planting of Amur cork trees, dogwoods, and European birches on the three terraced areas just southeast of the museum. Several sculptures were transferred to the garden, including Auguste Rodin's *Adam*, which the Nelson Trust had purchased in 1955; *Tom's Cubicle* by Alexander Calder, a Friends of Art gift; and a Henry Moore piece, *Relief #1, 1959*, given by Dorothy Clendening Clark. On the day of the dedication of the Sculpture Garden a magnificent bronze sculpture by Jacques Lipchitz, another gift from the Piersons, was seen for the first time. Sickman so admired the piece that he wrote, "Elmer, only a note to tell you of my extreme enthusiasm over the really great Lipchitz sculpture. With warmest regards to you and Georgia." The University Trustees and the director of the Nelson-Atkins Museum invited members of the Society of Fellows to a preview reception the afternoon of November 17, 1972, followed by the formal dedication of the Pierson Sculpture Garden. A special invitation went to Frank Vaydik, head of the Park Department, and his wife, with an addendum, "We would appreciate it very much if you would have some of the Park Department people clean up as much as possible the area around the east door of the Gallery and particularly around the terrace where the Pierson Sculpture Garden is located." Maintenance by the city was an ongoing problem.[26]

Although some people came to the museum to attend lectures or take classes or tours, more came to see the new galleries, the Sculpture Garden, exhibitions, and new acquisitions. They would not be disappointed. While financial and philosophical issues were causing stress for the director, curators, and trustees, the public would be unaware of the situation. Many generous

FIGURE 15.10 Iron gates beckon visitors beyond the museum into the Pierson Sculpture Garden where they can view beautiful landscaping and works of art like Auguste Rodin's *Adam*. (Purchase: William Rockhill Nelson Trust, 55-70) (VRLSC, NAMA)

patrons, too many to be mentioned, made cash and stock gifts, left bequests, gave needed items—like tea services and kitchen equipment—and established memorial and trust funds. Anonymous donors provided funds for remodeling the thirty-five-year-old Gothic Gallery and reinstallation of Romanesque and Gothic sculpture in 1968. Ruth Patton Kline donated thirty-four pieces of Hester Bateman silver in memory of her husband, Leonard Charles Kline. Louis Sosland not only gave money for works of art but also started a fund for curatorial travel, so necessary for curators to grow professionally and stay informed. In memory of Winifride Railey, Mrs. Railey's daughter and son-in-law, Catherine and William A. Repp, provided substantial funds "to be used for the development and expansion of the educational activities relating to the collections of the Nelson Gallery and Atkins Museum." Karen Dean (Mrs. George H.) Bunting besides being the volunteer Sales and Rental shop coordinator, gave the museum many important Japanese art objects, as well as some Chinese and Indian pieces. With lovely thank-you notes, Sickman acknowledged all gifts, large or small. However, in 1973, for Helen Beals, the eighty-two-year-old widow of former trustee David Beals II, Sickman not only sent her a thank-you note but also an invitation to accompany him to New York on

a shopping trip to spend her substantial accumulated annual funds. "I am sure we will be able to find some very desirable object for our collections," and he added, "I can promise you a most enjoyable time."[27]

Few gifts of art involved as many people and as many opinions as did the bequest of N. Clyde Degginger, who had died in 1967 and left a bequest to the City of Kansas City, Missouri, of a "bronze statuette memorializing the pioneer spirit." He asked that the director of the William Rockhill Nelson Gallery of Art, with the consent and approval of the University Trustees and the City Council of Kansas City, select the statue and place it in a prominent public place, preferably near an art museum. In May 1970, Sickman met with the mayor and the president of the Parks and Recreation Board to consider the Degginger Memorial. Three years later, the city and the museum decided to purchase a bronze sculpture from Henry Moore. Sickman sent Coe to England to meet Moore, and they reached a verbal agreement for the purchase of *Sheep Piece*, which Moore thought had "relevance to the pioneering spirit." Of course, the Board of Parks would have to approve and a location would have to be determined, while the public freely expressed opinions on both the site and the chosen artwork. Finally, after ruling out Kemper Arena, Loose Park, Swope Park, the airport, and Barney Allis Plaza, the Henry Moore Sculpture Site Selection Committee decided to place *Sheep Piece* on the Nelson-Atkins Museum of Art grounds. Henry Moore came to Kansas City to specify a location on a mound on the southwest corner of the grounds where William Rockhill Nelson had kept his dovecote. The Degginger Memorial was dedicated on May 17, 1976. Frank Vaydik, director of the Board of Parks and Recreation, said that the Parks Department "has envisioned for many years that the area south of the Gallery to 47th Street on both sides of the center mall be made into an outdoor sculpture garden." *Sheep Piece* would promote and stimulate interest in such a garden.[28]

One of the museum's most generous patrons was Helen Foresman Spencer. Her gifts to the Nelson-Atkins began coming in 1962 when she donated money to the Nelson-Atkins library. Between 1966 and 1968, Mrs. Spencer contributed funds for the purchase of European decorative arts, the installation of decorative art galleries, and the refurbishment of the Atkins Auditorium. In December 1971 she purchased an outstanding collection of Chinese furniture for the museum, and then in 1972 the Board of Directors of the Kenneth A. and Helen F. Spencer Foundation established a $1 million acquisition fund "to be expended at the discretion of the director, the curators, and trustees to acquire works of art." A gala dinner was held for Mrs. Spencer on September 25, 1972, to thank her for all she had contributed to the museum. A delighted Helen

Spencer wrote, "Never will I easily forget the setting for the most beautiful dinner and the honor bestowed on me last evening. . . . My deepest thanks."[29]

Helen Spencer's generosity was boundless. In late 1972 when Ted Coe heard that "one of the greatest paintings of the French Impressionists" had been put on the market, he contacted Spencer. She called a special meeting of her foundation's Board of Directors and, delightedly, was able to commit to buying a treasure for the Nelson-Atkins, Claude Monet's masterwork *Boulevard des Capucines*. Then, in 1973, as a fortieth anniversary present to the museum, Spencer purchased a Degas gouache. Writing to Coe, she said, "Since Larry Sickman is out of the country and you, as Assistant Director, are in full charge in his absence, it is with a great deal of excitement that I present you with this check for $1,025,000 to purchase the Degas," the most expensive piece of art yet acquired by the museum. In reply, Coe wrote, "There are no words to express, Aunt Helen, the pride I personally feel over your magnificent gift to the Gallery of Degas's *La Repetition*. It will always hang here as a great masterpiece, and I am sure that future generations will acknowledge your wisdom in adding a painting so significant that it immediately becomes a major part of the Nelson Gallery heritage."[30]

FIGURE 15.11 Laurence Sickman, Helen F. Spencer, and Ted Coe admire Mrs. Spencer's magnificent gift, Claude Monet's masterwork *Boulevard des Capucines*. (Purchase: the Kenneth A. and Helen F. Spencer Foundation Acquisition Fund, F72-35) (RG 70, NAMAA)

In 1973, when the Nelson-Atkins Museum of Art celebrated its fortieth anniversary, some other patrons besides Mrs. Spencer gave gifts of art, including Rita and Thomas Hart Benton, who donated two works by Benton's student Jackson Pollock. Also, more than one hundred individuals and companies donated $109,000 to an Anniversary Memorial Acquisition Fund. As a special exhibition to commemorate the anniversary, Sickman suggested displaying forty works of art, one from each year of the museum's existence. While Coe orchestrated this exhibit, Wilson, with help from the staff and his wife, installed the new Chinese painting gallery, working so hard that the bottoms of his "feet literally peeled off." The new gallery and the anniversary exhibition opened for the gala party held on December 11, which was attended by 2,660 guests. The remarkable Barbara Rahm (Mrs. Philip), a volunteer who was eventually appointed assistant curator in charge of gallery events, orchestrated the entire evening. Choosing red as the color theme, since ruby is the fortieth anniversary stone, Mrs. Rahm, with the help of thirty-some Westport Garden Club volunteers, decorated Christmas trees with red Italian lights, strung red banners, and arranged hundreds of red poinsettias. At 10:00 P.M. an enormous birthday cake emerged to the accompaniment of a drumroll. Sickman gushed that it was the "most successful social event the Gallery has enjoyed since its opening," which he remembered well, having been present there back in 1933.[31]

Not long after Ted Coe wrote to his former wife's aunt to thank her for the fortieth anniversary gift of the Degas, Sickman wrote another note acknowledging Mrs. Spencer's generous check to build an Impressionist Gallery in the Crowell Wing of the museum. Her Monet and Degas would hang there along with Odilon Redon's *Vase of Flowers*, a pastel Coe had acquired for the museum with funds provided by Mrs. Spencer in celebration of the opening of her gallery in 1976. At the same time, Helen Spencer decided to endow the Kenneth A. and Helen F. Spencer Art Reference Library. For Sickman this gift was "the capping stone" of his tenure as director. "We may look forward to the facilities for a really great art research library with a reading room in every way commensurate with the quality and beauty of the rest of the building," he wrote. He added one more heartfelt note to Helen Spencer: "So much of what we have accomplished is thanks to you, your generosity, support and concern, and your advice. You must, I am sure, realize how profoundly grateful I am personally for making so many of my plans come true."[32]

Laurence Sickman experienced many successes during his long career at the Nelson-Atkins Museum of Art and was revered beyond the museum walls.

In September 1973, the Freer Gallery in Washington, D.C., presented him with the Charles Lang Freer Medal for distinguished contributions to Asian studies, only the fifth recipient of the award and the first American. Also, in 1973, both Baker University in Baldwin City, Kansas, and Columbia University in New York City presented Sickman with doctorates in humane letters for his distinguished contribution to the study of Asian art. Later, Sickman was awarded the Hill Gold Medal by the Oriental Ceramics Society of London, and he was honored the year after his retirement with a special exhibit at the Nelson-Atkins: *Hills and Valleys Within: Laurence Sickman and the Oriental Collection.* However, Sickman said that "probably the most memorable event of my career" occurred in 1975 when the American Council of Learned Societies invited him, along with ten other American and Canadian scholars of Chinese art and architecture, to tour the People's Republic of China. This trip further enhanced Sickman's reputation as well as that of the museum and led to Kansas City being invited to host a "blockbuster" exhibition, *Archaeological Finds of the People's Republic of China.* Having toured in Europe and then Toronto, the show opened in the United States at the National Gallery in Washington, D.C., before coming to the Nelson-Atkins Museum of Art to run from April 20 to June 7, 1975. Marc Wilson was put in charge of the complicated set-up, as fifteen galleries plus part of Kirkwood Hall were necessary to show the sensational pieces culled from historic sites in China. More than 280,000 visitors toured the impressive exhibition, the costliest and largest exhibit the Nelson had mounted to date.[33]

Meanwhile, Coe was planning another "blockbuster" exhibition, this one to be held in London to commemorate the American Bicentennial. The idea for *Sacred Circles: 2000 Years of North American Indian Art* originated in 1972 when Margaret Weltmer Phinney (Mrs. Robert), a Kansas Citian residing in London, contacted Ted Coe because she knew about his knowledge and interest in Native American art. Coe, in turn, talked with Sir John Pope-Hennessy, director-elect of the British Museum, who presented the idea to the Arts Council of Great Britain, which agreed to sponsor the exhibit. Mrs. Phinney and a ladies' committee began fund-raising, and Coe began collecting objects for the show, taking advantage of business trips and friends to assemble 850 works of Native American art for the exhibition. Having written the catalog and obtained official recognition of the exhibition as part of the United States Bicentennial celebration in Great Britain, Coe was honored to have Vice President Nelson A. Rockefeller open *Sacred Circles* in London on October 7, 1976, where it ran until January 16, 1977. Heralded as a major British tribute to

America's birthday and as recognition of the oldest cultures existing on the North American continent, the show received outstanding reviews. Many Kansas Citians clamored to bring the exhibit home to the Nelson-Atkins Museum of Art, and Coe began seeking grants to be able to do so.[34]

When the University Trustees had appointed Ralph Tracy Coe as assistant director in 1965, Sickman had said he would be ready to retire in five years. However, in 1971 on the brink of his sixty-fifth birthday, Sickman asked the trustees their opinion of him staying on; they responded enthusiastically. Now six years later, at age seventy and after twenty-four years as director, Sickman was ready to become director emeritus as well as curator emeritus and resume the research and writing he had long neglected. Lauded for his many years of devoted hard work, Sickman would still spend most of his days of retirement at the museum, working as a consultant to the trustees, giving lectures, and completing a long-delayed publication on Chinese painting.

PART IV

AN ART MUSEUM FOR THE PEOPLE

DIRECTOR RALPH T. COE

W HEN RALPH T. Coe became director of the Nelson-Atkins Museum of Art on February 1, 1977, hundreds of letters of congratulations poured in from patrons, other curators and directors, art dealers and critics, university and college administrators, people who had worked on Ted's house, family, and friends far and wide. Many spoke of Coe's enthusiasm, connoisseurship, and dedication. "There should be bells and balloons to celebrate," acclaimed long-time docent Ruth Trelease. "Your appointment is a tremendously important one for the Gallery, Kansas City, and the entire region," noted Stu Hutchinson on behalf of the Friends of Art. Art dealer Germain Seligmann and his wife, former Nelson-Atkins director Ethlyne Jackson, congratulated Ted, "You know, of course, how close your museum has been to our hearts, Ethlyne's and mine, and it is thus particularly welcome news that another friend will now be in charge of that great institution." Kate Schaeffer from the Schaeffer Galleries in New York noted, "There are not many people of your enthusiasm and gifts so predestined for this position as you are, and I find it a great satisfaction that the right man comes to the right place."[1]

Of all the notes that Coe received, probably the one he most appreciated came from "Uncle" William Milliken, whom he had always admired and wanted to emulate. "It is a well deserved Triumph," Milliken said, "and your friends are delighted and Kansas City is lucky." Milliken also remembered that in 1931, the year he became director of the Cleveland Museum of Art, the Guelph Treasure arrived, establishing his reputation. In like manner, in Ted Coe's debut year, his *Sacred Circles* exhibition of American Indian art would be coming to Kansas City. For Coe, it was perhaps the best and the worst of times to assume his new position. Although this exhibit would bring the same kind of fame and glory to both Coe and the Nelson-Atkins as the Guelph Treasure

had brought Milliken and the Cleveland Museum of Art, Coe would be caught in a whirlwind trying to organize the exhibit, continue acting as a curator, and fulfill his many new responsibilities as director. Meanwhile, the Board of University Presidents now realized that the Nelson-Atkins Museum of Art had become a business far too large for three part-time trustees to manage and was ready to expand the governing base and seek a more secure financial foundation. Although many events and activities kept the museum vibrant, change was desperately needed.[2]

Coe was one of those people who could and would, on occasion, work himself sick, according to longtime friends. His directorship began with the potential to do just that. He now had fourteen curators and staff members reporting to him, but since he had no executive authority, Coe had to pass all decision-making on to the University Trustees, who, in turn, consulted him on a variety of issues. Just days after Coe had taken the helm, the University Trustees approached him to solicit his opinion on a proposed new membership group, a Contemporary Art Society that would sponsor and fund contemporary art shows approximately two to four times a year. Coe was enthusiastic about the idea and encouraged the trustees to approve the bylaws drafted by members of this new organization. "Many of you remember," Coe wrote in a letter to Friends of Art members, "that during the 1960's the Nelson Gallery was a leader in contemporary exhibitions, both in number and scope." Many of these shows Coe himself had organized. He regretted that because of budget constraints and other commitments, the museum had maintained a less active role in contemporary art. Now, however, with the University Trustees' approval, the Contemporary Art Society might amend this neglect. Since Ellen Goheen had become the first curator of Twentieth-Century Art in 1975, she would be their liaison. The group immediately began by supporting a February 1978 exhibit of Jasper Johns prints and lithographs organized by the museum, and by planning for a major work by environmental artist Christo Javacheff to do *Wrapped Walkways* in Loose Park in September 1978. When first announced, this latter project caused local controversy and confusion, but the 13,400 feet of golden walkways brought international attention and acclaim to the city and to the museum.[3]

Coe also plunged headlong into various speaking engagements. Seven days after he moved into his new office, he headed for New York to give the keynote address at the American Federation of Arts (AFA) meeting. His lecture— "American Indian Art Today: Lost and Found Traditions"—was, according to the president of the AFA, "a great success." Just a week later, Coe's secretary,

FIGURE 16.1 The newly created Contemporary Art Society planned *Wrapped Walkways,* by an environmental artist Christo Javacheff. The golden sidewalks in Loose Park attracted much media attention and were used by bikers and walkers. (VRLSC, NAMA)

June Finnell, cautioned him that he had already scheduled three more speaking dates in February, seven events in March, and six in April and May outside of the museum. Also in May, as a trustee of the AFA Board, he would be hosting and speaking at their spring meeting in Kansas City. Then in August, Coe would be one of the speakers to dedicate the Helen Foresman Spencer Museum of Art at the University of Kansas. In addition, he had plans to give lectures to docents and visitors. Coe, however, apparently unconcerned about himself being overscheduled, sent a memo to Ross Taggart, Ellen Goheen, and Marilyn Stokstad telling them to pay attention to the crowded lecture schedule. Besides lectures, it seemed that Coe was forever planning dinner engagements: after every major exhibit, for every important new acquisition, in appreciation of every new major gift. Then, of course, the *Sacred Circles* exhibit, which the public could view from April 16 until June 19, 1977, involved a great deal of the director's time.[4]

Coe was able to bring *Sacred Circles* to Kansas City from London because of grants he obtained. The National Endowment for the Arts (NEA) granted $100,000, and an additional $17,500 from the NEA Folk Art Department, which was matched by another $100,000 from the National Endowment for

the Humanities (NEH). Then when the exhibition needed a major corporate contributor, Dutton Brookfield had been instrumental in soliciting American Can Company, which contributed $100,000. Another $260,000 was raised in Kansas City in a campaign spearheaded by Coleman Branton and Morton Sosland. Several months after the *Sacred Circles* exhibition closed in Kansas City, when Coe was asked to speak before the Senate and House Appropriations Subcommittees, he said it was his "pleasure to testify as to the deeply salutary effects that grants from the National Endowment for the Arts have had upon the Nelson Gallery of Art of Kansas City, Missouri" and also on the city, as the Chamber of Commerce estimated that $8 million were added to the local economy during the *Sacred Circles* exhibit. More important, Coe noted, the exhibition "was the largest educational program ever mounted with Native American participation," with two hundred Native American dancers and artists. Five hundred elementary and secondary schools sent 25,220 students to see *Sacred Circles*, along with eighty-seven university groups and seventy art interest groups. In all, 241,175 visitors from across the country toured the exhibit, boosting the Nelson-Atkins's annual attendance to a near-record 480,224. *Sacred Circles*, the most comprehensive exhibition of American Indian art ever assembled, was quite an undertaking, but an unmitigated success. Tim Doke, director of communication for the State of Missouri, congratulated Coe, "I know Kansas City is proud of you—and so is the state of Missouri."[5]

Even while *Sacred Circles* was on exhibit, Coe was beset by a large number of collectors who wanted his assistance. From the beginning of his tenure at the Nelson-Atkins, he had encouraged art patrons, regardless of how much or how little money they had, to find a field they loved and to start collecting. Coe noted that even if only a small percentage of art works collected eventually entered the museum, "the stimulus provided the community and the involvement of persons in an intelligent way with the Gallery, its programs and standards, is in itself ample excuse for collaboration between staff members and interested collectors." In 1965 when the Society of Fellows was created, one of the benefits was that members could solicit art advice from curators. Coe noted in his 1965 *Annual Report* that he had worked with Helen Spencer, who purchased a Renoir pastel and a Berthe Morisot oil that year, with Mr. and Mrs. Morton Sosland, who had begun a collection of African and American Indian art, and with Mrs. C. Humbert Tinsman, who was interested in American painting. Other patrons he advised included Herman Sutherland, Mr. and Mrs. Crosby Kemper, Richard Bloch, Jean McDonald, Susan

Buckwalter, and Mrs. Barney Goodman. Mr. and Mrs. Jack W. Glenn "deserved special commendation," for they, as young collectors, had "assembled the most important modern collection now in the city, but willingly parted with one of their best paintings for purely altruistic reasons," a painting placed on display at the Nelson-Atkins.[6]

Now as Director Coe, he was still writing letters to dealers and artists trying to make connections between art patrons and works in which they would be interested. With Coe's influence, Donald D. (Casey) Jones, ombudsman for the *Kansas City Star*, began what would become an impressive collection of Native American art, which he would bequeath to the museum. Coe continued to find works of art that would please Helen Spencer and many other patrons. He had also begun to help Marion and Henry Bloch assemble a superb collection of Impressionist art, which would have a huge impact on the museum in later years.

Besides the success of *Sacred Circles*, another serendipitous coup during Coe's first year as director was the announcement of a number of important acquisitions. Writing in September 1977 to Adelyn Breeskin, consultant for the National Collection of Fine Arts at the Smithsonian, Coe gushed, "For the first time, the Nelson Gallery is going to have a good many millions in European and American acquisitions to announce over the year. I am really amazed myself and suppose it will never happen again." To begin with, banker R. Crosby Kemper generously augmented the American painting section of the museum with "a large and important" work by Frederic Edwin Church, *Jerusalem from the Mount of Olives*. When Coe's friend W. Howard Adams, director of the National Gallery of Art, wrote to congratulate Ted on the purchase of the Church painting, Coe proudly informed him that the Enid and Crosby Kemper Foundation gift also included two portraits by John Singleton Copley (*Portrait of John Barrett, Portrait of Mrs. John Barrett*), Winslow Homer's *Gloucester Harbor*, and two American genre paintings, William Sidney Mount's *Winding Up* and Eastman Johnson's *Thy Word Is a Lamp Unto My Feet and a Light unto My Path*. These gifts, which Coe said raised "the status of our American holdings to first class," resulted in a special exhibition held in December 1977, *Kaleidoscope of American Paintings: Eighteenth and Nineteenth Century*.[7]

Other important gifts that year included a beautiful Hopper watercolor, two Henry Moore sketches, an Archipenko sculpture, and "a fine Rigaud portrait." The Hyacinthe Rigaud *Portrait of the Marquise d'Usson de Bonnac* was acquired through the generosity of Mary W. Runnells. Back in 1969, Mrs.

FIGURE 16.2 The Enid and Crosby Kemper Foundation generously augmented the American painting collection, beginning with the monumental work by Frederic Edwin Church, *Jerusalem from the Mount of Olives*. (Gift of the Enid and Crosby Kemper Foundation, F77-40/1)

Runnells had written a letter to Laurence Sickman, informing him that she wanted to leave something to the museum in memory of her parents, Mr. and Mrs. Henry Malcolm Withers, former Kansas City residents. First, Mrs. Runnells suggested giving the museum a new period room, which Sickman discouraged. Conversations continued, with talk of a curatorial chair or a gift to the library, and finally in 1975 and 1976 Mrs. Runnells sent two $50,000 checks with instructions to Ted Coe to search for a portrait that would please her. Coe's first offering was a portrait of a young man, which Mrs. Runnells rejected, as he "looked much too French, arrogant, and snooty, and her parents would not like him." In 1977 Coe found the Rigaud portrait, which Mrs. Runnells liked very much and would also be a great addition to the Nelson collection. Unfortunately, Mrs. Runnells died before she could see her gift hanging in the museum she and her parents had loved so well.[8]

Then, almost magically, in September 1977 The Anonymous Donor appeared, sending a check for $1 million to Coe through the United Bank of Arizona. The donor requested only that the money be used "to buy colorful paintings like that Paris view Mrs. Spencer bought for you." Obligingly, Coe purchased *Landscape in Le Pouldu*, a painting by Paul Gauguin, completed

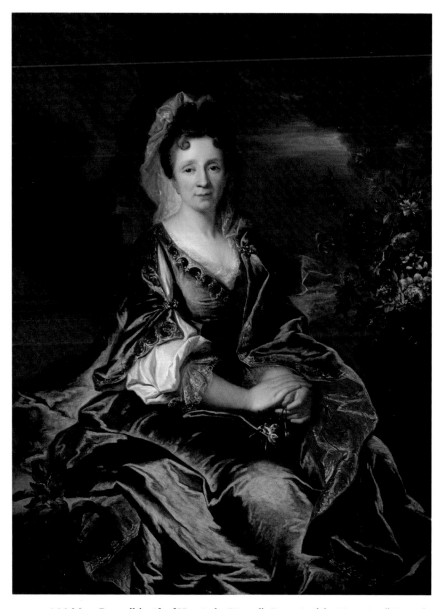

FIGURE 16.3 Mary Runnells's gift of Hyacinthe Rigaud's *Portrait of the Marquise d'Usson de Bonnac* was a very welcome addition to the museum's notable French eighteenth-century painting collection. (Purchase: acquired through the generosity of Mary Runnells, F77-14)

in 1894 in Brittany. The Anonymous Fund also bought Mary Cassatt's *At the Theatre*, which Coe claimed "is a candidate for the most beautiful pastel executed by an American artist." Later in 1977, another million-dollar check came from The Anonymous Donor, followed by a third and a fourth in 1978. With these funds the museum purchased six more fine European paintings: Paul Signac's *Chateau Gaillard, View from My Window, Petit-Andely*, a pointillist landscape; Edgar Degas's elegant pastel, *Little Milliners*; Jean Baptiste Siméon Chardin's *Still Life with Cat and Fish*; Berthe Morisot's *Daydreaming*; Giovanni Paolo Panini's *View of the Piazza del Popolo, Rome*; and *The Holy Family with the Infant St. John the Baptist and an Angel* by Guilio Cesare Procaccini.[9]

In all, between August 1977 and December 1979, The Anonymous Donor gave the Nelson-Atkins Museum five $1 million checks. The final contribution was made at noon on December 19, 1979, a Monday, a day the museum was closed. The mysterious benefactor arranged to meet Director Emeritus Laurence Sickman on the north steps of the museum. With his wife at the wheel of a white Cadillac with enormous fins, The Anonymous Donor got out of the car and handed Sickman the last check along with the personal message to use this money to buy works "in areas and of a kind that would bring me particular satisfaction and pleasure," Sickman related. "Seldom in my long career and never since my retirement have I had cause for so much gratitude," he emoted. Sickman "was in seventh heaven," according to Coe, especially since just a few days before this windfall, Wilson and Sickman had gone to the University Trustees with a request to buy a very special Chinese painting. The trustees had said they might be in favor of the purchase if the two men could find the money. Thus, thanks to The Anonymous Donor, the Nelson Trust was able to purchase a handscroll attributed to Qiao Zhongchang, *Illustration to the Second Prose Poem on the Red Cliff*, which, according to Wilson, is perhaps, the greatest late eleventh- to early twelfth-century Chinese painting in existence. "No other donor has given so generously in our forty-six year history," Coe wrote The Anonymous Donor, also relating that new postcards had been issued of four of the paintings that were purchased from The Anonymous Fund, and that the *Star* had just printed a color supplement to the paper that featured two of the donor's paintings—the Degas and the Berthe Morisot.[10]

While the director and the curators spent a great deal of energy wooing patrons and advising local collectors, gifts also came from donors outside Kansas City. Because of the esteem in which the Asian Department was held,

FIGURE 16.4 With money given by an anonymous donor, the museum was able to purchase several important works of art, including this pastel by Berthe Morisot, *Daydreaming*; the image was featured on postcards and in the *Kansas City Star*. (Purchase: acquired through the generosity of an anonymous donor, F79-47)

Marc Wilson had been able to attract donors like John Gruber of Washington, D.C., Mr. and Mrs. Frederick Kaler of Damariscotta, Maine, and John M. Crawford Jr., whom Wilson identified as "an internationally known collector from New York and long-time friend of the Gallery." Wilson had also developed a special relationship with Edith K. Ehrman, whose daughter (also named Edith), a collector of Japanese prints, had died at the young age of forty-two. To honor her daughter, Mrs. Ehrman had started the Edith Ehrman Memorial Fund, which began contributing $25,000 annually to the Nelson-Atkins for the purchase of Asian works of art, including the beautiful *Cosmic Mirror Stand*. Other gifts from non-resident donors increased, Director Coe explained at the annual meeting of the University Presidents and University Trustees in 1977 "as the reputation of the Gallery for fine installations and painstaking maintenance spreads beyond the immediate region." He specifically acknowledged the receipt of "a collection of superb,

FIGURE 16.5 The museum acquired many Asian works of art, such as the *Cosmic Mirror Stand*, through the Edith Ehrman Memorial Fund. (Purchase: the Edith Ehrman Memorial Fund, F95-18/2)

historically significant Napoleonic silver," presented by Mrs. Dan Gerber Sr. of Fremont, Michigan.[11]

Coe could not help but feel ebullient after his first full year as director. His accomplishments were recognized by University of Missouri President James C. Olson, who praised him for "outstanding achievement," and by University of Kansas Chancellor Archie Dykes, who wrote that because of Coe's "remarkable contributions . . . the year just concluded has been one of the great ones in the history of the Nelson Gallery." Now, at the beginning of 1978, Ted Coe turned his attention to staffing; important posts were unfilled.[12]

First, Coe suggested that the trustees interview Edgar Peters Bowron for the position of curator of European Art. Bowron, who was currently working at the Walters Art Gallery in Baltimore, was a graduate of Colgate, held an MA from the Institute of Fine Arts at New York University, and was working toward a PhD, which he would receive in June 1979. Bowron was also married and had three children, which the University Trustees considered a positive attribute, as they held the notion that having a spouse as a helpmate and hostess was important for any curator or director. Bowron was invited to visit Kansas City, where further discussion ensued. The trustees initially were concerned that Bowron was relatively young to hold the position—thirty-four years old—but then Wilson was thirty-six years old and had been curator of Oriental Art since he was thirty-two. The trustees then proposed inviting Bowron to work at the museum on a trial basis for six months, and "if his work was entirely satisfactory," they would invite him to stay. Understandably, Bowron did not favor this idea.[13]

Finally, in March, with the trustees' blessing, Coe approached Bowron with an offer to become both administrative assistant to the director and curator of Western European and Renaissance Art. This appointment would allow Coe to continue as curator of Nineteenth-Century Art; Ellen Goheen, curator of Twentieth-Century Art; and Marilyn Stokstad, as a consulting curator of Medieval Art, while Marc Wilson headed the Oriental Art Department; George McKenna served as registrar and curator of prints, and Ross Taggart remained senior curator. To facilitate the Bowrons' move, Milton McGreevy talked to Headmaster John Stander at Sunset Hill to arrange a teaching job for Mrs. Bowron and to ensure that the Bowron children would have free tuition at Sunset Hill and Pembroke Country Day. After both Mr. and Mrs. Bowron visited in April for another interview and lunch with the trustees and their wives, Bowron received a definite job offer as well as a place to live: the first floor of the duplex owned by the museum at 420 East Forty-Fifth Street. Bowron would start at the museum on July 1.

FIGURE 16.6 On July 1, 1978, Edgar Peter Bowron started his tenure at the museum as curator of Western European and Renaissance Art. Here, he appears flanked by Kathy and Ross Taggart at a Friends of Art, Art Deco Soiree. (RG 43/02, NAMAA)

Coe and the trustees began interviewing candidates for other positions. They hired Beverly Rosenberg as the first-ever public information officer. Previously, the museum had depended on a loose relationship with *Star* employees, Donald D. (Casey) Jones followed by Donald Hoffman, to handle publicity, which would be one of Rosenberg's jobs. Another target was for her to find a way to attract a broader audience to the museum, especially young people.

Besides Ms. Rosenberg, the museum also sought a new librarian, as Anne Tompkins had resigned. On February 9, 1978, Katherine Haskins, who ran the periodicals department in the Metropolitan Museum of Art library, came for an interview. The University Trustees were favorably impressed, and Coe arranged for her to start on May 1, 1978. When Haskins arrived at the Nelson-Atkins, she found most of the library's 15,000 volumes had been relocated to what had been art storage space, and she would be working from a temporary art reference desk in the Westport Garden Room. Construction of the new Kenneth A. and Helen F. Spencer Art Reference Library had begun in summer 1977 with excavation of the southwest terrace to create an 8,900 square foot underground area for the stacks, above which, on the ground floor, offices and a wood-paneled reference room would be located.

FIGURE 16.7 The grand opening of the Kenneth A. and Helen F. Spencer Art Library, which featured a wood-paneled reading room, was held in October 1978. (RG 30, NAMAA)

The grand opening of the new art library on October 25, 1978, should have been an exciting time to be the Nelson-Atkins librarian, but Haskins experienced a year of deep frustration. She complained to Coe about the museum's library funding and staffing, which she said fell "woefully behind its sister institutions." The St. Louis Art Museum had four librarians on staff; Cincinnati, five; Minneapolis, five; Detroit, four. Coe agreed that Haskins probably needed an assistant and asked her to write a job description and an advertisement. The museum, however, was unable to resolve Haskins's issues, and in November, Kathy Haskins tendered her resignation, effective December 14, 1979. She said she believed that her mandate had been "to create a viable and dynamic department," but due to "woefully inadequate staffing conditions," such was "patently impossible." Discouraged by the lack of funds and support, Haskins moved on to the Art Institute of Chicago.[14]

By February 1980, Coe had found a likely candidate to become the next librarian, Stanley Hess. Assistant librarian at the Cleveland Museum of Art, Hess came to the Nelson-Atkins Museum of Art in June with very definite

ideas, beginning with the benefits and salary he needed, and then turning to the matter of improving the library. He began by insisting on a no-smoking policy and a better cataloging system. Like his predecessors, Hess realized that the library needed increased funding and staffing. Although gifts and grants to the library had come from many sources besides Mrs. Spencer, including the Merrill Trust, the Rockefeller Foundation, the Kress Foundation, and private patrons including Jack Morgan, Milton and Barbara McGreevy, John Bender, Donald Hoffman, Donald D. Jones, and Richard Wood, a donation program needed to be established. A meeting with Jack Morgan produced a plan to form a new membership group: the Friends of the Kenneth and Helen Spencer Art Reference Library. Hess also organized a new cataloguing center, which opened in December 1981 with a small celebration that was "modest but very pleasant," Coe reported to "Aunt Helen" Spencer.[15]

Larry Eikleberry, director of education, left the museum in June 1978. Coe felt that the Education Department had lacked supervision, and he was especially disappointed that Eikleberry had not taken advantage of opportunities to involve the Education Department in the *Sacred Circles* exhibition. Therefore, Coe decided to seek a new education director "in order to orient the Education Department more toward museum functions (exhibitions, interpretation of collections, university liaison, symposiums) and to provide new stimulus and leadership for its program in general." When Ann Brubaker, who had been a Rockefeller Foundation Fellow at the Metropolitan, applied for the position, Coe and the trustees recognized that she was the perfect fit.[16]

Brubaker became director of education in mid-January 1979. "Her department's task for the near future," Coe stipulated, "will be to develop adult programs in art interpretation to parallel the strength we have had in children's programs and to work more closely with our exhibitions." Indeed, as a start, Brubaker and UMKC faculty coordinated a lecture program for the Folger's traveling exhibition *Shakespeare: The Globe and the World*, and she trained docents to conduct mini-tours of both the Shakespeare show and of museum highlights. Brubaker also made plans to restore and expand the Creative Arts Center, which had been "a nationally recognized model for museum-based-educational programs for children" under Eikleberry's predecessor, Seidelman, and which would regain much of its former eminence under the guidance of Anne-Marie Hunter. In addition, Brubaker inaugurated two new school tours and began the development of model adult education programs that would serve to attract funding, so essential to the Education Department. By spring 1980, Brubaker had secured grants from the George and Dolly La Tour Trust and the Parker B. Francis III Foundation to initiate adult programs over the next three years.[17]

FIGURE 16.8 Ann Brubaker
began as director of the
Education Department in
January 1979. (NAMADAA)

Although the University Trustees recognized that the curators were over-burdened and that the museum required more staff, by the end of 1978, their funds were so stretched that they began to seek a way to reduce personnel. Ten new people had been hired in the past year, and although most of these new hires replaced personnel that had left, the trustees felt that at least two of those positions should be eliminated. Why does Ross Taggart need an assistant, they queried, even though Taggart was juggling three jobs as curator of the Ancient World, curator of Decorative Arts, and curator of American Art? The trustees also questioned why Coe had insisted that a secretary be added to the payroll to assist Goheen and Rosenburg. As they set wages for the year, the University Trustees budgeted small raises for Director Coe, who earned slightly more than curators Ross Taggart, Marc Wilson, and Edgar Peter Bowron, while Ellen Goheen's salary was increased to less than half of her male colleagues, due partly to the fact that she did not have the credentials or experience they had.[18]

In an attempt to deal with their financial issues, six weeks before Coe assumed the directorship, the University Trustees had invited a consultant to come to Kansas City to talk with them and Society of Fellows president Dr. Nicholas Pickard about ways to gain corporate support for the museum. At the meeting ten ideas were generated, all of which seemed reasonable except for "A successful approach is to get a good group of gals to go up and down Main Street." This suggestion naturally was not used, but the Society of

Fellows began a new push to acquire corporate sponsors by making corporate membership in the Society of Fellows desirable and prestigious.[19]

With this thought in mind, in January 1977 Dr. Pickard visited a premiere Kansas City business, Hallmark Cards. Following a lengthy luncheon meeting, Hallmark executives said they would like to help the museum, but first the gallery needed to eschew its "ivory tower" attitude, involve more people in the community, and, most important, develop "a master plan that charts a future course." William A. Hall, assistant to the president of Hallmark, asserted that, if asked, the business community could offer many resources, including help with fund-raising, public relations, education, acquisitions, and exhibition.[20]

Just ten days after the Hallmark meeting, the Society of Fellows discussed appointing a Development Committee with a goal of building an endowment fund and involving a minimum of 125 corporate donors. In December 1977, Pickard suggested to Sickman and the University Trustees that the museum issue a revised "Nelson Gallery Foundation: Statement of Need" that would read, "The Nelson Gallery is a great cultural asset in Kansas City. . . . Our budget is amazingly small compared to that of other museums of similar quality and size." The museum needed help from the community because of (1) increases in wage scales, supplies, expenses, and (2) increased activity and greater public use. The statement would also elaborate the effects that monetary gifts would have on the museum.[21]

None of these ideas seemed adequate to cover the inadequacy of the budget and the overburdening jobs hoisted on staff and trustees. In the *Annual Report* of May 1, 1979, to April 30, 1980, Director Ralph T. Coe quoted his old friend Martin Friedman, director of the Walker Art Center in Minneapolis, who likened the Nelson-Atkins to a "sunken treasure." Coe said that the museum, with its excellent collection and beautiful facility, was "in a position to, and should be capable of exerting the cultural leadership its eminence as an art museum indicates." However, because of a $1.2 million budget, which was inadequate to manage the museum, "we may be following rather than leading" comparable museums, he feared. Moreover, "that descent would be a disaster for the Gallery and its hard-working staff, and it would have tragic repercussions in the community and region it serves." Although Coe admitted that "running a lean ship has its virtues, this philosophy has been carried as far as to infringe upon the best energies of the curators." In fact, Senior Curator Ross Taggart had grown tired of juggling multiple jobs and wished to retire in 1980, but the trustees convinced him to stay until the golden anniversary year of 1983. Barbara Rahm, who had coordinated gallery events for many years without

pay and been "promoted" to yet another unpaid position as assistant curator of special events, had been stretched beyond her limits and retired in 1980; she was replaced by a full-time, paid coordinator of special gallery events, Ruth "Boots" Leiter. Coe summarized what he saw in spring 1980: "While I am not advocating wholesale readjustment or panic to the situation," changes needed to be made "if the museum is to keep abreast of its peers and pull its weight as a qualified educational institution."[22]

One change that Coe felt would help the Nelson-Atkins keep up with its peers was to have a loan policy that allowed the museum some leverage to borrow pieces of art from other museums. Since before the museum opened, the trustees had questioned the ability of the Nelson-Atkins to be able to loan out art objects, based on the provision of Nelson's will that required that "all works and reproductions of works of fine arts purchased by the university trustees under the provisions of said will and testament shall be kept and remain at all times in Kansas City, Missouri." Through the museum's attorney, Robert Donnellan, Coe sent letters to Frederick L. Cummings, director of the Detroit Institute of Art; Sherman E. Lee, director of the Cleveland Museum of Art; Sir John Pope-Hennessey, chairman of the Department of European Painting at the Metropolitan; and Nancy Hanks, past chair of the National Endowment for the Arts, asking them to bear witness to the importance of major museums being able to loan art objects. The University Presidents went to probate court, and on March 7, 1980, the Circuit Court of Jackson County, Missouri, "ordered that the University Trustees are authorized to make temporary loans of works purchased under the provisions of the will of William Rockhill Nelson to such galleries, museums, and places of public exhibition, and on such terms and conditions, as in the judgment of the University Trustees will further and promote the objectives and purpose of Mr. Nelson's will, consistent with due care for the protection and preservations of the works." Thus, the court agreed with the casual opinion Meservey and Wilson had rendered in 1934 that the Nelson-Atkins Museum of Art should be able to borrow and loan works of art, thus fulfilling the purpose of Nelson's will to provide "works of fine arts which will contribute to the delectation and enjoyment of the public." Expanding the Nelson-Atkins's loan policy officially and legally was a major breakthrough.[23]

Meanwhile, the museum carried on—with tours, lectures, and exhibitions—as if there were no obstacles. Lectures sponsored by various groups continued, and in spring of 1981, Ethel B. Atha decided to start the Joseph S. Atha Memorial Lectures "to be delivered annually at the Nelson Gallery by distinguished scholars in the art world." Modest exhibitions included one on Japanese

woodblock prints put together by Jeanne Harris, assistant curator of Oriental Art. "The beautiful installation," according to Marc Wilson, "has not received the notice it deserves." The Friends of Art Guild organized an exhibition of American modernist painter Arthur Dove's work. Also, another "blockbuster" exhibition, *Eight Dynasties of Chinese Painting*, opened November 7, 1980. The Nelson-Atkins cooperated with the Cleveland Museum of Art, and the show drew enthusiastic responses from the general public as well as the professional community. Education Director Ann Brubaker prepared slide and text kits for teachers to use in conjunction with the exhibit, conducted teacher workshops, and developed a docent tour. Seven renowned authorities, including Director Emeritus Laurence Sickman and Curator of Oriental Art Marc Wilson, gave lectures on Sunday afternoons, which were free and open to the public. The impressive catalogue, *Eight Dynasties of Chinese Painting: The Collections of the Nelson Gallery-Atkins Museum, Kansas City, and The Cleveland Museum of Art*, featured essays by Wai-kam Ho, Sherman E. Lee, Laurence Sickman, and Marc F. Wilson. The Society of Fellows held its annual dinner the evening before the public opening of the exhibit and invited the Cleveland Museum of Art trustees and Director Sherman E. Lee. This "blockbuster" exhibit, followed by two more large exhibitions that winter, *Constructivism and Geometric Tradition* and *5000 Years of Korean Art*, as well as other smaller temporary displays, contributed to the exhaustion of the staff but increased attendance at the museum.[24]

With Milton McGreevy's resignation in March 1980, after thirty-one years of productive and dedicated service, the advent of a new University Trustee, Donald J. Hall, Hallmark Card's chief executive, provided a new perspective on the future of the museum. Having been in charge of a large corporation for many years, Hall immediately put his organization at the museum's disposal and recommended calling in consultants and relying on experts in various fields. The upcoming fiftieth anniversary of the Nelson-Atkins Museum of Art in 1983 provided additional motivation and opportunity for reorganization, goal-setting, and fund-raising, sparked by a surprising $1 million gift in 1980 from William Rockhill Nelson's *Kansas City Star* to celebrate the paper's one hundredth birthday.

The University Trustees—Hall, Sutherland, and Blackwell—decided a first step toward reorganization would be to hire someone to study the business operations of the museum, and the Hall Foundation agreed to pay for a consultant for three years. In an unprecedented move, the University Trustees called together an advisory group that interviewed several candidates and selected

FIGURE 16.9 With Milton McGreevy's resignation in March 1980, Donald J. Hall became a new University Trustee, contributing his expertise and putting his organization at the museum's disposal. (RG 70, NAMAA)

Arthur C. Frantzreb from McLean, Virginia, as a development consultant. After Frantzreb spoke with many members of the community, trustees, and staff over a period of several months, in November 1980 he issued a "State of Readiness Audit for Increased Philanthropic Support." Frantzreb pointed out that even though "the Gallery stands as the crown jewel among all regional educational and cultural institutions," it lacks certain criteria necessary to successfully launch a major fund-raising campaign. Specifically, to get support, donors needed to have confidence in the organization and administration of the institution as an educational and cultural asset. The museum needed to have a plan of action and a case statement to identify to private donors what the museum could and would do for the general public. All in all, on a scale of one to ten, the Gallery stood at three in terms of state of readiness to launch a major fund-raising drive.[25]

Frantzreb made five recommendations for the Nelson-Atkins Museum of Art to implement before it could move forward. Over the next year, the University Trustees acted on each of these recommendations. To begin, the museum retained a qualified management-consulting firm, Lawrence-Leiter & Company. One of their first steps, completed in December 1980, was to

identify the functions of each person who worked at the museum. The "State-
ment of Functions" for Coe consisted of seven, single-spaced pages and result-
ed in a determination that immediate steps needed to be taken to reduce the
overwhelming load placed on the director.[26]

Creating an internal planning committee "to study the role, mission, and
future direction of the Gallery" was Frantzreb's second recommendation.
Coe quickly established the Committee on the Future and asked Edgar Pe-
ter Bowron to head it. The committee met regularly during the fall of 1980
and accumulated reports from all senior staff members. Bowron himself
wrote the introduction on general curatorial information in which he stated
that although a curator at the Nelson has no job description, he or she "is re-
sponsible for knowing the art market and the important dealers and scholars
in his field, is expected to know what additions to the Gallery's collections
are desirable and be informed to make the qualitative judgment relative to
an acquisition." The curator also needs to publish, put together exhibitions,
and interpret and maintain the collection. However, Bowron said that without
additional staff, Nelson-Atkins curators are very limited in being able to fulfill
all these expectations.[27]

Reports from other senior staff members echoed Bowron's overall assess-
ment: Curators and staff were frustrated and felt overworked. Ross Taggart,
who had joined the staff in 1947 as registrar and was now senior curator,
lamented that he was involved in too many fields to do his work complete-
ly, and when he retired his position should be divided among three curators.
Moreover, his secretary, Mrs. Jean Drotts, had an impossible job. Not only was
she responsible for Gallery labels for the permanent collection and for exhi-
bitions, but she was also secretary to Marc Wilson (curator of Oriental Art),
Mike Hagler (gallery designer), and Mrs. Leiter (special events coordinator).
Ellen Goheen, curator of Twentieth-Century Art, said that because her depart-
ment had no mandate under the terms of Nelson's will, it had little support
from the trustees. Her job involved giving lectures and advice to collectors
and attending meetings as liaison to three membership groups—the Friends
of Art, the Guild, and the Contemporary Art Society—which left little time
for researching or managing the collection as she should. George McKenna,
as curator of Prints and Drawings as well as registrar, admitted that his morale
was low and his expectations "largely unfulfilled." His registrar's duties occu-
pied 90 percent of his time, and no funds existed for acquisition of prints. For-
rest Bailey, the conservator, reported that his department needed equipment
and money; he himself was paying for more than half of the consumables.
The librarian, Stanley Hess, said that in relationship to comparable American

museums, the Nelson's fine arts library collection was "an embarrassment." Marc Wilson perhaps summed up the situation best in his report: "It is evident that the Nelson Gallery-Atkins Museum is in transition. It is evident that the institution will expand and change in some ways. It has already begun to do so. It is also evident that, with ever increasing demands on the staff, the personal capacities of many persons have been strained to the limit and exceeded."[28]

Another of Frantzreb's recommendations was to reorganize the museum's finances. With a "Statement of Resolutions," written by the trust's attorney, Robert Donnellan, the University Trustees were able to legally consolidate the Nelson Foundation and the Nelson Trust into one account, with the foundation account being used for operations of the museum and income from the trust being dispersed to the foundation for the purchase of works of art. In April 1981, the trustees hired Steven P. Geiger as the gallery's first comptroller, and the gallery's Accounting Office moved into the museum. Hiring a comptroller was not enough; the museum really needed a business office. However, because William Rockhill Nelson's will had given the University Trustees the sole authority to control, invest, and reinvest income from the Nelson Trust, in order to hire a money management person or firm, Attorney Donnellan had to present the case to the Circuit Court. In July 1981, the University Presidents and University Trustees received a court order authorizing engagement of a professional money manager, and in November, Roger Van Wagoner assumed the position of business manager.

Frantzreb's fourth recommendation was that the museum hire a director of resource development. In June 1981, Nancy G. Holmquist was appointed head of the newly established Resource Development Office. Her responsibilities were "to research and study, design and implement a comprehensive program for financial support of budget and non-budgeted needs, special programs and private projects and endowments through private sector gifts and grants as well as from various agencies and organizations." Holmquist would report directly to Coe and be accountable to the trustees. The museum had never had a development program, and these duties had been spread out randomly, or not at all, as they applied to specific departments.[29]

Besides these new hires, other changes in personnel occurred in 1981. With the completion of the report from the Committee on the Future, Bowron announced his resignation. He had accepted a position as director of the North Carolina Museum of Art in Raleigh and would leave the museum in mid-March 1981. In April 1981, George McKenna relinquished his job as registrar to become full-time curator of Prints, Drawings, and Photographs, a very positive move for him and the museum. In his new position, McKenna

inaugurated a revival of interest in photographs and photographic exhibitions. Although he had little to no money to spend on photographs, he relied on donations that came from many sources, and in 1982 he launched a blockbuster exhibition, *Repeated Exposure: Photographic Imagery in the Print Media*. The idea for this innovative exhibit, which assembled prints that had been inspired by photographs, had originated in a conversation McKenna had with K. D. Bunting as they worked together annually on a photography show for the Sales and Rental Gallery. Sadly, Mrs. Bunting did not live to see *Repeated Exposure*. On May 1, 1981, Karen Dean (K. D.) Bunting died, marking the end of an era, for she had founded and administered the Sales and Rental Gallery for twenty-two years. Diana James now took the helm.[30]

Then Ellen Goheen resigned as curator of Twentieth-Century Art in August 1981 and simultaneously rejoined the staff as a part-time senior lecturer and coordinator of academic programs for the Education Department. In September, Jay Gates, former director of the Brooks Memorial Gallery, became assistant director of the museum, a position recommended in the reorganization structured by the Lawrence-Leiter team in order to relieve the director of some of his duties. Besides the fact that Gates had both administrative experience and a solid art history background, he also possessed "the temperament and intelligence needed to handle his diverse assignments effectively," according to Marc Wilson.[31]

Establishing an expanded governing board for the Nelson-Atkins Museum of Art was the last of Frantzreb's recommendations to be fulfilled. On December 21, 1981, the University Trustees published a document entitled "New Guidelines for the Future: A Broader Base for a Brighter Future," which announced the creation of four new offices: (1) Associate Trustees, (2) a Board of Trustees, which would consist of the University Trustees and the Associate Trustees, and which would have as standing committees: an executive committee, finance committee, acquisitions committee, and a planning and development committee; (3) Honorary Trustees, who could be appointed by the University Trustees because their experience would reflect honor on the museum; and (4) a Board of Governors, whose interest or advocacy for the museum deserved special recognition. In December 1981, three associate trustees were named—John A. Morgan, Estelle G. Sosland (Mrs. Morton), and James P. Sunderland—and by mid-January, Ilus W. Davis, Irvine O. Hockaday Jr., and Jean McDonald (Mrs. William M.) joined the Board of Trustees. Committee assignments were made, and on January 29, 1982, the University Trustees held a reception for the new Board of Governors.[32]

Before the public announcement of the new offices, Blackwell, Hall, and Sutherland planned a meeting to explain the governing changes to the curators and staff, which they asked Coe to set up for January 5. Although the trustees had heard rumors that there was a certain amount of dissatisfaction among the staff, Coe said he "felt things were in hand," that morale was fine. Moreover, the response to the public announcement in January 1982 was very positive. The *Kansas City Star* featured an article about the new management and how good it would be for both the museum and the city. Cliff Jones, though no longer a University Trustee had remained a stalwart patron of the museum, expressed his admiration of Blackwell, Sutherland, and Hall for this "positive, forward-looking move."[33]

Meanwhile, Coe continued to try to keep up with his many obligations. He knew that his most important role at the time was to put the museum in the position to raise money for its fiftieth anniversary. He himself had expressed that goal. However, besides being director of a museum that was in flux, he remained curator of two departments and was searching for people to fill some key positions, especially that of curator of Twentieth-Century Art. He was also organizing various exhibitions, the most important of which featured the work of the eighteenth-century French painter Jean-Baptiste Oudry that he was co-ordinating with the Louvre, which Coe called "a step in the direction of in-ternationalism for the Nelson Gallery." Moreover, he had initiated the Native American Arts and Crafts Show for the American Federation of Art, an exhibit of contemporary work made between 1965 and 1985 sponsored by the Amer-ican Can Company. In order to find Native American crafts, Coe had spent all his vacation time traveling to reservations and gathering material for the show that would open in 1985. The University Trustees were not happy about this endeavor. They "expressed doubt about the interest the Gallery should have in this activity and the amount of time Mr. Coe should devote to it, in light of the current heavy demands for reorganization of the staff and the proposed fund raising program." Coe told them he felt that he had been working on this show on his own time.[34]

In addition to these obligations, in 1981 Coe had been elected president of the Association of Art Museum Directors (AAMD), a great honor but also a time-consuming job, which meant many meetings and time spent away from his desk. He also was on the Selections Committee for the Art Dealers Asso-ciation of America and served on the Museum Advisory Panel for the Na-tional Endowment for the Arts (NEA). Tom Freudenheim, program director for the NEA, had actually written Menefee Blackwell to thank him and the

other University Trustees for sharing Ted Coe: "I realize that such service to all museums appears to be stealing your director away from his pressing tasks at home. But I cannot overemphasize the significance of his help to the museum field, so I must hope you will take pride in that act and in the additional glory it sheds on an already splendid museum."[35]

High praise from outside organizations notwithstanding, Coe's many absences began to pose a real problem. Although he loved being director, a dream come true, maybe it was not truly the job for him, as he also relished curating exhibitions, helping collectors, traveling to find art treasures, researching, and writing. Still, he had an excellent reputation. As recently as 1978, Coe had turned down an invitation to become director of the very prestigious Art Institute of Chicago because he felt he had an obligation and duty to the Nelson-Atkins Museum of Art. He told the chairman of the Art Institute's Board of Trustees, "After several days reflection I have come to the conclusion that I should bring to a solid state the administrative program I have begun here in Kansas City." Then when Chicago's Art Institute hired the director of the St. Louis Art Museum, Coe was again approached to go there. Although he was dedicated to the Nelson-Atkins, he was, perhaps, not the best administrator. He left paperwork undone and could not meet all of the trustees' expectations. On the other hand, the trustees did not fully understand or appreciate Coe's genius and all that he had accomplished in the way of inspiring collectors, creating enthusiasm for art, and instilling a love of the Nelson-Atkins Museum of Art. When on March 8, 1982, the University Trustees announced to the Board of Governors that Ralph T. Coe was taking "an extended leave of absence," they had found a convenient way to avoid admitting they had in fact let Coe go. It was a sad day for the museum and for Coe, and it left the interim director, Marc Wilson, with the very difficult task of bringing the staff together and forging ahead as the fiftieth anniversary celebration drew near.[36]

WILSON FACILITATES A SUCCESSFUL TRANSITION

WHEN THE MUSEUM'S fiscal year ended on April 30, 1983, Marc Wilson declared that it had been "the most momentous year since the institution opened in 1933." Indeed, the University Trustees had initiated sweeping changes in governance, staff, business operations, education, and the building itself. Even the name of the museum had been altered. The long title "The William Rockhill Nelson Gallery of Art and Atkins Museum of Fine Arts" had always proved unwieldy. Thus, the museum had often been referred to as "The Nelson" or "The Gallery," which did not recognize Mary Atkins's role in its establishment. Although native Kansas Citians as well as the *Kansas City Star* would continue to call the museum "The Nelson Gallery," the Board of Trustees and Wilson agreed on a new designation: "The Nelson-Atkins Museum of Art."[1]

Marc Wilson had been the logical choice to become interim director when Ted Coe left in March 1982. Wilson's experience as a Ford Fellow had allowed him to become acquainted with all aspects of museum management, and his seven years as head of the largest curatorial department at the Nelson-Atkins gave him perspective on the demands placed on the museum staff. He recognized that the sweeping changes being made by the board were courageous, necessary, and irreversible, and that his primary duty as interim director would be to help make this period of transition go smoothly. He therefore set three priorities. The first was to "regroup the staff, calm their anxieties, and restore their ability to function as a team working together under an articulated vision for the future." Second, he wanted to put the newly instituted system of governance into effect on a regular, routine basis. Third, he would work on developing plans for the fiftieth anniversary celebration. However, three months into his position as interim director, Wilson said he had clearly had to

concentrate almost solely on priority number one, as the staff had been "hem-orrhaging badly and in danger of massive defection." He also tried to protect current employees from ever-increasing burdens, urging the trustees not to add any more duties as "The staff has more to handle at the moment that it can effectively." Two key curatorial positions needed to be filled; staff additions needed to be made, and a permanent director needed to be found.[2]

Even though Coe's resignation was not announced until June 20, 1982, in April, Laurence Sickman, as consultant to the trustees, mentioned several pos-sible candidates. Meanwhile, with input from Wilson, the consulting firm of Lawrence-Leiter prepared a job description for the new director who, for the first time, would also be chief executive officer. This document, a far cry from the seven-page list of functions that had been Coe's responsibility, included fourteen major duties, one of which was to fully manage one curatorial de-partment "in order to maintain currency in a major field of art history." The University Presidents felt it was important that a national search for a new director be made, so in May the Board of Trustees appointed a search com-mittee. Twenty-one potential candidates presented themselves, and two out-standing applicants came to Kansas City for interviews. When Marc Wilson realized the chief contender for the directorship was his well-qualified friend and colleague Charles S. Moffatt, who was presently the curator of European Art at the Metropolitan and who had been the Ford Fellow succeeding Wilson at the Nelson-Atkins, Wilson decided that he too was qualified and interest-ed in the position. After talking with Marc and with his wife, Elizabeth, the Board of Trustees and the University Presidents agreed that Wilson should be appointed director. Satisfied that they had done due diligence in their search, the board was happy that the right person for the job was already in place. On December 1, 1982, University Trustee Menefee Blackwell announced to the Board of Governors that the Board of Trustees had appointed Marc F. Wil-son as director of the Nelson-Atkins Museum of Art, although, overwhelmed by fiftieth-anniversary preparations, the trustees failed to record Wilson's ap-pointment in their minutes until December 20.[3]

The fiftieth anniversary campaign was vitally important to the museum. James Forbes, who in November 1982 had replaced Nancy Holmquist as di-rector of development, expressed two main goals: "to involve as many people and organizations as possible in the institution so that it becomes an integral part of their lives," and "to provide for the future of the institution so that it may grow and flourish." The board chose a local firm, Fleishman-Hillard, Inc., to coordinate the fund-raising efforts with Forbes and the Planning and Development Committee headed by University Trustee Herman Sutherland.

The theme of "Share the Vision" encouraged new benefactors to follow in the footsteps of other major philanthropists who had made and maintained the museum, identified as Nelson, Atkins, Rozzelle, Kirkwood, Spencer, Kemper, Parker, Grant, Crowell, and Hall. The publicity booklet asserted that the Nelson-Atkins Museum of Art "is at the edge of greatness, propelled there in only fifty years by incredible bursts of generosity and fortune, guided there by talent, hard work, and care." Donald J. Hall, representing the Board of Trustees, and Carolyn Kroh, as president of the Friends of Art, wrote to all of the many friends of the museum, asking for their support and contributions to the Fiftieth Anniversary Fund. Our goal, they said, is to increase museum assets by $50 million to provide "income for operations, conservation of art objects, public service, education, and curatorial function." Considering that the fortieth anniversary had only generated $109,000, this financial target was extremely bold.[4]

However, by the time Herman Sutherland, as chair of the Planning and Development Committee, made the public announcement on February 20, 1983, that the Nelson-Atkins Museum hoped to raise $50 million in its "Share the Vision" campaign, $24.3 million had already been committed, beginning with the $1 million gift from the *Kansas City Star* announced in 1980, and an $11 million pledge from the Hall family designated to support the Oriental Department. Sutherland and his committee members proved to be the right people to solicit funds on behalf of the museum and the city. Donors were urged to think of spreading contributions over several years, of using trust devices, and of endowing galleries and curatorships. Anyone who contributed $250 or more (or $50 each year over the course of five years) would be listed on the Golden Anniversary Tablet, which would be posted in the museum. Besides these incentives, the Planning and Development Committee also relied on civic pride and the public's recognition of the Nelson-Atkins as an institution of enormous importance to the city.[5]

Aside from the money-raising aspects of the fiftieth anniversary, many special events were planned for the golden anniversary year, including lectures, luncheons, tours, and dinners. Over Labor Day weekend, a huge outdoor party attended by about fifty thousand people took place on the museum's south lawn, culminating in a French pyrotechnical artist's performance that quite literally went up in flames when dry grass caught on fire. The event drew much media attention, as did the anniversary jubilee held on the eve of the museum's birthday, December 10, 1983. Barbara Rahm came out of retirement to assist Ruth "Boots" Leiter, coordinator of special gallery events. On the night of the party, flaming torches led the way up the steps into the north entrance of the

museum and into Kirkwood Hall, which was decorated with 3,600 tiny lights and red and gold banners. Guests visited the new installations of Native American and twentieth-century art and toured the thirteen European painting galleries that had been repainted, rehung with new cloth, and re-illuminated. More than 4,000 people were present when University Trustee Menefee Blackwell announced the news that the museum had raised $51.5 million, a phenomenal achievement. The crowd cheered as curtains parted and a ten-tiered cake lit with fifty candles rolled in. The cake, donated by Andre Bolier and his son Marcel, weighed 650 pounds and contained 170 pounds of butter, 50 pounds of chocolate, and 1,300 eggs. It was cut with a samurai sword to much applause. The story of the fiftieth anniversary became even more triumphant as donations continued after the celebration, eventually totaling $58,123,187. Marc Wilson exalted, "We may now look forward to a bright future for the Museum and to fulfilling the expectations implicit in such a generous outpouring of public confidence."[6]

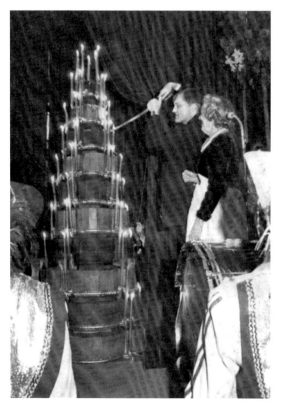

Figure 17.1 Marc Wilson, assisted by Barbara Rahm, lit the candles for the museum's fiftieth anniversary jubilee. (50th Anniversary VF, NAMAA)

Ross Taggart had promised to stay on in his position as senior curator through the museum's fiftieth anniversary celebration, a promise he kept. He had served the Nelson-Atkins ably for thirty-six years. "No other employee of the institution within my memory," Wilson related to the Board of Trustees, "has sacrificed so much for the well being of the museum as has Ross." Ross's wife, Kathy Taggart, had retired in 1982 after ten years as executive secretary of the Society of Fellows and various other duties before that. Wilson suggested that the board consider giving the Taggarts round-trip plane tickets to London as well as a $1,000 stipend to reward them for their devotion to the museum.[7]

Ann Brubaker, as the able head the Education Department, experienced many successes during and after the anniversary year, including sponsoring a program with Historic Kansas City focusing on the museum and its neighborhood. In March 1983 the museum received a $100,000 grant from the Oppenstein Brothers Foundation to fund an adult education program, which would meet the needs of a diverse audience through lectures, workshops, family programs, and illustrated gallery guides for the thirteen European painting galleries that had been reinstalled. The Tour Department also received a $100,000 grant from the Louise and Elizabeth Flarsheim Charitable Trust, which would support the position of tour coordinator for four years, an important job as 64,300 children and adults had taken tours in the 1983/1984 fiscal year. The Education Department was also making progress on a new docent handbook, the first section of which, on European painting, had already been completed. Meanwhile, Young Audiences and the Learning Exchange continued to partner with the Nelson-Atkins in a project called "Learning Through the Arts," considered "a model for museum-school relationships." Five to six hundred students a year participated in this program, which involved a series of gallery visits and studio experiences, integrating school curriculum with art. The Creative Arts Center was overhauled during fiscal year 1985/1986 to focus on goals that were "process-oriented" rather than "product-oriented." Additional docent and staff training resulted in these goals being integrated into tours and classes. Grants from the Powell Family, Francis Families Foundation, and Southwestern Bell supported the department's staff. Wilson said in May 1986 that the "museum's education programs were never better."[8]

By 1983 the new governance established at the end of 1981 was working well. The Board of Trustees, which included the three University Trustees—Herman Sutherland, Donald J. Hall, and Menefee Blackwell—and the Associate Trustees—John Morgan, Estelle Sosland, James Sunderland, Ilus Davis, Irvine Hockaday, and Jean McDonald—oversaw and reviewed all aspects of

the museum, while a University Trustee headed each of the three major committees. Marc Wilson felt it was vitally important that committee members be given serious responsibilities, which helped them embrace and develop support for the museum. The Planning and Development Committee, headed by Sutherland, had done splendid work for the fiftieth-anniversary campaign and then began structuring a five-year strategic plan, later changed into the more long-range "Vision 2010." Blackwell headed the Finance Committee, which worked with the business manager to budget for a fiscally responsible museum. John MacDonald oversaw investments for the Finance Committee as the museum continued to divest itself of real estate except for properties contiguous to to its grounds.

Donald J. Hall chaired the Acquisitions Committee on which Henry Bloch, Jean McDonald (Mrs. William), George E. Powell Jr., Laura Fields (Mrs. Michael), and Estelle Sosland (Mrs. Morton) served. The committee, which renamed itself "The Committee on the Collections," determined its responsibilities at its organizational meeting in April 1982: (1) to review and approve the overall scheme of acquisitions that Marc Wilson had written; (2) to determine a policy for de-accessioning (removing works that were not deemed museum quality); (3) to develop guidelines for accepting gifts; (4) to receive recommendations for acquisitions; (5) to maintain a working relationship with the Board of Directors and the curatorial staff; and (6) to serve as a source of encouragement for raising funds for acquisitions. At this first meeting, Wilson offered members a brief history of the collections and an overview of the museum's collecting strategy, always valuing the best work by the best artists. He also charged all curators to make illustrated presentations on the strengths and weaknesses of their collections and their plans for development. In subsequent meetings, Wilson assigned a curator or other staff member to make a presentation, prepared in advance, on subjects such as the status of a certain art market, an upcoming exhibition, an interpretation of an artwork, conservation of an art object, or plans for future acquisitions.[9]

Routinely, the Committee on the Collections met monthly the Friday (later Thursday) before the Board of Trustees met on Monday. Besides a presentation, the protocol was for the director and/or members of the curatorial staff to present a list of any artworks that they wanted to acquire either by purchase or by gift, and also art objects they recommended deaccessioning that were either redundancies or not the best examples in their field. Sometimes, pages of art objects came before the committee for their consideration. Although Wilson had wanted committee members to have responsibilities and feel as if their positions were important, one time he had second thoughts when a member

of the committee vetoed a painting Wilson had wanted the museum to buy. Subsequently, when the painting was acquired by the National Gallery and declared a great treasure, Wilson said it was like putting salt on his wound. However, the members of the Committee on the Collections continued to approve or decline curatorial recommendations for acquisitions and deaccessioning and also began to oversee conservation and lending policies that had been established in 1980 when the Nelson Trust's attorney, Robert Donnellan, had gone to probate court and won authorization for the Nelson-Atkins Museum of Art to deviate from Nelson's will and make loans of objects purchased by his trust to other museums "in order to attract reciprocal arrangements that would be of advantage to the Gallery."[10]

Meanwhile, Wilson and the Board began to reorganize the staff, creating some newly endowed curatorships and filling the two important positions vacated by Coe and Goheen. In June 1982, the trustees offered Roger B. Ward the job of curator of European Painting and Sculpture. Ward was a graduate of the University of Kansas and held a PhD from the Courtauld Institute at the University of London. Wilson said that although Ward was young and lacked museum experience, he was selected because "In a word, he is brilliant" and has "inherent talent and promise."[11]

Ward set to work on several ambitious tasks. He assumed responsibility for the *Jean-Baptiste Oudry Exhibition* that Coe had initiated in cooperation with the Louvre, and which would show at the Nelson-Atkins from July 16 to September 4, 1983. The exhibit had drawn little attention from American museums until art critic John Russell of *The New York Times* visited Kansas City, saw the power of Oudry's still life paintings, and praised the Nelson-Atkins for its insistence on mounting an exhibit of Oudry's work.[12]

Roger Ward, already struck by the quality of the European collection, determined to build on its strengths and fill in the gaps. In his first year, he was able to acquire five important works, which Wilson pronounced "of superb quality": Camille Pissarro's *Wooded Landscape at L'Hermitage, Pontoise*; Guercino's *St. Luke Displaying a Painting of the Virgin;* Dirck Van Baburen's *Christ Crowned with Thorns*; and the "first really important acquisitions of European sculpture made in many years," Augustin Pajou's *Bust of Jean-François Ducis* and Massimiliano Soldani Benzi's bronze *Leda and the Swan with Cupid*.[13]

In addition, not long after becoming curator, Ward began a quest to replace the frames on 112 European paintings that he found either incompatible with the provenance of the painting or uncomplimentary to the artwork. "Frames provide an exciting context for great paintings that deserve the best," he asserted, and "the impression reframing makes on the viewers is dramatic, if

subconscious." Ward's search for appropriate antique frames resulted in re-framing such paintings as Caravaggio's *St. John the Baptist in the Wilderness* and Rubens's *Sacrifice of Isaac*. The entire reframing project took Ward ten years and cost the museum $500,000, "money well spent," according to Ward. His reframing efforts drew national attention, not just in the art world but also from such publications as *Town and Country*.[14]

In trying to fill the post of curator of Twentieth-Century Art, which Goheen had vacated in 1981, Wilson felt that it was very important to find a person "whose knowledge is authoritative and whose presence is, frankly, charismat-ic." He or she must "act as a leader for a group of young people who will be future patrons of the Gallery and who are currently most interested in this field." Deborah Emont Scott, who had been at the Memphis Brooks Museum, met these criteria. In September 1983, the trustees appointed her Sanders So-sland Curator of Twentieth-Century Art, a position endowed by Mrs. Frank Lipari and other Sosland family members. Scott would be the first curator at the museum who had an academic concentration in contemporary art. In her first year at the museum, She helped the Friends of Art choose works that would strengthen the collection, and shortly thereafter the Committee on the Collections authorized Scott to acquire important twentieth-century works by James Rosenquist, Robert Rauschenberg, and Jennifer Bartlett.[15]

Samuel Sosland and his family endowed a curatorship for American art. Re-markably, the Nelson-Atkins had never had a curator of American art; Senior Curator Taggart had managed the American collection along with his other duties. Although J. C. Nichols in his 1933 opening speech had said, "there is no part of the collection which we present with greater satisfaction than that devoted to American work," no director of the Nelson-Atkins had shown much interest in American art. In 1933 Gardner put together five American period rooms and hung some eighteenth- and nineteenth-century paintings. Few American paintings were purchased after 1933 up until 1976, when R. Crosby Kemper presented the museum $1 million to augment the American collection. When the museum had been offered a Copley painting in 1954, the University Trustees turned it down as too expensive. That $45,000 painting went to the Ima Hogg Collection in the Museum of Fine Arts in Houston and in 1982 was deemed to be worth $2 million.[16]

Jay Gates, former assistant director of the museum, was named the first Samuel Sosland Curator of American Art in April 1983. However, when Gates resigned in December 1983 to become the director of the Spencer Museum at the University of Kansas, Henry Adams stepped in as the second Samuel

Sosland Curator of American Art. In his first year, Adams was able to acquire the magnificent Thomas Eakins's *Portrait of Monsignor, James P. Turner*, using Enid and Crosby Kemper Foundation funds. During fiscal year 1986/1987, Adams boasted, "In this last year no other museum in the country—or anywhere else for that matter—has acquired so many great American paintings as the Nelson." John Singer Sargent's *Mrs. Cecil Wade* and Thomas Hart Benton's *Persephone*, Adams attested, "rank among the very greatest masterpieces of American painting," yet the Nelson-Atkins also acquired works by John F. Kensett, John La Farge, Frederic Remington, Childe Hassam, and Maurice Prendergast—"all of the highest quality." In 1990, three notable acquisitions included paintings by George Ault, Reginald Marsh, and Charles Wilson Peale. Peale's *Portrait of Catherine and Elizabeth Hall* was a gift from descendants of the two Hall girls, William B. and Harvey Fullerton, and the retired Ross Taggart had arranged the transaction.[17]

Two other new curatorships were created in 1983. Dorothy H. Fickle became the museum's first assistant curator of Indian and Southeast Asian Art, while Mary Jo Arnoldi was appointed assistant curator in charge of African, Oceanic, and New World cultures. Arnoldi, like Scott, had specialized training in her field, and she became the first curator to hold a joint appointment to the faculty of the University of Missouri at Kansas City (UMKC). Eighteen months later when Arnoldi resigned to take a position at the Smithsonian, David Binkley stepped in to take her place and also to teach at UMKC.

In 1986 Dr. Binkley made an appeal to the Committee on the Collections to augment the African collection. Although the museum had fourteen or fifteen fine pieces, Binkley explained, his goal would be to add fifty to sixty pieces in order to have "a minimum representative collection that would reflect through examples of supreme achievement, the cultural complexities of Africa, over its thousand-year history of making works of art." Wilson agreed with Binkley that it was an opportune time to purchase top-tier pieces of African art, and the George H. and Elizabeth O. Davis Fund could be used for this purpose. Binkley's appeal to the committee was well received, and through his efforts the African collection was improved, especially by the 1987 purchase of a sixteenth-century *Commemorative Head of an Oba*. Wilson considered it to be such a "rare and beautiful bronze sculpture" from the Benin Kingdom in Nigeria that in order to buy this piece, he personally solicited funds from Adele and Don Hall and Herman and Helen Sutherland to supplement money contributed from the Nelson Trust and Foundation. When Wilson showed the Oba head to the ailing Laurence Sickman, he, like Wilson, was awed by the sculpture.[18]

Figure 17.2 Henry Adams, the second Samuel Sosland Curator of American Art, boasted that during FY 1986/87, "no other museum in the country—or anywhere else for that matter—had acquired so many great American paintings," including John Singer Sargent's masterpiece *Mrs. Cecil Wade*. (Gift of the Enid and Crosby Kemper Foundation, F86-23)

Figure 17.3 The purchase of a rare and beautiful sixteenth-century bronze *Commemorative Head of an Oba (King)* from the Benin Kingdom of Nigeria augmented the African collection. (Purchase: William Rockhill Nelson Trust through the generosity of Donald J. and Adele C. Hall, Mr. and Mrs. Herman Robert Sutherland, and an anonymous donor; The Nelson Gallery Foundation; and the exchange of a Trust property, 87-7)

Another endowed position, created by the Hall Family Foundation, went to Wai-kam Ho, who became the Laurence Sickman Curator of Chinese Art. "Mr. Ho," according to Marc Wilson, "is inarguably the world's most accomplished scholar of Chinese art." Robert Cohon, a specialist in ancient Greek and Roman art, became curator of Ancient Art and also assumed a teaching position at UMKC. Cohon and another new appointee, Joseph Kuntz, named associate curator in charge of Medieval and European Decorative Arts, took over most of Ross Taggart's work. After Kuntz's untimely death in January 1985, Catherine Lippert served as acting curator of Decorative Arts until the arrival of Christina H. Nelson in 1989.[19]

With an enlarged and vigorous new curatorial staff, Marc Wilson charged every curatorial department to begin "collection assessment and documentation; advanced research on the collections; generation of special exhibitions; improvement of the presentation of the collections; interpretation of the collections through labeling, gallery guides, and lecturing; patronage development; collection development; and publications." From May 1, 1983, to April 30, 1984 (FY 1983/1984), the curators certainly rose to the challenge of generating special exhibitions, as they mounted twenty-seven, which Michael Hagler, curator of Exhibitions and Design, supervised. Many of these exhibits highlighted the Nelson-Atkins collections—of prints, of Chinese ceramics, of Southwest Native American pottery—while others were traveling exhibitions with varied content, including the Oudry exhibit, prints by Matisse, and photographs by Gordon Parks.[20]

The Board of Trustees had put in place a committee to oversee exhibitions, and in 1982 it considered forming a committee to study the relationship between the Friends of Art and the museum. Arthur Frantzreb's audit report had indicated that the museum was handicapped by not having a general membership organization, and Bowron's Committee on the Future recommended incorporating the Friends of Art into the new structure as the museum's primary support organization, an option that the trustees favored. They noted that the Friends "have done much for the Gallery and . . . should be the ones to help the Nelson to the greatness of its next fifty years." Yet the Friends of Art had been an autonomous organization since its inception and this issue, the trustees surmised, "had to be approached in a most tactful and careful manner." Unfortunately, before the tactful approach could be made the Friends of Art heard rumors that they were going to be asked to give up their autonomy.[21]

No one questioned that the Friends of Art organization was an asset to the museum, but the idea of incorporating the group into the museum was controversial. A Friends of Art survey completed in January 1983 showed that

although only 71 percent of its members knew that the organization was autonomous, the majority of members wanted to keep it independent. Many talks ensued, and in February 1984, as the Friends of Art were making plans to celebrate their fiftieth anniversary, their president, Carolyn Kroh, told the trustees that the issue of the Friends becoming integrated with the museum had become "highly emotional." Nonetheless, changes were happening. As of January 1, 1984, the Friends of Art ceded control of the Sales and Rental Gallery, which they had run for twenty-five years. The Nelson Foundation temporarily took over operation of the gallery before the board decided to close it in the fall of 1986. As Marc Wilson wrote to Diana James, who had been K. D. Bunting's assistant and had taken over the gallery's operation after Bunting's death, "The Sales and Rental Gallery of the late '60s was quite a different thing from today's." In 1968, the 832 registered renters had borrowed 526 objects; during fiscal year 1985/1986, the gallery only rented out forty works. The sales part of the gallery had likewise diminished. Reasonably priced art works were difficult to acquire, and art patrons now had many more choices of places to buy art. On October 30, 1986, Marc Wilson and Diana James wrote a letter to artists whose work had been on display in the Sales and Rental Gallery expressing their deep regret that the Sales and Rental Gallery would cease its operations at this time. Another letter was sent to the fifty-three volunteers, coordinated by Marsha Moseley, thanking them for their years of service.[22]

Besides relinquishing control of the Sales and Rental Gallery, in November 1983 the Friends transferred management of the Coffee Lounge to the Nelson Foundation. When the Hallmark Educational Fund provided the means to put a roof over Rozzelle Court during the winter of 1981/82, the Coffee Lounge moved there, becoming the Rozzelle Court Restaurant. The expanded operation was now under professional management instead of being staffed by Friends of Art volunteers. The Friends also passed on supervision of the Gallery Film Program to the Education Department but cooperated with that department to initiate a Speakers' Bureau. Docents were trained to give an hour-long presentation about the museum's collection and services, and they continued to provide the backbone of the Education Department's Tour Program, giving tours to 53,221 adults and children in FY 1983/1984. The Guild of the Friends of Art, which constituted about one-fourth of the membership, also thrived under the leadership of Linda Woodsmall, sponsoring lectures, family festivals, exhibitions, artists' breakfasts on Saturday mornings, art and architecture tours of private homes, and trips. The Information Desk was staffed by 118 Friends of Art volunteers, and other members provided help with special exhibitions, in the children's library, and in other areas requested by the museum.[23]

The Friends of Art membership had slumped but rebounded in 1984 to an all-time high of seven thousand members, yet change was in the offing. As Marc Wilson noted, "The Friends of Art grew up together with the Museum. . . . The Museum has, not without some trepidation and longing for the way we were, been moving from an entrepreneurial style of operation to one that is corporate in character and organization." The Friends of Art needed to change also. Besides, the original purpose of the Friends of Art, which had been to purchase twentieth-century artworks, no longer existed, as the Nelson Gallery Foundation was not governed by Nelson's thirty-year rule and could buy contemporary art. Moreover, the art market had made acquiring the most important pieces of modern art out of reach of the Friends of Art. Given all these considerations, in fall 1985 the then-current Friends of Art president, Gary Gradinger, worked with the new director of development, Michael Churchman, to draft a letter stating, "The Board of Governors of the Friends of Art and the Trustees of the Nelson-Atkins Museum of Art have agreed in principle to make the Friends an integral part of the Museum's new three-part membership program." On May 1, 1986, the Friends of Art gave up its autonomy and became the general membership organization of the museum. The remaining Friends of Art money was used in conjunction with Nelson Foundation funds to buy Wayne Thiebaud's *Apartment Hill*, the last gift from the Friends. After the merger the Friends of Art, as the general membership organization, grew in the first year to nine thousand members.[24]

The Contemporary Art Society (CAS), which began in 1978 as a group affiliated with the Friends of Art, also disbanded. Interest in the society had waned. When University Trustee Herman Sutherland received a letter from the CAS in 1988 asking what he thought about the organization donating the $51,000 left in its treasury to UMKC or some other group, Sutherland objected strenuously. The money should go back to the Nelson-Atkins, which "has done more, by many times, than any other source, to bring contemporary art into our area." The year after the CAS disbanded, the museum created Horizons. Advertised as an "exciting new way to learn more about national and international contemporary art," Horizons planned four special exhibitions during FY 1989/1990. Horizons members would be invited to special opening receptions and talks by distinguished contemporary artists and critics and would also have travel opportunities. Funded by the Jules and Doris Stein Foundation, H. Tony Oppenheimer, Pat Oppenheimer, and the National Endowment for the Arts, Horizons had more to offer members than had the Contemporary Art Society. Deborah Emont Scott, curator of Contemporary Art, coordinated Horizons programs with other programs at the museum.[25]

Figure 17.4 When the Friends of Art gave up its autonomy to become the museum's primary support organization, the group's last gift was Wayne Thiebaud's *Apartment Hill*. (Purchase: acquired through the generosity of the Friends of Art and the Nelson Gallery Foundation, F86-4)

When the Friends of Art became incorporated into the museum, instead of purchasing a work of art, they had considered leaving what funds they had remaining in their treasury as a dowry to keep the museum open one night a week, a concept that Marc Wilson reintroduced in 1988. He suggested to the Board of Trustees that keeping evening hours made the museum more accessible to a wider and more diverse audience, a useful fact to cite when applying for grants. "Many other museums do stay open [one or more nights a week]" Wilson urged, including Chicago, Cleveland, St. Louis, Dallas, Denver, Minneapolis, and Indianapolis. Although the Nelson-Atkins had tried one open night in the late 1960s and again in the early 1970s, the museum had not publicized or promoted these evenings, and they fell flat. Now it was time to make this concept work toward increasing interest in the museum, and the Friends of Art cooperated by starting a fundraiser, Taste for Art, to underwrite Friday evening openings. This time the idea took root, as the extended hours proved to attract new audiences.[26]

The Nelson-Atkins Museum of Art now had three membership groups: the Friends of Art, the Society of Fellows, established in 1965, and the Business Council, formed in 1985. The idea of the Business Council germinated with the Fiftieth Anniversary Fund, when the board realized that the sixty-eight corporate members of the Society of Fellows, who contributed $1,500 per year in dues, were the same people in charge of institutions that donated large sums to the capital campaign. In order to sustain and expand this business support, trustee Henry Bloch led the movement to form the Business Council. He knew firsthand that other museums, notably the Metropolitan Museum of Art, had this kind of organization, as his own company, H & R Block, had been asked to join the Metropolitan's Business Committee.[27]

Henry Bloch became chairman of the Business Council and asked eight civic leaders to form the Steering Committee: G. Kenneth Baum, Donald H. Chisholm, Cliff C. Jones, Morton I. Sosland, George Kroh, Harry C. McCray, John A. Morgan, and Herman Sutherland. Together the committee determined four goals: (1) to increase the museum's operating revenue with unrestricted funds; (2) to foster a closer alliance between the business community and the museum; (3) to cultivate future leaders and trustees; (4) and to encourage businesses to invest in museum projects, especially exhibitions. Incentives to join the Business Council included being able to use the museum's facilities for business events, membership in the Society of Fellows for the CEO, advertisement of the business members, and an annual dinner with a well-known business speaker. Bloch had already arranged for Carl Spielvogel, chairman of the Metropolitan's Business Committee, to speak in October 1985.

By the end of the Business Council's first year of its existence, ninety-seven companies had joined it in six different categories of support ranging from $2,500 to $100,000 plus annually. As a way of expressing gratitude to these charter members, Chairman Bloch arranged for a day trip to Washington, D.C., on February 11, 1986, to see the exhibition *Treasure Houses of Britain* at the National Gallery. Thanks to the generosity of Eastern Airlines and Passport Travel and the careful planning of the Steering Committee, the D.C. trip, which included a private reception and tour of the White House, was, according to Marc Wilson, "one of the most enjoyable and successful events ever staged." Many letters of enthusiasm from the charter Business Council members raised the question of what to do from there, but the Steering Committee determined additional perquisites, including "high-powered special trips, a day junket to a nearby city or a long weekend to an art destination on the east or west coast." Also, members were invited to private evening receptions for exhibitions and to take part in a program of Lunch Breaks, a chance for members to come to the museum for an hour, grab something to eat, get a peek at a new acquisition, visit the conservation lab, or chat with a curator. The Business Council at the Nelson-Atkins became the most successful one of any art museum in the country. By the time the organization turned twenty-five years old in 2010, its members had contributed collectively an average of $610,000 a year to the unrestricted funds of the museum.[28]

The Society of Fellows also experienced some reorganization. The Fellows had, since their inception, provided the cultivated base of support for the museum. They were treated to beautiful receptions at the museum, and there was a feeling of mutual respect between the curatorial staff and the Fellows. Their loyalty was demonstrated by the fact that 79 percent of the Fiftieth Anniversary Fund came from their pockets. After the Business Council was formed, however, the membership of the Fellows stagnated, so parties in private homes were held to solicit new members. One hundred new Fellows resulted from this intervention. Also, many special and extensive trips were organized, including a thirty-two-day trip to Japan, China, and Hong Kong; a Four Great Capital Cities Tour in Central Europe; and an art trip to New York, which included a party hosted by David Stickelber in his New York apartment. Stickelber would become an Atkins trustee, as would Dr. Nicholas Pickard, who retired in 1984 as executive director of the Fellows, having served in that role since 1972, and before that as president of the Friends of Art from 1959 to 1966. The trustees knew Pickard would be hard to replace. However, Dr. James C. Olson, who had just retired as University of Missouri president, stepped graciously into the position of Society of Fellows executive director.[29]

In 1989, the three membership groups had become even more complicated by the addition of the Nelson Society, created as a higher level of the Society of Fellows in order to avoid raising dues for the Fellows. The trustees added additional perquisites for Nelson Society members and planned a special inaugural trip for them to Los Angeles to tour the Getty and attend the black-tie dinner opening at the Los Angeles County Museum of a retrospective exhibit of the work of Thomas Hart Benton, a Missouri native son. Henry Adams curated this major Benton show, which Ellen Goheen, who had been called back into service as administrator of Collections Management and Special Exhibitions, helped organize and catalog. *Thomas Hart Benton: An American Original* would show at the Nelson-Atkins Museum from April 16 to June 18, 1989. Meanwhile, with the addition of the Nelson Society, two levels of Fellows, six categories of Friends of Art membership, and six possible types of Business Council members, the trustees decided for efficiency "to unify the membership staff functions of the Friends of Art, Society of Fellows, and Business Council into one Membership Department."[30]

Figure 17.5 One of the highlights of the Thomas Hart Benton retrospective, which Henry Adams organized in 1989, was *Persephone*, considered to be Benton's most important easel painting. (Purchase: acquired through the generosity of the Yellow Freight System Foundation, Mrs. Herbert O. Peet, Richard J. Stern, the Doris Jones Stein Foundation, the Jacob L. and Ella C. Loose Foundation, Mr. and Mrs. Richard M. Levin, and Mr. and Mrs. Marvin Rich, F86-57) (RG 24/50, NAMAA)

Almost from the advent of his tenure as director, Wilson made publications a priority—not only exhibition catalogues but catalogues of the collections. Having been given a two-to-one matching grant in 1986 from the Andrew Mellon Foundation to fund scholarly publications over a three-year period, Wilson chided, "Failure to match the Mellon grant would be a disgrace." In a letter to the University Trustees, Wilson spelled out, "First, serious publications are an important way in which the museum can discharge its obligation to generate and diffuse knowledge and information about art. As you recall from the terms of Colonel Nelson's will, it was an important goal he sought to achieve through the establishment of his trust." Incentivized, Ward wrote a catalogue to accompany the exhibit he had mounted, *The Bountiful Decade: Selected Acquisitions, 1977–1987*. In 1988, Goheen published *The Collections of the Nelson-Atkins Museum of Art*, with commentary on many of the museum's most important works. The Henry Moore Sculpture Garden, established in 1989, was well documented in a book written by Deborah Emont Scott. Henry Adams completed the *Handbook of American Paintings* in 1991. In 1996, George McKenna published a beautiful catalogue on the museum's collection of prints from 1460 to 1995, and Eliot Rowlands's catalogue: *Italian Paintings, 1300–1800: The Collection of the Nelson-Atkins Museum of Art*, became a model for future collection publications. Also, in time for the sixtieth anniversary, a sixth edition of the museum's handbook had been compiled and edited by Roger Ward and Patricia Fidler.[31]

In the *Annual Report* for FY 1989/1990, Marc Wilson looked back on the 1980s as "one of the most dynamic periods in the Museum's history, rivaling perhaps, even the glorious decade of the 1930s that saw the founding of the museum." He recalled that Ralph T. Coe had, with justification, sounded calls of alarm in 1980 because of the museum's woefully inadequate resources. "Those of us who are veterans of that era," Wilson said, "remember the struggle and how much was done by so few." Yet, because of new governance with an expanded board, better organization of the administration, supportive membership groups, and the great success of the Fiftieth Anniversary Fund, the museum had moved forward to a new plateau. The Nelson-Atkins had been able to expand its curatorial and support staff. Now eight curatorial departments existed; in 1980, there had only been four. In the Conservation Department, Forrest Bailey now had support as three separate areas of operations had been isolated: (1) painting, (2) works of art on paper, and (3) objects. The Enid and Crosby Kemper Foundations had, Wilson maintained, "almost single handedly built one of the most prominent departments of

American art in the nation." The museum had acquired several important European paintings, including those purchased during FY 1989/1990: Élisabeth-Louise Vigée Le Brun's *Portrait of Marie Gabrielle de Gramont, Duchesse de Caderousse*; Gustave Caillebotte's Impressionist painting, *Portrait of Richard Gallo*; and the French Romantic master Eugene Delacroix's *Christ on the Sea of Galilee*. Meanwhile, the Print Department had also experienced a spectacular year. Finally, the opening of the Henry Moore Sculpture Garden in 1989 was perhaps the most important event of the previous decade, an event that drew international attention. Twelve monumental Moore works had been placed on the museum's south lawn, a collaboration of the Nelson-Atkins Museum of Art, the Hall Family Foundation, and the Department of Parks and Recreation of Kansas City, Missouri.[32]

However, what stood out the most to Marc Wilson as he surveyed the previous decade was the schedule of exhibitions. During FY 1989/1990, five outstanding exhibitions had opened. "Such a schedule," Wilson said, "would have been inconceivable, indeed perhaps even unimaginable, a decade earlier." Three of the exhibits originated at the Nelson-Atkins: *Thomas Hart Benton: An American Original*; *Art by Chance: Fortuitous Impressions*; and *Master Drawings from the Nelson-Atkins Museum of Art*. In addition, the Nelson-Atkins showed the popular *Yani: The Brush of Innocence*, which had opened at the Freer Gallery of Art, Washington, D.C., and which drew national attention with an article in *Smithsonian Magazine*, the second such article about the Nelson-Atkins in a year, as one had also been written on the Benton exhibit. Then, in a remarkable synchronous effort, four museums teamed up with the Nelson-Atkins to present *Impressionism: Selections from Five American Museums*, sponsored by the Turner Trust and the Ford Motor Company. A great feeling of serendipity ended the decade. The Nelson-Atkins had opened its doors to more people in the 1980s, representing new and diverse groups and creating more varied educational and cultural opportunities.[33]

Besides all the positive changes that had been made, deep sadness befell the Nelson-Atkins family when in 1988 Director Emeritus Laurence Sickman died. He had been associated with the museum since its beginnings, and he never lost touch with it. Although he had retired in 1977, he had continued to serve as advisor to the Board of Trustees, his contract having been renewed every five years, including in 1987. When writing to University Trustee Donald Hall in 1986 to thank him for what the Halls had done for the Oriental Art Department, Sickman said, "You can rest assured that no one could have had a more enjoyable or rewarding life than I." His life had been the Nelson-Atkins

Museum of Art, and it was no surprise that in his will he left everything he had to the museum. Appropriately enough, a memorial service for Sickman was held in Atkins Auditorium.[34]

Despite mourning the loss of Laurence Sickman, an optimistic and celebratory tone prevailed as the museum entered the 1990s. The Society of Fellows held a gala event in 1990, attended by 504 members, to celebrate their twenty-fifth anniversary. The board expanded to include new Associate Trustees, and in 1991 the University Presidents appointed a new University Trustee, Henry W. Bloch. Bloch had long been associated with the museum, having started the Business Council and having served as an Associate Trustee since 1983. He would take the place of Menefee D. Blackwell, who resigned after thirty-four years of dedicated work on behalf of the Nelson Trust and Foundation. Blackwell would join the esteemed and short list of Honorary Trustees. His name would also be long remembered because when he died in 2000, his bequest would be used to endow the directorship of the museum. Thus, Marc Wilson would become the first Menefee D. and Mary Louise Blackwell Director and CEO.

In 1993, just two years after Blackwell retired, Herman R. Sutherland also joined the ranks of Honorary Trustees. He had served as a University Trustee for twenty-three years. "It was almost a full time job for him," fellow trustee Don Hall remarked. "I doubt there is anyone who has worked more tirelessly and loyally for a nonprofit institution," Hall added. The University Presidents appointed Estelle Sosland to fill Sutherland's position. Sosland had been an Associate Trustee since 1981 and was not only the first female Associate Trustee and the first female University Trustee, but she would also become the first female chair of the board. A renewed Board of Trustees stood ready to guide the museum onto the next phase of development.[35]

In preparing for the sixtieth anniversary of the museum in 1993, the Board of Trustees and Marc Wilson determined that this anniversary would be a celebration rather than a fundraiser. Many events were planned during 1993, including a public birthday party held on July 18 on the gallery grounds from 1:00 to 5:00. To commemorate the first sixty years of the museum, Michael Churchman and Scott Erbes completed a book, *High Ideals and Aspirations*, the title being taken from J. C. Nichols's opening speech given in 1933. In addition, *Culinary Masterpieces*, a cookbook designed to provide a tangible and long-lasting way to celebrate the museum's sixtieth anniversary, had been assembled by a large group of volunteers. Ellen Goheen had acted as the museum's advisor on the project, which intended to "create culinary equivalents

to the Nelson's outstanding works of art," Wilson said in the book's foreword. Culminating the anniversary year, the museum's membership was invited to a ball, held on December 11, 1993, chaired by Jim and Polly Brunkhardt and Jack and Karen Craft. Guests were encouraged to visit the ancient and medieval art galleries that had been reinstalled and reopened in time for the gala celebration.[36]

Three curators resigned in 1993. Although each would be missed, their departures did not raise any red flags. Dorothy Fickle, who had so meticulously managed the South and Southeast Asian Department, retired and moved to Seattle before finishing the catalogue she had intended to write but not before presiding over *Gods, Guardians, and Lovers*, an exhibition of temple sculptures from North India. Dr. Doris Meth Srinivasan would be appointed in November 1994 to take Fickle's place. Henry Adams, Samuel Sosland Curator of American Art, decided he wanted to become a museum director. After his many contributions, especially publications, to the Nelson-Atkins, he resigned to take a position at the Cummer Museum in Jacksonville, Florida. Assistant Curator of American Art Margaret Conrads would take Adams's place. Wai-kam Ho also retired, this after publishing his brilliant two-volume book on *The Century of Tung Ch'i-ch'ang* exhibition, which won the Shimada Prize, "the most prestigious prize one can receive for scholarship and a publication in East Asian art," according to Wilson. This exhibition, co-sponsored by the Beijing Palace Museum and the Shanghai Museum, was ground-breaking because, for the first time, the Chinese government allowed its museums to loan treasured works to an American museum. Before Wai-kam Ho retired in December 1993, he introduced his successor, Dr. Xiaoneng Yang, to the Nelson-Atkins Museum of Art, making the transition nearly flawless.[37]

The museum was not without its problems. The city's upkeep of the facility continued to be patchy. The building desperately needed a new roof to replace the sixty-year-old, leaky one. Sidewalks and other improvements also beckoned, and the grounds required attention. Security and life safety issues also needed to be addressed. In addition, the museum simply had run out of space for display of art objects, for new offices, and to hold ancillary activities. When Marc Wilson noticed that carpentry work was being done in art storage space, spewing sawdust over artworks, he authorized carving out an area underneath a south first-floor stairway in order to create a workshop of sorts. Art storage areas were full to capacity, and space had been rented off-campus. Office space was at such a premium that a suggestion, quickly squashed, was to give up an art gallery. Some office space was rented, but hopes were to eventually use one

or more of the houses on Forty-Fifth Street or Laura Nelson Kirkwood's former home to handle the expanded staff. Long-range planning began in 1994 to address some of these pressing issues and to, once again, raise funds in order to expand the facilities and services.

◆

BEYOND THE BLUEPRINT

T HE SIXTIETH ANNIVERSARY celebration of the Nelson-Atkins Muse-
um of Art caused the Board of Trustees and Director Wilson to realize
the museum had reached a plateau. It was time to move forward, to ex-
pand beyond the blueprint both physically and philosophically. Not only had
the collection outgrown its space, but the museum's functions also extended
far beyond the walls in acting as both an educational institution and a reposi-
tory of art. The "big picture," Wilson told the board, is that art museums have
"come to the end of an era" and are turning "from glamorous but ephemeral
values to those that emphasize long-term substance." As plans began to per-
colate for a major building project, Wilson and board members also foment-
ed ideas for reallocation and rejuvenation of various collections along with
dreams of a renovated, world-class learning center. Marc Wilson's concept of
the new museum was that it should evolve, and all of its aspects should be
reevaluated. Fortunately, the trustees and benevolent patrons shared his vision
of expanding the building and learning center, rejuvenating the galleries, and
cultivating a larger patronage. Again, as so often had occurred in the past, the
right people were in the right place at the right time to transform the Nelson-
Atkins Museum of Art.[1]

In 1994, the Board of Trustees adopted a long-range plan, which called for
the Nelson-Atkins Museum of Art's first expansion outside its original blue-
print, a testament to the forward-thinking trustees who in 1933 built the origi-
nal museum three times as large as it needed to be. Many of the Nelson-Atkins's
peer museums—and certainly all that were as old as the Nelson-Atkins—had
already built major additions. In 1958, the Cleveland Museum of Art had dou-
bled its size, and in 1971 it opened another wing to house classrooms, lecture
halls, and the Education Department. Likewise, the Minneapolis Institute of

Art had expanded in 1974 and then would build on again in 2006, while the St. Louis Art Museum added an extension in the 1950s. The Dallas Museum of Art, which had opened in 1936, was perhaps the champion at adding space, having constructed a two-story addition in 1965, a new decorative arts wing in 1985, a new building in 1991, and the Nasher Sculpture Center in 2000. When the Denver Art Museum decided to build on in 1971, it was considered the "forerunner in the worldwide transformation of the temple-style museum into a proliferation of unprecedented and startling architectural forms." Like the Denver Art Museum, the Cleveland Museum of Art, and others, the Nelson-Atkins was a temple-style, neoclassical museum, so architecturally pristine that area architectural students were often given the intriguing problem of how to expand the building without losing the integrity of the original structure. Respected architects would soon take up this challenge, but thirteen years would elapse between the concept of expansion and the opening of the Bloch Building in 2007.[2]

The long-range plan of 1994 was quickly deemed short-sighted and vague, as it put more emphasis on the outcome—an expanded facility—than on the other changes needed to move the museum to a new level of excellence. Therefore, in 1995, the board adopted a more ambitious fifteen-year plan, "Vision 2010," which supported major program development as well as expansion of the building. On January 1, 1996, the trustees approved a $125 million capital campaign goal, and the three University Trustees—Don Hall, Henry Bloch, and Estelle Sosland—together pledged $60 million. Morton Sosland and Adele Hall became cochairs of what was called "The Generations Capital Campaign," so-named because the board planned for the improvements to the museum to last for generations. Although Morton Sosland and Adele Hall launched their fund-raising efforts on January 15, 1996, two years later, the Generations Campaign was revised, now with a goal of raising $175 million to cover the increases in costs not just for the building program but also for upkeep and maintenance of the museum. In August 1998 the city of Kansas City, Missouri, agreed to transfer ownership of the Nelson Gallery building and land, given to the city by Irwin Kirkwood, to the museum's trustees. (The Atkins trustees, who were now David Stickelber and James Ludlow Miller, both longtime friends of the museum, had never given up ownership of the Atkins side of the museum.) In a brief outdoor ceremony in which Mayor Emanuel Cleaver presented the deed to Donald J. Hall, the museum's senior trustee, the city relinquished all rights to the property and all maintenance responsibilities and gave the trustees permission to forge ahead with their building project.[3]

FIGURE 18.1 The Generations Capital Campaign Committee included, *left to right, back row,* Henry Bloch, Michael Churchman, Marc Wilson, R. Eric Staley, and Donald Hall; *front row,* Steven Holl, Adele Hall, Karen Christiansen, Estelle Sosland, Morton Sosland. (RG 40/01, NAMAA)

While plans for expanding the building simmered on the back burner and the museum continued to cope with budget deficits and the shortage of office and exhibition space, expansion occurred outside the walls of the Nelson-Atkins. The Pierson Sculpture Garden had begun the transformation of the seventeen-acre south lawn of the museum into a place that attracted international attention for both its art and its design. The opening of the Henry Moore Sculpture Garden in June 1989 had allowed the Kansas City museum to become the largest repository of Henry Moore sculptures in the United States. Critics agreed that the sculpture garden strengthened the museum's original design with its "ordered, refined, subtle, timeless and precise" delineation. At the time of the garden's dedication, Donald J. Hall, chairman of the Hall Family Foundation, declared, "The sculpture garden will help to fulfill our belief that art is vital to our quality of life and cultural well-being." Extending this idea, in May 1991, the Hall Family Foundation purchased new additions from the Patsy and Raymond Nasher collection, including sculptures by Constantin Brancusi, Alberto Giacometti, Carl Andre, and Max Ernst, "at one stroke putting the Nelson Atkins Museum at the forefront of American museums which are active in collecting twentieth century sculpture," according to Wilson.[4]

In 1994, the museum trustees launched the Modern Sculpture Initiative to continue the direction already taken in the Henry Moore Sculpture Garden. That same year the Sosland family commissioned Claes Oldenburg and his wife, Coosje van Bruggen, to design a sculpture for the Nelson-Atkins's grounds. The couple "responded to the formality of the original neo-classical building and the green expanse of its lawn by imagining the Museum as a badminton net and the lawn as a playing field." Oldenburg and van Bruggen designed, built, and placed four birdies or shuttlecocks on the grounds to look as if they had just landed, a concept way beyond reality as each shuttlecock weighs 5,500 pounds, stands eighteen feet tall, and has a sixteen-foot diameter. Made from aluminum and fiberglass-reinforced plastic, *Shuttlecocks* was installed and celebrated at a family event in July 1994. As Wilson reported at the time, the sculptures "caused both delight and, perhaps in some quarters, dismay, but moved the museum significantly closer to its goal of creating the Kansas City Sculpture Park." Ever growing in popularity, *Shuttlecocks*, over the years became an iconic and identifying image for the Nelson-Atkins Museum of Art and for Kansas City.[5]

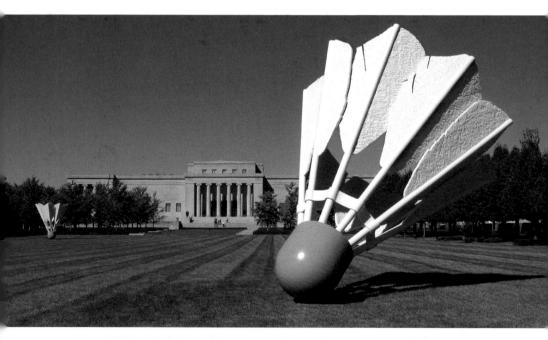

FIGURE 18.2 Claes Oldenburg and Coosje van Bruggen designed and installed *Shuttlecocks,* a gift from Estelle and Morton Sosland, which was celebrated at a family event in July 1994. (Purchase: acquired through the generosity of the Sosland Family, F94-1/3,4)

In May 1996 the Henry Moore Sculpture Garden expanded again. Generous contributions allowed for the creation of a new East Garden, which housed works by George Segal, Mark di Suvero, Isamu Noguchi, and Alexander Calder. Meanwhile, the Nelson-Atkins Museum and some neighboring institutions began working with the Kansas City Parks and Recreation Department to create a "cultural parks district." The plans were to link and coordinate the museum's Henry Moore Sculpture Garden with Theis Park, south of the museum, and Southmoreland Park, to the west of the museum, along Oak Street. As plans moved ahead, Wilson proposed a new name for the area—the Kansas City Sculpture Park, which seemed fitting since the purpose was to invite all Kansas Citians to enjoy the parks as their own.[6]

Besides going beyond the blueprint with its sculpture garden, the museum had embarked on some new initiatives. Wilson advocated forming a volunteer council to unify all volunteer tasks into one organizing instrument. Volunteers needed to be recognized not only for the number of hours they gave to the museum—25,000 hours during 1993 to 1994—but for their energy, ideas, and ambassadorship. Also, in August 1993, the museum hired its first archivist, Charles Hill. The archives had been established in 1992 with funding from the National Historical Publication and Records Commission and the William T. Kemper Foundation. They were housed off-campus and then moved into the Spencer Art Reference Library in 1995. The new head librarian, Susan Malkoff Moon, formerly of the J. Paul Getty Museum, who had replaced Stanley Hess when he resigned, took on two major projects: integrating the Western and Asian holdings of the library and completing an inventory of the collection. Moon also collaborated with staff at the Linda Hall Library to inaugurate the "Leonardo" information system. The Spencer Art Reference Library catalog went completely online in October 1996, and digitization began on the slide library. By 1999, with 93,720 volumes and 97,075 slides, Moon reported that the library was experiencing a space crisis.[7]

In the Education Department, Ann Brubaker saw the greatest change in the Creative Arts Center to be the increased interest in single-visit workshops. Attendance was up 47 percent. Also, Brubaker had initiated extensive teacher services, including courses, resource packets, and the publication of *Insights*, a teacher services newsletter. In addition, the Education Department offered adult programs related to major loan exhibitions and sponsored non-credit and credit courses through the University of Missouri-Kansas City. Kate Livers, coordinator of tour programs, initiated four new school tours and oversaw the three-year docent-training program. Training teen guides expanded to a

year-round endeavor, and the Board of Trustees initiated a standing commit-
tee on education, which helped with outreach programs. In 1996/97, the Ed-
ucation Department provided special services to more than twenty different
cultural organizations and community groups. It also oversaw such activities
as the Atha lectures, the Atkins lectures, which were started in 1995, and the
Smith College Antique Forum, which in 1996 was in its thirtieth year, all of
which were extremely important facets of the museum's programming and
partnerships. In 1999, Ann Brubaker assumed a new title, director of educa-
tional affairs, and both the library and the archives, which no longer had an
archivist, were put under her jurisdiction.[8]

One of the most innovative changes in museum policy concerned admis-
sion charges. The policy of how much, when, and who should be charged ad-
mission had been debated since the opening of the museum. William Rockhill
Nelson had wanted his collection of Western Art to be free and open to the
working public, which the city of Kansas City, Missouri, and the University
Trustees had decided meant that the museum should have free admissions
on Sundays, a policy that had continued. The contract the city had with the
museum also allowed that "school children shall be admitted free at all times,"
a document that had been changed in 1987 to read, "Children on school tours
shall be admitted free at all times." Admission fees for adults on Tuesdays
through Saturdays had, over the years, crept up to three dollars for adults and
one dollar for children, but there were always exemptions for Art Institute
students, Society of Fellows patrons, and so forth. The system was compli-
cated, but not nearly as complicated as that of some other museums. The Art
Institute of Chicago, for example, had free admission on winter weekends and
Friday evenings for Illinois residents but at other times charged different rates
for adults and for teens depending on whether they lived outside the state, in
Illinois, or in Chicago.[9]

In October 2000, the Ford Motor Company began sponsoring Ford Free Fri-
days at the Nelson-Atkins Museum of Art, providing free admission to every-
one on Fridays, the day on which the museum stayed open late. In the first six
months, attendance on Fridays after 4:00 P.M. increased 41 percent, and both
the bookstore and the café experienced increased revenue. The success of Ford
Free Fridays prompted the Board of Trustees in October 2001 to approve free
general admissions. Their rationale was that "Anyone should be able to come
to the Nelson-Atkins and see great works of art." The policy would create good
will, especially at a time when, because construction had begun on the build-
ing, there was no parking at the museum. When this policy was analyzed again

five years later, the free admissions decision stood. The spreadsheet showed that admissions income had been for the most part "revenue-neutral," as fees for parking and special exhibits actually made up for what had previously been collected for general admissions. Besides the value of the perception of free admission was the incentive to become members of the museum. Members not only received free parking and admission to special exhibitions, but they could feel that they were contributing to the general welfare of the community, "removing all barriers" to the museum. As Wilson said, having free admissions "sends a very important message to people citizens, people of all stripes and backgrounds that this institution is there for them."[10]

Some very interesting and diverse exhibitions enticed new audiences to the Nelson-Atkins Museum of Art in the 1990s. In March 1994, 50,456 school children toured a major photographic show, *Songs of My People, African Americans: A Self Portrait*, while 103,206 people took part in a structured museum program related to the exhibit. The Education Department prepared teacher resource packets, trained docents, and created a photojournalism project for high school students. The next year, in June 1995, Margaret Conrads, Samuel Sosland Curator of American Art, organized *Across Continents and Cultures: The Art and Life of Henry Ossawa Tanner* and in 1996 coordinated with a five-museum consortium to launch the exhibit *Made in America: Ten Centuries of American Art*. Doris Srinivasan, curator of South and Southeast Asian Art, worked on a Pakistani art exhibit, and David Binkley, curator of the Arts of Africa, Oceania, and the Americas, was the in-house curator for an exhibition organized by the Heard Museum of Phoenix, Arizona, titled *Inventing the Southwest: The Fred Harvey Company and Native American Art*. Many visitors flocked to see an exhibition entitled *Discovery and Deceit: Archaeology and the Forger's Craft*, which Robert Cohon, curator of Ancient Art, organized and oversaw in its nationwide tour. Equally popular was the Egyptian mummy exhibition Cohon planned in 1999. October 2000 saw the opening of *Tempus Fugit: Time Flies*, an award-winning millennial exhibition organized by Jan Schall, curator of Modern and Contemporary Art, the last major show before construction began on the museum.[11]

Also, changes in personnel occurred during the late 1990s. George McKenna retired in 1996 as curator of Prints, Photographs, and Drawings after a remarkable forty-four-year career at the museum. Longtime chief conservator Forrest Bailey left in April 1998 after twenty-six years, and Elisabeth Batchelor was named to take his position in December. The Department of Twentieth-Century Art was renamed the Department of Modern and Contemporary Art

in preparation for the advent of the twenty-first century. Deborah Emont Scott, now entitled Sanders Sosland Curator of Modern and Contemporary Art, also assumed the role of the museum's first chief curator in May 1998. When Scott relinquished her role as modern art curator in 2002, Dr. Jan Schall, the associate curator, took her place. Ellen Goheen relinquished her job in 1999 as administrator of Collections Management and Special Exhibitions, after serving in a variety of positions during her thirty-one years at the Nelson-Atkins Museum of Art. In May 2000 Cindy Cart was appointed curator for a newly created Department of Exhibitions Management. The coordinator of special events, Ruth "Boots" Leiter retired in 1999, and DeSaix Adams succeeded her.

Undoubtedly the most innovative curatorial change occurred with the departure of David Binkley, curator of the Arts of Africa, Oceania, and the Americas. Binkley had served in his position since 1985 when he had taken over after Mary Jo Arnoldi's short tenure. Before 1983 the department did not exist, although for a few years Ted Coe, who was very knowledgeable about Native American art, had acted as the part-time curator of what was called "ethnographic art." When Binkley arrived, he successfully grew the African collection, making it not only respectable but admirable. With his resignation in January 1999 to become curator of African art at the Smithsonian, Wilson convinced the board to divide Binkley's department into an African art and a Native American art department and to hire two new curators. Wilson maintained that lumping together the art of Africa, Oceania, and the Americas and then often calling it "primitive art" or "ethnographic art" was insensitive and insulting. In September 1999, Dr. Elizabeth Cameron joined the museum staff as head of the Department of African Art, and a search began for a curator of American Indian art.

Finding the perfect curator of American Indian art took time, and the position was, frankly, a novelty among American art museums. In fact, the Nelson-Atkins would become one of the few encyclopedic museums with a curatorship devoted exclusively to Native American art. Fortunately, trustee Fred L. Merrill and his wife, Virginia, longtime friends of the museum, stepped forward and provided the leadership and support to establish the Department of American Indian Art, while Wilson sought to engage the services of Gaylord Torrence, a professor of fine arts at Drake University in Des Moines and a renowned authority on Native American art. Torrence had come to Kansas City in 2001 as a consultant to render judgment on the basketry, ceramics, and ceremonial objects in the Donald D. (Casey) Jones bequest of American Indian art, which Jones had accumulated with the expert

advice of Ted Coe. Now Wilson convinced Torrence to return to Kansas City as the Fred and Virginia Merrill Curator of American Indian Art, promising him the opportunity to build the Native American collection and redesign the collection's gallery.[12]

Wilson introduced Torrence to the members of the Committee on the Collections in May 2002, a committee that was now chaired by Henry Bloch and included Jean Deacy, Sheila Dietrich, Shirley Helzberg, Alan Kosloff, Dick Levin, Jerry Nerman, Don Tranin, Addie Ward, Laura Fields, Don Hall, Julia Irene Kauffman, and Estelle Sosland. First, Torrence gave an overview of the collection he was now overseeing, explaining that in 1931, the University Trustees purchased pieces from the Heye Collection and in 1933 added Southwest Indian art objects offered by the Fred Harvey Company. The museum also had objects on loan from Conception Abbey and 115 pieces from the Casey Jones bequest, along with the $1.4 million Jones had left for American Indian acquisitions, a bequest from Judith Cooke, some gifts, and other funds from deaccessions. Torrence announced that the "Nelson-Atkins Museum of Art has the foundation for the best collection in the Midwest," with a strong core collection representing works from most areas of North America and excellent opportunities to build the collection. The field of American Indian art was late in coming to the art museum world, and generally to academe, and many important pieces lay in the hands of private collectors, though Torrence expected that many of the pieces they held would come on the market within the next five years. Gaylord Torrence ended his presentation to the Committee on the Collections with a quote from Ted Coe's 1977 *Sacred Circles* catalogue: "The day when American Indian art could be dismissed as unartistic and provincial is over. It is beginning to receive world-wide attention after centuries of neglect and much prejudice." Using Casey Jones's bequest, the committee approved purchase of an Eskimo *Bow Drill* and a Sioux (Lakota) *Courting Flute*. Torrence acquired additional exceptional Native American works for the museum in 2003, when a refurbished American Indian gallery opened.[13]

Three months after Gaylord Torrence's appointment, another new curatorship was endowed. Catherine Futter was appointed the first Helen Jane and Hugh "Pat" Uhlmann Curator of Decorative Arts. In her introduction to the Committee on the Collections, Futter focused on the strengths of the collection such as the Burnap Collection of English Pottery, the Folgers Coffee Silver Collection of English silver coffee pots, and some works of European and American furniture, including the Bulkley and Herter bookcase made for the first World's Fair held in the United States.

FIGURE 18.3 Of particular interest in the decorative arts was this monumental Gothic Bulkley and Herter bookcase, which was displayed at New York's Crystal Palace exhibit in 1853 and included in the traveling exhibition *Inventing the Modern World: Decorative Arts at the World's Fairs, 1851–1939.* (Purchase: William Rockhill Nelson Trust through exchange of gifts, bequests, and other Trust properties, 97-35)

She also discussed the quality of some of the period rooms and their furnishings. Her belief, supported by Wilson, was that the level of all works of art on view at the museum should meet the same high standards. Therefore, some pieces were removed and later deaccessioned. One work that was removed for the refurbishment of the European galleries in 2004 was a ceiling originally purchased in 1932: a painted ceiling said to have been made in the fifteenth century in Tarragona, Spain. Research into the materials and stylistic analysis confirmed that the wood work was actually late nineteenth or early twentieth century; the ceiling was later deaccessioned.[14]

Shortly after Catherine Futter's appointment, Ian Kennedy became the Louis L. and Adelaide C. Ward Curator of European Art, following the resignation of Roger Ward in September 2001. Kennedy immediately set to work refurbishing and reinstalling the European painting galleries, including Gallery 115, which, Kennedy attested, held the two most important works in the collection—paintings by Caravaggio and by Rembrandt. Kennedy was happy to work with Futter, who began integrating decorative arts into European painting galleries. She moved appropriate period pieces of furniture and put

china and silver objects on display, relating decorative art to paintings that echoed similar themes, subjects, or contexts. Futter had new display cases built locally that had the same elegant appearance of the original 1933 cabinets but that had concealed conservation chambers and easy-to-read labels built in at the proper slant. When Kennedy escorted the Committee on the Collections through the renovated French and Italian galleries in September 2006, he demonstrated how effectively Futter had integrated the decorative arts into the collections. Also, a new installation of the Burnap Collection highlighted some of the pieces now considered to be most remarkable, including the Staffordshire *Pair of Hawks* dating from about 1750, a Wedgwood potpourri urn, and Staffordshire slipware chargers designed by William Talor (ca. 1661) and Ralph Toft (ca. 1660–80). Marc Wilson attested that Futter "had done a brilliant installation" and that what Kennedy had accomplished in the European painting galleries was masterful.[15]

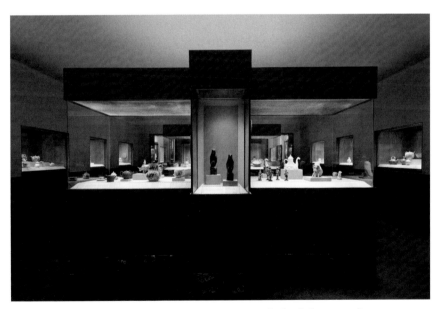

FIGURE 18.4 In 2006, the Burnap Collection was reinstalled to help visitors better understand the social and historical context of English pottery. (NAMADAA)

While curators continued to plan exhibitions, research and write about their collections, acquire new acquisitions, refurbish galleries, and provide educational opportunities, the museum had moved ahead with plans for its major addition. After the building committee had completed a detailed schema of the museum's space needs for exhibition, storage, office, library, conservation,

education, and other functions, the Nelson-Atkins Museum of Art had begun a
search for an architect. Intent on identifying a world-renowned architect whose
work would add prestige to the Nelson-Atkins, Don Hall, as chairman of the
Board of Trustees, put together an impressive Architect Selection Committee.
Besides Marc Wilson and University Trustee Henry Bloch, the committee in-
cluded Bill Lacy, president of Purchase College and executive director of the
prestigious Pritzker Architecture Prize; J. Carter Brown, director emeritus
of the National Gallery of Art and chairman of the Pritzker Prize; Ada Louis
Huxtable, respected author and *Wall Street Journal* architectural critic; Vicki
L. Noteis, an architect and planning director for the city of Kansas City; John
C. Gaunt, dean of the School of Architecture and Urban Design at the Univer-
sity of Kansas; Arthur Brisbane, president and publisher of William Rockhill
Nelson's *Kansas City Star;* and Kathleen Collins, president of the Kansas City
Art Institute. In spring 1999 Cary Goodman of Gould Evans Goodman, the
local firm overseeing architectural selection, announced the six finalists. The
committee had reviewed the work and qualifications of dozens of architects,
and the six they had determined most worthy hailed from Boston, New York,
France, Japan, Houston, and Switzerland. All had worked internationally. All
had excellent reputations.[16]

The six finalists were invited to Kansas City in April 1999 for a two-day ori-
entation so they could understand the museum's needs and see the building
and the setting. They understood at the outset that disturbing the vista on the
south side of the Nelson-Atkins would not be acceptable, as the seventeen-acre
landscaped sculpture park led up to the top of the hill on which the museum
perched. Most assumed that the expansion would take place of the north side.
In fact, sketches made by Wight and Wight when they were designing the orig-
inal structure showed dotted lines indicating suggested future wings jutting out
from the east and west ends of the north side of the building. Now it would be
up to each candidate to come up with her or his own original plan. Each archi-
tect was given a large black notebook and two months to complete a design.[17]

In late June 1999, the six finalists came back to Kansas City and gave pre-
sentations. As it so happened, all but one of the competing architects designed
additions on the north side of the museum. The last architect to present, Steven
Holl, had a totally different concept. His design was of a new building that
would not compete with the original neo-classical museum. He envisioned the
1933 building as "the stone"—heavy, hermetic, with inward views—and the
new building as "the feather"—light, meshing the exterior with the interior,
with views into the landscape. Holl's plan placed the new building on the east
side of the current museum along Rockhill Road and featured a series of glass

pavilions that would reflect light during the day and emit a glow from within at night. The 840-foot-long building, the equivalent of a sixty-seven-story-high edifice, would add approximately 150,000 square feet to the museum, increasing its size by 64 percent while maintaining the pristine neo-classical presence of the old building from both the south and the north facades. After the completion of all the presentations, the Architect Selection Committee convened and in less than thirty minutes chose Steven Holl as the architect for the new Bloch Building, with local partners BNIM. In July 2001, *Time Magazine* would name Holl "America's Best Architect."[18]

"The year 2001," Marc Wilson declared, "is an exciting time to be involved with the Nelson-Atkins Museum—perhaps the most exciting since the Museum opened its doors in 1933." On April 2, 2001, Phase I of the construction project began with a groundbreaking ceremony. First, J. E. Dunn, the local contractors chosen to handle the expansion project, began the excavation for the new parking garage, a two-story underground space for 453 cars. Built under what had been the north lawn and parking area, the roof of the garage was actually a reflecting pool, designed by Steven Holl in collaboration with American artist Walter De Maria. His creation, *One Sun / 34 Moons*, featured a convex bronze and steel slab covered in gilt, which represented the sun and appeared to float on the water, surrounded by thirty-four moons, or portals, that reflected light into the parking garage below.

Although very different from what J. C. Nichols had envisioned many years before, finally the reflecting pool he had always wanted had come to fruition. Appropriately, a granite courtyard named for J. C. Nichols surrounded the pool. A gift from J. C.'s son, Miller, and his wife, Jeannette, the J. C. Nichols Plaza graciously beckoned visitors into both the Bloch Building and the Nelson-Atkins's north entrance. The entrance court was dedicated on October 12, 2002, shortly after the parking garage opened to the public in August.[19]

The museum did not close down as renovations began, and exhibitions continued into the new millennium. *Winslow Homer and the Critics: Forging a National Art in the 1870s* brought national media attention during its February to May 2001 showing. A surprising number of visitors—80,000—attended the exhibit; most of them had to take a shuttle from Manor Square, since there was no parking at the museum. An even more astounding 114,000 people saw the exhibition *Eternal Egypt*, on view from April 13 to July 7, 2002, before the parking garage had been completed. In addition to this exhibit, which Wilson called "compelling" and an exhibit of French paintings from the Walters Art Museum, two American art exhibitions—one on George Catlin and the other showing the works of Marsden Hartley—showed before

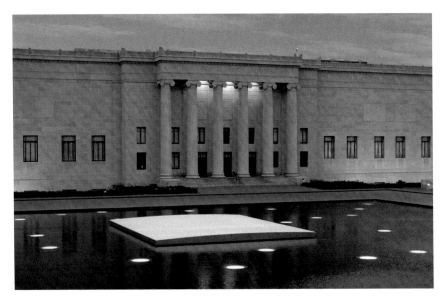

FIGURE 18.5 American artist Walter De Maria's creation *One Sun / 34 Moons* was architecturally part of the reflecting pool on the north side of the museum, with a bronze and steel slab covered in gilt representing the sun and the thirty-four moons acting as portals of light for the parking garage below. (Purchase: acquired through the generosity of the Hall Family Foundation, 2002.6)

calling a hiatus to major exhibitions. Renovations on the special exhibition rooms needed to begin.[20]

While the foundation for the new museum was being poured and the old building was being put back into pristine condition by tuck-pointing and cleaning it, construction began on the Ford Learning Center. The Ford Motor Company had since its founding in 1903 promoted cultural life in the United States by supporting numerous art institutions and cultural programs, including the Ford Fellows. "At Ford, education is our top priority," a Ford executive iterated in a sponsor statement. Ford invested in communities in which its employees worked, and Ford had a long history in Kansas City. The company opened its first branch sales office in downtown Kansas City in 1906 and its first Ford assembly plant outside of Detroit in 1912. When the Ford Motor Company built its Ford Claycomo Plant in 1951, it was the company's largest plant outside of Detroit. In 2001, the Claycomo Plant had 7,500 employees. The Ford Company had always been supportive of the Nelson-Atkins Museum of Art's educational programs, and now Ford was going to make an enormous impact by sponsoring the Ford Learning Center, "a state of the art facility

and innovative program that will provide unprecedented services to schools, teachers, children and families throughout the community."[21]

Work on the Ford Learning Center began in late 2002. At that time 5,195 square feet had been devoted to educational programs. The new space would contain 14,378 square feet. Located on the ground floor of the original Nelson-Atkins building and connected to the east entrance of the museum's addition, the new facility would include seven renovated classrooms; a new Educator Resource Center with loan materials, online resources, and professional support; a new Orientation/Training Center; and a gallery that would exhibit art by children and adults participating in the center's program. Since one in three museum visitors participates in an educational program—tours, classes, workshops, or lectures—"the Education Division is a vital link between the Nelson-Atkins Museum of Art and its public," the fact sheet on the new center read, offering a variety of learning experiences. The Ford Learning Center would facilitate enhanced educational initiatives, including Art Partners, special family events, and an innovative teen programs in which the museum partnered with schools and youth agencies, including the Boys and Girls Clubs and the Greater Kansas City Public Library. The new Creative Arts Center could expand on its already nationally recognized program with a variety of workshops, classes, and outreach programs. Adult programs included talks, lectures, and performances, and credit and non-credit courses offered through UMKC. Tour programs could be expanded, and teen guides could be hired and trained in the new training center. In September 2005, Bill Ford came for the dedication of the Ford Learning Center, which opened to rave reviews and extensive media coverage.[22]

FIGURE 18.6 The Ford Learning Center, opened in 2005, provided state-of-the-art facilities for classrooms, studios, display, and educator resources. (NAMADAA)

Even as improvements were being made in the older building, progress continued on the new Bloch Building. In October 2005, workmen set in place the new building's exterior glass walls, which had been specially manufactured in Germany. In November, renovation of Kirkwood Hall was completed. The stone had been cleaned, new lighting and sound systems installed, and the Adelaide Cobb Ward Sculpture Hall, which linked Kirkwood Hall to the Atkins staircase leading into the new building, was dedicated. Addie Ward, who had been a trustee at the Nelson-Atkins Museum of Art since 1993, expressed her pride in being able to contribute to the sculpture hall that had been created out of the former special exhibition rooms. She remarked on the "amazing transformation" of the space that would connect the marble and stone of the old building to the glass and steel lobby of the new building. Shortly after the dedication, the Adelaide Cobb Ward Sculpture Hall—Addie had insisted on Cobb in the name, as she was the last of the Cobbs—received an architectural prize for its design and function. Besides linking the two buildings, the hall provided access on both sides to large exhibition galleries. Also, several important sculptures found a new home there, including Francesco Mosca's *Atalanta and Meleager with the Calydonian Boar*, which was purchased by the Nelson Trust in 1934, and the magnificent marble *Lion* from Attica, which the trustees bought in 1933.[23]

Meanwhile, installation of exterior glass walls in the Bloch Building was completed in February 2006, and work began on interior walls and ceilings. In March the first piece of art—a fountain designed by Isamu Noguchi—was installed at the south end of the Bloch Building. In the older building, refurbished European galleries reopened in April. Then, in September 2006, the Kansas City Sculpture Park, which had been remodeled due to construction, reemerged with five days of celebratory events. To mark the tenth anniversary of the park, the Hall Family Foundation announced the donation to the museum of all its previously loaned sculptures—eighty-four in all.[24]

While new construction and renovations proceeded, some staff changes occurred as well. In January 2006, Marilyn Carbonell arrived to head Library Services, which included the Spencer Art Reference Library, the Museum Archives, and the Visual Resource Library. Along with a new facility, Carbonell called for a transformation of library services, projecting a four-part plan to increase the library's public hours; improve access to resources and the collection through new technology; expand the collection and services; and utilize best practices and eliminate catalogue backlogs.[25]

When Ann Brubaker retired in March 2006 as head of the Education Department after twenty-eight productive years at the museum, she felt she was

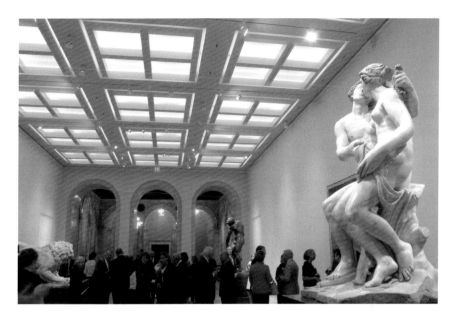

FIGURE 18.7 The Adelaide Cobb Ward Sculpture Hall linked Kirkwood Hall to the Atkins staircase leading to the Bloch Building. It featured massive sculptures by Auguste Rodin (Purchase: William Rockhill Nelson Trust, 55-70) and Francesco Mosca. (Purchase: William Rockhill Nelson Trust, 34-94)

leaving the department in great shape. The Ford Learning Center provided an amazing facility. The Tour Department had expanded. Besides school tours, special exhibit tours, and regular adult tours, the Museum Guides program, a new model for adult tours, was inaugurated in spring 2007. Adam Johnson was hired as the new head of adult programs in 2008, and a Department of Adult Programs and Interpretive Media was created in the Education Division in 2010. In addition, the Education Department had developed many new community connections. The Incentive Program, which Brubaker had organized in fall 2004 to encourage public school students to visit the museum, was thriving. In 2007, 7,482 students visited from schools in Kansas City, Missouri (which had an 89 percent minority enrollment) and Kansas City, Kansas (with a 73 percent minority population). In addition, the Community Partnerships Program connected the museum with nine organizations such as El Centro Early Childhood Center and the City Union Mission. Although teachers from these organizations had expressed doubts, Jerry McEvoy, executive director of the Swope Corridor Renaissance group, wrote in 2007, "When we first sent a group to the Nelson, we were unsure how the third grade students would

react. If you recall, we did have a problem. We could not get them back on the bus!!" McEvoy raved. "No museum that I'm aware of is offering inner-city children the quality of art classes our kids get at the Nelson. . . . Our students love coming to the museum and to classes. They learn art, they learn history, and equally important, they learn that a community of people cares for them. Your staff exudes that care week in and week out." Obviously, the Education Department was thriving, expanding, and meeting new needs.[26]

After very careful planning by curators and staff, they began to move offices, departments, and artwork into the new building in 2007. The Spencer Art Reference Library was the first to reopen in March, by appointment only. Located above the central lobby and filled with light, the library abutted the administrative offices on the north and meeting rooms on the south.

FIGURE 18.8 The light-filled Spencer Art Reference Library was the first area to open in the new Bloch Building. (NAMADAA)

Below the library was the plaza level where visitors could enter via a new café, although most patrons would come into the building through the lower level where the parking garage was located. They would pass the bookstore and enter an expansive space, the Bloch Lobby, which included the information desk. Proceeding south through the building, patrons could visit the contemporary William T. Kemper Galleries, arranged in chronological order from the 1940s to the present. Besides supporting the Generations Campaign,

which funded the construction of the Bloch Building, the William T. Kemper Collecting Initiative funded the acquisition of contemporary art, which now included the monumental twenty-six by thirty-three foot *Dusasa I*, created by Ghanian artist El Anatsui and which hung in the Bloch Lobby. The African art galleries followed the contemporary galleries, as well as the Hallmark Cards Galleries, featuring the Hallmark Photographic Collection.

FIGURE 18.9 Hung in the Bloch Lobby, this massive contemporary sculpture, *Dusasa I* by Ghanian artist El Anatsui, was another generous gift of the William T. Kemper Foundation. (Purchase: acquired through the generosity of the William T. Kemper Foundation—Commerce Bank, Trustee, 2008.2)

In December 2005, Donald J. Hall, as University Trustee and a man committed to the Nelson-Atkins and to Kansas City, transferred the entire Hallmark Photographic Collection to the museum—6,500 images taken by nine hundred American photographers from 1839 to the present day. The collection, which Hallmark had begun in 1969, was "one of the most significant gifts ever to come to an American museum," Wilson explained, as well as "one of the largest and most distinguished collections of American photography

in the United States." The new 3,000-square-foot photography gallery would have two functions, with one part devoted to a historical rotation of art photos from the collection and the other space to be used for special thematic or monographic exhibitions. Again, the Nelson-Atkins stood in the forefront of art museums in its collection and display of photography, as only a handful of American museums had a historical collection of images on view.[27]

FIGURE 18.10 The Hallmark Photographic Collection given to the museum in 2005 included a number of singular works with no other known example, such as the treasured photograph *House of a Thousand Windows* by Alvin Langdon Coburn. (Gift of Hallmark Cards, Inc., 2005.27.297)

At the southern end of the Bloch Building, visitors entered the H & R Block Galleries, designed with the flexibility to host large exhibitions. The Isamu Noguchi Sculpture Court occupied the southernmost end of the Bloch Building and was named for longtime museum supporters, Tinka and Harry McCray. Harry McCray became a University Trustee in 2007 (when Henry Bloch changed his status to Honorary Trustee) and served as chairman of the Board of Trustees from 2007 to 2009. All the while, throughout the new Bloch Building, the architectural design and the light compete for the visitor's attention, while the Gallery Walk along the entire west side of the building provides outdoor views of the sculpture garden.

Wilson declared the opening of the Bloch Building to the public on June 7, 2007, "the highlight of the year, and perhaps the most remarkable event since the Museum's birth in 1933." Major donors and "upper level" members of the museum experienced a series of gala events during the week leading up to the opening of the Bloch Building, culminating in the "Asymmetrical Evening," a party for 2,400 guests, chaired by Liza Townsend and Joan Marsh. Besides the permanent exhibits in the new building, two inaugural shows were highlighted in the exhibition galleries. One was *Developing Greatness: The Origins of American Photography, 1839–1885*, curated by Keith Davis, Hallmark's photography curator who became the Nelson-Atkins's first curator of Photography. The other exhibit, *Manet to Matisse: Impressionist Masters from the Marion and Henry Bloch Collection*, featured works that the Blochs had collected over a twenty-year span with the guidance and support of former director Ralph T. Coe. The Blochs had personally invited Coe to the opening.[28]

Thousands of people flocked to see the new building in the days and weeks after its debut. The completion of the Bloch Building, magnificent as it was, however, would not be the be-all and end-all of renovations or innovations at the Nelson-Atkins, for many other exciting changes were in the works. The seventy-fifth anniversary of the museum in 2008 did not go totally unnoticed. The museum received 396 birthday gifts, 131 of which would be exhibited in 2010 as *Magnificent Gifts for the 75th*. A new edition of the handbook, *The Nelson-Atkins Museum of Art: A Handbook of the Collection*, was published in 2008. It was the seventh edition but the first one in full color. From May 3 to July 20, 2008, a special exhibition of contemporary painting, *Sparks! The William T. Kemper Collecting Initiative*, reviewed the ten years of collecting history of the William T. Kemper Collecting Initiative.[29]

Moreover, refurbishment continued on the galleries in the original Nelson-Atkins building. Most important, Margaret Conrads, Samuel Sosland Curator

of American Art; Gaylord Torrence, Fred and Virginia Merrill Curator of American Indian Art; and Catherine Futter, the Helen Jane and R. Hugh "Pat" Uhlmann Curator of Decorative Arts, began formalizing plans for the total remodeling of the American and American Indian art galleries. Back in September 2001, Conrads had written to Marc Wilson that the guiding principles for the reinstallation of the American galleries would be "to show our best works" and to tell the essential story of American art. Those principles did not change as the plans for the new galleries proceeded. Conrads chose paintings that would hang in the newly refurbished galleries, including works by Benjamin West, Charles Peale, John Singleton Copley, John Singer Sargent, George Caleb Bingham, and Thomas Hart Benton. She sent eleven paintings to the conservation department for restoration and had twenty-one paintings reframed, while she worked with Futter to add decorative arts to the American galleries. As Futter explained, "the decorative arts help tell a richer story of American art and history by complementing the paintings and sculpture and filling in areas in which the collection does not have depth." Futter was able to complement the paintings with contemporary decorative arts, especially those from the mid to late nineteenth century. One of the exciting new elements of the new American galleries was the reinstallation of the hall from the Robert Hooper House in Danvers, Massachusetts. The room was restored to its original dimensions and paint colors and reinstalled in time for the opening of the new Sarah and Landon Rowland American Art Galleries in April 2009.[30]

Sarah and Landon Rowland had established the Ever Glades Fund in 2002, and through their fund had made many generous donations to the American art collection before supporting the American art galleries. When in 1994 R. Crosby Kemper and his wife, Mary "Bebe" Hunt Kemper, transferred their art interests into establishing the Kemper Museum of Contemporary Art just west of the Nelson-Atkins, they succeeded in expanding the cultural district, but their patronage of the American art department was sorely missed. The Rowlands stepped into the breach. Sarah Rowland had been a trustee of the museum since 1999 and would serve as a University Trustee from 2009 to 2015 and as chairman of the board from December 2009 to May 2013. She and her husband made a profound difference in the museum through their dedication and donations, providing it with important paintings such as those by Fitz Henry Lane, Raphaelle Peale, Thomas Cole, and Lilla Cabot Perry, and through their support of the Sarah and Landon Rowland American Art Galleries.

FIGURE 18.11 The Sarah and Landon Rowland American Art Galleries opened in April 2009 and featured not only paintings but also decorative arts such as the *Chest-on-Chest*, which J. C. Nichols had bargained to buy in 1934. (Purchase: William Rockhill Nelson Trust, 34-123) (NAMADAA)

Meanwhile, Gaylord Torrence began refining the American Indian collection and making plans for the future. In 2003, working with in-house designer Rebecca Young, Torrence had reinstalled the 1,500-square-foot American Indian gallery on the third floor. He had chosen sixty-five pieces of extraordinary quality, including eighteen objects from the Donald Jones bequest, and had showcased works loaned from local private collectors and institutions. In anticipation of moving the American Indian collection into a larger space on the second floor that now housed the Parker-Grant Gallery, which would be transferred to the Bloch Building, Torrence worked on building and honing the collection. His charge was to create a "core collection based on aesthetic merit—not ethnography—that would present the most comprehensive range of major forms of native art from across the continent—pre-contact to contemporary." The museum's plan for the American Indian Collection was ambitious, and it became even more so when in 2004, due to support within the community and beyond the Kansas City region, additional space was allocated, so that the new American Indian Galleries would occupy the former Spencer and Bloch Galleries as well as the Parker-Grant Gallery. With the original space allotted to American Indian art having more than doubled, Torrence would have the room to display 210 masterworks from sixty-five Nations, spanning time and representing every major form of artistic expression in North America. The comprehensiveness of the collection had been greatly enhanced by gifts from Kansas City and across the nation, including the transformative gift from Morton and Estelle Sosland of thirty-four outstanding examples of Northwest Coast art, one of which was a magnificent Kwakiutl *Chief's Mask*. Of the new

FIGURE 18.12 The transformative gift of thirty-four outstanding examples of Northwest Coast art from the Estelle and Morton Sosland Collection included this Kwakiutl *Dzunukwa Mask or Gikamhi (Chief's Mask)*. (From the Estelle and Morton Sosland Collection, 2009.41.1)

acquisitions, which Torrence had purchased or secured from private collectors, an Arikara *Shield* from North Dakota was "probably the most important object that I will acquire," he related.[31]

FIGURE 18.13 Gaylord Torrence refined the American Indian art collection, adding such treasures as the Arikara *Shield* (Purchase: the Donald D. Jones Fund for American Indian Art, 2004.35)

The American Indian art galleries would be innovative and spacious. When Torrence showed the model of the new galleries to the Committee on the Collections in 2006, he explained that the Nelson-Atkins would be using "a vastly different method of exhibiting American Indian Art that will distinguish us from other art museums." It would be obvious when the galleries opened in 2009 that the museum had given American Indian art "great prominence, placing the expanded galleries directly adjacent to American painting, sculpture, and decorative arts—to establish what constituted an American wing." Besides being appropriately placed in proximity to the American art galleries (which did not happen at the Metropolitan until Torrence himself guest-curated a special installation in the museum's American wing in 2019) and having the advantage of a luxurious amount of space, more than 6,000 square feet, the installation of the collection was masterful. Rebecca Young designed the innovative and dramatic casework in association with Goppion, the internationally renowned case designer and manufacturer in Milan, Italy. The works of Native American art displayed in these remarkably beautiful glass vitrines enabled visitors to view objects from different vantage points. "The goal will be to place the Nelson-Atkins on the cutting edge of recognition and connoisseurship," Torrence had related during the planning stage, and the goal had been met. The opening of the new American Indian galleries in November 2009 was the high point of the fiscal year ending in April 2010 and reflected Wilson's overriding philosophy that all works of art from all cultures should be displayed so that "every work could remain an individual, but close and dense enough that the pieces could reinforce one another."[32]

The Steven Holl–designed addition to the Nelson-Atkins Museum of Art had received much architectural acclaim. Named by *Time* magazine as 2007's number-one architectural marvel, in 2008 the Bloch Building received the Capstone Architectural Design Award. Just two years later, the new suite of American and American Indian galleries were given a "wow" report from many publications including *The Wall Street Journal*, which said the artworks were "astutely chosen and arrestingly installed." It was difficult to discern who was more proud of the new American wing—Gaylord Torrence, Margaret Conrads, Catherine Futter, Marc Wilson, or the trustees. Wilson, however, gleaned great pleasure from the fact that the American wing, which completed the remodeling of the second floor of the museum, had been executed under his watch.[33]

Wilson would retire in June 2010 but not before he oversaw one last major project: the renovation of the ancient galleries and the opening of a new Egyptian gallery, featuring the funerary assemblage of the Lady Meretites.

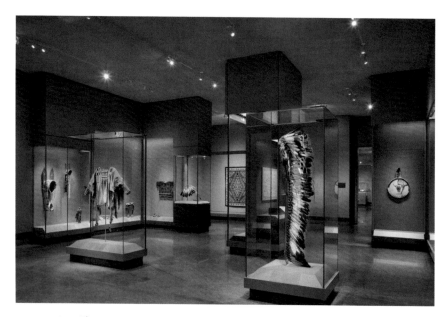

FIGURE 18.14 The innovative and spacious Native American art galleries opened in November 2009, completing the American Wing on the second floor of the museum. (NAMADAA)

When in April 2000 an exhibit entitled *Eternal Egypt: Masterworks of Ancient Art from the British Museum* came to the Nelson-Atkins, the public response was overwhelming. Despite parking difficulties, over 100,000 visitors saw the exhibition, one of the three largest and most complex ever presented at the Nelson-Atkins. *Eternal Egypt* was so popular that Robert Cohon, curator of Ancient Art, told the Committee on the Collections that, given the public's fascination with Egyptian antiquities, the museum was searching for a mummy to enhance its already significant Egyptian collection. In April 2003, Cohon informed the committee that a fourth-century funerary assemblage of an Egyptian noblewoman named Meretites had been offered to the museum. After surmounting several hurdles, in 2007 the Nelson-Atkins was finally able to purchase the 2,300-year-old collection of funeral objects from Meretites's tomb. Although the mummy of Meretites was not included in this funerary assembly, an unrelated mummy of Ka-i-nefer had previously been found. The seven-foot-tall gilt sarcophagus of Meretites proved to be the highlight of the new Egyptian gallery. Susan B. and Mark A. Susz, whose daughter Emily had been inspired by her UMKC professor Robert Cohon, the Nelson-Atkins curator, had provided funding for the renovation of the ancient art galleries. New

lighting, new casework, and updated insulation and accommodations to meet extreme conservation requirements all contributed to an exhibit that aimed to be both educational and wondrous. The Egyptian Art Gallery in the Susan B., Mark A., and Emily Susz Galleries opened in April 2010, just before Marc Wilson's retirement on June 1.[34]

CHAPTER 19

❖

"NOW, THAT'S THE REAL THING."

A S MARC WILSON approached the end of his twenty-eight years as director, he must have felt deep satisfaction, as it was his vision, shared by trustees and patrons, that had led to the museum's spectacular renewal and growth. During his tenure the Nelson-Atkins had expanded to include the Kansas City Sculpture Park, with the iconic *Shuttlecocks,* the Ford Learning Center, and the Bloch Building. The museum had acquired 15,000 new works of art, which included the Hallmark Photographic Collection, and had reinstalled many galleries, most recently the American, Native American, and Ancient Art. The Nelson-Atkins Museum of Art could now be ranked as one of the most outstanding museums in the nation.

However, Wilson also understood the need for caution. As Morton Sosland had told the Board of Trustees in 2004, "We must provide the wherewithal to assure that what happens within the precincts of this [the Nelson-Atkins building] and the new Bloch Building exceeds the wonders of those buildings themselves." The facilities were magnificent, but as Sosland warned, "a few errant museums" had completed great new structures but then "neglected the overriding need for quality programs and art. It is our duty this does not happen here." Therefore, the museum would increasingly have to provide educational, cultural, and social opportunities in order to attract new patrons, who were needed to support the endowment and capital improvements and to contribute to the ongoing operating expenses. As the general public still had the perception that the museum was a wealthy institution that only required donations for extraordinary projects, "a shift in external perception," Sosland said, would be necessary. His words, although spoken five years before the search for a new director began, certainly influenced the board to find someone who could change the perception of the museum as a place for a select

333

population of the highly educated, wealthy, and art-savvy. The board recognized that the museum needed to appeal to a broader audience and provide recreational and social activities as well as educational programs for adults, children, and families in order to compete with the wide array of venues available to the general public.[1]

When Marc Wilson announced his intentions to retire on June 1, 2010, the Board of Trustees formed a search committee and began compiling a position-specification paper, which would be several pages long. The trustees were looking for someone to expand the base of supporters, broaden the museum's audience through innovative exhibitions and programs, cultivate relationships with local cultural and educational institutions, increase the use of technology to access the collection and library, build national and international recognition of the museum, and forge relationships with the staff, trustees, volunteers, and patrons. Overall, the new director needed to be "an inspiring, energetic, and civic-minded leader who will serve as the Museum's chief advocate locally, nationally, and internationally." By November 2009, the firm of Russell Reynolds Associates had posted the specifications for the new director/CEO, and the vetting process began. Possible candidates came to Kansas City for a first round of interviews in January and the second round the first week in February. On March 15, 2010, the board announced the appointment of Julián Zugazagoitia as the Menefee D. and Mary Louise Blackwell Director/CEO of the Nelson-Atkins Museum of Art.[2]

Julián Zugazagoitia had an international background. Born in Mexico City, Zugazagoitia was educated in France, receiving an art degree from the École du Louvre and a PhD in philosophy from the Sorbonne. He had served as a consultant, lecturer, and curator around the globe for the United Nations Educational, Scientific and Cultural Organization (UNESCO), had been a consultant to the Getty Conservation Institute in Los Angeles, and had served as the executive assistant to the director of the Solomon R. Guggenheim Museum in New York. For the past seven years, Zugazagoitia had been the director/CEO of El Museo del Barrio in New York City, a leading museum of Latino/a and Latin American art, and had served on the board of the Association of Art Museum Directors since 2007.

Although Wilson had offered to stay on for a few weeks or months to ease Zugazagoitia into his new position, the trustees thought it would be better for the new director to jump right in. The situation could not have been more dissimilar from the setting Zugazagoitia had left. Kansas City was a vastly different place than New York City, and the Nelson-Atkins Museum of

FIGURE 19.1 Julián Zugazagoitia was appointed the Menefee D. and Mary Louise Blackwell Director/CEO of the Nelson-Atkins Museum of Art in 2010. (NAMADAA)

Art bore little resemblance to El Museo del Barrio. Moreover, the first time Zugazagoitia had visited Kansas City was in January 2010, and before assuming his post at the museum he had only returned for a subsequent interview and then to find a home for his family—his wife and two children. Wilson left on June 1; Zugazagoitia assumed his position as director of the Nelson-Atkins Museum of Art on September 1, 2010. Unlike any of his predecessors, however, on his first day on the job Zugazagoitia walked into a museum that had a functioning infrastructure, with directors of human resources, design, marketing and communication, and finance. Most important, Karen L. Christiansen, as COO (chief operating officer), had been at the museum since 1999 and knew all the ropes.

Moreover, the governance of the museum, which was in transition when Marc Wilson took over for Ted Coe, was now well established. The trustees included the three University Trustees, and now eighteen Associate Trustees. Together these trustees monitored the Nelson Trust and the Nelson Foundation and provided leadership for various committees, including development, finance, investment, audit, collections, governance, buildings and grounds, exhibitions, and education. The trustees also promoted the three main membership societies: the Friends of Art, the Society of Fellows, and the Business

Council. The Print Society was still functioning, and the Advocates, a group started in 2007 by trustee Alan Marsh, was created to engage targeted individuals and family who had not previously been a part of the museum family.

Zugazagoitia was fortunate to inherit a well-functioning museum, and he embraced the trustees' directive to develop a comprehensive knowledge of the museum's history, collections, exhibitions, operations, finances, organization, programs, and supporters. All three of Zugazagoitia's predecessors had been curators at the museum prior to becoming directors and had known the history, the collection, the trustees, staff, and major donors. They also had known Kansas City and were already part of the community. As a newcomer, Zugazagoitia would need to familiarize himself with the museum and the city. Meanwhile, the community would already know something about him, as the distribution of five to eight thousand letters to key stakeholders was part of the plan to introduce the new director. Accompanied by several trustees, he would meet with various groups during his first weeks at the Nelson-Atkins Museum of Art.[3]

Zugazagoitia had to learn about the early history of the museum quickly, as he was hit right away with the problem of what to do about Stone House, the home that William Rockhill Nelson had built for his daughter Laura Nelson Kirkwood and her husband Irwin. The Kirkwoods had lived in this house, across Rockhill Road from the museum, until October 1921, when they had moved into Oak Hall, the Nelson home that had been torn down to build the William Rockhill Nelson Gallery of Art. In 1922, Stone House had been sold to Devere Dierks, who had lived there with his wife until 1953, when the Dierks family donated the house to the Nelson-Atkins Museum of Art. Subsequently, the museum had leased the house to the Rockhill Tennis Club. The club had built tennis courts and a pool and converted the house to a clubhouse. Over the years there had been a series of issues with neighbors, the museum, and the Rockhill Tennis Club regarding zoning, finances, parking, and so on. In the 1990s the club had wanted the museum to finance a million-dollar plan to enhance the facility, which had not happened. In June 2010, before Zugazagoitia had arrived, the museum had terminated the lease with the Rockhill Tennis Club in order to use the property for museum purposes, and now Zugazagoitia dealt with the aftermath of that action. He began to learn about the Rockhill and Southmoreland neighborhoods and how plans had evolved and would continue to develop for the large cultural area that included these neighborhoods as well as the University of Missouri-Kansas City, the Kansas City Art Institute, the Ewing Marion Kauffman Foundation, the Linda Hall Library, the Stowers Institute, the Nelson-Atkins Museum of Art, and other institutions.[4]

FIGURE 19.2 Stone House was the home that William Rockhill Nelson had built for his daughter, Laura Nelson Kirkwood, and her husband, Irwin Kirkwood. (NAMADAA)

At his first board meeting in September, Zugazagoitia outlined his initial goals. First, he wanted to develop a new strategic plan. He had already met with members of the Andrew W. Mellon Foundation, who indicated they would give monetary support for this project, which would involve eighteen months of research, discovery, and planning conducted by a village of volunteers, staff, trustees, neighbors, and patrons. In the plan that was adopted in April 2013, the board identified six key focus areas and rewrote the museum's mission statement, beginning, "The Nelson-Atkins Museum of Art is where the power of art engages the spirit of community."

Zugazagoitia's next goal was to meet with all the curators to acquaint himself with the collections and to encourage the curatorial staff to continue to produce scholarly publications, which Wilson had deemed essential to a vital museum, a concept the trustees enthusiastically endorsed. Besides exhibition catalogues, curators would continue to work on publications highlighting specific collections, such as the publication in 2011 of *Masterworks of Chinese Art* and in 2017 of *Masterworks from India and Southeast Asia*. From these meetings with individual curators, Zugazagoitia came up with the idea of a monthly program during which he and a curator would have a conversation about art, exploring the most remarkable treasures of the Nelson-Atkins collection. Held

in the Atkins Auditorium, "Art Tasting with Julián" became a popular Thursday evening event. It received coverage from the *Kansas City Star* and the *New York Times*, and in 2013 premiered on KCPT (Kansas City Public Television). In 2014 "Art Tasting with Julián" was even nominated for an Emmy award.[5]

Zugazagoitia also approached the curatorial staff to learn from them what exhibitions they had mounted during the past two decades. In the process, curators could remember their successes and shortcomings and make plans for the future. Besides getting an overview of exhibits from the curators, in those early days, every time Zugazagoitia met with a group—volunteers, trustees, Society of Fellows, neighbors, etc.—he distributed notecards and asked individuals to write down their favorite and least favorite exhibits and what exhibition they would most like to see brought to the Nelson-Atkins. He learned, not surprisingly, that opinions varied. For example, the 2008 show *Art in the Age of Steam: Europe, America, and the Railway, 1830–1960* ranked in the top-five exhibitions and also in the bottom five. However, there was consensus that most people wanted to see a Picasso show brought to the museum. Zugazagoitia pursued the idea of a Picasso exhibition from the very beginning of his directorship.[6]

Meanwhile, through the process of surveying staff and patrons, Zugazagoitia's hope was to fulfill one of the priorities set by the trustees in his position specifications: to oversee "the creation of a vibrant and balanced approach to exhibitions and programming." Zugazagoitia believed that each curatorial department should be given equal opportunities to launch exhibits and that exhibits should meet the needs of diverse audiences. He emphasized the importance of balance, not only in subject matter but also in using the museum's own art in exhibitions at least as often as importing expensive exhibitions. Creating traveling exhibitions was also a priority, but two goals needed to be kept in mind, Cindy Cart, curator of Exhibitions Management, reminded curators: (1) to maximize the impact of an exhibit beyond Kansas City, and (2) to help recoup the expenses incurred in putting the exhibit together.[7]

A variety of innovative exhibitions took place during Zugazagoitia's first years as director. In 2011 Jane Aspinwall mounted a photography exhibit, *Heavens: Photographs of the Sky and Cosmos*, and Ling-en-Lu, assistant curator of Early Chinese Art, collaborated with the American Art Department in the paper exhibition, *Landscape East/Landscape West: Representing Nature from Mount Fuji to Canyon de Chelly*. In 2012, Catherine Futter organized *Inventing the Modern World: Decorative Arts at the World's Fairs, 1851–1939*. As she told the Board of Trustees, "This is the first exhibit of its kind, and the show focuses on world fairs as global meeting places where innovation

and utopian visions were fostered." (This idea is reminiscent of the fact that Mary Atkins drew part of her inspiration for an art museum by attending the World's Fair in Chicago.) After 50,000 visitors toured the World's Fair exhibit at the Nelson-Atkins, resulting in 423 new Friends of Art members, Futter's exhibit traveled to the Carnegie Museum of Art, the Mint Museum of Charlotte, North Carolina, and the New Orleans Museum of Art. Jan Schall coordinated an exhibit in June 2012 called *Showcase: Collecting for Kansas City.* The exhibition highlighted works from every curatorial department and acknowledged local donors who over the previous two years had given 868 pieces of art to the museum, including such major donations as two Catlin paintings given by Katherine and Paul DeBruce.[8]

Exhibitions also included art by George Ault, Claude Monet, Auguste Rodin, and native son George Caleb Bingham. Chinese painting, American folk art, and the Starr miniature collection were subjects of exhibitions that attracted a variety of visitors. In 2013 *Frida Kahlo, Diego Rivera, and Masterpieces from Modern Mexico from the Jacques and Natasha Gelman Collection* was the first large exhibit supported by the Donald J. Hall Initiative, created on the occasion of his retirement from the Board of Trustees after serving as a University Trustee for three decades. Also, in 2013, Kimberly Masteller, the Jeanne McCray Beals Curator of South and Southeast Asian Art, and Robert Cohon worked together to present the exhibition *Roads of Arabia*, which was opened by the HRH Prince Sultan bin Salman and was held from April 25 to July 6, 2014.

Then in September 2014, a major achievement for the Nelson-Atkins was the opening of *The Plains Indians: Artists of Earth and Sky.* The idea for this exhibition originated at the Musée quai Branly–Jacques Chirac in Paris, a museum that features the indigenous art of the Americas, Africa, Asia, and Oceania. The Musée quai Branly had asked Gaylord Torrence to curate a show of Plains Indian art, which he agreed to do if the exhibition could also come to Kansas City. An agreement was reached, establishing a relationship between the Musée quai Branly and the Nelson-Atkins, which proved to be of importance. After showing in Paris, *The Plains Indians* opened at the Nelson-Atkins on September 26, 2014, with Native American tribal leaders giving the artwork both private and public blessings. The exhibit displayed Plains Indians masterwork ranging from a 2,000-year-old stone pipe to a 2014 beaded adaptation of designer shoes. Many Nations were represented as well as a variety of artistic media—painting and drawing; sculptural work in stone, wood, antler, and shell; porcupine quill and glass bead embroidery; feather work; richly ornamented clothing; and ceremonial objects. Plains Indian dancers

and drummers performed for the duration of the exhibition, which closed on January 11, 2015. Viewed by 62,000 visitors to the Nelson-Atkins, *The Plains Indians: Artists of Earth and Sky* went on to the Metropolitan, cementing the importance of the show.[9]

Meanwhile, Zugazagoitia continued to give thought to the Picasso exhibition he wanted to present. In 2012, he had proposed mounting an exhibit from the museum collection of photographs of Picasso taken by Kansas City native David Douglas Duncan. Picasso and Duncan had formed a deep friendship, revealed in the spontaneity and forthrightness of the photos Duncan had taken of the artist. The thirty-two photographs in the exhibit *Bonjour Picasso!* provided a wonderful perspective on Picasso and a tease for the future exhibition, which Zugazagoitia was finally able to acquire in October 2017. After intense negotiations with the Musée national Picasso–Paris, the Musée quai Branly–Jacques Chirac, and the Picasso family, who were the prime lenders, the Nelson-Atkins would be the only museum in the United States to exhibit *Through the Eyes of Picasso*. The exhibition, which attracted a remarkable 100,000 visitors in Kansas City, then traveled to the Museum of Fine Arts, Montreal, and the Musée quai Branly–Jacques Chirac, Paris.[10]

FIGURE 19.3 Thirty-two photographs of Picasso taken by Kansas City native David Douglas Duncan provided a prelude to the October 2017 *Through the Eyes of Picasso* exhibition. (*Picasso in a Yellow Robe,* Gift of David Douglas Duncan, 2014.11.156)

Finally, at that same first board meeting, Julián Zugazagoitia announced that another goal he had was to look at the accomplishments of the past and develop a new vision. That vision included involving more people with the museum—those of all ages, ethnic groups, and economic levels. He wanted, and would very soon see, attendance climb to over a half million people a year. Media coverage was key, and the museum had already promoted various events through mixed media campaigns, one of which won an award in November 2010. Besides television, radio, and newspaper exposure, under the direction of Toni Wood, the Marketing and Communication Department was using multiple methods of communicating with the public, and her department would increase these efforts. All members of the museum's membership groups received emails to announce new exhibits, classes, and events. A mailing of a bimonthly flyer, *Art Scene*, provided a calendar and guide to featured programs and festivities. As a founding member of the Kansas City Arts Consortium, the Nelson-Atkins Museum of Art posted articles in a magazine, *KC Studio*, published by the Arts Engagement Foundation of Kansas City, and the museum contributed to another publication called *Insights*. Biannually, a member magazine, called *Member Magazine* until 2018 when it was renamed *Art and Soul*, presented museum news, had feature articles, highlighted recent events with photographs and text, and listed major donors and donations.

Certainly media exposure and interesting exhibitions continued to attract returning and new visitors to the museum, but social activities have increased in importance during the years since Zugazagoitia became director. In 2014, the museum launched "Third Thursdays," as "your not so-quiet night at the museum!" Live music, art activities, and programs feature local talent. The museum is open to visitors who want to tour the galleries, but musical entertainment and a bar are also set up in the Bloch Lobby. While Third Thursdays are adult events, festivals, which entice a wide variety of visitors, are family affairs. Mother's Day has long been a day of festivities, and Chinese New Year, which was first celebrated in 1996 when six hundred people attended, grew to attract five thousand visitors in 2015, and eight thousand in 2016, when the event was moved from Friday evening to Sunday. Beginning in 2011, the museum began celebrating the Mexican tradition of the Day of the Dead. An American Indian Cultural Celebration was held when the new American Indian galleries opened, and again in 2014–15 during the Plains Indian special exhibit, and thereafter annually. A Passport to India Festival began in 2012, and in 2014 the first "Big Picnic" was held in conjunction with the Kansas City, Missouri, Parks and Recreation

Department. This event to celebrate the twenty-fifth anniversary of the museum's sculpture park, renamed the Donald J. Hall Sculpture Park, would become another traditional festival. In addition, in 2018 "Open Spaces," a

FIGURE 19.4 The first Big Picnic was held in 2014 to celebrate the twenty-fifth anniversary of the museum's sculpture park, renamed the Donald J. Hall Sculpture Park. (NAMADAA)

city-wide art festival, was held to feature contemporary visual and performing artists, and in summer 2019 a nine-hole miniature golf course, inspired by masterpieces from the collection, would entice families to the museum grounds.[11]

Zugazagoitia's vision also included developing new fund-raising events and support groups, always with the idea of more community involvement. A planned-giving society, the William Rockhill Nelson Society was created in April 2011. To introduce it, the Board of Trustees and Zugazagoitia invited a select group to a founding celebration during which he and a William Rockhill Nelson enactor put on a dramatic production introduced with, "Tonight we hope you will be inspired by the story of a man whose consistent goal in every endeavor was to improve his community–both during and after his life." The William Rockhill Nelson Society has grown and thrived, as has another group, The Committee of 100, established in 2012 by women who wanted to support their museum.[12]

Zugazagoitia wanted to find a new idea for a general fund-raising event. In April 2011, he and Paul DeBruce, trustee and chair of the Finance Committee, took a trip to Atlanta to attend a wine auction benefitting the High Museum. The auction, which generated $1.8 million, provided the two men with a model for a donor event. Launched in 2012, with the very clever name of "ShuttleCork," the wine auction was a big success. Since it was billed as a casual event rather than a black-tie affair, ShuttleCork appealed to a broad range of people, many of whom were not members of the museum and had not previously attended an event at the Nelson-Atkins. In 2013, DeBruce determined that the auction could be improved by making it a two-day event, with the first evening focusing on wine dinners in private homes. By 2014, ShuttleCork netted the museum $800,000, and DeBruce projected a $1 million goal for 2015 and continued high expectations for the future. In 2019, ShuttleCork netted the museum $1.4 million.[13]

To fulfill another of the board's priorities, Zugazagoitia encouraged his staff to expand technology. A new website was created, including a collection search so comprehensive that it relieves the need to produce an updated handbook. (The last one had been issued in 2008.) The website user can learn about classes, exhibits, and hours of operation, and can access works of art by title, artist, and nationality and learn about the work's provenance and history of exhibition. Audio guides were first introduced in 2004 for use in the European and Decorative Arts Galleries, but new audio guide devices were purchased in 2010 that allow visitors to browse, interact, and explore more than two hundred works in the Nelson-Atkins collection. Trustees were the first to try out the new devices and found them very satisfactory. Thanks went to the co-chair of the Development Committee, Kenneth Baum, and his wife for providing the funds to help bring the museum further into the twenty-first century. The museum has adopted new technologies as they have emerged, and it will continue to do so in the future.[14]

Meanwhile, educational programs thrive and, as always, remain one of the most important parts of the museum's mission. The Ford Learning Center has updated one classroom to allow students to generate computer art, and to create their own advertisements and videos during daylong workshops. Continuing exploration of new programming ideas keeps the learning center vital. Docents, staff, and teachers developed five new school tours in 2013, which were based on the state's Common Core curriculum in order to integrate art with classroom studies. Tours have changed; no longer are docents there merely to impart information but also to get students to look at

and engage in art. The Nelson-Atkins joined other museums to offer "one-day university" classes for adults, featuring renowned professors in a program called Pure Joy of Learning. The Education and Interpretative Programs director, Anne Manning, now heads five divisions: library, interpretation and evaluation, education volunteers, public programs, and school and education services, because education is such an important part of the Nelson-Atkins.[15]

The acquisition of works of art, however, remains the lifeblood of any art museum. Although the Nelson Trust and the Nelson Foundation continue to make purchases, in the twenty-first century, gifts represent roughly 80 percent of new acquisitions. As the *Kansas City Collects* exhibit showed, donors' gifts augment every department in the museum and the donors are as diverse as the gifts themselves. Some highlights include the George Caleb Bingham portraits of Dr. John Sappington and his wife, Mrs. Jane Breathitt Sappington, given in 2011 by Mary Katherine Horner and Charles D. Horner. Paul DeBruce and Linda Woodsmall-DeBruce made the promised gift of magnificent bronze doors, twentieth-century versions of Lorenzo Ghiberti's Renaissance masterpieces, *The Gates of Paradise*, which they had discovered on a trip to Florence. The Hall Family Foundation added works to the sculpture garden: Roxy Paine's *Ferment* in 2011, and in 2014, *The Glass Labyrinth* by Robert Morris.

In 2015, the Hall Family Foundation gave a transformative $10 million donation to acquire photographic collections. With these funds, over the course of the subsequent three years, photography curators Keith Davis, Jane Aspinwall, and April Watson sought to purchase significant photographs to augment the strong American collection and also nineteenth- and twentieth-century European photographs and contemporary pieces. In 2018, in time for the Hall Family Foundation's seventy-fifth anniversary, the curators put one hundred of the eight hundred new photographs purchased on display in a truly one-of-a-kind exhibition called *The Big Picture*. Keith Davis wrote the exhibition catalog, which includes a history of the museum's photography collection. With this latest gift from the Hall Family Foundation, the photography collection at the Nelson-Atkins earned an international reputation, as nearly all major photographers and creative movements are represented. The museum has become "*the* prime regional destination for the serious study of original photographs," according to Davis, adding yet another jewel to the museum's crown.[16]

Another transformative gift came from Marion and Henry Bloch in 2015. The Blochs had begun collecting Impressionist and Post-Impressionist paintings in the late 1970s under the guidance of Ted Coe, and over the course of twenty years had accumulated an impressive collection including masterpieces

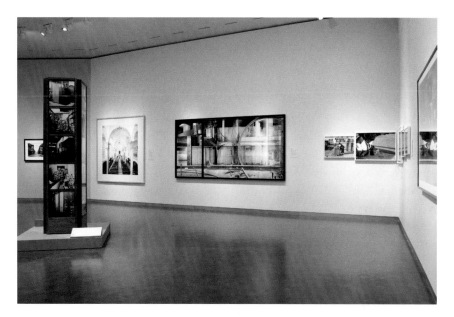

Figure 19.5 A transformative $10 million gift from the Hall Family Foundation promoted the Nelson-Atkins Museum of Art's photography collection to international status. One hundred nineteenth- and twentieth-century photographs were displayed in an impressive exhibition called *The Big Picture*. (NAMADAA)

by Pierre Bonnard, Eugène Boudin, Gustave Caillebotte, Paul Cézanne, Edgar Degas, Paul Gauguin, Pierre-Auguste Renoir, Édouard Manet, Claude Monet, Berthe Morisot, Paul Signac, Alfred Sisley, Vincent van Gogh, Camille Pissarro, and George Seurat. Coe and Bloch had traveled to see works of art together and exchanged many letters, but the letter Bloch wrote to Ted Coe on November 1, 1995, that now hangs outside the Bloch galleries, sums up their close relationship: "I wanted to tell you how much I appreciate the wonderful advice you have always given Marion and me. I don't know if I've ever said this before, but without you we never could have acquired the collection we enjoy so much."[17]

The Blochs had promised their Impressionist paintings to the museum as a bequest. However, once Marion died in September 2013, Henry decided that he would rather view his paintings in what would be their permanent home, the new Bloch Galleries at the Nelson-Atkins Museum of Art. Thus, in 2015, Bloch donated the collection of twenty-nine masterworks to the museum, except for one work by Edgar Degas that had previously been given to the museum.

FIGURE 19.6 Henry and Marion Bloch pose in front of Camille Pissarro's *Rue Saint-Honoré, Sun Effect, Afternoon* (Gift of Henry W. and Marion H. Bloch, 2015.13.18)

A very strange set of circumstances led up to this 2008 gift of Degas's *Dancer Making Points*. The Blochs had purchased the pastel in good faith from the Peter Findlay Gallery in New York in 1993. However, the painting had apparently been in the collection of heiress Huguette Clark until it mysteriously disappeared from her Fifth Avenue New York apartment sometime prior to November 1992. A subsequent FBI investigation proved inconclusive. The Blochs learned about the situation from the FBI. Representatives for Huguette Clark and the Blochs entered into discussions and reached an amicable resolution. On October 27, 2008, Huguette M. Clark's lawyer, the Blochs' lawyer, and museum director Marc Wilson arrived at the Blochs' home. Henry Bloch carried the Degas out the front door, returned the pastel to Huguette Clark by handing it to her lawyer, who in turn gave the painting to Marc Wilson, who accepted the Degas as a gift from Clark to the museum. Then Wilson handed the Degas back to the Blochs to enjoy on loan from the museum until their promised collection was accessioned on June 15, 2015.[18]

FIGURE 19.7 Edgar Degas's *Dancer Making Points* was part of the Marion and Henry Bloch Collection, but due to unusual circumstances, the pastel was given to the museum in 2008, several years before the remainder of the collection. (Gift of Marion and Henry Bloch, 2008.53)

With the donation of the Blochs' much-esteemed collection, the Marion and Henry Bloch Family Foundation also provided funding to totally transform the museum's northeast quadrant on the plaza level into seven brilliant new galleries, which opened in March 2017. The Bloch collection would be integrated with European paintings, sculptures, pastels, decorative arts, and drawings from the permanent collection of the Nelson-Atkins to provide a chronological sequence of European art from 1750 to 1945. Innovative lighting and sound systems and "smart" benches make the new galleries technologically impressive, and the effect of walking into the museum and entering the Bloch Galleries is magical. As a tribute to the Bloch family, the museum published a handsome handbook titled *Bloch Galleries: Highlights from the Collection of the Nelson-Atkins Museum of Art*. The Bloch Galleries were the capstone of the many gifts and contributions Henry and Marion Bloch made over the years, gifts that transformed the Nelson-Atkins Museum of Art. The whole museum family, as well as all of Kansas City, mourned Henry's passing on April 23, 2019, at age ninety-six. He was an inspiration as a gentle and enthusiastic leader. "Henry is irreplaceable," Julián Zugazagoitia simply stated.[19]

As the collections and programs have continued to improve and expand under Zugazagoitia's directorship, the governance of the museum has also expanded and changed. In 1981, Associate Trustees had been chosen to govern the Nelson Foundation while the three University Trustees, appointed by the University Presidents of Kansas, Oklahoma, and Missouri, managed the Nelson Trust. As the foundation had grown into a much larger entity than the trust, in 2002, under Donald Hall's leadership, the Nelson Trust became the support organization of the Nelson Foundation rather than the reverse. In 2015, with Shirley Helzberg at the chair of the Board of Trustees, court action was again taken. The University Presidents decided that their oversight was unnecessary, as was their designation of University Trustees. They determined that a full board of twenty-one to twenty-four trustees could oversee both the trust and the foundation. The trustees drew up a new set of bylaws for "Twenty-first Century Museum Governance," enabling all trustees to be on equal footing and limiting terms of eligibility. Thus, just as the museum has continued to become a more democratic institution, offering free admission and open doors to all visitors, so has its governing body.[20]

Zugazagoitia, his staff, and a forward-thinking Board of Trustees have brought the Nelson-Atkins Museum of Art to a very good place in 2019, and the idea that the museum is the "art and soul" of Kansas City does not seem to be a stretch. Serendipitously, the museum's founders, trustees, directors,

benefactors, and patrons have all recognized the importance of the Nelson-Atkins Museum of Art to the city itself. As Richard Green, chair of the Board of Trustees, relates, "The vibrant connection between the museum and community has existed since the museum's founding almost a century ago. Today, we continue to serve as a vital partner in the educational, social, and cultural life of Kansas City." The role of the museum in the fabric of life will continue

FIGURE 19.8 Richard Green, chairman of the Board of Trustees, stands in front of the *Gates of Paradise* bronze doors, a promised gift from Paul DeBruce and Linda Woodsmall-DeBruce. (NAMADAA)

to change as society changes, and the issues the Nelson-Atkins has always had with space, display, and storage also will continue as the collection grows. However, the Nelson-Atkins has been fortunate to have the right people in the right place at the right time to make the museum a very special place.[21]

As if to compensate for being in fly-over country, Kansas Citians have always tried to do things better and bigger than anyone else. William Rockhill Nelson, whose favorite expression was, "Now that's the real thing!", would have used those very words to describe the current art museum. That is the way he described the eighteen-mile "driveway" he built to his Sni-A-Bar Farm and the huge *Kansas City Star* building he erected. Certainly, the Nelson-Atkins Museum of Art would also be "the real thing." Mary Atkins, whose dream to bring culture to Kansas City would know that her aspirations have been realized,

not only in her Atkins Museum of Fine Arts but in the annual Atkins lectures. People less fortunate than she, people who could not travel to Europe or collect art themselves, could enjoy going to an art museum in Kansas City, the city in which she and her husband had made their fortune.

The original University Trustees—J. C. Nichols, Herbert V. Jones, and William Volker—and the Atkins trustees—A. W. Childs and Herbert V. Jones—along with Fred C. Vincent, chairman of the original building committee, had the vision to build a museum far larger and far more grand than necessary and to fill that museum with only the best works of art by the best artists. Other trustees have shared this vision, as have the directors. Paul Gardner, who had a sense of drama and eye for detail, shaped the original galleries. Laurence Sickman brought fame to the museum with his acquisitions of Asian art and his scholarly pursuits. Ted Coe inspired collectors of all genres, laid the groundwork for many great collections to be given to the museum, and made contemporary art acceptable. Marc Wilson envisioned the renaissance of the museum, the second stage of its development, in both its physical design and the expansion of its collection. Julián Zugazagoitia has ably brought the Nelson-Atkins Museum of Art into the twenty-first century with a bright future ahead, realizing that an art museum needs to be more than a place to appreciate art but also an educational institution and a social gathering place.

Serendipitously, the Nelson-Atkins staff has always been characterized as hardworking, diligent, creative, and unassuming, and, finally, the museum would be nothing without its many donors, patrons, and volunteers. Over the years, a plethora of benefactors who have had the vision, the means, and the desire to improve the Nelson-Atkins Museum of Art have come forward at the right time. With the passing of Henry Bloch and Morton Sosland in April 2019, within two days of each other, two of the brightest lights have gone out for the museum and, seemingly, their deaths represent the end of an era. Hopefully, however, as has happened so often in the museum's eighty-five-year history, new and creative benefactors will step forward to guide the Nelson-Atkins Museum of Art onward as a premiere encyclopedic museum of art, representing all peoples and available to all people.

Appendix

Herman R. Sutherland 1970-1993
Donald J. Hall 1980-2011
Henry W. Bloch 1991-2007
Estelle G. Sosland 1993-2009
Harry C. McCray Jr. 2007-2009
Sarah Rowland 2009-2015
Shirley Bush Helzberg 2010-2016
Charles Sosland 2010-2016
The designation of University Trustee ended in 2015

University Presidents
(Oversight of the Museum by the University Presidents ended in 2015)

University of Missouri Presidents

Stratton D. Brooks 1923-1930
Walter Williams 1931-1935
Frederick A. Middlebush 1935-1954
Elmer Ellis 1955-1966
John C. Weaver 1966-1970
C. Brice Ratchford 1971-1976
James C. Olson 1976-1984
C. Peter McGrath 1984-1991
George A. Russell 1991-1996
Manuel T. Pacheco 1997-2002
Elson S. Floyd 2003-2007
Gary D. Forsee 2008-2011
Timothy M. Wolfe 2012-2015

University of Kansas Chancellors

Ernest H. Lindley 1920-1939
Deane W. Malott 1939-1951
Franklin D. Murphy 1951-1960
W. Clarke Wescoe 1960-1969
E. Laurence Chalmers Jr. 1969-1972
Raymond Nichols 1972-1973
Archie Reece Dykes 1973-1980
Delbert M. Shankel 1981-1982
Gene Arthur Budig 1981-1994
Delbert M. Shankel 1994-1995
Robert Hemingway 1995-2009
Bernadette Gray-Little 2009-2017

University of Oklahoma Presidents

William B. Bizzell 1926-1941
Joseph A. Brandt 1941-1943
George L. Cross 1944-1968
J. Herbert Hollomon 1968-1970
Paul F. Sharp 1971-1976

IMAGE CREDITS

Front cover

Guanyin of the Southern Sea, Chinese, 11th/12th century, Liao (907-1125) or Jin Dynasty (1115-1234). Wood with polychrome, 95 x 65 inches. Purchase: William Rockhill Nelson Trust, 34-10. *The Assembly of Tejaprabha*, Chinese, from the Guangsheng Lower Monastery, Hongdong, Shanxi Province, early 14th century, Yuan Dynasty (1279-1368). Ink and mineral colors on clay, 281 x 584 inches. Purchase: William Rockhill Nelson Trust, 32-91/1. Photo: Jamison Miller

2.1 William Merritt Chase, American (1849-1916). *William Rockhill Nelson*, 1907. Oil on canvas, 60 x 50 1/8 inches. Gift of William Rockhill Nelson, 34-316. Photo: Jamison Miller

2.2 Photo: E.J. Davison

5.1 Photo: Strauss-Peyton Studio

5.2 Photo: Harron-Johnson Studio

5.3 Photo: Thomson Studio

5.4 *Foundation Figure*, Girsu (modern Tello), second Dynasty of Lagash, reign of Gudea, ca. 2090 B.C.E. Bronze, 8 x 3 1/4 x 3 3/4 inches. Purchase: William Rockhill Nelson Trust, 30-1/50. Photo: Jamison Miller

7.1 Nathaniel Dance-Holland, English (1735-1811). Portrait of Miss Sarah Cruttenden, 1770/1775. Oil on canvas, 50 x 40 inches. Purchase: William Rockhill Nelson Trust, 30-6. Photo: Chris Bjuland and Joshua Ferdinand

7.2 Tiziano Vecellio, called Titian, Italian (1488/1490-1576). *Antoine Perrenot de Granvelle*, 1548. Oil on canvas, 43 13/16 x 34 3/4 inches. Purchase: William Rockhill Nelson Trust, 30-15. Photo: Robert Newcombe

7.3 *Etruscan Statuette*, from Apiro, Italy, 460-450 B.C.E. Bronze, height: 16 inches. Purchase: William Rockhill Nelson Trust, 30-12. Photo: E. G. Schempf

7.4 Vincent van Gogh, Dutch (1853-1890). *Olive Trees*, 1889. Oil on canvas, 28 3/4 x 36 1/4 inches. Purchase: William Rockhill Nelson Trust, 32-2. Photo: Jamison Miller

7.6 Chen Chun, Chinese (1483-1544). *Life Cycle of the Lotus* (section), Ming Dynasty (1368-1644). Handscroll: color on paper, 12 x 229 3/4 inches overall. Purchase: William Rockhill Nelson Trust, 31-135/34. Photo: Robert Newcombe

7.7 *Ritual Disc with Dragon Motifs (Bi),* Chinese, Eastern Zhou Dynasty (771-256 B.C.E.). Jade (nephrite), diameter: 6 1/2 inches. Purchase: William Rockhill Nelson Trust, 33-81. Photo: Joshua Ferdinand

7.8 Xu Daoning, Chinese (ca. 970-1051/1052). *Fishermen's Evening Song.* Northern Song Dynasty (960-1127). Handscroll; ink and slight color on silk, 19 x 82 1/2 inches. The Nelson-Atkins Museum of Art, Kansas City, Missouri. Purchase: William Rockhill Nelson Trust, 33-1559. Photo: John Lamberton

7.9 *Guardian Lion*, Chinese, from the Zhi-yun Cave, Longmen, Henan Province, Tang Dynasty (618-906), probably 681. Gray limestone, 4 feet 7 1/2 inches x 39 inches x 12 inches. Purchase: William Rockhill Nelson Trust, 33-670. Photo: Jamison Miller

7.10 *Eagle Feather Headdress*, Northern Cheyenne, Montana, ca. 1875. Eagle, hawk, owl and raven feathers, rawhide, native leather, wool and cotton cloth, glass beads, ermine skin, silk ribbon, and horsehair, height: 70 inches. Purchase: William Rockhill Nelson Trust, 31-125/38. Photo: Jamison Miller

7.11 *Jar*, Kiua Polychrome, Santo Domingo or Cochiti, New Mexico, ca. 1770. Clay, pigment and native leather, h x diam: 19 1/4 x 19 1/2 inches. Purchase: William Rockhill Nelson Trust, 33-1140. Photo: Robert Newcombe

7.12 Photo: Strauss-Peyton Studio

9.8 Giovanni Domenico Tiepolo, Italian (1727-1804). *Apparition of the Angel to Hagar and Ishmael*, ca. 1751. Oil on canvas, 33 1/16 x 41 5/16 inches. Purchase: William Rockhill Nelson Trust, 30-23. Photo: Jamison Miller

9.9 Rembrandt Harmensz. van Rijn, Dutch (1606-1669). *Young Man in a Black Beret*, 1666. Oil on canvas, 32 1/8 x 25 3/8 inches. Purchase: William Rockhill Nelson Trust, 31-75. Photo: Jamison Miller

9.10 Frans Hals, Dutch (1581/1585-1666). *Portrait of a Man*, ca. 1650. Oil on canvas, 41 1/4 x 35 1/2 inches. Purchase: William Rockhill Nelson Trust, 31-90. Photo: Jamison Miller

9.11 Gilbert Stuart, American (1755-1828). *The Right Honorable John Foster*, ca. 1790-1791. Oil on canvas, 83 5/8 x 59 7/8 inches. Purchase: William Rockhill Nelson Trust, 30-20. Photo: Jamison Miller

10.2 Photo: Harry Barth

10.3 Photo: Harry Barth

11.1 Emil Nolde, German (1867-1956). *Masks*, 1911. Oil on canvas, 28 3/4 x 30 1/2 inches. Gift of the Friends of Art, 54-90. Photo: Chris Bjuland and Joshua Ferdinand

11.3 Raphaelle Peale, American (1774-1825). *Venus Rising From the Sea—A Deception*, ca. 1822. Oil on canvas, 29 1/8 x 24 1/8 inches. Purchase: William Rockhill Nelson Trust, 34-147. Photo: Jamison Miller

12.1 Don Lorenzo Monaco and assistant (Bartolomeo di Fruosino?), Italian (Florentine, ca. 1375-1423/1424). *Madonna of Humility*, ca. 1410. Tempera and gold leaf on wood panel, 44 7/16 x 26 3/16 inches. Purchase: William Rockhill Nelson Trust, 40-40. Photo: Matt Pearson

12.2 *Offering Procession of the Empress as Donor with Her Court,* Chinese, from Longmen, Bin-yang Central Cave, Henan Province, ca. 522 C.E., Northern Wei Dynasty (386-534). Fine, dark gray limestone with traces of coloring, 76 x 109 inches. Purchase: William Rockhill Nelson Trust, 40-38. Photo: John Lamberton

12.4 Hans Memling, Netherlandish (ca. 1430-1494). *Madonna and Child Enthroned*, ca. 1465-1470. Oil on wood panel, 29 11/16 x 20 9/16 inches. Purchase: William Rockhill Nelson Trust, 44-43. Photo: Melville McLean

12.5 *Chimera Tomb Guardian* (pair), Chinese, early 3rd century C.E., Eastern Han Dynasty (25–220 C.E.). Limestone, 51 1/2 x 69 x 18 inches each. Purchase: William Rockhill Nelson Trust, 44-26/1, 2. Photo: Jamison Miller

12.6 Camille Pissarro, French (1830-1903). *Poplars, Sunset at Eragny*, 1894. Oil on canvas, 28 15/16 x 23 7/8 inches. Gift of the Laura Nelson Kirkwood Residuary Trust, 44-41/2. Photo: Chris Bjuland and Joshua Ferdinand

12.9 Abd Allah Musawwir, Persian (active mid-16th century). *The Meeting of the Theologians*, 1540-1550. Bukhara, Uzbekistan, Shaybanid Dynasty (1500-1598). Opaque watercolor and gold on paper, Persian inscriptions in Thuluth and Nastaliq scripts, image: 11 3/8 x 7 1/2 inches. Purchase: William Rockhill Nelson Trust, 43-5. Photo: E. G. Schempf

13.1 Photo: Laurence Sickman

13.2 Michelangelo Merisi, called Caravaggio, Italian (1571-1610). *Saint John the Baptist in the Wilderness*, 1604. Oil on canvas, 68 x 52 inches. Purchase: William Rockhill Nelson Trust, 52-25. Photo: Jamison Miller

13.3 Giovanni Bellini, Italian (1431/1436-1516). *Madonna and Child,* ca. 1485. Oil on canvas, transferred from wood panel, 28 9/16 x 21 13/16 inches. Gift of the Samuel H. Kress Foundation, F61-66. Photo: Jamison Miller

13.6 Nicolas de Largillière, French (1656-1746). *Augustus the Strong, Elector of Saxony and King of Poland*, ca. 1714-1715. Oil on canvas, 57 1/2 x 45 1/2 inches. Purchase: William Rockhill Nelson Trust, 54-35. Photo: Jamison Miller

13.7 Petrus Christus, Flemish (ca. 1410-1475/1476). *Virgin and Child in a Domestic Interior,* ca. 1460-1467. Oil on wood panel, 27 3/8 x 20 1/16 inches. Purchase: William Rockhill Nelson Trust, 56-51. Photo: Jamison Miller

13.8 Edward Weston, American (1886-1958). *Dunes, Oceano*, 1936. Gelatin silver print, 7 1/2 × 9 1/2 inches. Gift of Mr. and Mrs. Milton McGreevy through the Mission Fund, F57-76/25. Photo: Robert Newcombe

13.9 Aristide Maillol, French (1861-1944). *Ile de France*, ca. 1910. Bronze, height: 65 1/2 inches. Purchase: the Mary Atkins and Ellen St. Clair Estates, A54-94. Photo: Robert Newcombe

13.11 *Charger*, England (London), dated 1668. Earthenware with tin glaze, diameter: 16 1/2 inches. Gift of Frank P. Burnap, 56-101. Photo: John Lamberton

14.1 Claude Monet, French (1840-1926). *Water Lilies,* ca. 1915-1926. Oil on canvas, 78 3/4 x 167 1/2 inches. Purchase: William Rockhill Nelson Trust, 57-26. Photo: Louis Meluso

14.3 Photo: Harry Barth

14.4 Andy Warhol, American (1928-1987). *Baseball*, 1962. Oil and silkscreen on canvas, 91 1/2 x 82 inches. Gift of the Guild of the Friends of Art and other friends of the Museum, F63-16. Photo: Matt Pearson. Art © Andy Warhol Foundation for the Visual Arts / ARS, New York

14.5 Photo: Strauss-Peyton Studio

15.1 Peter Paul Rubens, Flemish (1577-1640). *The Sacrifice of Isaac*, ca. 1612-1613. Oil on wood panel, 55 1/2 x 43 1/2 inches. Purchase: William Rockhill Nelson Trust, 66-3. Photo: Jamison Miller

15.6 Adam Weisweiler, German (1744-1820); active Paris, France, 1777-1809. *Chest of Drawers with Doors*, ca. 1780. Ebony, mahogany, Japanese lacquer, varnish and copper alloy with mercury gilding and marble, 38 5/8 x 58 7/8 x 24 inches. Purchase: the Kenneth A. and Helen F. Spencer Foundation Acquisition Fund, F70-43 A,B. Photo: Jamison Miller

15.8 Photo: William H. Haney

15.9 Photo: William H. Haney

16.2 Frederic Edwin Church, American (1826-1900). *Jerusalem from the Mount of Olives*, 1870. Oil on canvas, 54 1/4 x 84 3/8 inches. Gift of the Enid and Crosby Kemper Foundation, F77-40/1. Photo: Jamison Miller

16.3 Hyacinthe Rigaud, French (1659-1743). *Portrait of the Marquise d'Usson de Bonnac*, 1706-1707. Oil on canvas, 54 7/16 x 41 1/16 inches. Purchase: acquired through the generosity of Mary Runnells, F77-14. Photo: Jamison Miller

16.4 Berthe Morisot, French (1841-1895). *Daydreaming*, 1877. Pastel on canvas, 19 3/4 x 24 inches. Purchase: acquired through the generosity of an anonymous donor, F79-47. Photo: Melville McLean

16.5 *Cosmic Mirror and Stand*, Chinese, Han Dynasty (206 B.C.E.-220 C.E.), 1st Century C.E. High-tin bronze alloy and gilt bronze (lacquered wood sections are modern replacements), 14 5/8 x 11 inches. Purchase: the Edith Ehrman Memorial Fund, F95-18/2. Photo: Robert Newcombe

16.6 Photo: William H. Haney

16.8 Ann Brubaker, Director of Education, 1993. Photo: Robert Newcombe

16.9 Photo: George Jervas Photo Studio

17.2 John Singer Sargent, American (1856-1925). *Mrs. Cecil Wade,* 1886. Oil on canvas, 66 x 54 1/4 inches. Gift of the Enid and Crosby Kemper Foundation, F86-23. Photo: Jamison Miller

17.3 *Commemorative Head of an Oba*, African, Nigeria, Benin Kingdom, 16th century. Brass, height: 9 1/8 inches. Purchase: William Rockhill Nelson Trust through the generosity of Donald J. and Adele C. Hall, Mr. and Mrs. Herman Robert Sutherland, and an anonymous donor; The Nelson Gallery Foundation; and the exchange of a Trust property, 87-7. Photo: E. G. Schempf

17.4 Wayne Thiebaud, American (born 1920). *Apartment Hill*, 1980. Oil on linen, 65 x 48 inches. Purchase: acquired through the generosity of the Friends of Art and the Nelson Gallery Foundation, F86-4. Photo: Jamison Miller. Art © Wayne Thiebaud / Licensed by VAGA at Artists Rights Society (ARS), New York

17.5 Photo: E. G. Schempf

18.2 Claes Oldenburg, American (born Sweden, 1929) and Coosje van Bruggen, American (born The Netherlands, 1942-2009). *Shuttlecocks*, 1994. Aluminum, fiberglass-reinforced plastic, paint, h x diam: 19 feet 2 9/16 inches x 15 feet 11 7/8 inches. Purchase: acquired through the generosity of the Sosland Family, F94-1/1-4. Photo: Louis Meluso. Art © Claes Oldenburg and Coosje van Bruggen

18.3 Gustave Herter, designer, American (born Germany), 1830-1898. Ernst Plassmann, wood-worker, American (1823-1877). Bulkley and Herter, manufacturer, United States (New York, NY), ca. 1852-1858. *Bookcase*, 1852-1853. White oak, eastern white pine, eastern hemlock, yellow poplar and later stained glass, 11 feet 2 1/2 inches x 9 feet 10 3/4 inches x 30 1/4 inches. Purchase: William Rockhill Nelson Trust through exchange of the gifts of Mr. and Mrs. Frank P. Burnap, Mrs. William H. Chapman, Mr. Earle W. Grant, Mr. and Mrs. Lawrence Denman, Mrs. David M. Lighton, Mrs. Inez Grant Parker, Mrs. Helen F. Spencer, Mrs. William D. Wight, Mrs. Mary Russell Perkins from the estate of Katherine Harvey, Mr. and Mrs. Frederick M. Mont, Mrs. E. A. Grosvenor Blair, Mrs. Fred Wolfer-man, Mrs. Elizabeth Hay Bechtel in honor of Helen Spencer, Mr. George L. Artamonoff and Mrs. Lyell Ritchie, Mr. and Mrs. Edgar L. Berkley, Mrs. Virginia Jones Mullin, and Mrs. James D. McColl; the bequest of Helen F. Spencer; and other Trust properties, 97-35. Photo: Robert Newcombe

18.4 Burnap Collection , Gallery P12 documentation, April 2019. Photo: Dana Anderson

18.5 Walter De Maria, American (1935-2013). *One Sun / 34 Moons*, 2002. Gilt bronze, stainless steel, water, neon, and glass, Moon or skylight diameter: 36 inches each; Sun: 17 x 486-5/16 x 405-1/4 inches; Pool: 1608 11/16 inches x 1933 1/3 inches x 9 inches. Purchase: acquired through the generosity of the Hall Family Foundation, 2002.6. Photo: Jamison Miller. Art © Estate of Walter De Maria

18.6 Ford Learning Center, Classroom Space, 2005. Photo: Dewey Chapman

18.7 Adelaide Cobb Ward Sculpture Hall Opening, September 24, 2005. Photo: Mark McDonald

18.8 Reading Room, Spencer Art Reference Library, the Bloch Building, 2007. Photo: Roland Halbe

18.9 El Anatsui, Ghanaian (born 1944, lives and works in Nigeria). *Dusasa I*, 2007. Found alumi-num and copper wire, 26 x 33 feet. Purchase: acquired through the generosity of the William T. Kemper Foundation—Commerce Bank, Trustee, 2008.2. Photo: Tiffany Matson. Art © courtesy of the artist and Jack Shainman Gallery, NY

18.10 Alvin Langdon Coburn, English (born America, 1882-1966). *House of a Thousand Windows*, 1912. Platinum print, 16 3/16 × 12 7/16 inches. Gift of Hallmark Cards, Inc., 2005.27.297.

18.11 American Galleries Reinstallation, March 12, 2009. Photo: Bob Greenspan

18.12 *Dzunukwa Mask or Gikamhl (Chief's Mask)*, Kwakwaka'wakw (Kwakiutl), ca. 1870. Wood (alder), pigment, human hair and bear hide, without hair: 11 x 7 5/8 x 5 3/4 inches. From the Estelle and Morton Sosland Collection, 2009.41.1. Photo: John Lamberton

18.13 *Shield,* Arikara artist, North Dakota, ca. 1850. Buffalo rawhide, native tanned leather, pigment, Diameter: 20 inches. Purchase: the Donald D. Jones Fund for American Indian Art, 2004.35. Photo: Jamison Miller

18.14 American Indian Gallery Renovation, November 2009. Photo: Bob Greenspan

19.1 Julián Zugazagoitia, Spring 2010. Photo: Bob Greenspan

19.3 David Douglas Duncan, American (1916-2018). *Picasso in a yellow robe*, printed 2013. Inkjet print, 20 7/8 × 14 1/16 inches. Gift of David Douglas Duncan, 2014.11.156. Photo: John Lamberton

19.4 KC's Big Picnic family festival on July 20, 2014 in the Donald J. Hall Sculpture Park. Photo: Jenny Wheat

19.5 The Big Picture: A Transformative Gift from the Hall Family Foundation, April 28-October 7, 2018. Photo: Dana Anderson

19.6 Photo: Mark McDonald

19.7 Edgar Degas, French (1834-1917). *Dancer Making Points*, 1879-1880. Pastel and gouache on paper mounted on board, 19 1/4 x 14 1/2 inches. Gift of Marion and Henry Bloch, 2008.53. Photo: Joshua Ferdinand

19.8 Board of Trustees meeting, June 8, 2018. Photo: Jason Tracy

Notes

Introduction

1. Spaeth, *American Art Museums*, 3–5. According to Spaeth, the Charleston, South Carolina, Library Society, formed in 1773, was the first group to establish a museum, but Peale's museum was probably the first art museum open to the public. Keppel and Duffus, *Arts in American Life*, 64.

2. Glaab and Brown, *History of Urban America*, 264.

Chapter 1

1. "A Surprise to Art Lovers," *Kansas City Times*, Oct. 17, 1911, and "Made Wealth a Reality," *Kansas City Star,* Oct. 16, 1911, clippings in Atkins file, MVSC, KC Public Library; *Last Wills*, 43.

2. Untitled article, *Kansas City Times*, Oct. 17, 1911, Untitled article, *Kansas City Star*, Oct. 18, 1911, "A Surprise to Art Lovers," *Kansas City Times*, Oct. 17, 1911, Untitled article, *Kansas City Journal*, Oct. 17, 1911, clippings in Atkins file, MVSC, KC Public Library.

3. Sandy, *Here Lies Kansas City*, 19.

4. Brown and Dorsett, *K.C.: A History*, 37–39.

5. "Retiring and Little Known Mary Atkins and Her Dream of Beauty," *Kansas City Star,* March 18, 1931, clipping in Scrapbook, vol. 1, RG 72, NAMAA; Haskell et al., *Founders and Benefactors*, 9.

6. Glaab and Brown, *A History of Urban America*, 260–62; "Retiring and Little Known Mary Atkins," *Kansas City Star*, March 18, 1931, clipping in Scrapbook, vol. 1, RG 72, NAMAA.

7. Wilson, *City Beautiful Movement*, 47.

8. "Jacquemot-Salmon: Marriage of the High School Instructor in French and German," *Kansas City Star*, April 20, 1894.

9. Ibid.

10. "Retiring and Little Known Mary Atkins and Her Dream of Beauty," *Kansas City Star*, March 18, 1931, clipping in Scrapbook, vol. 1 RG 72, NAMAA.

11. *Report of the Superintendent of Schools of the School District of Kansas City, Missouri, Year Ending June 30, 1900,* 140.

12. Mary Atkins' Expense Journal and Mary Atkins' 1900 Passport, both in Atkins Collection, MSS 003, NAMAA; "In Society," *Kansas City Star,* June 3, 1900.

13. Mary Atkins Expense Journal, Atkins Collection, MSS 003, NAMAA; "A Niece Arrived Too Late, *Kansas City Times,* Oct. 18, 1911, clipping in Atkins file, MVSC, KC Public Library.

14. "Retiring and Little Known Mary Atkins," *Kansas City Star,* March 18, 1931, clipping in Scrapbook, vol. 1, RG 72, NAMAA.

15. Frederica Smeltzer Evans, interview with author, April 7, 1986; "Memorial Tablet Unveiled—Atkins Museum on 100th Birthday Anniversary of the Founder of the Museum," *Kansas City Star,* Oct. 22, 1936, clipping in Atkins file, MVSC, KC Public Library. Alice Murphy (1871–1909) was a well-respected painter; the University of Kansas Museum of Art held an exhibition of her paintings in 1972.

16. Untitled article, *Kansas City Star,* Oct. 17, 1911, clipping in Atkins file, MVSC, KC Public Library.

17. "Made Wealth a Realty," *Kansas City Star,* Oct. 16, 1911, and "How Land Makes Men Rich," *Kansas City Times,* Oct. 30, 1911, clippings in Atkins Scrapbook, Commerce Bank KC; *Last Wills,* 40–43; "Retiring and Little Known Mary Atkins," *Kansas City Star,* March 18, 1931, clipping in Scrapbook, vol. 1, RG 72, NAMAA; "Real Estate," Ernst—Mary Atkins Collection, MSS 020, NAMAA. Mary Atkins's bequests included $10,000 to the Nettleton Home, $5,000 to the Women's Board of Foreign Missions of the Christian Church, $10,000 to the Gillis Orphans Home, $5,000 to the Humane Society, $10,000 to the Orphans School of the Christian Church in Fulton, Missouri, $5,000 to the Thomas Swope Settlement, $100,000 to the Linwood Boulevard Christian Church, and $25,000 to the First Christian Church.

18. Speech by A. W. Childs, June 11, 1913, clipping in Atkins Scrapbook, Commerce Bank KC; *Last Wills,* 40–42.

19. Speech by Childs, June 11, 1913, clipping in Atkins Scrapbook, Commerce Bank KC.

20. "Institute Will Step Back," *Kansas City Journal,* Oct. 17, 1911, and "Plan of Municipal Skyscraper Heard," *Kansas City Post,* Oct. 19, 1911, clippings in Atkins Scrapbook, Commerce Bank KC.

21. Wilson, *City Beautiful Movement,* 105–17.

22. "Penn Valley to Station Street," *Kansas City Star,* Feb. 25, 1913, "Approve New Park Plan," *Kansas City Star,* Feb. 28, 1913, "New Station Hill Plan," *Kansas City Star,* March 2, 1913, clippings in Atkins Scrapbook, Commerce Bank KC; *Last Wills,* 43; "Beautification of the Station Park May Now Go Forward," *Kansas City Times,* Sept. 24, 1916, "Refer Site Ordinance," [source unidentified], Feb. 3, 1920, "Art Museum Near Union Station Is Proposed in Plans Draw Up by Kessler," *Kansas City Post,* July 16, 1919, and "Fine Arts in Penn Valley?" *Kansas City Star,* Oct. 6, 1912, clippings in Atkins Scrapbook, Commerce Bank KC.

Chapter 2

1. Curl, "William Rockhill Nelson Gallery of Art and Atkins Museum of Fine Arts," 9.

2. Harris, "Development," 6; Sutton, "Editorial: The Colonel's Gift"; *Star* Staff, *William Rockhill Nelson: The Story,* 15.

3. Brown and Dorsett, *K.C.: A History*, 115; Reddig, *Tom's Town*, 39.

4. Reddig, *Tom's Town*, 38, 39; Schirmer and McKinzie, *At the River's Bend*, 166.

5. Reddig, *Tom's Town*, 38; "Fifty Years of the Star," *Kansas City Star*, Sept. 18, 1930, clipping in Scrapbook, vol. 1, RG 72, NAMAA.

6. Wilson, *City Beautiful Movement*, 15; *Star* Staff, *William Rockhill Nelson: The Story*, 24–25.

7. Reddig, *Tom's Town*, 44.

8. Ibid., 38, 44; Brown and Dorsett, *K.C.: A History*, 110.

9. Wilson, *City Beautiful Movement*, 11, 21; *Star* Staff, *William Rockhill Nelson: The Story*, 24–25.

10. Reddig, *Tom's Town*, 45.

11. Brown and Dorsett, *K.C.: A History*, 163, 164.

12. Reddig, *Tom's Town*, 38, 43; Wilson, *City Beautiful Movement*, 40–45; Hoffman, "In the Beginning."

13. *Star* Staff, *William Rockhill Nelson: The Story*, 91; Worley, *J. C. Nichols*, 59.

14. Harris, "Development," 7.

15. Reddig, *Tom's Town*, 45; Worley, *J. C. Nichols*, 59–60.

16. Worley, *J. C. Nichols*, 59–61. According to Worley, Nelson intended for Warwick Boulevard to join with Armour Boulevard and become an integral part of the City Beautiful boulevard system, but the Park Board did not approve this proposal. The City of Westport did agree to build Warwick, however, and Nelson planted the street with trees to make it an appropriate entryway to his Southmoreland area. Harris, "Development," 9.

17. *Western Gallery of Art Illustrated Catalogue*; Curl, "William Rockhill Nelson Gallery of Art," 11.

18. "In Gallery and Studio," *Kansas City Star*, June 14, 1930, clipping in Scrapbook, vol. 1, RG 72, NAMAA.

19. *Star* Staff, *William Rockhill Nelson: The Story*, 177, 180.

20. "Laura Nelson Kirkwood—Objects [*sic*] d'Art," Kirkwood Collection, MSS 004, NAMAA. Catherine L. Futter, Director of Curatorial Affairs at the Nelson-Atkins, was able to verify that the following were all bequests of William Rockhill Nelson: Constable, *Cottage in Suffolk*, 34-308/2; Gainsborough, *Girl Standing with Dog*, 34-308/3; Gheeraerts, *Portrait of Frances Knyvett, Countess of Rutland*, 34-308/4; and Hoppner: *Portrait of a Man*, 34-308/1. All four were later sold. The other four paintings were in Laura Kirkwood's estate and were not accessioned until 1941.

21. Reddig, *Tom's Town*, 81.

22. Johnson, *William Rockhill Nelson and the* Kansas City Star, 151; *Last Wills*, 7.

23. *Last Wills*, 10; Simpson, *History of the Founding*, 8.

Chapter 3

1. Haskell et al., *Founders and Benefactors*, 11; Untitled article, *Kansas City Star*, Feb. 28, 1926, clipping in Laura Kirkwood file, MVSC, KC Public Library.

2. *Star* Staff, *William Rockhill Nelson: The Story*, 176.

3. "In Gallery and Studio," *Kansas City Star*, June 14, 1930, clipping in Scrapbook, vol. 1, RG 72, NAMAA; *Last Wills*, 15.

4. *Last Wills*, 15.

5. Haskell et al., *Founders and Benefactors*, 17.

6. "A Rozzelle Trust Suit," *Kansas City Times*, Dec. 2, 1960, clipping in Rozzelle file, MVSC, KC Public Library; *Last Wills*, 35.

7. Untitled article, *Kansas City Star*, Feb. 28, 1926, clipping in Laura Kirkwood file, MVSC, KC Public Library.

8. Haskell et al., *Founders and Benefactors*, 13; Untitled article, *Kansas City Star*, Feb. 28, 1926, clipping in Laura Kirkwood file, MVSC, KC Public Library; Gilbertson, *Barstow School*, 1.

9. Harris, "Development," 29; Haskell et al., *Founders and Benefactors*, 15–16.

10. Haskell et al., *Founders and Benefactors*, 15–16.

11. "Society," *The Independent*, Oct. 10, 1914, and "Tittle Tattle," *The Independent*, Feb. 6, 1915, *The Independent* Archives, vol. 32, pp. 4, 7; *Star* Staff, *William Rockhill Nelson*: *The Story*, 101.

12. *Last Wills*, 10.

13. Untitled article, *Kansas City Star*, Feb. 28, 1926, clipping in Laura Kirkwood file, MVSC, KC Public Library; Haskell et al., *Founders and Benefactors*, 18; Untitled article, *The Independent*, June 7, 1919, *The Independent* Archives, vol. 42, p. 6.

14. *Last Wills*, 19, 20, 22.

15. Ibid., 22; Wilson, *City Beautiful Movement*, 18.

16. Nelson Trust, Minutes, Jan. 29, 1927, folder 58, Volker Records, KC0059, SHS-MO; Harris, "The Development," 25–26, 31.

17. Nelson Trust, Minutes, Jan. 29, 1927, folder 58, Volker Records, KC0059, SHSMO.

18. Untitled article, *Kansas City Star*, Aug. 29, 1927, clipping in Irwin Kirkwood file, MVSC, KC Public Library; *Last Wills*, 27–28.

Chapter 4

1. Keppel and Duffus, *Arts in American Life*, 15, 65–67, 138.

2. Lerman, *The Museum*, 15–18; Spaeth, *American Art Museums*, 15.

3. Spaeth, *American Art Museums*, 3; Lerman, *The Museum*, 18; Pach, *Art Museum in America*, ix.

4. Spaeth, *American Art Museums*, vii; Museum of Fine Arts, Boston, "About the MFA," www.mfa.org/about.

5. Spaeth, *American Art Museums*, 7.

6. Ibid., 201–5; Marcus, *Treasures of the Philadelphia Museum*, i–iv; Philadelphia Museum of Art, "Our Story," www.philamuseum.org/information/45-19.html.

7. *City Art Museum of St. Louis: Handbook of Collections*, vii.

8. Keppel and Duffus, *Arts in American Life*, 65; Schirmer and McKinzie, *At the River's Bend*, 164; "City Planning," *Kansas City Times*, Oct. 18, 1911, clipping in Atkins file, MVSC, KC Public Library.

9. Spaeth, *American Art Museums*, 201–5; *The Toledo Museum of Art—1983 Annual Report*.

10. Minneapolis Institute of Art, "History + What's Next," https://new. artsmia.org /about/mission-and-history/; Spaeth, *American Art Museums*, 238; Wittke, *First Fifty Years*.

11. "Colonel Swope Planned to Give," *Kansas City Star*, Oct. 18, 1911, clipping in Atkins file, MVSC, KC Public Library; Sandy, *Here Lies Kansas City*, 147.

12. "A Surprise to Art Lovers," *Kansas City Times*, Oct. 17, 1911, Untitled article, *Kansas City Star*, March 27, 1910, Untitled article, *Kansas City Times*, Oct, 17, 1911, clippings in Atkins file, MVSC, KC Public Library.

13. Glaab and Brown, *History of Urban America*, 100.

14. Harris, "Development," 12; Brown and Dorsett, *K.C.: A History*, 179.

15. "Atkins Estate Sells Lot," *Kansas City Star*, March 12, 1920, Memo, Feb. 10, 1920, and "New Atkins Museum Site," *Kansas City Star*, June 22, 1927, clippings in Atkins Scrapbook, Commerce Bank KC; Harris, "Development," 21; Untitled article, *Kansas City Journal*, Feb. 16, 1927, clipping in Atkins file, MVSC, KC Public Library; "Last Will and Testament of Ellen St. Clair," Brous Collection.

16. "Offer Memorial Changes," *Kansas City Star*, May 9, 1926, clipping in Wight Scrapbook, Patterson Collection.

17. "New Atkins Museum Site," *Kansas City Star*, June 22, 1927, and "Art Museum Ideas To Be Sought in the East," *Kansas City Star*, April 4, 1927, clippings in Atkins Scrapbook, Commerce Bank KC.

18. "New Atkins Museum Site," *Kansas City Star*, June 22, 1927, clipping in Atkins Scrapbook, Commerce Bank KC.

19. Nelson Trust, Minutes, Jan. 29, 1927, folder 58, Volker Records, KC0059, SHSMO.

Chapter 5

1. Nelson Trust, Correspondence, file 4934, Univ. of MO, President's Office, Papers, C2582, SHSMO.

2. *Last Wills*, 7; Nelson Trust, Minutes, March 3, 1926, folder 57, Volker Records, KC0059, SHSMO.

3. "His Charity Grew into Way of Life," *Kansas City Star*, April 13, 1986, clipping in Biography File, Plaza Library, Kansas City, Missouri; Sandy, *Here Lies Kansas City*, 155; Brown and Dorsett, *K.C.: A History*, 155.

4. Glaab and Brown, *History of Urban America*, 291; "Nichols, Jesse C.," in *Who's Who in America*, vol. 27, *1951–1952*; Sandy, *Here Lies Kansas City*, 113; Worley, *J. C. Nichols*, 97; Brown and Dorsett, *K.C.: A History*, 173.

5. "Host on His Birthday," *Kansas City Times*, Nov. 11, 1948, and "Real Estate Firm Observes Golden Anniversary," *Kansas City Star*, June 29, 1969, clippings in the Jones file, MVSC, KC Public Library; Russell Jones, interview with author, Aug. 6, 1992.

6. Nelson Trust, Minutes, March 4, 1926, folder 57, Volker Records, KC0059, SHS-MO. In his will (*Last Wills*, 27), Irwin Kirkwood bequeathed $5,000 to Caroline T. Wilson and $5,000 to Anne Wilson MacLaughlin.

7. Untitled article, *Kansas City Star*, July 21, 1942, clipping in the Wilson file, MVSC, KC Public Library.

8. Nelson Trust, Minutes, March 4, 1926, folder 57, Volker Records, KC0059, SHS-MO; *Last Wills*, 7–8.

9. Haskell, *Boss-Busters and Sin Hounds*, 248.

10. Nelson Trust, Minutes, March 30, May 1, June 10 and 25, 1926, folder 57, Volker Records, K0059, SHSMO.

11. Nelson Trust, Minutes, July 9 and 12, 1926, folder 57, Volker Records, K0059, SHSMO.

12. Ibid.; Reddig, *Tom's Town*, 129.

13. "Fifty Years of the Star," *Kansas City Star*, Sept. 18, 1930, clipping in Scrapbook, vol. 1, RG 72, NAMAA; Nelson Trust, Minutes, March 11, 1929, folder 4946, Univ. of MO, President's Office, Papers, C2582, SHSMO.

14. *Last Wills*, 9.

15. Nelson Trust, Minutes, Jan. 29, 1927, folder 57, Volker Records, K0059, SHSMO; Harris, "Development," 29.

16. Nelson Trust, Minutes, July 11, 1927, folder 4942, and Dec. 19, 1927, folder 4943, Univ. of MO, President's Office, Papers, C2582, SHSMO.

17. Nelson Trust, Minutes, April 29, 1927, file 58, Volker Records, KC0059, SHSMO.

18. Nelson Trust, Minutes, Oct, 4, 1927, and Dec. 6, 1927, folder 58, Volker Records, KC0059, SHSMO; Oct. 3, 1927, folder 4945, Univ. of MO, President's Office, Papers, C2582, SHSMO; *Last Wills*, 6.

19. Nelson Trust, Minutes, Oct. 19, 1928, folder 4945, Univ. of MO, President's Office, Papers, C2582, SHSMO.

20. "A University Start," *Kansas City Star*, May 1931, clipping in Wight Scrapbook, and Ernest E. Howard to W. D. Wight, Dec. 30, 1932, Patterson Collection.

21. Nelson Trust, Minutes, June 8, 1928, folder 4945, Univ. of MO, President's Office, Papers, C2582, SHSMO.

22. Nelson Trust, Minutes, Dec. 5, 1927, folder 4943, and June 4 and 8, 1928, folder 4944, Univ. of MO, President's Office, Papers, C2582, SHSMO.

23. *Last Wills*, 19.

24. Nelson Trust, Minutes, Oct. 28, 1927, folder 4943, Univ. of MO, President's Office, Papers, C2582, SHSMO; Christine Preston Thomson, interviews with author, Dec. 5 and 26, 1992; "Laura Nelson Kirkwood—Objects [*sic*] d'Art," Kirkwood Collection, MSS 004, NAMAA. The Constable, Gainsborough, Gheeraerts, and Hoppner paintings were all sold in the 1990s.

25. Curl, "William Rockhill Nelson Gallery of Art and Atkins Museum of Fine Arts," 12; "So Does Oak Hall," *Kansas City Star*, July 24, 1988.

26. Nelson Trust, Minutes, June 8, 1928, folder 4944, and March 31, 1930, folder 4949, Univ. of MO, President's Office, Papers, C2582, SHSMO; Taggart, McKenna, and Wilson, *Handbook of the Collections*, 1:11.

27. *Last Wills*, 6.

28. Nelson Trust, Minutes, Dec. 17, 1926, and March 29, 1927, folder 58, Volker Records, KC0059, SHSMO.

29. Nelson Trust, Audits, 1926–1928, folder 5017, Trustees Minutes, May 10, 1930, folder 4949; Audits, 1931–1932, folder 5019; 1933–1934, folder 5020; 1935–1936, folder 5021; and 1937–1938, folder 5022, all in Univ. of MO, President's Office, Papers, C2582, SHSMO.

30. Nelson Trust, Minutes, Jan. 7–9, 1930, folder 4958, Univ. of MO, President's Office, Papers, C2582, SHSMO; "Ready on Art Gallery," *Kansas City Times*, June 27, 1930, clipping in Scrapbook, vol. 1, RG 72, NAMAA; Harris, "Development," 54.

31. Nelson Trust, Minutes, Jan. 7–9, 1930, folder 4958, Univ. of MO, President' Office, Papers, C2582, SHSMO; "Hyde, Arthur M.," in *Who's Who in America*, vol. 20, *1938–1939*.

Chapter 6

1. *Last Wills*, 15, 20, 29, 35, 43; Simpson, *History of the Founding*, 16; "Ready on Art Gallery," *Kansas City Times*, June 27, 1930, clipping in Scrapbook, vol. 1, RG 72, NAMAA.

2. "Obituary: Fred Cameron Vincent," *Kansas City Star*, April 20, 1945, clipping in Vincent file, MVSC, KC Public Library; Baxter, *Notable Kansas Citians*.

3. Memo, Feb. 10, 1920, in Atkins Scrapbook, Commerce Bank KC; Mitchell, *There Is No Limit*, 119; "Obituary: John F. Downing," *Kansas City Times*, Sept. 5, 1935, clipping in Downing file, MVSC, KC Public Library.

4. Sandy, *Here Lies Kansas City*, 161; "Wight, Thomas," in *Who's Who in America*, vol. 27, *1951–1952*; Mitchell, *There Is No Limit*, 119.

5. Ehrlich, *Kansas City, Missouri*, 108; Mitchell, *There Is No Limit*, 119; Dorothy Wight Buckley, "William Rockhill Nelson Gallery of Art," speech to the DAR, n.d., Cooper Collection.

6. Jean Rosahn Wight, interview with author, Aug. 11, 1992.

7. "New Atkins Museum Site," *Kansas City Star*, June 22, 1927, in Atkins Scrapbook, Commerce Bank KC; Simpson, *History of the Founding*, 25; Wittke, *First Fifty Years*, 41.

8. Buckley, "William Rockhill Nelson Gallery of Art," Cooper Collection; Simpson, *History of the Founding*, 26.

9. Cart, "From the Survey"; "John S. Wolcott House"; *Last Wills*, 22.

10. Nelson Trust, Minutes, Feb. 4, 1929, folder 4946, and Dec. 6, 1928, folder 4945, Univ. of MO, President's Office, Papers, C2582, SHSMO; Ethlyne Jackson Seligmann, letter to Lindsay Hughes Cooper, n.d., Cooper Collection; "The Nelson Gallery with Vast Halls and 100 Rooms Gets Ready for Treasures of the Ages," *Kansas City Star*, Sept. 11, 1932, clipping in Cooper Collection.

11. Nelson Trust, Minutes, March 25, 1929, folder 4946, Dec. 2, 1929, folder 4947, and Jan. 7–9, 1930, folder 4948, Univ. of MO, President's Office, Papers, C2582, SHSMO.

12. Nelson Trust, Minutes, March 17, 1930, folder 4948, Univ. of MO President's Office, Papers, C2582, SHSMO; Curl, "William Rockhill Nelson Gallery of Art and Atkins Museum of Fine Arts," 15–16; Simpson, *History of the Founding*, 25.

13. "Envisioning the William Rockhill Nelson Gallery of Art and Its Setting on the Oak Hall Tract with the Proposed Mirror Lake and Spacious Grounds to the South," *Kansas City Star*, March 17, 1929, clipping in Scrapbook, vol. 1, RG 72, NAMAA; Nelson Trust, Minutes, March 25, 1929, folder 4946, Univ. of MO, President's Office, Papers, C2582, SHSMO; "With the Spirit of Art," *Kansas City Times*, April 5, 1931, clipping in Scrapbook vol. 1, RG 72, NAMAA; Nelson Trust, Minutes, July 7, 1930, folder 4950, April 30, 1929, folder 4946, and Sept. 30, 1929, folder 4947, Univ. of MO, President's Office, Papers, C2582, SHSMO.

14. Buckley, "William Rockhill Nelson Gallery of Art," Cooper Collection; Simpson, *History of the Founding*, 30; "Volker Fountain," Box 14, folder 16, Director Records: Sickman, RG 01/02, NAMAA.

15. Wittke, *First Fifty Years*, 41, 42.

16. Sandy, *Here Lies Kansas City*, 65; "Hare, S. Herbert," in *Who's Who in America*, vol. 27, *1951–1952*; Millstein, "Citybuilders to the Nation."

17. Mobley, "Business is Blooming"; Mitchell, *There Is No Limit*, 122–23.

18. Nelson Trust, Minutes, March 17, 1930, folder 4948, May 10, 1930, folder 4949, and July 14, 1930, folder 4950, Univ. of MO, President's Office, Papers, C2582, SHSMO; "An Art Gallery Start," *Kansas City Star*, July 16, 1930, clipping in Scrapbook, vol. 1, RG 72, NAMAA; Simpson, *History of the Founding*, 16.

19. "Ready on Art Gallery," *Kansas City Times*, June 27, 1930, "An Art Gallery Start," *Kansas City Star*, July 16, 1930, and "The Huge Spread of Projected William Rockhill Nelson Gallery of Art Reveals Itself as Piers Rise from Solid Rock and Terrace Retaining Walls Take Form," *Kansas City Star*, Sept. 28, 1930, clippings in Scrapbook, vol. 1, RG 72, NAMAA.

20. Simpson, *History of the Founding*, 17–19.

21. "The Nelson-Atkins Museum of Art, 1933–1983," program for 50th Anniversary Jubilee, Dec. 10, 1983, Cooper Collection; "John C. Long: Turning Point in My Career," *Kansas City Star*, March 26, 1933, clipping in Long file, MVSC, KC Public Library.

22. Thomson, interview with author, Dec. 26, 1992; Nelson Trust, Minutes, July 16, 1934, folder 4967, Univ. of MO, President's Office, Papers, C2582, SHSMO; "Expenditures by the City of Kansas City, Missouri," Trustees folder, file I, Director's Records, NAMA (This document and several others were present when the author originally conducted research and before the establishment of the NAMAA; they could not be found in the current archives). Although Vincent turned over the Nelson Gallery of Art to the city, the Atkins Trust maintained ownership of the Atkins Museum of Fine Arts.

Chapter 7

1. Nelson Trust, Minutes, Feb. 4, 1929, folder 4946, Univ. of MO, President's Office, Papers, C2582, SHSMO; *Last Wills*, 21.

2. Spaeth, *American Art Museums*, 50.

3. Taggart, McKenna, and Wilson, *Handbook of the Collections*, 1:8; Nelson Trust, Minutes, Dec. 6, 1928, folder 4945, Univ. of MO, President's Office, Papers, C2582, SHSMO.

4. Nelson Trust, Minutes, Oct. 31, 1928, folder 4945, and April 13, 1930, folder 4949, Univ. of MO, President's Office, Papers, C2582, SHSMO.

5. Nelson Trust, Minutes, April 8, 1930, folder 4949, Univ. of MO, President's Office, Papers, C 2582, SHSMO; Ethlyne Jackson to Lindsay H. Cooper, n.d., Cooper Collection; "Steady Search for Art," *Kansas City Star*, April 17, 1930, clipping in Scrapbook, vol. 1, RG 72, NAMAA.

6. Wittke, *First Fifty Years*, 49; Nelson Trust, Minutes, April 8, 1930, folder 4949, Univ. of MO, President's Office, Papers, C2582, SHSMO; Rowlands, "An Excellent Art Scout."

7. Harold Woodbury Parsons to Laurence Sickman, May 14, 1953, Box 1c, folder 23, Sickman Papers, MSS 001, NAMAA.

8. Nelson Trust, Minutes, April 8, 1930, folder 4949, Univ. of MO, President's Office, Papers, C2582, SHSMO; "Steady Search for Art," *Kansas City Star*, April 17, 1930, clipping in Scrapbook, vol. 1, RG 72, NAMAA.

9. Nelson Trust, Minutes, March 31 and April 8, 1930, folder 4949, Univ. of MO, President's Office, Papers, C2582, SHSMO.

10. "Errors of Museums," *Kansas City Star*, March 4, 1931, clipping in Scrapbook, vol. 1, RG 72, NAMAA; Stratton Brooks to William Volker, March 28, 1929, F. A. Middlebush, Faculty Correspondence, "P," file 1778, Univ. of MO, President's Office, Papers, C2582, SHSMO; "$400,000 in Art," *Kansas City Times*, May 20, 1930, and "Art, Plans Take Form," *Kansas City Times*, Jan. 16, 1931, clippings in Scrapbook, vol. 1, RG 72, NAMAA; Harold Woodbury Parsons to J. C. Nichols, Feb. 20, 1934, Box 4, folder 24, Director Records: Gardner, RG 01/01, NAMAA.

11. Nelson Trust, Minutes, April 8, 1930, folder 4949, Univ. of MO, President's Office, Papers, C2582, SHSMO; Harold Woodbury Parsons to Laurence Sickman, May 14, 1953, Box 1c, folder 23, Sickman Papers, MSS 001, NAMAA.

12. "Ten Masterpieces Form the First Nelson Gallery Group," *Kansas City Star*, April 17, 1930, and "Buy Ten Paintings," *Kansas City Star*, April 17, 1930, clippings in Scrapbook, vol. 1, RG 72, NAMAA; Nelson Trust, Minutes, April 29, 1930, folder 4949, Univ. of MO, President's Office, Papers, C2582, SHSMO.

13. "Art Display Draws 800," *Kansas City Times*, April 21, 1930, clipping in Scrapbook, vol. 1, RG 72, NAMAA.

14. "The First Nelson Gallery Purchases," *Kansas City Star*, April 18, 1930, and Untitled article, *Kansas City Post*, May 11, 1930, clippings in Scrapbook, vol. 1, RG 72, NAMAA; Ethlyne Jackson to Herbert V. Jones, Aug. 11, 1945, Box 6, folder 25, and "Paintings recommended for sale or swap or trade," 1947, Box 2, folder, 40, Director Records: Gardner, RG 01/01, NAMAA; "Checklist of European Paintings on Exhibit," Docents' Papers, Wolferman Collection.

15. "$400,000 in Art," *Kansas City Times*, May 20, 1930, and "A Big Addition to Art," *Kansas City Star*, May 20, 1930, clippings in Scrapbook, vol. 1, RG 72, NAMAA.

16. Editorial, *Kansas City Post*, June 15, 1930, and "Art News," *Kansas City Post*, June 29, 1930, clippings in Scrapbook, vol. 1, RG 72, NAMAA; M. Knoedler to J. C. Nichols, Aug. 22, 1930, "30-18 Millet" file, Accession Records, OR, NAMA; "Three Great Paintings," *Kansas City Star*, June 20, 1930, clipping in Scrapbook, vol. 1, RG 72, NAMAA.

17. "Portrait of Miss Cruttenden," *Christian Science Monitor*, June 17, 1930, Editorial, *Kansas City Star*, Jan. 7, 1931, and "Three Old Masters Added to Nelson Art Collection," *Kansas City Post*, July 22, 1930, clippings in Scrapbook, vol. 1, RG 72, NAMAA.

18. "Art Fund to Two Million," *Kansas City Star*, May 10, 1930, clipping in Scrapbook, vol. 1, RG 72, NAMAA.

19. Nelson Trust, Minutes, Aug. 5 and 11, 1930, folder 4950, Univ. of MO, President's Office, Papers, C2582, SHSMO; Marc Wilson, interview with author, Jan. 9, 2019.

20. "Nelson Trustees to See Art in New York," *Kansas City Post*, Jan. 6, 1931, and "Nelson Museum Trustees Acquire Ten Art Treasures," *Kansas City Post*, April 17,1930, clippings in Scrapbook, vol. 1, RG 72, NAMAA; Nelson Trust, Minutes, June 16, 1930, folder 4949, Univ. of MO, President's Office, Papers, C2582, SHSMO.

21. Nelson Trust, Minutes, Oct. 20, 1930, folder 4950, Univ. of MO, President's Office, Papers, C2582, SHSMO; "Art Trustees Deny Buying 'Junk' in East," *Kansas City Post*, Oct. 24, 1930, clipping in Scrapbook, vol. 1, RG 72, NAMAA.

22. Nelson Trust, Minutes, Jan. 27, 1931, folder 4951, Univ. of MO, President's Office, Papers, C2582, SHSMO; Wittke, *First Fifty Years*, 86, 99; Spaeth, *American Art Museums*, 19.

23. Nelson Trust, Minutes, Jan. 6 and 27, 1931, folder 495, April 24 and May 29, 1930, folder 4949, Univ. of MO, President's Office, Papers, C2582, SHSMO.

24. Nelson Trust, Minutes, Jan. 27 and Feb. 20, 1931, folder 4951, Univ. of MO, President's Office, Papers, C2582, SHSMO; "Warner, Langdon," in *Who's Who in America*, vol. 17, *1932–1933*; Wittke, *First Fifty Years*, 99; Untitled article, *Kansas City Star*, March 13, 1931, clipping in Scrapbook, vol. 1, RG 72, NAMAA.

25. Nelson Trust, Minutes, Aug. 31, 1931, folder 4952, Univ. of MO, President's Office, Papers, C2582, SHSMO; Laurence Sickman, interview with author, April 7, 1986.

26. Churchman, *Laurence Sickman*, 12–13, 17–18.

27. Ibid., 13, 29.

28. Nelson Trust, Minutes, Nov. 27, 1931, folder 4953, Univ. of MO, President's Office, Papers, C2582, SHSMO; Churchman, *Laurence Sickman*, 13.

29. Churchman, *Laurence Sickman*, 26.

30. Ibid., 26–27; Sickman, interview with author, April 7, 1986.

31. Nelson Trust, Minutes, Jan. 12, 1932, folder 4954, Univ. of MO, President's Office, Papers, C2582, SHSMO.

32. Nelson Trust, Minutes, Feb. 3, 1932, folder 4954, Univ. of MO, President's Office, Papers, C2582, SHSMO; Sickman, interview with author, April 7, 1986; Laurence Sickman to Paul Gardner, Feb. 18, 1933, Box 5, folder 41, Director Records: Gardner, RG 01/01, NAMAA.

33. *Nelson-Atkins Museum of Art: Handbook* (2008), xi.

34. Churchman, *Laurence Sickman*, 35; Laurence Sickman to J. C. Nichols, June 20, 1933, Sickman Accounts folder, file I, Director's Records, NAMA (not found in current archives); Laurence Sickman to Paul Gardner, July 7, 1933, Box 5, folder 41, Director Records: Gardner, RG 01/01, NAMAA.

35. Laurence Sickman to Sybil Brelsford, July 15, 1933, Box 5, folder 41, Director Records: Gardner, RG 01/01, NAMAA; Sickman, interview with author, April 7, 1986;

Taggart, McKenna, and Wilson, *Handbook of the Collections*, 2:31; Churchman, *Laurence Sickman*, 35–37.

36. Nelson Trust, Minutes, Jan. 17, 1933, folder 4958, Univ. of MO, President's Office, Papers, C2582, SHSMO; Sickman Accounts, Box 5, folder 41, Director Records: Gardner, RG 01/01, NAMAA.

37. Nichols, "Opening of William Rockhill Nelson Gallery of Art and Mary Atkins Museum of Fine Arts," Dec. 11, 1933, Speeches, folder 37, Nichols Company Records, KC0106, SHSMO-KC; Gaylord Torrence, interview with author, Oct. 25, 2018.

38. Nelson Trust, Minutes, June 16, 1930, folder 4949, and Dec. 22, 1931, folder 4953, Univ. of MO, President's Office, Papers, C2582, SHSMO; Small, "Passionate Collector"; Gaylord Torrence, email to author, Sept. 19, 2018; *Nelson-Atkins Museum of Art: Handbook* (2008), 131.

39. Nelson Trust, Minutes, Feb. 3, 1932, folder 4954, Univ. of MO, President's Office, Papers, C2582, SHSMO; "Gardner, Paul," in *Who's Who in America*, vol. 26, *1950–1951*.

40. Nelson Trust, Minutes, April 15, 1932, folder 4955, and Nov. 25, 1932, folder 4957, Univ. of MO, President's Office, Papers, C2582, SHSMO.

41. Nelson Trust, Minutes, May 8, 1933, folder 4959, and Oct. 24, 1932, folder 4957, Univ. of MO, President's Office, Papers, C2582, SHSMO.

42. Nelson Trust, Minutes, March 28, 1933, folder 4958, Univ. of MO, President's Office, Papers, C2582, SHSMO; "Cornelius, Charles O.," in *Who's Who in America*, vol. 17, 1932–1933; Nelson Trust, Minutes, June 6, 1933, folder 4960, Univ. of MO, President's Office, Papers, C2582, SHSMO.

Chapter 8

1. Lindsay H. Cooper, "Notes on P.G.," Cooper Collection; Frances O'Donnell Clark, interview with author, April 25, 1986; Lindsay Hughes Cooper, interview with author, June 14, 1991.

2. Nelson Trust, Minutes, Oct. 19, 1932, folder 4947, Univ. of MO, President's Office, Papers, C2582, SHSMO; "Expenditures by the City of Kansas City, Missouri," Trustees folder, file I, Director's Records, NAMA (not found in the current archives).

3. Nelson Trust, Minutes, March 28, 1933, folder 4958, Univ. of MO, President's Office, Papers, C2582, SHSMO; Herman R. Sutherland, letter to author, Dec. 2, 1986.

4. Nelson Trust, Minutes, Oct. 19, 1932, folder 4947, Univ. of MO, President's Office, Papers, C2582, SHSMO; *Last Wills*, 7, 10, 15.

5. George Herrick to Lindsay H. Cooper, Aug. 4, 1981, and Lindsay H. Cooper, "Night of Remembrances," speech, Dec. 1983, Cooper Collection.

6. Cooper, "Night of Remembrances," Cooper Collection; Nelson Trust, Minutes, Aug. 19, 1933, folder 4962, Univ. of MO, President's Office, Papers, C2582, SHSMO.

7. Nelson Trust, Minutes, May 24, 1933, folder 4960, and July 25, 1933, folder 4961, Univ. of MO, President's Office, Papers, C2582, SHSMO; Cooper, "Night of Remembrances," Cooper Collection; Nelson Trust, Minutes, Sept. 19, 1933, folder 4962, Univ. of MO, President's Office, Papers, C2582, SHSMO; Otto Wittmann to Herman R. Sutherland, July 8, 1980, Cooper Collection.

8. Nelson Trust, Minutes, Oct. 29, Sept. 13, and Oct. 29, 1933, folder 4962, Univ. of MO, President's Office, Papers, C2582, SHSMO.

9. Lindsay H. Cooper, "Cooper Notes," Cooper Collection; Nelson Trust, Minutes, Sept. 19, 1933, folder 4962, Univ. of MO, President's Office, Papers, C2582, SHSMO.

10. Cooper, interviews with author, Aug. 10, 1992, June 14, 1991, and Jan. 20, 1986; Cooper, "Night of Remembrances," Cooper Collection.

11. Cooper, interview with author, June 14, 1991; Paul Gardner to Lindsay and Frank Cooper, Sept. 4, 1971, Cooper Collection; Nelson Trust, Minutes, memo page, folder 4963, Nov. 17–Dec. 30, 1933, folder 4964, Univ. of MO, President's Office, Papers, C2582, SHSMO.

Chapter 9

1. Nelson Trust, Minutes, Nov. 17–Dec. 30, 1933, folder 4963, and Oct. 19, 1933, folder 4962, Univ. of MO, President's Office, Papers, C2582, SHSMO.

2. Accession cards for art objects from Oak Hall, OR, NAMA.

3. "In Gallery and Studio," *Kansas City Star*, June 14, 1930, clipping in Scrapbook, vol. 1, RG 72, NAMAA; Nelson Trust, Minutes, July 10 and 13, 1933, folder 4961, Univ. of MO, President's Office, Papers, C2582, SHSMO.

4. Nelson Trust, Minutes, Nov. 6, 1933, folder 4962, and Nov. 17–Dec. 30, 1933, folder 4964, Univ. of MO, President's Office, Papers, C2582, SHSMO.

5. "Here and There in Society," *Kansas City Star*, Dec. 10, 1933, clipping in Wight Scrapbook, Patterson Collection; Nelson Trust, Minutes, Nov. 17–Dec. 30, 1933, folder 4964, Univ. of MO, President's Office, Papers, C2582, SHSMO; "Good Old Days at the Gallery," *Kansas City Times*, Dec. 12, 1973, clipping in Cooper Collection.

6. Nelson Trust, Minutes, Nov. 17–Dec. 30, 1933, folder 4964, Univ. of MO, President's Office, Papers, C2582, SHSMO; Cooper, interview with author, June 14, 1991.

7. "New Art Gallery for Kansas City"; Nelson Trust, Minutes, Nov. 17–Dec. 20, 1933, folder 4964, Univ. of MO, President's Office, Papers, C2582, SHSMO; Nichols, "Opening," speech, Dec. 11, 1933, folder 37, Nichols Company Records, KC0106, SHSMO.

8. Nichols, "Opening," speech, Dec. 11, 1933, folder 37, Nichols Company Records, KC0106, SHSMO.

9. Ibid.; Nelson Trust, Minutes, Nov. 17–Dec. 30, 1933, folder 4964, Univ. of MO, President's Office, Papers, C2582, SHSMO; "New Art Gallery for Kansas City."

10. Clark, interview with author, April 25, 1986.

11. Haskell et al., *Founders and Benefactors*, 11; Spaeth, *American Art Museums*, 229.

12. "Kansas City's New Museum," 523; "An Art Gallery Three Years Growing"; "New Art Gallery for Kansas City"; "Kansas City, William Rockhill Nelson Gallery of Art."

13. "Gallery and Museum Comprise a Temple of Art Revealing Treasures of Fifty Centuries," *Kansas City Star*, Dec. 10, 1933, clipping in Wight Scrapbook, Patterson Collection.

14. Ehrlich, *Kansas City, Missouri*, 180; Curl, "William Rockhill Nelson Gallery of Art and Atkins Museum of Fine Arts," 15–17.

15. Curl, "William Rockhill Nelson Gallery of Art and Atkins Museum of Fine Arts," 17–18.

16. Buckley, "William Rockhill Nelson Gallery of Art," Cooper Collection.

17. Ibid.; *Gallery Tour Booklet for Docents*, 6–7.

18. Architectural sketches from William Wight's notebook, Patterson Collection; Buckley, "William Rockhill Nelson Gallery of Art," 2, Cooper Collection; Curl, "William Rockhill Nelson Gallery of Art and Atkins Museum of Fine Arts," 24–25.

19. Curl, "William Rockhill Nelson Gallery of Art and Atkins Museum of Fine Arts," 29.

20. Ibid.; Buckley, "William Rockhill Nelson Gallery of Art," Cooper Collection.

21. Buckley, "William Rockhill Nelson Gallery of Art," Cooper Collection; Nichols, "Opening," p. 3, speech, Dec. 11, 1933, folder 37, Nichols Company Records, KC0106, SHSMO.

22. Curl, "William Rockhill Nelson Gallery of Art and Atkins Museum of Fine Arts," 33; "30-23 Tiepolo" file, Accession Records, OR, NAMA.

23. "32-16: Chardin" file, and Ralph T. Coe to David Carritt, Oct. 16, 1973, Accession Records, OR, NAMA.

24. Curl, "William Rockhill Nelson Gallery of Art and Atkins Museum of Fine Arts," 45.

25. "Kansas City's New Museum," 523.

26. "Fine Arts in Penn Valley?" *Kansas City Star*, Oct. 6, 1912, clipping in Atkins Scrapbook, Commerce Bank KC.

Chapter 10

1. "Gallery and Museum Comprise a Temple of Art Revealing Treasures of Fifty Centuries," *Kansas City Star*, Dec. 10, 1933, clipping in Wight Scrapbook, Patterson Collection.

2. Everard, "Museums and Exhibitions," 141.

3. Newcomb, "Museums Thrive on Depression?" 470.

4. *Last Wills*, 7.

5. Nelson Trust, Minutes, Nov. 24, 1932, folder 4957, Univ. of MO, President's Office, Papers, C2582, SHSMO; Lerman, *The Museum*, 127; Spaeth, *American Art Museums*, 202; Mary Thacher Denison, "In Gallery and Studio," *Kansas City Star*, July 14, 1930, clipping in Wight Scrapbook, Patterson Collection; Wittke, *First Fifty Years*, 61.

6. Hartt, "Docentry: A New Profession," 703.

7. J. C. Nichols to Ethlyne Jackson, July 19, 1945, Box 6, folder 25, Director Records: Gardner, RG 01/01, NAMAA.

8. Clark and Langworthy, "The Early Years"; Clark, interview with author, April 25, 1986.

9. Clark, interview with author, April 25, 1986.

10. "Children's Course in Art," n.d., Box 2, folder 51, Director Records: Gardner, RG 01/01, NAMAA; O'Donnell and Langworthy, "The Early Years"; "Activities at the Nelson Gallery of Art," *Junior League News* 9 (Oct. 1935): #2, Box 2, folder 51, Director Records: Gardner, RG 01/01, NAMAA.

11. Curl, "William Rockhill Nelson Gallery of Art and Atkins Museum of Fine Arts"; Paul Gardner to Principals of the Kansas City School District, Nov. 4, 1940, Box 2, folder 51, Director Records: Gardner, RG 01/01, NAMAA.

12. Clark, interview with author, April 25, 1986; O'Donnell and Langworthy, "The Early Years."

13. Clark, interview with author, April 25, 1986.

14. Paul Gardner to J. C. Nichols, June 13, 1939, Box 6, folder 9, Director Records: Gardner, RG 01/01, NAMAA.

15. "Report of the Junior Education Department," 1941, Box 2, folder 51, Director Records: Gardner, RG 01/01, NAMAA.

16. Ibid.; O'Donnell and Langworthy, "The Early Years."

17. Cooper, interview with author, June 14, 1991; "Report of the Junior Education Department," 1941,Box 2, folder 51, Director Records: Gardner, RG 01/01; O'Donnell and Langworthy, "The Early Years"; Jeanne Turner Baldwin, "Story of Marionettes and Puppets at the Nelson-Atkins Museum," 1–2, Marionettes, VF, NAMAA.

18. Paul Gardner to Maurice DaVinna, Nov. 14, 1938, Box 5, folder 12, Director Records: Gardner, RG 01/01, NAMAA.

Chapter 11

1. *Last Wills*, 7.

2. Clark, interview with author, April 25, 1986; Cooper, interview with author, Jan. 20, 1986.

3. Ibid.

4. Paul Gardner to Lindsay and Frank Cooper, Sept. 24, 1971, Cooper Collection.

5. *Last Wills*, 7.

6. Ibid., 10; Nelson Trust, Minutes, Oct. 26, 1931, folder 4953, and Sept. 12, 1932, folder 4956, Univ. of MO, President's Office, Papers, C2582, SHSMO; Milton McGreevy to Paul Gardner, Nov. 24, 1952, Box 6, folder 25, Director Records: Gardner, RG 01/01, NAMAA; "In the Circuit Court of Jackson County, Missouri," March 7, 1980, Box 6, folder 20, Director Records: Coe, RG 01/03, NAMAA; *Last Wills*, 8.

7. *Last Wills*, 7; "Art, Plans Take Form," *Kansas City Times*, Jan. 16, 1931, Scrapbook, Vol. 1, NAMAA; Pickard, "People in the Nelson Gallery," A-5.

8. Dorothy H. Clark to Herman Sutherland, March 23, 1966, Box 7, folder 1a, Inez Parker to Laurence Sickman, Oct. 5, 1968, Box 11, folder 7, and "A New Gallery for Modern Art," May 13, 1971, clipping in Box 11, folder 8, all in Director Records: Sickman, RG 01/02, NAMAA.

9. Lee Pentecost, "Fifty Years of Collecting: The Friends of Art at the Nelson," Kroh Collection.

10. Pickard, "People in the Nelson Gallery: A History of the Friends of Art," B-3, B-4.

11. Ibid., B-5.

12. Lee Pentecost, "Fifty Years of Collecting: The Friends of Art at the Nelson," Kroh Collection; Ralph T. Coe, "Brief Account of the Friends of Art (1934–1971): Artistic Support as a Civic Response," Box 11, folder 8a, Director Records: Sickman, RG 01/02, NAMAA.

13. Lee Pentecost, "Fifty Years of Collecting: The Friends of Art at the Nelson," Kroh Collection; *Western Gallery of Art Illustrated Catalogue*.

14. Clark, interview with author, April 25, 1986; Nelson Trust, Minutes, March 26, 1934, folder 4965, Univ. of MO, President's Office, Papers, C2582, SHSMO.

15. Nelson Trust, Minutes, Oct. 20, 1930, folder 4950, Univ. of MO, President's Office, Papers, C2582, SHSMO.

16. Nelson Trust, June 2, 1933, folder 4960, Univ. of MO, President's Office, Papers, C2582, SHSMO.

17. J. C. Nichols to Paul Gardner, June 11, 1934, J. C. Nichols folder, file 1, Director's Records, NAMA (not found in current archives).

18. Paul Gardner to Alice Klauber, Aug. 27, 1941, and Paul Gardner to Mrs. Charles Ingram, June 27, 1942, Box 3, folder 8, Director Records: Gardner, RG 01/01, NAMAA.

19. Paul Gardner to D. M. Hall, April 11, 1942, and Paul Gardner to H. V. Jones, May 16, 1942, Box 3, folder 8; and Paul Gardner to J. C. Nichols, Oct. 11, 1935, Box 3, folder 5, Director Records: Gardner, RG 01/01, NAMAA.

20. J. C. Nichols to John E. Wilson, June 17, 1935, Box 6, folder 26, Director Records: Gardner, RG 01/01, NAMAA.

21. Nelson Trust, Minutes, Feb. 23, 1934, folder 4965, Univ. of MO, President's Office, Papers, C2582, SHSMO; *Nelson-Atkins Museum of Art: Handbook* (2008).

22. J. C. Nichols to Roy Roberts, Jan. 15, 1934, and J. C. Nichols to Richard Fowler, Jan. 15, 1934, Box 1, folder 28, Director Records: Gardner, RG 01/01, NAMAA.

23. Nelson Trust, Minutes, Feb. 23, 1934, folder 4965, and May 28, 1934, folder 4966, Univ. of MO, President's Office, Papers, C2582, SHSMO.

24. Nelson Trust, Minutes, Jan. 15, 1934, folder 4965, Univ. of MO, President's Office, Papers, C2582, SHSMO.

25. J. C. Nichols to H. V. Jones, Jan. 18, 1934, Box 6, folder 26, Director Records: Gardner, RG 01/01, NAMAA; Nelson Trust, Minutes, March 26, 1934, folder 4965, Univ. of MO, President's Office, Papers, C2582, SHSMO.

26. Nelson Trust, Minutes, July 16, 1934, folder 4967, Univ. of MO, President's Office, Papers, C2582, SHSMO.

27. Publicity folder, Box 5, folder 12, Director Records: Gardner, RG 01/01, NAMAA.

28. "The William Rockhill Nelson Gallery of Art and Atkins Museum of Kansas City, Missouri Is Celebrating Its Fifth Anniversary," Box 5, folder 12, Director Records: Gardner, RG 01/01, NAMAA.

Chapter 12

1. "Kansas City's Tenth Anniversary," *Art News* 42 (December 15-31, 1943): 13, clipping in Box 5, folder 12, Director Records: Gardner, RG 01/01, NAMAA.

2. Marc F. Wilson, "Laurence Sickman," in Churchman, *Laurence Sickman*, 20; Sir Harold Acton, "Reminiscences of Laurence Sickman," in ibid., 38–39.

3. *Last Wills*, 6.

4. Fowler, *Leaders in Our Town*, 50.

5. Paul Gardner to University Trustees, Nov. 22, 1942, Box 6, folder 25, Director Records: Gardner, RG 01/01, NAMAA.

6. J. C. Nichols to Ethlyne Jackson, January 9, 1943, Box 6, folder 2, Director Records: Gardner, RG 01/01, NAMAA.

7. J. C. Nichols to Sybil Brelsford, March 15, 1943, Box 80, folder 15, Nelson Trust Office Records, RG 80/15, NAMAA; Ethlyne Jackson to J. C. Nichols, March 26, 1943, Box 6, folder 2, Director Records: Gardner, RG 01/01, NAMAA.

8. Memo from Ethlyne Jackson to University Trustees, Dec. 1943, and "Semi-Monthly Payroll," Feb. 16–29, 1944, Box 6, folder 2, University Trustees to Paul Gardner, Sept. 18, 1942, University Trustees to Ethlyne Jackson, March 15, 1943, "Staff" folder, Box 6, folder 2, all in Director Records: Gardner, RG 01/01, NAMAA.

9. J. C. Nichols to Ethlyne Jackson, April 24, 1943, Box 6, folder 25, and J. C. Nichols to Ethlyne Jackson, Feb. 2, 1943, Box 1, folder 16, Director Records: Gardner, RG 01/01, NAMAA; Paul Gardner to Ethlyne Jackson, Feb. 16, 1943, Trustees folder, file I, Director's Records, NAMA (not found in the current archives).

10. Germain Seligmann to H. V. Jones, Nov. 21, 1941, Trustees folder, file I, Director's Records, NAMA (not found in the current archives).

11. J. C. Nichols to Harold Woodbury Parsons, Oct. 6, 1943, Trustees folder, file I, Director's Records, NAMA (not found in the current archives).

12. Ethlyne Jackson to J. C. Nichols, Sept. 8, 1943, Box 6, folder 25, Director Records: Gardner, RG 01/01, NAMAA; Ethlyne Jackson to J. C. Nichols, Sept. 23, 1943, Trustees folder, file I, Director's Records, NAMA (This last document was not found in the current archives.); Harold Woodbury Parsons to J. C. Nichols, April 11, 1945, Box 4, folder 23, Director Records: Gardner, RG 01/01, NAMAA.

13. Ethlyne Jackson to J. C. Nichols, Oct. 1, 1943, Box 6, folder 25, Director Records: Gardner, RG 01/01, NAMAA.

14. J. C. Nichols to Ethlyne Jackson, May 13, 1944, Box 6, folder 6, Director Records: Gardner, RG 01/01, NAMAA.

15. "China's Art to Her Aid," March 13, 1943, unidentified newspaper, and Unidentified clipping, March 1944, Cooper Collection.

16. J. C. Nichols to Ethlyne Jackson, Nov. 8, 1944, Box 6, folder 25, Director Records: Gardner, RG 01/01, NAMAA; Ethlyne Jackson to J. C. Nichols, June 3, 1944, Trustees folder, file I, Director's Records, NAMA (This last document was not found in the current archives.)

17. Cooper, interview with author, Jan. 26, 1986; J. C. Nichols to Sybil Brelsford, July 11, 1944, Box 1, folder 28, Director Records: Gardner, RG 01/01, NAMAA.

18. "October Calendar of Events" (Kansas City: The Nelson-Atkins Museum, Oct. 1988); "Laura Nelson Kirkwood—Objects[sic] d'Art," Kirkwood Collection, MSS 004, NAMAA; Catherine Futter, email to author, July 11, 2018.

19. Nelson Trust, Minutes, Oct. 28, 1927, file 4943, Univ. of MO, President's Office, Papers, C2582, SHSMO; "Laura Nelson Kirkwood—Objects [sic] d'Art," and "Catalog: Laura Nelson Kirkwood Trust: Of Paintings, Etchings, Antique Furniture, Oriental Rugs, Silverware, Antique War Weapons, and Old Ornaments," Kirkwood Collection, MSS 004, NAMAA; Last Wills, 18.

20. Last Wills, 10, 15; Nelson Trust, Minutes, June 26, 1933, folder 4960, Univ. of MO, President's Office, Papers, C2582, SHSMO; Assistant to the University Trustees to Board of Directors, School District of Kansas City, Missouri, Aug. 22, 1933, "Western Gallery" file, OR, NAMA; Ethlyne Jackson to the University Trustees, Sept. 6, 1945, Box 6, folder 41, Director Records: Gardner, RG 01/01, NAMAA.

21. "Outgoing Receipts," Sept. 1, 1954, Feb. 19 and 23, and March 10, 1970, Feb. 8 and Nov. 19, 1973, July 10 and Oct. 9, 1974, "Western Gallery" file, OR, NAMA; Last Wills, 10.

22. "The Monuments Men," www.monumentsmenfoundation.org/the-heroes/the-monuments-men (accessed May 20, 2018).

23. Ibid.; Paul Gardner to Ethlyne Jackson, Feb. 1944, and Ethlyne Jackson to J. C. Nichols, Feb. 21, 1944, Box 3, folder 59, Director Records: Gardner, RG 01/01, NAMAA.

24. J. C. Nichols to Laurence Sickman, March 31, 1944, Box 3, folder 31, Nichols Trust Files, RG 80/10, NAMAA.

25. Otto Burchard to Laurence Sickman, March 23, 1953, Box 1a, folder 19, Sickman Papers, MSS 001, NAMAA.

26. Wilson, "Laurence Sickman," in Churchman, *Laurence Sickman*, 21; Sickman, interview with author, April 7, 1986, confirmed in author interview with Marc Wilson, Feb. 19, 2019; MacKenzie Mallon, email to author, March 14, 2019.

27. MacKenzie Mallon, email to author, March 14, 2019.

28. Ethlyne Jackson to J. C. Nichols, Aug. 5, 1945, Box 5, folder 25, Director Records: Gardner, RG 01/01, NAMAA.

Chapter 13

1. "The Heroes," Monuments Men Foundation, www.monumentsmenfoundation.org/the-heroes (accessed May 12, 2018).

2. Paul Gardner to University Trustees, May 2, 1950, Box 6, folder 25, Director Records: Gardner, RG 01/01, NAMAA.

3. Long Construction Company to Paul Gardner, April 12, 1950, Budgets and Accounts folder, file I, Director's Records, NAMA (not found in the current archives); Paul Gardner to Margit Varga, Dec. 5, 1947, Box 5, folder 12, Director Records: Gardner, RG 01/01, NAMAA.

4. Nelson-Atkins Museum of Art, "Nelson-Atkins Receives $1 Million Grant from Beals Trust," press release, Jan. 11, 2016, www.nelson-atkins.org/9916-2/ (accessed June 2, 2018).

5. Nelson Trust, Minutes, Nov. 21, 1952, April 23 and June 20, 1953, Vol. 9, NAMAA.

6. "Public Relations from December 1953," Box 12, folder 6, Series III, Director Records: Sickman, RG 01/02, NAMAA.

7. "Samuel H. Kress Foundation Annual Report 1966," Box 25, folder 15, and "Samuel H. Kress Foundation Annual Report 1977," Box 25, folder 18, Series V, Director Records: Wilson, RG 01/04, NAMAA; Kress Foundation, "About Us," http://www.kressfoundation.org/about/. These Kress Foundation paintings were donated to the museum in 1961: Memmi's *The Virgin and Child* (F61–62), Signorelli's *The Flight into Egypt: Christ Among the Doctors* (F61–65), Bellini's *Madonna and Child* (F61–66), Daddi's *Madonna and Child Enthroned with Eight Saints and Eight Angels* (F61–61), di Paolo's *Madonna and Child between Saints Jerome and Augustine* (F61–58), and nine other paintings and two sculptures.

8. Nelson Trust, Minutes, Oct. 18, 1953, Vol. 9, NAMAA.

9. Paul Gardner's 15th Anniversary Speech, Gallery 1954–1959 folder, file I, Director's Records, NAMA (not found in the current archives).

10. Nelson Trust, Minutes, Nov. 24, 1952, April 1 and 18, 1953, Vol. 9, NAMAA.

11. Laurence Sickman to Mrs. Kreamer and Mrs. Riss, June 10, 1953, Box 5, folder 3, Series III, Director Records: Sickman, RG 01/02, NAMAA.

12. "Patrick Joseph Kelleher (1918–1985)," www.monumentsmenfoundation.org /the-heroes/the-monuments-men/kelleher-capt.-patrick-j. (accessed May 20, 2018); Nelson Trust, Minutes, Sept. 5 and Oct. 24, 1953, Vol. 9, NAMAA.

13. Paul Gardner to University Trustees, April 29, 1953, Box 2, folder 2, Director Records: Gardner, RG 01/01, NAMAA; "Acquisitions by Purchase," 2, and "Considerations for Acquisition Policy," App. I of *Annual Report 1954*, NAMAA.

14. "Considerations for an Acquisition Policy," *Annual Report* 1954, NAMAA.

15. "Considerations for an Acquisition Policy" and "Acquisitions by Purchase," *Annual Report* 1954, NAMAA; Mallon, "Discriminating Thieves." The portrait that was reputed to be by David is not now deemed to be by David and is no longer in the Nelson-Atkins collection.

16. "Acquisitions by Purchase," *Annual Report 1955*, NAMAA; Nelson Trust, Minutes, March 20, March 30, and May 12, 1956, Vol. 10, NAMAA.

17. Davis, *Big Picture*, 12, 13, 58.

18. "Special Events," *Annual Report 1956*, NAMAA.

19. Nelson Trust, Minutes, Feb. 3 and March 5, 1954, Vol. 9, NAMAA; Clara S. Hockaday to Laurence Sickman, Jan. 4, 1954, Milton McGreevy to Clara Hockaday, Feb. 5, 1954, and Memo to Laurence Sickman, May 3, 1954, Box 8, folder 21, Series III, Director Records: Sickman, RG 01/02, NAMAA; "Social Activities," *Annual Report 1954*, NAMAA.

20. Caldwell to Mrs. R. Crosby Kemper, July 6, 1954, Box 8, folder 21, Series III, Director Records: Sickman, RG 01/02, NAMAA; "Comments of the Director," *Annual Report 1955*, NAMAA.

21. Nelson Trust, Minutes, Feb. 22, 1963, Vol. 12, NAMAA; "Comments of the Director," *Annual Report 1965*, NAMAA; Nelson Trust, Minutes, June 18, 1958, Vol. 10, NAMAA.

22. Laurence Sickman to Enid Kemper, June 23, 1956, Laurence Sickman to Peggy Barnes, July 3, 1958, Laurence Sickman to Claire Hockaday, July 13, 1964, Laurence Sickman to Libby Adams, July 5, 1966, Laurence Sickman to Barbara Seidlitz, July 7, 1969, and Laurence Sickman to Mary Grant, June 28, 1973, Box 8, folder 21, Series III, Director Records: Sickman, RG 01/02, NAMAA.

23. Nelson Trust, Minutes, Dec. 2, 1954, Vol. 9, and July 14, 1955, Vol. 10, NAMAA; "Special Events," *Annual Report* 1956 and "Comments of the Director," *Annual Report 1957*, NAMAA.

24. Nelson Trust, Minutes, Sept. 10, Dec. 28, and Dec. 30, 1954, Vol. 9, NAMAA; *Last Wills*, 8; Patrick J. Kelleher, "Acquisitions by Purchase: Report of Curator of European Art," *Annual Report 1954*, NAMAA.

25. Nelson Trust, Minutes, Nov. 8, 1956, Vol. 10, NAMAA.

26. "The Friends of Art," *Annual Report 1956*, NAMAA.

27. Nelson Trust, Minutes, July 16 and Sept. 19, 1958, Vol. 10, NAMAA; "Comments of the Director," *Annual Report 1967*, NAMAA.

28. The Nelson Gallery Trustees: Milton McGreevy, David T. Beals, and Menefee D. Blackwell to Dr. Nicholas Pickard, July 25, 1958, Box 7, folder 3, Series III, Director

Records: Sickman, RG 01/02, NAMAA; "Friends of Art Report" *Annual Report 1958*, NAMAA.

29. "Comments of the Director," *Annual Report 1958*, NAMAA; Milton McGreevy to David Beals, Nov. 24, 1958, Box 8, folder 14, Series III, Director Records: Sickman, RG 01/02, NAMAA.

30. Nelson Trust, Minutes, Sept. 19, 1958, Vol. 10, NAMAA.

31. "The Building and Collections," Box 8, folder 14, Series III, Director Records: Sickman, RG 01/02, NAMAA.

32. "Gifts to the Frank P. and Harriet C. Burnap Collection of English Pottery," *Annual Report 1954*, *Annual Report 1955*, and "Comments of the Director," *Annual Report 1957*, *Annual Report, 1967*, NAMAA; Nelson Trust, Minutes, Jan. 9 and Sept. 19, 1954, and Nov. 19, 1957, Vol. 9, NAMAA; "The Frank P. and Harriet C. Burnap Collection of English Pottery," in Taggart, McKenna, and WIlson, *Handbook of the Collections,* vol. 1. Note: Charles II was so pleased with the Yacht *Mary* that he had it copied so that he and his brother, the Duke of York, could race their boats from Greenwich to Gravesend and back, the first yacht race in the world. NB: The Victoria and Albert Museum in London contested the export of the Yacht Dish to America, causing a delay in its arrival.

33. "The Building and Collections," Box 8, folder 14, Series III, Director Records: Sickman, RG 01/02, NAMAA; Nelson Trust, Minutes, June 18, 1958, Vol. 10, NAMAA.

34. "The Building and Collections," Box 8, folder 14, Series III, Director Records: Sickman, RG 01/02, NAMAA; Nelson Trust, Minutes, Jan. 27, 1957, Vol. 10, NAMAA.

Chapter 14

1. Nelson Trust, Minutes, Jan. 24, 1954, Vol. 9, Dec. 8, 1956, and Dec. 5, 1958, Vol. 10, NAMAA.

2. "Comments of the Director: Staff," *Annual Report 1959*, NAMAA; Kansas City Art Institute Students, "Petition," Jan. 7, 1957, OR, NAMA.

3. Nelson Trust, Minutes, June 10, 1959, Vol. 11, NAMAA; "Comments of the Director: Staff," *Annual Report 1959*, NAMAA; Ralph T. Coe to Bill Wixom, Dec. 13, 1978, Box 1, folder 11, Director Records: Coe, RG 01/03, NAMAA.

4. Nelson Trust, Minutes, Sept. 21 and Oct. 9, 1959, and May 4, 1960, Vol. 11, NAMAA.

5. Nelson Trust, Minutes, April 16, 1958, Vol. 9, May 7 and Oct. 7, 1960, Vol. 11, NAMAA; "Comments of the Director," *Annual Report 1969*, NAMAA.

6. Laurence Sickman to Mrs. A. Janssen Wooldridge, Dec. 8, 1959, Box 7, folder 7, Series III, Directors Records: Sickman, RG 01/02, NAMAA.

7. "The Junior Gallery and Creative Arts Center," Box 1, folder 1, Westport Garden Club Records, RG 71/01, NAMAA.

8. "The Wonders of the World in Pictures," *Kansas City Star*, Jan. 31, 1960, and "About 300 at Opening at New Junior Gallery," *Kansas City Star*, Jan. 31, 1960, clippings in Box 1, folder 1, Westport Garden Club Records, RG 71/01, NAMAA.

9. Laurence Sickman to Marilyn P. (Mrs. Doyle) Patterson, June 7, 1960, Box 5, folder 3, Series III, Director Records: Sickman, RG 01/02, NAMAA.

10. James E. Seidelman, "Department of Education," *Annual Report 1956*, NAMAA; University Trustees to Ladies of the Junior League of Kansas City, Missouri, June 5, 1964, Box 14, folder 4, and Sickman to Mrs. A.J. Woolridge, May 7, 1963, Box 5, folder 3, Series III, Director Records: Sickman, RG 01/02, NAMAA.

11. "Report of the Curator of Painting and Sculpture," *Annual Report 1960*, NAMAA.

12. Sarah Ingram-Eiser, interview with author, Aug. 31, 2018; Jane Rosenthal to Mrs. Margaret Parkin, June 15, 1960, and Margaret R. Parkin to Jane Rosenthal, June 30, 1960, Guild Records 1960–1963, Friend of Art Records, RG 43/02, NAMAA.

13. Jane Rosenthal to Milton McGreevy, June 15, 1960, Guild Records 1960–1963, Friends of Art Records, RG 43/02, NAMAA.

14. Guyton Hamilton to Dear Member [of the Guild], Oct. 6, 1960, Guild Records 1960–1963, Friends of Art Records, RG 43/02, NAMAA.

15. "Comments of the Director," *Annual Report 1960*, NAMAA; "Guild Art Theatre folder," Box 22, Friends of Art Records, RG 43/02, NAMAA; Mary Lou Brous, interview with author, July 11, 2018.

16. Ralph T. Coe to Helen Frankenthaler, Jan. 8, 1975, Box 1, folder 19, Series I, Goheen Files, RG 95, NAMAA.

17. "Weddings: Sarah Foresman Weds Ralph T. Coe," *Kansas City Star*, Aug. 31, 1961; "Comments of the Director," *Annual Report 1964*, NAMAA; Ingram-Eiser, interview with author, Aug. 31, 2018.

18. Nelson Trust, Minutes, Dec. 18, 1963, Vol. 12, NAMAA; Ingram-Eiser, interview with author, Aug. 31, 2018.

19. Nelson Trust, Minutes, April 27 and June 19, 1964, Vol. 12, NAMAA; Ingram-Eiser, interview with author, Aug. 31, 2018.

20. "Attendance," Box 7, folder 6, Director Records: Sickman, RG 01/02, NAMAA; "Comments of the Director," *Annual Report 1963*, NAMAA; Nelson Gallery Foundation, Trustees Minutes, July 19, 1963, Vol. 1: 1954–1966, NAMAA.

21. "Comments of the Director," *Annual Report 1964*, NAMAA.

22. Ralph T. Coe, "Post-Pop Possibilities: Howard W. Jones," 1965, Box 6, folder 1, and "Ethnic Art from the Collection of Mr. and Mrs. Herbert Baker," Box 5, folder 25, Sub-series D, Assistant Directors' Records, RG 99, NAMAA.

23. Charlotte Vander Veer, "Report to the Trustees, Dr. Laurence Sickman and Staff of the William Rockhill Nelson Gallery of Art, Atkins Museum of Fine Arts, Kansas City, Missouri," June 1963, and Memorandum from Laurence Sickman, Jan. 22, 1974, Series III, Box 9, folder 12, Director Records: Sickman, RG 01/02, NAMAA; Helen F. Spencer to Trustees of the Nelson Gallery Foundation, Jan. 3, 1963, Nelson Gallery Foundation, Trustees Minutes, Vol. I: 1954–1966, NAMAA.

24. *Last Wills*, 6.

25. Nelson Trust, Minutes, May 12, June 19, and Dec. 8, 1962, April 26, 1962, Vol. 11, 1959–1962, NAMAA.

26. Nelson Trust, Minutes, April 26 and May 11, 1963, Vol. 12, NAMAA.

27. Nelson Trust, Minutes, March 3, 1964, Vol. 12, NAMAA; Cliff Jones to Milton McGreevy and Chuck Blackwell, Oct. 28, 1964, Box 9, folder 11, Directors Records: Sickman, RG 01/02, NAMAA.

28. Cliff Jones to L. Sickman, Feb. 13, 1969, Cliff Jones to L. Sickman, Feb. 12, 1969, and Jones to McGreevy, Blackwell, and Sickman, Nov. 11, 1968, Box 9, folder 1, Series III, Director Records: Sickman, RG 01/02, NAMAA.

29. Nelson Gallery Trust, Trustees Minutes, May 12, 1956, Vol. 12, NAMAA.

30. Nelson Trust, Minutes, Jan. 8, 1965, Vol. 12, NAMAA; "Invitation to Join the Society of Fellows," Box 13, folder 5, Series III, Director Records: Sickman, RG 01/02, NAMAA.

31. Nicholas Pickard to Laurence Sickman, June 21, 1974, Box 13, folder 2, Director Records: Sickman, RG 01/02, NAMAA.

32. "1967 Recruitment letter for Society of Fellows," Series III, Box 13, folder 5, Director Records: Sickman, RG 01/02, NAMAA; Chuck Blackwell to Milton McGreevy and Cliff Jones, Feb. 22, 1968, Box 13, folder 7, Series III, Director Records: Sickman, RG 01/02, NAMAA.

33. Nelson Trust, Minutes, Jan. 27, 1963, Vol. 12, NAMAA.

34. "Organizational Meeting," Nov. 16, 1965, and "List of donors, patrons, benefactors," Box 13, folder 5, Series III, Director Records: Sickman, RG 01/02, NAMAA.

35. James M. Kemper Jr. to Ted Coe, Aug. 27, 1964, and Laurence Sickman to James M. Kemper, Sept. 15, 1964, Box 6, folder 10, Series III, Director Records: Sickman, RG 01/02, NAMAA.

36. Clark Mtze to L. Sickman, Sept. 15, 1965, and L. Sickman to Mrs. Jane DeHart Mathews, March 3, 1969, Box 10, folder 13, Series III, Director Records: Sickman Records, RG 01/02, NAMAA; National Endowment for the Arts, "About the NEA," https://www.arts.gov/about-nea (accessed July 31, 2018).

37. "Ford Foundation," https://www.fordfoundation.org/about/about-ford/our-or igins/(accessed July 28, 2018) (The Ford Foundation today has a $12 billion endowment and makes grants of $500 million annually.); "News from the Ford Foundation," Jan. 13, 1964, Box 6, folder 2, and "Ford Foundation Conference on the Situation of the Artist and the Institutions in the Arts 1957–1967," Box 5, folder 15, Series III, Director Records: Sickman, RG 01/02, NAMAA.

Chapter 15

1. Sherman E. Lee, "The Idea of An Art Museum," *Harper's Magazine*, Sept. 1968, clipping in Box 7, folder 1a, and Laurence Sickman, "Address to Society of Fellows," Oct. 26, 1971, Box 13, folder 3, Series III, Director Records: Sickman, RG 01/02, NAMAA.

2. Sickman, "Address to Society of Fellows," Oct. 26, 1971, Box 13, folder 3, and Sickman to Cliff Jones, Jan. 30, 1967, Box 14, folder 4, Series III, Director Records: Sickman, RG 01/02, NAMAA.

3. Nelson Trust, Minutes, May 13, 1967, Vol. 13, NAMAA; Sickman to Friend of the Gallery, Oct. 6, 1966, Box 7, folder 2, and "A Distinguished Repertoire of Significant Cinema: 1966–1967," Box 5, folder 11, Series III, Director Records: Sickman, RG 01/02, NAMAA.

4. "Gallery Plea to City," *Kansas City Star*, May 26, 1943, clipping, Box 1, folder 27, and L. B. Saunders to William A. Hall, June 20, 1980, Director Records: Coe, RG 01/03,

NAMAA; Nelson Trust, Minutes, Sept. 11, 1967, Vol. 13, NAMAA; "Report of the Superintendent," *Annual Report 1967*, NAMAA.

5. Nelson Trust, Minutes, June 26, 1968, Vol. 13, NAMAA; Clarence Simpson to L. Sickman, Nov. 13, 1968, Box 14, folder 5, Series III, Director Records: Sickman, RG 01/02, NAMAA.

6. Nelson Trust, Minutes, July 5, 1968, Vol. 13, NAMAA; L. S. Saunders to William A. Hall, June 20, 1980, Box 1, folder 27, Director Records: Coe, RG 01/03, NAMAA.

7. Laurence Sickman to Cliff Jones, July 9, 1968, Box 14, folder 5, and Cliff Jones to Chuck Blackwell, April 8, 1968, and Blackwell to L. Sickman, March 28, 1969, Box 12, folder 15, Series III, Director Records: Sickman, RG 01/02, NAMAA.

8. Sherman E. Lee, "The Idea of An Art Museum" *Harper's Magazine*, Sept. 1968, clipping in Box 7, folder 1a, Series III, Director Records: Sickman, RG 01/02, NAMAA; Memorandum from Ralph T. Coe to Director and Trustees, Oct. 2, 1967, Box 1, folder 1, and Ralph T. Coe to n.n., May 16, 1968, Box 1, folder 2, *Magic Theater* Records, RG 24/01, NAMAA.

9. Goheen, interview with author, June 29, 2018.

10. Sickman to the Trustees, March 27, 1969, Box 14, folder 5, Series III, Director Records: Sickman, RG 01/02, NAMAA.

11. Ralph T. Coe, "Position Paper on Adult Education at the Nelson Gallery," Box 1, folder 12, Series III, Director Records: Sickman, RG 01/02, NAMAA.

12. "Comments of the Director," *Annual Report 1967*, NAMAA; Ross Taggart to Mrs. T. C. Erickson, June 18, 1975, Box 11, folder 15, and Sickman to Leigh Brew, July 23, 1974, Box 7, folder 13, Series III, Director Records: Sickman, RG 01/02, NAMAA.

13. Eikleberry, "Department of Education," Box 1, folder 12, Series III, Director Records: Sickman, RG 01/02, NAMAA.

14. Memo to M. Ryman, J. Sanditz, P. Reid, N. Willits, B. Lillard, N. Williams, J. Olsen from Larry Eikleberry, Nov. 27, 1970, Box 5, folder 2, Series III, Director Records: Sickman, RG 01/02, NAMAA; Goheen, interview with author, June 29, 2018.

15. "Meeting on tours and docent training," Aug. 11, 1971, Box 5, folder 2, Series III, Director Records: Sickman, RG 01/02, NAMAA; Elizabeth Goldring and Jane Farmer, "A New Approach to the Art Museum Visit," April 4, 1971, Box 1, folder 3, Goheen Files, RG 95, NAMAA; "Comments of the Director," *Annual Report 1971*, NAMAA.

16. Larry D. Eikleberry, "The Deliberations, etc.," March 31, 1972, Box 1, folder 12, and "$25,000 to Nelson-Gallery Foundation," Box 10, folder 8, Series III, Director Records: Sickman, RG 01/02, NAMAA.

17. "Joins the Nelson Gallery," *Kansas City Star*, March 21, 1971, clipping in Box 6, folder 7, Series III, Director Records: Sickman, RG 01/02, NAMAA.

18. Laurence Sickman to the Ford Foundation, March 17, 1969, Box 6, folder 7, Marc Wilson to Marcia Thompson, Jan. 20, 1971, Box 6, folder 6, Series III, Director Records: Sickman, RG 01/02, NAMAA.

19. L. Sickman to Marcia Thompson, July 14, 1969, Box 6, folder 1, Series III, Director Records: Sickman, RG 01/02, NAMAA.

20. Nelson Trust, Minutes, May 24, 1969, Vol. 13, NAMAA; "Report of the Assistant Director," *Annual Report 1968*, NAMAA; Nelson Trust, Minutes, May 9, 1975, Vol. 14, NAMAA; *Annual Report: 5/1/78–4/30/79*, NAMAA.

21. J. F. Ponder to L. Sickman, Sept. 27, 1966, and L. Sickman to Ponder, Oct. 6, 1966, Box 12, folder 3, Milton McGreevy to Laurence Sickman, Chuck Blackwell and Cliff Jones, Feb. 17, 1968, Box 10, folder 4, Series III, Director Records: Sickman, RG 01/02, NAMAA.

22. Memorandum to the Trustees from Laurence Sickman, Sept. 5, 1968, Inez Parker to Sickman, Sept. 5, 1968, Laurence Sickman to Inez Parker, Sept. 11, 1968, Inez Parker to Laurence Sickman, Sept. 16, 1968, Trustees of the Nelson Foundation to Inez Parker, Sept. 19, 1968, Sickman to Inez Parker, Sept. 19, 1968, Sickman to Earle Grant, Oct. 7, 1968, Box 11, folder 7, Series III, Director Records: Sickman, RG 01/02, NAMAA.

23. L. Sickman's memorandum to the Trustees, Nov. 5, 1968, L. Sickman to Inez Parker, Feb. 11, 1969, L. Sickman to Jerry [Gerald] Parker, Jan. 2, 1970, L. Sickman memorandum to the Trustees, Jan. 14, 1970, Milton McGreevy, Menefee D. Blackwell and Herman Sutherland to Mayor Davis, Jan. 14, 1970, and "Parker Grant Gallery" booklet, Box 11, folder 8, Series III, Director Records: Sickman, RG 01/02, NAMAA.

24. Nelson Gallery Foundation, Trustees Minutes, Dec. 18, 1963, Vol. 1: 1954–1966, NAMAA; Nelson Trust, Minutes, Aug. 9, Sept. 10, and Oct. 22, 1966, Vol. 12, NAMAA; Herman Sutherland to Mrs. Frank G. Crowell, Nov. 9 and Dec. 20, 1966, Box 13, folder 6, Series III, Director Records: Sickman, RG 01/02, NAMAA; Laurence Sickman, "Bequests and Special Gifts," *Annual Report 1969*, NAMAA; Patricia C. Miller, interview with author, Sept. 7, 2019; Stuart Hutchinson to Ted Coe, Oct. 29, 1977, Box 1, folder 8, Series IV, Director Records: Coe, RG 01/03, NAMAA.

25. Ingram-Eiser, interview with author, Aug. 31, 2018.

26. "Elmer F. Pierson Sculpture Garden Recapitulation," Aug. 15, 1974, "Meeting," Dec. 6, 1971, McGreevy to Blackwell, Sutherland, and Robert Hodge, Dec. 15, 1971, "A Sculpture Garden for Kansas City at The Nelson Gallery of Art," and McGreevy to Frank Vaydik, Nov. 10, 1972, Box 12, folder 13, Series III, Director Records: Sickman, RG 01/02, NAMAA.

27. Blackwell to Sickman, Dec. 21, 1974, L. Sickman to Helen Beals, Jan. 4, 1974, Box 7, "Gifts and Bequests," folders 13–16, Series III, Director Records: Sickman, RG 01/02, NAMAA.

28. Jane Wade Lombard to Henry Moore, April 1, 1974, "A Resolution," July 14, 1976, Frank Vaydik to Mayor Charles Wheeler, Laurence Sickman, and Henry Moore Sculpture Site Selection Committee, Sept. 24, 1975, and Henry Moore to Jane Wade Lombard," Aug. 28, n.y., Box 5, folder 1, Series III, Director Records: Sickman, RG 01/02, NAMAA.

29. "Comments of the Director," *Annual Report 1968*, *Annual Report 1969*, *Annual Report 1971*, NAMAA; L. Sickman to Helen Spencer, Jan. 3, 1969, Helen Spencer to Larry Sickman, Aug. 17, 1972, and Helen Spencer to L. Sickman, Sept. 26, 1972, Box 13, folder 14, Series III, Director Records: Sickman, RG 01/02, NAMAA.

30. Helen Spencer to Ralph T. Coe, Nov. 16, 1973, and Ted Coe to Helen Spencer, Nov. 15, 1973, Box 13, folder 14, Series III, Director Records: Sickman, RG 01/02, NAMAA.

31. "Report of the Assistant Director," "Comments of the Director," *Annual Report 1973*, NAMAA; Marc F. Wilson, interview with author, Nov. 30, 2018.

32. L. Sickman to Helen Spencer, Sept. 15, 1976, Box 13, folder 14, Series III, Director Records: Sickman, RG 01/02, NAMAA.

33. L. Sickman to Anne Keatley, Feb. 26, 1974, and "Archaeological Delegation," Box 9, folder 3, Series III, Director Records: Sickman, RG 01/02, NAMAA.

34. Coe, "Final Report to the National Endowment for the Humanities by the Nelson Gallery of Art," Box 7, folder 35, Series IV, Director Records: Coe, RG 01/03, NAMAA.

Chapter 16

1. Ruth Trelease to Coe, Jan. 22, 1977, Box 1, folder 2; Stuart Hutchinson to Coe, Feb. 21, 1977, and Germain Seligmann to Coe, Feb. 15, 1977, Box 1, folder 4; Kate Schaeffer to Coe, March 4, 1977, Box 1, folder 6, Series I, Sub-series A, Director Records: Coe, RG 01/03, NAMAA.

2. William Milliken to Coe, Jan. 31, 1977, Box 1, folder 1, Series I, Sub-series A, Director Records: Coe, RG 01/03, NAMAA; Father Thomas Wiederholt, interview with author, Sept. 13, 2018.

3. Coe to Friends of Art, Oct. 17, 1977, Box 1, folder 22, Series I, Sub-series A, Director Records: Coe, RG 01/03, NAMAA; "Comments of the Director," *Annual Report FY 1977–1978*, NAMAA.

4. June Finnell, "List of Ted's Speaking Engagements to Date," Feb. 28, 1977, Box 1, folder 3, and Coe to Taggart, Goheen, Stokstad, Sept. 30, 1977, Box 1, folder 8, Series I, Sub-series A, Director Records: Coe, RG 01/03, NAMAA; Coe to Wilder Green, Feb. 1, 1977, Green to Coe, Feb, 9, 1977, and "Itinerary, AFA Trustees' Trip," Feb. 18, 1977, Box 3, folder 39, Series IV, Director Records: Coe, RG 01/03, NAMAA.

5. "Testimony Before the Senate and House Appropriations Subcommittees," April 18 and 19, 1978, Box 7, folder 37, Series IV, Director Records: Coe, RG 01/03, NAMAA; Tim Doke to Ted Coe, June 20, 1977, Box 1, folder 8, Series I, Director Records: Coe, RG 01/03, NAMAA; *Annual Report FY 1977–1978*, NAMAA.

6. "Report of the Assistant Director," *Annual Report 1965*, NAMAA.

7. R. T. Coe to Adelyn Breeskin, Sept. 26, 1977, Box 1, folder 9, W. Howard Adams to Coe, n.d., and Coe to Adams, Dec. 12, 1977, Box 1, folder 11, Series I, Director Records: Coe, RG 01/03, NAMAA; "Comments of the Director," *Annual Report FY 1977–1978*, NAMAA.

8. Mary W. Runnells to L. Sickman, n.d., Sickman to Mrs. Runnells, Nov. 26, 1969, Oct. 19, 1970, and Jan. 2, 1975, McGreevy to Ted Coe and L. Sickman, Jan. 8, 1976, and McGreevy to Mrs. Runnells, June 15, 1977, Box 12, folder 8, Director Records: Sickman, RG 01/02, NAMAA.

9. "Comments of the Director," *Annual Report, 1977–1978*, "Comments of the Director," *Annual Report FY 1978–1979*, NAMAA.

10. L. Sickman to The Anonymous Donor, Dec. 12, 1979, and Coe to The Anonymous Donor, Jan. 19, 1979, Box 4, folder 1, Series IV, Director Records: Coe, RG 01/03, NAMAA; Marc Wilson, interview with author, Nov. 30, 2018; *Nelson-Atkins Museum of Art: Handbook* (2008), 340.

11. "Report of the Department of Oriental Art," *Annual Report FY 1978–1979*, NAMAA; Nelson Trust, Minutes, July 9, 1977, Vol. 14, NAMAA.

12. James C. Olson to Coe, June 13, 1978, and Archie Dykes to Coe, July 20, 1978, Box 1, folder 15, Series I, Sub-series A, Director Records: Coe, RG 01/03, NAMAA.

13. Nelson Trust, Minutes, Jan. 16 and 25, Feb. 1, and April 14, 1978, Vol. 15, NAMAA.

14. K. Haskins to R. T. Coe, Jan. 3, 1979, and Haskins to Coe, Nov. 6, 1979, Box 6, file 25, Series IV, Director Records: Coe, RG 01/03, NAMAA.

15. Coe to Helen Spencer, Jan. 3, 1981, Box 6, folder 27, Series IV, Director Records: Coe, RG 01/03, NAMAA.

16. "Comments of the Director," *Annual Report FY 1977–1978*, NAMAA.

17. "Comments of the Director," *Annual Report FY 1977–1978, Annual Report FY 1978–1979*, NAMAA; Ann Brubaker, "History of Education Department," Nov. 1980, Box 1, folder 1, Education Department Records, RG 32, NAMAA.

18. Nelson Trust, Minutes, Dec. 20, 1978, Vol. 15, NAMAA.

19. "Trustees' luncheon with Tom Gorman," Dec. 10, 1976, Box 13, folder 1, Series III, Director Records: Sickman, RG 01/02, NAMAA.

20. William A. Hall to Dr. Nicholas Pickard, Jan. 13, 1977, Box 13, folder 1, Series III, Director Records: Sickman, RG 01/02, NAMAA.

21. "Nelson Gallery Foundation: Statement of Need," Jan. 17, 1978, and "Revamp of Statement," Feb. 15, 1978, Box 13, folder 1, Series III, Director Records: Sickman, RG 01/02, NAMAA.

22. "Comments of the Director," *Annual Report FY 1979–1980*, NAMAA.

23. Robert I. Donnellan to Frederick L. Cummings, Sherman E. Lee, Nancy Hanks, Sir John Pope-Hennessey, Sept. 6, 1979, and "In the Circuit Court of Jackson County, Missouri," March 7, 1980, Box 6, folder 20, Director Records: Coe, RG 01/03, NAMAA; *Last Wills*, 11, 8.

24. "Atha Lectures," Box 15, folder 20, Series V, Director Records: Wilson, RG 01/04, NAMAA; Marc Wilson, *Annual Report FY 1980–1981*, NAMAA. Jeanne Harris would retire December 31, 1987 after having served in the Oriental Department since spring 1949.

25. Arthur C. Frantzreb, "State of Readiness Audit for Increased Philanthropic Support," 2, Nov. 1980, Box 4, folder 11, Series IV, Director Records: Coe, RG 01/03, NAMAA.

26. David R. Bywaters to Ted Coe, "Draft of Statements of Functions," Dec. 19, 1980, Box 6, folder 22, Series IV, Director Records: Coe, RG 01/03, NAMAA.

27. Ibid., 4; "Staff Reports for the Committee on the Future," Oct. 2, 1980, Box 4, folder 11, Series IV, Director Records: Coe, RG 01/03, NAMAA.

28. "Staff Reports for the Committee on the Future," 5–7, 17–18, 27–29, 8, Box 4, folder 11, Series IV, Director Records: Coe, RG 01/03, NAMAA.

29. "Comments of the Interim Director," *Annual Report, FY 1981–1982*, NAMAA.

30. Davis, *Big Picture*, 32.

31. "Comments of the Interim Director," *Annual Report, FY 1981–1982*, NAMAA.

32. Nelson Trust, Minutes, Dec. 21, 1981, and Jan. 20 1982, Vol. 15, NAMAA; "New Guidelines for the Future," Box 11, folder 3, Series III, Director Records: Wilson, RG 01/04, NAMAA.

33. Nelson Trust, Minutes, Jan. 20, 1982, Vol. 15, NAMAA; Cliff C. Jones to Chuck Blackwell, Jan. 30, 1982, Box 16, folder 10, Series V, Director Records: Wilson, RG 01/04, NAMAA.

34. Coe to Milton Gerod, Sept. 6, 1979, Box 1, folder 23, Series I, Sub-series A, Director Records: Coe, RG 01/03, NAMAA; Nelson Trust, Minutes, Oct. 19, 1981, Vol. 15, NAMAA.

35. Tom Freudenheim to Menefee D. Blackwell, Nov. 13, 1980, Box 7, folder 5, Series IV, Director Records: Coe, RG 01/03, NAMAA.

36. Coe to James W. Alsdorf, July 31, 1978, Box 1, folder 15, Series I, Director Records: Coe, RG 01/03, NAMAA; Nelson Trust, Minutes, March 8, 1982, NAMAA.

Chapter 17

1. "Comments of the Interim Director," *Annual Report FY 1981–1982*, NAMAA.

2. Memo to Board of Trustees from Marc Wilson, June 1982, Box 6, folder 27, Series III, Assistant Director Records, RG 99, NAMAA; Nelson Gallery Foundation, Trustees Minutes, Feb. 21, 1983, NAMAA.

3. "Job Description: Director/CEO," Box 11, folder 3, Series III, Director Records: Wilson, RG 01/04, NAMAA; Nelson Trust, Minutes, July 10 and Aug. 16, 1982, Vol. 15, NAMAA.

4. James Forbes, "Development Status Report," Dec. 17, 1982, Box 11, folder 2, Series III, Director Records: Wilson, RG 01/04, NAMAA; "The Vision," 50th Anniversary: Development and Fundraising Campaign, VF, NAMAA; Donald J. Hall and Carolyn Kroh to Friends of Art, Oct. 10, 1983, Box 1, folder 1, Series V, Director Records: Sickman, RG 01/02, NAMAA.

5. Marc Wilson, *Annual Report, FY 1983–1984*, NAMAA.

6. Laura Hockaday, "$51.5 million Gift Exceeds Jubilee Goal," *Kansas City Star*, Dec. 11, 1983, clipping in 50th Anniversary file, VF, NAMAA; Marc Wilson, *Annual Report, FY 1983–1984*, NAMAA.

7. Wilson to Board of Trustees, Nov. 25, 1983, Box 11, folder 5, Series III, Director Records: Wilson, RG 01/04, NAMAA.

8. Ann Brubaker to Marc Wilson, April 4, 1983, Box 11, folder 5, Series III, Director Records: Wilson, RG 01/04, NAMAA; Marc Wilson to John A. Morgan, March 3, 1983, and John A. Morgan to Marc Wilson, March 22, 1983, Box 21, folder 2, Series V, Director Records: Wilson, RG 01/04, NAMAA; Marc Wilson, "Comments of the Director," *Annual Report, FY 1985–1986*, NAMAA.

9. "Acquisition Committee—Organizational Meeting," April 16, 1982, Box 15, folder 11, Series V, Director Records: Wilson, RG 01/04, NAMAA; Marc Wilson, Memorandum to George McKenna, Wai-kam Ho, David Binkley, Robert Cohon, Dorothy Fickle, Feb. 8, 1988, Box 11, folder 11, Series III, Director Records: Wilson, RG 01/04, NAMAA.

10. *Last Wills*, 11; Nelson Trust, Minutes, July 28, 1979, Vol. 15, NAMAA; Marc Wilson, interview with author, Nov. 30, 2018.

11. Wilson to University Trustees and Associate Trustees, March 26, 1982, Box 11, folder 1, Series III, Director Records: Wilson, RG 01/04, NAMAA.

12. John Russell, *New York Times*, July 31, 1983, clipping attached to letter from Marc Wilson to Board of Trustees, Aug. 2, 1983, Box 11, folder 5, Series III, Director Records: Wilson, RG 01/04, NAMAA.

13. Marc Wilson, "Comments of the Director," *Annual Report FY 1983–1984*, NAMAA.

14. Nelson Trust, Minutes, March 15, 1982, Vol. 15, NAMAA; Carlos A. Rosas, "Frame Up," *Town and Country*, Oct. 1995, clipping in VF, "Roger Ward," NAMAA.

15. Marc Wilson, *Annual Report, FY 1983–1984*, NAMAA.

16. J. C. Nichols, "Opening of William Rockhill Nelson Gallery of Art and Mary Atkins Museum of Fine Arts," Dec. 11, 1933, Speeches, folder 37, Nichols Company Records, KC0106, SHSMO-KC.

17. Henry Adams, "Report of the Samuel Sosland Curator of American Art," *Annual Report, FY 1986–1987*, NAMAA; Marc Wilson, "Director's Report," *Annual Report FY 1990–1991*, NAMAA.

18. Marc Wilson, "Comments of the Director," *Annual Report FY 1987–1988*, NAMAA; Committee on the Collection Minutes, Nov. 14, 1986, Box 11, folder 8b, Series III, Director Records: Wilson, RG 01/04, NAMAA; Marc Wilson, interview with author, Nov. 30, 2018.

19. Marc Wilson, "Comments of the Director," *Annual Report FY 1983–1984*, NAMAA.

20. Marc Wilson, "Comments of the Director," *Annual Report FY 1983–1984*, NAMAA.

21. Ibid., Nelson Trust, Minutes, May 17 and July 19, 1982, Vol. 15, NAMAA.

22. Alberta McGrath, "Friends of Art Report," *Annual Report FY 1982–83*, NAMAA; Carolyn Kroh to Irv Hockaday and Marc Wilson re: Friends of Art, Feb. 29, 1984, Box 22, folder 8, and Marc Wilson to Michael Churchman, Nov. 28, 1985, Box 22, folder 10, Series V, Director Records: Wilson, RG 01/04, NAMAA; Marc Wilson to Diana James, Sept. 2, 1986, and Marc Wilson and Diana James to n.n., Oct. 30, 1986, Box 30, folder 36, Series V, Director Records: Wilson, RG 01/04, NAMAA.

23. Marc Wilson, "Comments of the Director," *Annual Report FY 1983–1984*, NAMAA.

24. Marc Wilson to n.n., "re: Friends of Art," n.d, Memo: Wilson to Michael Churchman with draft of letter to Friends of Art members, Nov. 25, 1985, Box 22, folder 8, NAMAA; Marc Wilson, "Comments of the Director," *Annual Report FY 1986–1987*, NAMAA.

25. Herman Sutherland to Marc Wilson, April 11, 1988, Box 20, folder 5, and "Horizons: Experience the Art of Our Times," Box 24, folder 26, Series V, Director Records: Wilson Records, RG 01/04, NAMAA.

26. Director and Staff to the Trustees, "Evening hours," Aug. 9, 1988, Box 22, folder 13, Series V, Director Records: Wilson, RG 01/04, NAMAA.

27. "The Business Council: A Capsule History," Box 16, folder 18, Series V, Director Records: Wilson, RG 01/04, NAMAA.

28. Ibid., Marc Wilson to Leonard Hershman, March 5, 1986, Box 16, folder 3, Robert H. West to Program Committee members of the Business Council, Sept. 10, 1987, Box 16, folder 15, Series V, Director Records: Wilson, RG 01/04, NAMAA.

29. "Dr. Nicholas S. Pickard," Dec. 1984 Monthly Calendar, Box 30, folder 30, Series V, Director Records: Wilson, RG 01/04, NAMAA; Marc Wilson, interview with author, Jan. 9, 2019.

30. "Membership Reorganization Plan," Box 30, folder 32, Series V, Director Records: Wilson, RG 01/04, NAMAA.

31. Marc Wilson to Blackwell, Sutherland, Hall, Feb. 23, 1988, Box 11, folder 11, Series III, Director Records: Wilson, RG 01/04, NAMAA.

32. Marc Wilson, "Summary," *Annual Report FY 1989–1990*, NAMAA.

33. Ibid.

34. Nelson Gallery Foundation, Trustees Minutes, Jan. 19, 1987, FY 1986–1991, NAMAA; Laurence Sickman to Don Hall, Jan. 9, 1986, Box 30, file 24, Series V, Director Records: Wilson, RG 01/04, NAMAA.

35. "Obituary: Herman R. Sutherland," *Kansas City Star*, Dec. 29, 2006.

36. Trustees of the Nelson Gallery Foundation, *Culinary Masterpieces*.

37. Marc Wilson to the University Trustees, June 30, 1993, Box 11, folder 15, Series III, Director Records: Wilson, RG 01/04, NAMAA.

Chapter 18

1. Marc Wilson to the Board of Trustees, March 4, 1992, Box 11, folder 12, Series III, Director Records: Wilson, RG 01/04, NAMAA; Board of Trustees Minutes, July 15, 1994, FY 1993–1996, NAMAA.

2. Denver Art Museum, "Mission and History," https://denverartmuseum.org/about/mission-history (accessed March 19, 2018); *Bold Expansion*, 9.

3. Marc Wilson, "Summary," *Annual Report FY 1995–1996*, and *Annual Report FY 1998–1999*, NAMAA.

4. "Henry Moore Sculpture Garden to Open in Kansas City, June 1989," press release, VF, Henry Moore Sculpture Garden, NAMAA; "Henry Moore Sculpture Garden," *Merit*, Nov. 1991, Box 16, folder 6, Series V, Director Records: Wilson, RG 01/04, NAMAA; "Director's Report," *Annual Report FY 1990–1991*, NAMAA.

5. Nelson-Atkins Museum of Art, "Shuttlecocks," www.art.nelson-atkins.org/objects (accessed Jan. 13, 2019); Marc Wilson, "Summary," *Annual Report FY 1994–1995*, NAMAA.

6. Board of Trustees Minutes, Nov. 15, 1993, Feb. 21, 1994, and Board of Trustees Minutes, FY 1993–1996, NAMAA.

7. Marc Wilson, "Summary," *Annual Report FY 1998–1999*, NAMAA; Trustees Minutes, June 20, 1994, Board of Trustees Minutes, 1993–1994, NAMAA.

8. Ann Brubaker, "Report of the Director of Education," *Annual Report FY 1991–1992, Annual Report FY 1996–1997, Annual Report, FY 1998–1999*, and *Annual Report, FY 2000–2001*, NAMAA.

9. Art Institute of Chicago, "Visit," https://artic.edu/visit (accessed March 20 and July 26, 2018).

10. Memo from Toni Wood with insight from Karen Christiansen, July 18, 2006, and "Free Museums: Nelson-Atkins Museum," n.d., both in Box 15, folder 8, Series V, Director Records: Wilson, RG 01/04, NAMAA; Marc Wilson, interview with author, Nov.

30, 2018; Lou Smith, "Finance Committee Report," April 18, 2005, Board of Trustees Minutes, May 2002–April 2007, NAMAA.

11. Marc Wilson, "Summary," *Annual Report FY 1993–1994*, *Annual Report FY 1997–1998*, and *Annual Report FY 2000–2001*, NAMAA.

12. In 2001 museum leaders chose the name "Department of American Indian Art" to align with the National Museum of the American Indian. Eighteen years later, the name "Native American" has emerged as the preferred designation of most Native peoples. Therefore, in June 2019, the department was renamed the "Department of Native American Art." However, according to Gaylord Torrence, both "American Indian" and "Native American" are respectful and appropriate designations to be used interchangeably in discussion, text, and common usage.

13. Committee on the Collections minutes, May 17, 2001, Board of Trustees Minutes, May 2002–April 2007, NAMAA; "Highlights," *Annual Report FY 2002–2003*, NAMAA.

14. Presentation by Catherine Futter to the Committee on the Collections, Oct. 18, 2002, and Presentation by Catherine Futter to the Committee on the Collections, Dec. 12, 2003, Board of Trustees Minutes, May 2002–April 2007, NAMAA; Catherine Futter, email to author, Jan. 7, 2019.

15. Presentation by Ian Kennedy to the Committee on the Collections, May 16, 2003, and Sept. 15 2006, Presentation by Catherine Futter to the Committee on the Collections, Dec. 15, 2006, Board of Trustees Minutes, May 2002–April 2007, NAMAA.

16. Marc Wilson, "Summary," *Annual Report FY 1998–1999*, NAMAA.

17. *Bold Expansion*, 15.

18. Ibid., 15, 16, 20; Marc Wilson, "Summary," *Annual Report FY 2000–2001*, NAMAA.

19. Marc Wilson, "Summary," *Annual Report FY 2000–2001*; Wilson, "Summary," *Annual Report FY 2001–2002*, NAMAA.

20. Marc Wilson, "Highlights," *Annual Report FY 2002–2003*, NAMAA.

21. "Ford Motor Company's Cultural Contributions in Kansas City," 2001 typescript, "Sponsor Statement: Ford Learning Center," and "Ford Free Fridays," VF, Drawer 2, NAMAA.

22. "Ford Learning Center: Fact Sheet," May 2, 2001, and "About the Nelson-Atkins Museum's Education Division," May 2, 2001, Box 22, folder 1, Series V, Director Records: Wilson, RG 01/04, NAMAA.

23. "Adelaide Cobb Ward Sculpture Hall Unveiled"; Adelaide Cobb Ward, interview with author, March 26, 2019.

24. Nelson-Atkins Museum of Art, "Donald J. Hall Sculpture Park," https://www .nelson-atkins.org/collection/donald-j-hall-sculpture-park/ (accessed Oct. 7, 2018); Jan Schall, "Committee on the Collections," April 21, 2011, Board of Trustees Minutes, 2010–2011, NAMAA.

25. Presentation by Marilyn Carbonell to the Board of Trustees, June 19, 2006, Board of Trustees Minutes, May 2002–April 2007, NAMAA.

26. "School and Teacher Services," and Jerry McEvoy to Christine Minkler, Nov. 12, 2007, Box 20, folder 30, Series V, Director Records: Wilson, RG 01/04, NAMAA.

27. Marc Wilson, "Summary," *Annual Report 2005–2006*, NAMAA; *Bold Expansion*, 48, 54; Davis, *Big Picture*, 42.

28. Marc Wilson, "Highlights," *FY Annual Report 2007–2008*, NAMAA; Father Thomas Wiederholt, interview with author, Sept. 13, 2018.

29. Chris Purcell, "Timeline," NAMAA.

30. Margi Conrads to Marc Wilson, Sept. 24, 2001, Box 16, folder 4, Series V, Director Records: Wilson, RG 01/04, NAMAA; Catherine Futter to the Committee on the Collections, March 14, 2008, Board of Trustees Minutes, 2007–2008, NAMAA.

31. Committee on the Collections, Nov. 12, 2009, Board of Trustees Minutes, NAMAA; Gaylord Torrence, notes on 2017 talk at Boston MFA, copy in Wolferman Collection.

32. Gaylord Torrence, notes on 2017 talk at Boston MFA, copy in Wolferman Collection; Gaylord Torrence to the Committee on the Collections, June 13, 2003, Dec. 17, 2004, and Oct. 13, 2006, Board of Trustees Minutes, May 2002–April 2007, NAMAA; "Acquisitions," *Annual Report 2009–2010*, NAMAA; Thorson, "Collector's Corner: Marc and Elizabeth Wilson," March 1, 2017, http:/kcstudio.org/collectors-corner-marc and elizabeth-wilson/.

33. Frese, "Ten Years after Opening, New Challenge for Bloch Building," *Kansas City Star*, June 7, 2017; Rosenbaum, "Elevating American Indian Art," *Wall Street Journal*, Jan. 12, 2010.

34. "Summary," *Annual Report FY 2001–2002*, NAMAA; Cohon to the Committee on the Collections, Sept. 13, 2002, and April 14, 2003, Board of Trustees Minutes 2002–2007, NAMAA; "Nelson-Atkins Museum of Art Egyptian Gallery"; "Nelson-Atkins Museum to Open New Egyptian Galleries"; Marc F. Wilson, interview with author, June 2, 2019.

Chapter 19

1. Spencer, "After nearly three decades as director, the Nelson-Atkins Museum of Art's Marc Wilson retires today"; Morton Sosland, "Is this an election or isn't it?" March 15, 2004, Box 22, folder 5, Series V, Director Records: Wilson, RG 01/04, NAMAA.

2. Russell Reynolds Associates, "Position Specifications, Director/CEO The Nelson-Atkins Museum of Art," Box 9, Director Records: Zugazagoitia, RG 01/05, NAMAA. Longtime University Trustee Menefee (Chuck) Blackwell and his wife, Mary Lou, left their entire estate to the Nelson-Atkins Museum of Art. Thus, the directorship was thereafter named for them.

3. Board of Trustees Minutes, June 21, 2010, NAMAA.

4. Board of Trustees Minutes, July 20, 1992, NAMAA.

5. Board of Trustees Minutes, Oct. 21, 2013, and Sept. 15, 2014, NAMAA.

6. Julián Zugazagoitia, interview with author, Sept. 26, 2018.

7. Board of Trustees Minutes, May 19, 2014, NAMAA; Karen Christiansen, interview with author, July 24, 2018.

8. Board of Trustees Minutes, Sept. 10, 2012, NAMAA.

9. Committee on the Collections, Dec. 14, 2012, Board of Trustees Meeting Minutes, 2011–2012, and Committee on the Collections, Nov. 13, 2013, Board of Trustees Minutes, 2013–2014, NAMAA; "Plains Indians Masterworks at Nelson-Atkins."

10. Board of Trustees Minutes, Oct. 11, 2012, and Oct. 14, 2016, NAMAA.

11. Anne Manning to the Board of Trustees, "Family Festivals," June 30, 2016, Board of Trustees Minutes, NAMAA.

12. "William Rockhill Nelson Society," April 20, 2011, Box 17, Director Records: Zugazagoitia, RG 01/05, NAMAA.

13. Board of Trustees Minutes, April 25, 2011, May 20, 2013, and May 19, 2014, NAMAA.

14. "Audio Guides, 2004–2007," Box 15, folder 17, Series V, Director Records: Wilson, RG 01/04, NAMAA; Board of Trustees Minutes, Oct. 18, 2010, NAMAA.

15. Report from Judy Koke, Director of Education and Interpretative Programs, Board of Trustees Minutes, June 17, 2013, NAMAA.

16. Committee on the Collections, June 16, 2011, Board of Trustees Minutes 2011–2012, NAMAA; Martin, "New Photography Acquisitions"; Davis, *Big Picture*, 50.

17. Henry Bloch to Ted Coe, Nov. 1, 1995, letter posted in Bloch Galleries, NAMA.

18. Committee on the Collections, March 15, 2012, Board of Trustees Minutes 2011-2012, NAMAA; Thomas Bloch, interview with author, Feb. 23, 2019; Galante, "Strange Story of How a $10 million Painting"; Degas, *Dancer Making Points*, www.art.nelson -atkins.org/objects/55627/dancer-making-points.

19. Adler and Smith, "Henry Bloch, Co-founder of H & R Block, Dies at 96," April 24, 2019, *Kansas City Star*.

20. "Twenty-first Century Museum Governance," Feb. 23, 2016, Board of Trustees Minutes, NAMAA; Karen Christiansen, email to author, Jan. 5, 2019.

21. Rick Green to Friends, Members, and Art Patrons.

BIBLIOGRAPHY

Printed Sources

"Adelaide Cobb Ward Sculpture Hall Unveiled." *Art Daily*, November 5, 2005. artdaily.org/news/15404/Adelaide-Cobb-Ward-Sculpture-Hall-Unveiled#.XUIaRi-2ZOCd (accessed April 29, 2019).

Adler, Eric, and Joyce Smith. "Henry Bloch, Co-founder of H & R Block, Dies at 96." *Kansas City Star*, April 24, 2019.

"An Art Gallery Three Years Growing." *Literary Digest* 116 (Dec. 30, 1933): 21.

Baxter, Katherine. *Notable Kansas Citians of 1915–1916–1917-1918*. Kansas City, MO: Kellogg-Baxter Printing, 1925.

Bold Expansion: The Nelson-Atkins Museum of Art Bloch Building. Kansas City, MO: Nelson-Atkins Museum of Art in association with Scala Publishers, 2007.

Brown, A. Theodore, and Lyle W. Dorsett. *K.C.: A History of Kansas City, Missouri*. Boulder, CO: Pruett Publishing, 1978.

Cart, Doran. "From the Survey." *Historic Kansas City Foundation Gazette* 10, no. 3 (May/June 1986): 7.

Churchman, Michael, ed. *Laurence Sickman: A Tribute*. Kansas City, MO: Nelson-Atkins Museum of Art, 1988.

The City Art Museum of St. Louis: Handbook of Collections. St. Louis, MO: Buxton and Skinner, 1953.

Clark, Frances O'Donnell, and Georgia H. Langworthy. "The Early Years." Unpublished paper. Copy in author's personal collection.

Curl, Sara. "The William Rockhill Nelson Gallery of Art and the Atkins Museum of Fine Arts." *Teachers College Scout* 5, no. 1 (April 1934): 35,36.

Davis, Keith F. *The Big Picture: The Hallmark Photographic Collection at the Nelson-Atkins Museum of Art*. Kansas City, MO: Hall Family Foundation in association with the Nelson-Atkins Museum of Art, 2018.

Ehrlich, George. *Kansas City, Missouri: An Architectural History, 1826–1990*. Revised and enlarged edition. Columbia: University of Missouri Press, 1992.

Everard, L. C. "Museums and Exhibitions." In *Encyclopedia of the Social Sciences*, 11:138–42. New York: Macmillan, 1933.

Fowler, Richard B. *Leaders in Our Town*. Kansas City, MO: Burd Fletcher, 1952.

Frese, David. "Ten Years after Opening, New Challenge for Bloch Building." *Kansas City Star*, June 7, 2017.

Galante, Meredith. "The Strange Story of How a $10 million Painting Owned by Heiress Huguette Clark Wound Up on the Wall of an Art Collector." *Business Insider*, March 15, 2012.

Gallery Tour Booklet for Docents. Kansas City, MO: Education Department, William Rockhill Nelson Gallery of Art and Mary Atkins Museum of Fine Arts, 1971.

Gilbertson, Catherine P., ed. *The Barstow School Through Eighty Years*. Kansas City, MO: Barstow School, 1965.

Glaab, Charles N., and A. Theodore Brown. *A History of Urban America*. 3rd ed. New York: Macmillan, 1983.

Green, Rick. Letter to Friends, Members, and Art Patrons. *Art and Soul* (Nelson-Atkins Museum of Art), Winter 2019: 15.

Harris, Nancy Whitnell. "The Development of the Educational and Cultural Center in Kansas City's Brush Creek Valley." Master's thesis, University of Missouri-Kansas City, 1988.

Hartt, Mary Bronson. "Docentry: A New Profession." *Outlook* 94 (March 26, 1910): 701–8.

Haskell, Harry. *Boss-Busters and Sin Hounds: Kansas City and Its Star*. Columbia: University of Missouri Press, 2007.

Haskell, Henry J., et al. *The William Rockhill Nelson Gallery of Art and Mary Atkins Museum of Fine Arts: Founders and Benefactors*. Kansas City, MO: n.p., 1939.

Hoffman, Donald. "In the Beginning." *Kansas City Star Magazine*, April 24, 1983, 18.

"In Society." *Kansas City Star*, June 3, 1900.

"Jacquemot-Salmon: Marriage of the High School Instructor in French and German." *Kansas City Star*, April 20, 1894.

"John S. Wolcott House." Posted on www.jcprd.com, March 8, 2018. Reprinted from the Johnson County Museum's *Album* 14, no. 3 (Summer 2001).

Johnson, Icie F. *William Rockhill Nelson and the Kansas City Star*. Kansas City, MO: Burton Publishing, 1935.

"Kansas City, William Rockhill Nelson Gallery of Art." *Museums Journal* 33 (Feb. 1934): 417.

"Kansas City's New Museum." *American Magazine of Art* 26, no. 12 (Dec. 1933): 523–30.

Keppel, Frederick P., and R. L. Duffus. *The Arts in American Life*. New York: McGraw Hill, 1969.

The Last Wills: William Rockhill Nelson, Mr. Ida H. Nelson, Mrs. Laura Nelson Kirkwood, Frank F. Rozzelle, Mrs. Mary Atkins. Kansas City, MO: New England National Bank and Trust Co, 1927.

Lerman, Leo. *The Museum: One Hundred Years and the Metropolitan Museum of Art*. New York: Viking Press, 1969.

Mallon, MacKenzie. "Discriminating Thieves." *Art and Soul* (Nelson-Atkins Museum of Art), Winter 2019, 5.

Marcus, George H., ed. *Treasures of the Philadelphia Museum of Art and the John G. Johnson Collection*. Philadelphia: Philadelphia Museum of Art, 1973.

Martin, James. "New Photography Acquisitions Fill Out 'The Big Picture' at the Nelson-Atkins." *KC Studio* (May/June 2018): 100–101.

Millstein, Cydney. "Citybuilders to the Nation." *Corporate Report* 12 (Feb. 1986): 39.

Mitchell, Giles Carroll. *There Is No Limit: Architecture and Sculpture in Kansas City*. Kansas City, MO: Brown-White, 1934.

Mobley, Jane. "Business Is Blooming." *Corporate Report* 12 (Feb. 1986): 36–40.

Nelson-Atkins Museum of Art. "Nelson Atkins Receives $1 Million Grant from Beals Trust." Press release, Jan. 11, 2016. www.nelson-atkins.org/9916-2/ (accessed June 2, 2018).

The Nelson-Atkins Museum of Art: A Handbook of the Collection. Kansas City, MO: Nelson-Atkins Museum of Art, 2008.

"Nelson-Atkins Museum of Art Egyptian Art Gallery in the Susan B. and Mark A. Susz Galleries." *Architect* magazine website: Project, posted June 10, 2013. https://www.architectmagazine.com/project-gallery/nelson-atkins-museum-of -art-egyptian-art-gallery-in-the-susan-b-and-mark-a-susz-galleries (accessed May 24, 2019).

"Nelson-Atkins Museum to Open New Egyptian Galleries." *Art Daily*, June 3, 2010. http://artdaily.com/news/37923/Nelson-Atkins-Museum-in-Kansas-City-to -Open-New-Egyptian-Galleries-#.XPUtA1NKj2Q (accessed May 24, 2019).

"New Art Gallery for Kansas City." *Christian Century*, Jan. 24, 1934, 132.

Newcomb, Russell. "Museums Thrive on the Depression?" *American Mercury* 32 (Aug. 1934): 468–72.

"Obituary: Herman Sutherland." *Kansas City Star*, Dec. 29, 2006.

Pach, Walter. *The Art Museum in America*. New York: Pantheon Books, 1948.

Pickard, Dr. Nicholas. "People in the Nelson Gallery: A History of the Friends of Art." Unpublished paper. Copy in NAMAA.

"Plains Indians Masterworks at Nelson-Atkins after Popular Paris Run." *Auction Central News*, Sept. 11, 2014.

Reddig, William M. *Tom's Town: Kansas City and the Pendergast Legend*. 1947. Reprint, Columbia: University of Missouri Press, 1986.

Report of the Superintendent of Schools of the School District of Kansas City, Missouri: Year Ending June 30, 1900. Kansas City, MO: School District of Kansas City. https://archive.org/details/reportofsuperint1899kans (accessed June 10, 2018).

Rosenbaum, Lee. "Elevating American Indian Art." *Wall Street Journal*, January 12, 2010.

Rowlands, Eliot. "'An Excellent Art Scout': Harold Woodbury Parsons (1882–1967) and the Formation of the European Collections at the Art Museums of Cleveland and Kansas City." Unpublished paper, 2017. Copy provided by the author.

Sandy, Willa. *Here Lies Kansas City: A Collection of Our City's Notables and Their Final Resting Places*. Kansas City, MO: Bennett Schneider, 1984.

Schirmer, Sherry Lamb, and Richard D. McKinzie. *At the River's Bend: An Illustrated History of Kansas City*. Woodland Hills, CA: Windsor Publications, 1982.

Simpson, Clarence W. *A History of the Founding and First Forty Years of the William Rockhill Nelson Gallery of Art and Mary Atkins Museum of Fine Arts*. Kansas City, MO: University Trustees, Nelson Trust, 1976.

Small, Lawrence M. "A Passionate Collector." *Smithsonian Magazine,* Nov. 2000. https://www.smithsonianmag.com/history/a-passionate-collector-33794183/.

"So Does Oak Hall." *Kansas City Star*, July 24, 1988.

Spaeth, Eloise. *American Art Museums: An Introduction to Looking*. New York: McGraw-Hill, 1960.

Spencer, Laura. "After nearly three decades as director, the Nelson-Atkins Museum of Art's Marc Wilson retires today." KCUR, June 1, 2010. https://www.kcur.org /post/last-day-director-nelson-atkins-museum-arts-marc-wilson#stream/0 (accessed Feb. 21, 2018).

Staff of the *Kansas City Star. William Rockhill Nelson: The Story of a Man, a Newspaper, and a City*. Cambridge, MA: Riverside Press, 1915.

Sutton, Denys. "Editorial: The Colonel's Gift." *Apollo 96* (Dec. 1972): 470.

Taggart, Ross E., George L. McKenna, and Marc F. Wilson, eds. *Handbook of the Collections in the William Rockhill Nelson Gallery of Art and Mary Atkins Museum of Fine Arts*. 5th ed., 2 vols. Kansas City, MO: University Trustees, William Rockhill Nelson Trust, 1973.

The Toledo Museum of Art—1988 Annual Report. Toledo, OH: n.p., 1983.

Thorson, Alice. "Collector's Corner: Marc and Elizabeth Wilson." http://kcstudio.org /collector's corner-marc-and-elizabeth-wilson (accessed March 1, 2017).

Trustees of the Nelson Gallery Foundation. *Culinary Masterpieces*. New York: Rizzoli International Publications, 1993.

"Weddings: Sarah Foresman Weds Ralph T. Coe." *Kansas City Star*, Aug. 31, 1961.

The Western Gallery of Art Illustrated Catalogue. Kansas City, MO: Kansas City Art Association, 1897.

Who's Who in America. Vol. 17, 1932–33; Vol. 20, 1938–1939; Vol. 26, 1950–51; Vol. 27, 1952–53. Chicago: A. N. Marquis, 1933–1953.

Wilson, William H. *The City Beautiful Movement in Kansas City*. Columbia: University of Missouri Press, 1964.

Wittke, Carl. *The First Fifty Years: The Cleveland Museum of Art, 1916–1966*. Cleveland: John Huntington Art and Polytechnic Trust and Cleveland Museum of Art, 1966.

Worley, William S. *J. C. Nichols and the Shaping of Kansas City: Innovation in Planned Residential Communities*. Columbia: University of Missouri Press, 1990.

Manuscript Collections

Commerce Bank of Kansas City, Country Club Plaza.
Atkins Trustees, Atkins Scrapbook. (When James Miller was an Atkins trustee, this scrapbook was at Commerce Bank; its current whereabouts are unknown.)

Kansas City [MO] Public Library
Missouri Valley Special Collections (MVSC), Photos; Clippings files: Mary Atkins
 file, John F. Downing file, Herbert V. Jones file, Irwin Kirkwood file, Laura Kirk-
 wood file, John C. Long file, Frank Rozzelle file, Fred Cameron Vincent file, John
 E. Wilson file.
Plaza Library clippings files: Biography Files.

The Nelson-Atkins Museum of Art (NAMA)
Accession Records, Office of the Registrar (OR)
Nelson-Atkins Museum of Art Digital Asset Archive (NAMADAA)
VRL Slide Collection (VRLSC)

The Nelson-Atkins Museum of Art Archives (NAMAA)
Annual Reports
Board of Trustees Minutes
Bruce Mathews Strauss-Peyton Photograph Collection, MSS 21
Education Department Records, RG 32
Ellen Goheen Files, RG 95
Ephemera Collection, RG 70
Event Planning Records, RG 45
Friends of Art Records, RG 43/02
Generations Capital Campaign Committee Records, RG 40/01
High Ideals and Aspirations Records, RG 73
Jane Rosenthal Scrapbook, MSS 006
J. C. Nichols Trust Files, RG 80/10
Laura Nelson Kirkwood Collection, MSS 004
Laurence Sickman Papers, MSS 001
Lisa Campbell Ernst—Mary Atkins Collection, MSS 020
Magic Theater Records, RG 24/01
Mary Atkins Collection, MSS 003, MS 119
Mary Clifton Womer Papers, MSS 08
Office of the Assistant Director, RG 99
Office of the Director Records, Paul Gardner Files, RG 01/01
Office of the Director Records, Laurence Sickman Files, RG 01/02
Office of the Director Records, Ralph T. Coe Files, RG 01/03
Office of the Director Records, Marc Wilson Files, RG 01/04
Office of the Director Records, Julián Zugazagoitia, RG 01/05
Paul Gardner Papers, MSS 02
Purcell, Chris, "Timeline."
Scrapbook Collection, RG 72
Spencer Art Reference Library Records, RG 30
Thomas Hart Benton: An American Original Records, RG 24/50
Vertical File (VF)
VRL Digital Collection (VRLDC)

Westport Garden Club Records, RG 71/01
William Rockhill Nelson Gallery Foundation, Trustees' Minutes
William Rockhill Nelson Trust, Trustees Minutes.
William Rockhill Nelson Trust Office Records, RG 80/15

State Historical Society of Missouri
University of Missouri, President's Office, Papers, 1892–1966 (C2582), SHSMO.

State Historical Society of Missouri Research Center, Kansas City
J. C. Nichols Company Records (KC0106), SHSMO-KC.
William Volker and Company Records (KC0059), SHSMO-KC.

Other Archival Sources and Private Collections
Brous, Mary Lou. Private Collection.
Cooper, Lindsay Hughes. Private Collection.
The Independent (magazine) Archives.
Jones, Russell S. Private Collection.
Kroh, Carolyn. Private Collection.
Patterson, Craig Wight. Private Collection: Elsa Symonds Wight Scrapbook; William
 Wight's notebook; various papers.
Wolferman, Kristie. Private Collection: Docents' Papers; Notes; Correspondence.

Interviews

Bloch, Thomas. Interview with author, February 23, 2019, Kansas City, MO.
Brous, Mary Lou. Interview with author, July 11, 2018, Mission Hills, KS.
Christiansen, Karen. Interview with author, July 24, 2018, Kansas City, MO.
Clark, Frances O'Donnell. Interview with author, April 25, 1986, and July 27, 1992,
 Kansas City, MO.
Cooper, Lindsay Hughes. Interview with author, January 20, 1986, June 14, 1991, and
 August 10, 1992, Kansas City, MO.
Evans, Frederica Smeltzer. Telephone interview with author, April 7, 1986.
Goheen, Ellen. Interview with author, June 29, 2018, Kansas City, MO.
Ingram-Eiser, Sarah. Interview with author, August 31, 2018, Kansas City, MO.
Jones, Russell. Interview with author, August 6, 1992, Shawnee Mission, KS.
Miller, Patricia Cleary. Interview with author, June 28, 2018, and September 7, 2019,
 Kansas City, MO.
Sickman, Laurence. Telephone interview with author, April 7, 1986.
Thomson, Christine Preston. Interview with author, December 5 and December 26,
 1992, Kansas City, MO.
Torrence, Gaylord. Interview with author, October 25, 2018, and January 30, 2019,
 Kansas City, MO.
Ward, Adelaide Cobb, Interview with author, March 26, 2019, Kansas City, MO.
Wiedcrholt, Father Thomas. Interview with author, September 13, 2018, Kansas City,
 MO.
Wight, Jean Rosahn. Telephone interview with author, August 11, 1992.

Wilson, Marc. Interview with author, November 30, 2018, Kansas City, MO; Telephone interview with author, January 9, February 19, and June 2, 2019.
Zugazagoitia, Julián. Interview with author, February 23 and September 26, 2018, Kansas City, MO.

Internet Sites

Art Institute of Chicago. www.artic.edu, accessed March 20 and July 26, 2018.
Denver Art Museum. www.denverartmuseum.org, accessed March 19, 2018.
Ford Foundation. www.fordfoundation.org, accessed July 28, 2018.
Minneapolis Institute of Art. www.artsmia.org, accessed March 4, 2018.
Monuments Men Foundation. www.monumentsmenfoundation.com, accessed May 2018.
Museum of Fine Arts, Boston. www.mfa.org, accessed February 16, 2018.
National Endowment for the Arts. www.arts.gov, accessed July 31, 2018.
Nelson-Atkins Museum of Art. www.nelson-atkins.org, accessed repeatedly.
Philadelphia Museum of Art. www.philamuseum.org, accessed March 13, 2018.
Samuel H. Kress Collection. www.kressfoundation.org, http://www.kressfoundation.org/collection/repositorymap.aspx?id=72, accessed June 10, 2018.

INDEX

Note: Page numbers in *italics* refer to illustrations.

86–87; envisions a mirror lake, 76, 77, 317;
builds art collection, 83–109 passim, 160–
162; opening speech, 120, 288; educational
concerns, 142, 144; role in setting museum
policy, 151–163 passim; develops wartime
relationship with acting director,170–179;
death in 1950, 186; J.C. Nichols Courtyard,
317; mentioned, 168, 187

Nichols, Jessie (Mrs. J. C.), 119, 152

Nichols, Miller and Jeannette, 169, 317

Noguchi, Isamu, 309; fountain designed by,
320; Isamu Noguchi Sculpture Court, 325

Nolde, Emil, *Masks,* 155, *156*fig. 11.1

O

O'Donnell, Frances: administered docent
program, 144–147, 148; background, 144;
hired as director of junior education, 144,
157–158; reminisces, 121, 151, 152; starts
children's art classes, 148–149

Oak Hall: as bequest to Irwin Kirkwood, 39–
40; as Nelson's home, 26, *27*fig. 2.2, 28, 31,
36; as site for Nelson-Atkins Museum, 49,
58, 59; estate from, 62–63, 118, 176–177;
razing, 40–41; mentioned, 336

Oldenburg, Claes and Coosje van Bruggen,
*Shuttlecocks, 308*fig. 18.2, 308, 333

Olmsted, Frederick Law: as designer
of Central Park, 3, 24; of Columbian
Exposition, 12; mentioned, 79

Olson, Dr. James C.: as University of Missouri
president, 267; as executive director of the
Society of Fellows, 297

Opie, John, *Portrait of Thomas Gertin,* 88, 89

Oppenheimer, Pat and Tony, 294

Oppenstein Brothers Foundation, 285

Oriental Art: collection, 195, 196, 267;
Department received Hall Family grant,
283; Sickman became curator of, 167;
Wilson became curator of, 243; *See also*
Asian Art, Chinese Art, Japanese Art

Oudry, Jean-Baptiste, 279, 287, 292

P

Panini, Giovanni Paolo, *View of the Piazza del
Popolo, Rome,* 264

Paolo, Giovanni di, 190

Park Board. *See* Kansas City Park Board

Parker B. Francis III Foundation, 270

Parker-Grant Gallery, 155, 244–246, *246*fig.
15.7, 247; mentioned, 327

Parker, Gerald, 244, 245, 246

Parker, Inez Grant (Mrs. Gerald), 154, 155,
227, 244–246

Parkin, Margaret R., 218

Parsons, Harold Woodbury: as advisor to
Cleveland Museum of Art, 64, 85–86;
appointed art adviser to Nelson Trust,
86; background, 85–86; influence on
collection, 86–95 passim, 117, 152–153,
160, 162, 173, 174; services no longer
needed, 187–188; mentioned, 128

Pater, Jean Baptiste, *L'Accord Parfait,* 162

Patterson, Marilyn P. (Mrs. Doyle), 217

Peale, Charles Wilson, 3; *Portrait of Catherine
and Elizabeth Hall,* 289

Peale, Raphaelle, *Venus Rising from the Sea-A
Deception,* 161, *161*fig. 11.3, 326

Peale, Rembrandt, 135

Peeke, Colonel C. M., 227

Pendergast, Jim and Tom, 23, 24, 46, 55, 71

Penn Valley Park: as civic center, 18, 48,
59–60; as location for Atkins Museum, 43,
47, 49, 74

Performing Arts Foundation of Kansas City,
236

Period rooms: American, 108–109, 121; 131,
134–135; Georgian and French Regency
installed, 134, 288; installation of, 81;
mentioned, 146, 186, 207, 288, 314

Philadelphia Museum of Art, 45, 62, 96

Philharmonic Orchestra. *See* Kansas City
Philharmonic Orchestra

Phinney, Margaret Weltmer (Mrs. Robert),
253

Photography: beginning of fine arts
collection of, 196, 199; exhibits, 196–197,
292, 326, 338; Hall Family Foundation
transformative gift for, 344–345; Hallmark
Photographic Collection, 323–324; *324*fig.
18.10; new 3,000 foot gallery designated
for, 324; Sales and Rental Gallery shows
of, 278; studio for, 63; *The Big Picture,* 344,
*345*fig. 19.5

Piacentini, Michelangelo, 183